SPEAK
TRUTH
TO
POWER

SPEAK TRUTH TO POWER

HUMAN RIGHTS DEFENDERS WHO ARE CHANGING OUR WORLD

KERRY KENNEDY

PHOTOGRAPHS BY EDDIE ADAMS

EDITED BY NAN RICHARDSON

UMBRAGE EDITIONS | NEW YORK, NY

DEDICATION

To the memory of Digna Ochoa,
who died for her work in human rights in Mexico,
and for Anonymous,
and all the unsung who show us
not how to be saints,
but how to be fully human

For our children—
Cara, Mariah, and Michaela—
and yours.
—Kerry Kennedy

To Adelaide Suprano Adams,
ninety-seven years old,
the most beautiful woman
I know and love. Thank you, Mom,
for making me understand
the meaning of life.
—Eddie Adams

The generous support of the following individuals and foundations
made this book and its accompanying exhibition and education campaign, including the website *www.speaktruth.org*, possible:
Daniel and Ewa Abraham, Tom Adams and Jeanna Lavan, Elliot Broidy, Peter L. Buttenwieser, Ron and Beth Dozoretz, Gail and Al Engelberg,
Tom Gibson, Jane and Mark Hirsh, Matt Gohd Family Foundation, David and Storrie Hayden, Alexandra, Teddy, and Audrey King, Sidney Kimmel,
Cheryl and Hani Masri, Lynne O'Brien, The Pittman Family Foundation, Joseph E. Robert, Jr., Robert H. Smith, Mary and Steven Swig,
Carrie Trybulec, Vardis and Marianna Vardinoyannis, Agnes Varis and Agvar Chemicals Inc., Kevin Ward, Lou Weisbach, and Dirck and Daniel Ziff;
Assemblages.com, Inc., The Arca Fund, Apotex Corporation, Byron Chemical Company, Inc., Cabell Brand, Coudert Brothers, Faulding Pharmaceuticals,
The Paul and Phyllis Fireman Fund, The Fleet Foundation, eshare communications, Furthermore, the publication program of The J. M. Kaplan Fund,
The Marjorie Kovler Fund, KRKA, d.d.,The General Motors Foundation, Global Emerging Markets North America, Inc.,
Impax Laboratories, Inc., The John F. Kennedy Center for Performing Arts, The Joseph P. Kennedy, Jr. Foundation,
The Robert F. Kennedy Memorial, NOVO MESTO, The Open Society Institute, Ranbaxy Pharmaceuticals, Inc., The Reebok Foundation,
Samson Medical Technologies, L.L.C., Screamingmedia Inc., The Beatrice Snyder Foundation, Stonyfield Farm;
American Airlines, Arti Transcribers, Four Seasons Hotels, Marriott Hotels,
Northwest Airlines, Starwood Hotels, Umbrage Editions, United Airlines.

TABLE OF CONTENTS

INTRODUCTION
BY KERRY KENNEDY

In a world where there is a common lament that there are no more heroes, too often cynicism and despair are perceived as evidence of the death of moral courage. That perception is wrong. People of great valor and heart, committed to noble purpose, with long records of personal sacrifice, walk among us in every country of the world. I have spent the last two years traveling the globe to interview the fifty-one individuals from nearly forty countries and five continents included in these pages, people whose lives are filled with extraordinary feats of bravery. I've listened to them speak about the quality and nature of courage, and in their stories I found hope and inspiration, a vision of a better world.

The individuals portrayed here include the internationally celebrated, such as Baltasar Garzón of Spain, Vaclav Havel of the Czech Republic, Sister Helen Prejean and Marian Wright Edelman of the United States, and Muhammad Yunus of Bangladesh, as well as Nobel Prize laureates His Holiness the Dalai Lama, Archbishop Desmond Tutu, Elie Wiesel, Oscar Arias Sánchez, Rigoberta Menchú Tum, José Ramos-Horta, and Bobby Muller. But the vast majority of these defenders of human rights are mostly unknown and (as yet) unsung beyond their national boundaries, such as environmental feminist Wangari Maathai of Kenya, former sex slave and leading abolitionist Juliana Dogbadzi of Ghana, domestic violence activist Marina Pisklakova of Russia, mental disability-rights advocate Gabor Gombos of Hungary, leading human rights lawyers Asma Jahangir and her sister Hina Jilani of Pakistan, and over thirty more.

For many of these heroes, their understanding of the abrogation of human rights has been profoundly shaped by their personal experiences: of death threats, imprisonment, and in some cases, bodily harm. However, this is not, by any measure, a compilation of victims. Rather, courage, with its affirmation of possibility and change, is what defines them, singly and together. Each spoke to me with compelling eloquence of the causes to which they have devoted their lives, and for which they are willing to sacrifice them—from freedom of expression to the rule of law, from environmental defense to eradicating bonded labor, from access to capital to the right to due process, from women's rights to religious liberty. As the Martin Luther Kings of their countries, these leaders hold in common an inspiring record of accomplishment and a profound capacity to ignite change.

Told in the defender's own voices, the interviews in this book provoke fundamental questions for the reader: why do people who face imprisonment, torture, and death, continue to pursue their work when the chance of success is so remote and the personal consequences are so grave? Why did they become involved? What keeps them going? Where do they derive their strength and inspiration? How do they overcome their fear? How do they measure success? Out of the answers emerges a sympathetic and strength-giving portrait of the power of personal resolve and determination in the face of injustice.

These fundamental questions have a special interest for me personally. As a mother of three young girls, I deeply wished to understand if there were steps I could take to encourage my own daughters to develop similar attributes, or if moral courage was something certain people are born with, inherently, while the rest of us (with our own lesser sensibilities) are left to muddle through. If we are capable of less, then are we off the hook? Condemned to be sinners, is there any point in striving to be saints?

With these considerations in mind, then, the criteria for the decisions that went into this narrow selection of individuals were complex. After nineteen years in the human rights field, there were certain individuals with whom I had worked and knew intimately that I wanted to include. There were certain

issues I thought should be represented as well as specific countries with egregious violations to highlight. I called upon friends and colleagues from human rights organizations across the world to suggest women and men dramatically changing the course of events in their respective communities and countries. From the outset, the goal was to show the range of these activities, their omnipresence in every continent, and the number of men and women alike participating in them. The resulting group (though so many other "heroes" are out there, their accomplishments enough fill a veritable encyclopedia) combine a wonderful mixture of absolute self-confidence and disarming humility. And some strong themes in their interviews began to emerge.

Almost all spoke about their faith in a higher power, most referenced a structured religion, a number had ambitions at some point to join a religious order, and at least six actually have (The Dalai Lama, Desmond Tutu, Bishop Wissa, Digna Ochoa, Dianna Ortiz, and Helen Prejean). Many talked more generally about being called to their work by some outside force. Juliana Dogbadzi spoke of "a calling," while Archbishop Desmond Tutu compared such an avocation to the prophets of old, with words burning in their throats. Fauziya Kassindja attributed her salvation to part of a divine plan wherein, "Everything happens for a purpose and whatever happens is destined," concluding, "God made this possible."

Strikingly, most of the defenders expressed an overpowering inner conviction, a driving force that helped sustain their path, in spite of dark moments. Gabor Gambos expressed it succinctly: "I had no alternative [but to] take up this role and find myself, or leave it and be lost forever." Ka Hsaw Wa explained how he overcame his own self-recriminations: watching many of his former classmates return from the United States with money and PhDs, he asked himself, "What am I doing...I don't gain anything for myself and I can't seem to do any-

thing to lessen the suffering....I blame myself for not being able to do enough," by coming to the recognition that, "If I turn my back and walk away, there would be no one to address the issue." Hafez Abu Seada and Zbigniew Bujak echoed that sentiment, speaking of taking on the task in order to help the next generation: "If not us, who else?" Koigi wa Wamere spoke of the long road a human rights defender must walk, and of the difficulty in returning to the struggle once you knew the consequences, but like José Ramos-Horta, remembered, "the spirits of those telling me to fight on," and stayed the course. Some described themselves, existentially enough, as dissidents through accidents of fate, like Vaclav Havel and Rigoberta Menchú Tum. Perhaps Harry Wu put the dilemma of personal sacrifice most clearly when he explained, "Once in exile, why shouldn't I have enjoyed the rest of my life? Why did I need to go back to China? The answer is that I tried to enjoy it, but I felt guilty—especially when people were calling Harry Wu a hero." Selflessness for a greater good was a refrain echoed by his compatriot Wei Jingsheng, who said, "It is impossible to balance personal life and commitment to your country when you face a massive oppressor. Your responsibility has to be with those who suffer. And if you do not fight tyranny, the tyrants will never let you have an ordinary life—so you simply have to give your life to the larger responsibility." All the defenders share a special empathy for others, a quality the Dalai Lama named as compassion, in Tibetan *nying je*: "The less we tolerate seeing others' pain, the more we do to ensure that no action of ours ever causes harm."

This sensitized appreciation for others developed in these remarkable individuals in various ways. Several defenders recalled an early moment or incident that galvanized their social conscience forever. Some told stories of searing childhood encounters with injustice, as when Digna Ochoa spoke of her union-organizing father's abduction and the family's bitter realization that they couldn't afford a

lawyer to help; or when Raji Sourani spoke of watching soldiers beat and shoot classmates in his grade school, and when Patria Jimenez spoke of bigotry in her own family against gays and her own experience of prejudice as a lesbian. Many defenders are members of groups that have endured sustained repression, and so have come to a natural understanding of the issues and desire to overcome the wrongs of the past, notably Marian Wright Edelman, and Juliana Dogbadzi. Others saw injustice in a community they were not a part of and took up the cause, such as Bruce Harris and Sister Helen Prejean. And still others had enjoyed the comforts of being among the elite in their countries, yet risked ostracization—and worse—to right wrongs committed by their peers, notably Natasa Kandic, Kailash Satyarthi, and Mohammad Yunus.

And while the overwhelming number of the individuals here share a past that includes torture, death threats, harassment, detention, and imprisonment, they would mention these experiences only when pressed. The diffidence was understandable on the most basic level, as avoidance of the memory of pain and suffering. As Dianna Ortiz put it, "No one should have to re-enter the torture chamber." But there were other reasons. Raji Sourani explained, "We have to be strong enough to make people feel we can defend them; we have to be strong enough to take care of the real victims."

Among the diversity of voices and causes two common themes emerged that took me by surprise. One was the centrality of maintaining a sense of humor. Vaclav Havel spoke eloquently on the subject, arguing that, "to stay human, it's important that you keep a certain distance...of absurdity," while Asma Jahangir told of gathering her colleagues after particularly terrifying incidents "for a good laugh," and Bruce Harris shared the grim humor of human rights work, relating how after his Guatemalan office was riddled by machine guns, his New York headquarters sent

him a bulletproof vest, "complete with a money-back guarantee." The second theme was the role of righteous anger. When asked about their source of strength to overcome fear, many described a calm at their moment of truth. While in Western European society, women are taught to repress anger, Digna Ochoa's fury and outrage at the cruelty of the perpetrator actually helped her prevail, proving that anger, too, can be harnessed for noble purpose. On the pyramids, constructed by slave labor, ancient graffiti reads, "No one was angry enough to speak out;" yet the defenders show us how to raise up our voices against injustice.

Despite the overwhelming powers arrayed against them, these men and women are, as a whole, an optimistic lot. Archbishop Tutu emphasizes this attitude when he says, "We have a God who doesn't say, 'Ah ... Got you!' No. God says, 'Get up,' and God dusts us off and God says, 'Try again.' " Perhaps the stance should be qualified as less optimistic than hopeful. Overwhelmingly pragmatic and realistic about the prospects for change, all too aware of the challenges they face, nonetheless they continue to roll their boulders back up the hill. Oscar Arias Sánchez points out, "In a world which presents such a dramatic struggle between life and death, the decisions we make about how to conduct our lives, about the kind of people we want to be, have important consequences. In this context, one must stand on the side of life....One works for justice not for the big victories, but simply because engaging in the struggle is itself worth doing."

But those who seek social justice do share a unifying sense of fulfillment. Marian Wright Edelman references Henrik Kierkegaard, who wrote that we must all: "Reach into the envelope that God has placed in our soul to determine why we were placed on this earth." In this group of women and men, one feels immediately that they have discovered the meaning of their own lives, and accordingly devoted themselves to the tasks for which they were placed among us. Perhaps this

accounts for the deep spirituality and sense of peace one feels around so many of the defenders; peace at an essential, deep level, not to be confused with satisfaction. For the defenders have dreams, too. Abubacar Sultan said, "I hope that some day we will have a world in which children can be treated like children again, given all the opportunity they deserve as human beings." That is, in essence, the ambition of all the people in this book. Just as they challenge governments, these individuals challenge each of us to move beyond physical comforts to some higher order of aspirations and to take up the cause of a more just, more decent world. When the Dalai Lama demands that we think of those who destroyed his country and massacred his people, not as murderers and thieves, but as human beings deserving of our compassion, it is this sense of love, not at the policy and statistical level, but at the human one, that shows us how lives can be changed because of our actions—or lost due to our failure to act.

These voices are, most of all, a call to action, much needed because human rights violations often occur by cover of night, in remote and dark places. For many of those who suffer, isolation is their worst enemy, and exposure of the atrocities is their only hope. We must bring the international spotlight to violations and broaden the community of those who know and care about the individuals portrayed. This alone may well stop a disappearance, cancel a torture session, or even, some day, save a life. Included in the book (pages 250-251) is the resource guide of contact information for the defenders and their organizations in the hope that you, the reader, will take action, send a donation, ask for more information, get involved. The more voices are raised in protest, the greater the likelihood of change. That lift to the human spirit is difficult to measure but well worth undertaking.

Abubacar Sultan, who risked his own life again and again to rescue child soldiers in Mozambique, explained why he continues his work: "You are a human being and there are other human beings there; you are in a better position than they are. So you need to sacrifice. It's hard to explain. It is, perhaps, a kind of gift that you have inside yourself."

On October 19, 2001, two years after I interviewed Digna Ochoa, armed gunmen broke into her office and shot her dead. The killers left a warning that other human rights defenders who persisted would meet a similar fate. Her death sent shock waves through all Latin America—especially in Mexico, where President Vincente Fox had come to power after seventy years of one-party rule, pledging to improve Mexico's human rights situation. Her killers have never been found, but her work in human rights lives on. In the human rights world you *must* act on faith that what you are doing might make a difference, and is therefore worth doing. How you measure success in that context, I'm not sure. I do know from the reaction of many people who have transcribed and edited these words and read them in their present form for the first time that the experience of the interviews is haunting, transformative. Meeting heroes like Digna Ochoa, who gave her life for her beliefs, will help readers and viewers alike discover that gift inside themselves, and in turn help them transform their own communities, and our shared world.

I grew up in the Judeo-Christian tradition where we painted our prophets on ceilings and sealed our saints in stained glass. They were superhuman, untouchable, and so we were freed from the burden of their challenge. But here on earth, people like these and countless other defenders are living, breathing human beings in our midst. Their determination, valor, and commitment in the face of overwhelming danger challenge each of us to take up the torch for a more decent society. Today we are blessed by the presence of these people. They are teachers, who show us not how to be saints, but how to be fully human.

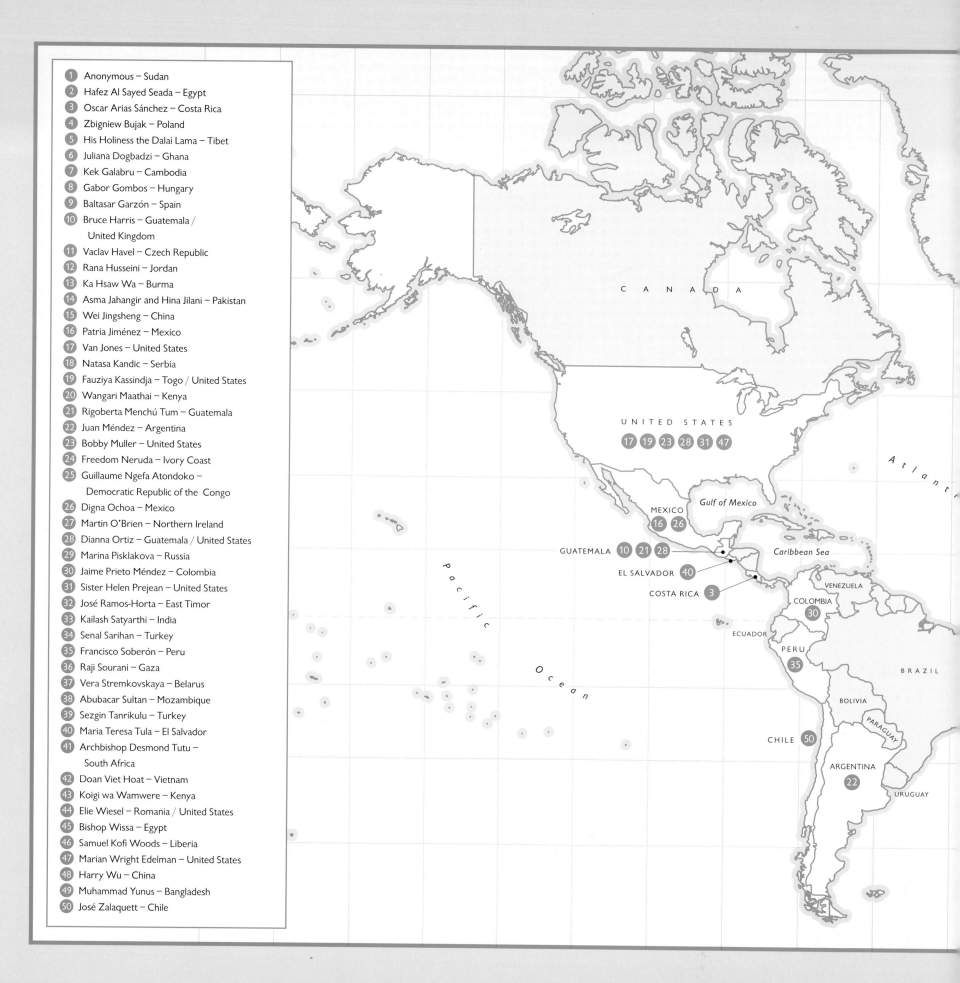

1. Anonymous – Sudan
2. Hafez Al Sayed Seada – Egypt
3. Oscar Arias Sánchez – Costa Rica
4. Zbigniew Bujak – Poland
5. His Holiness the Dalai Lama – Tibet
6. Juliana Dogbadzi – Ghana
7. Kek Galabru – Cambodia
8. Gabor Gombos – Hungary
9. Baltasar Garzón – Spain
10. Bruce Harris – Guatemala / United Kingdom
11. Vaclav Havel – Czech Republic
12. Rana Husseini – Jordan
13. Ka Hsaw Wa – Burma
14. Asma Jahangir and Hina Jilani – Pakistan
15. Wei Jingsheng – China
16. Patria Jiménez – Mexico
17. Van Jones – United States
18. Natasa Kandic – Serbia
19. Fauziya Kassindja – Togo / United States
20. Wangari Maathai – Kenya
21. Rigoberta Menchú Tum – Guatemala
22. Juan Méndez – Argentina
23. Bobby Muller – United States
24. Freedom Neruda – Ivory Coast
25. Guillaume Ngefa Atondoko – Democratic Republic of the Congo
26. Digna Ochoa – Mexico
27. Martin O'Brien – Northern Ireland
28. Dianna Ortiz – Guatemala / United States
29. Marina Pisklakova – Russia
30. Jaime Prieto Méndez – Colombia
31. Sister Helen Prejean – United States
32. José Ramos-Horta – East Timor
33. Kailash Satyarthi – India
34. Senal Sarihan – Turkey
35. Francisco Soberón – Peru
36. Raji Sourani – Gaza
37. Vera Stremkovskaya – Belarus
38. Abubacar Sultan – Mozambique
39. Sezgin Tanrikulu – Turkey
40. Maria Teresa Tula – El Salvador
41. Archbishop Desmond Tutu – South Africa
42. Doan Viet Hoat – Vietnam
43. Koigi wa Wamwere – Kenya
44. Elie Wiesel – Romania / United States
45. Bishop Wissa – Egypt
46. Samuel Kofi Woods – Liberia
47. Marian Wright Edelman – United States
48. Harry Wu – China
49. Muhammad Yunus – Bangladesh
50. José Zalaquett – Chile

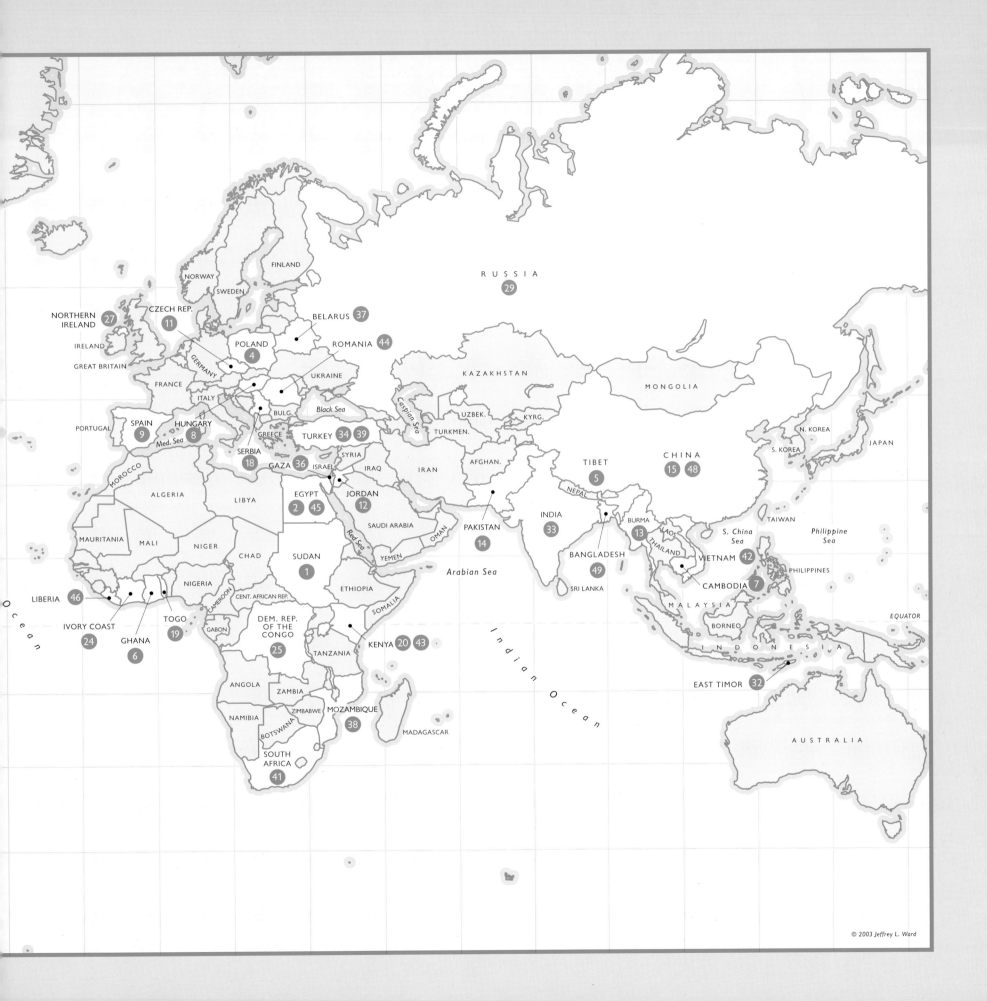

ABUBACAR SULTAN

MOZAMBIQUE

CHILD SOLDIERS

"The boy's family was shot in front of him and cut to pieces.
He shared with me the worst moments of his young life."

The war in Mozambique (1985–1992) left 250,000 children displaced and 200,000 orphaned, while tens of thousands more were forcibly recruited and put into combat. It was rare that government forces and guerrillas engaged— combat was waged almost exclusively against unarmed civilians. In the midst of the brutality Abubacar Sultan traveled the country across roadless lands and on tiny planes to rescue the children of war—kids, six to thirteen years old, who had been forced to witness and, in some cases, to commit atrocities against family members and neighbors. Sultan trained over five hundred people in community-based therapies and his project reunited over 4,000 children with their families. Sultan put his life at grave risk on a daily basis. Today he continues his work with children, concentrating on community education and children's rights through his initiative Wona Sanaka.

When the war started in Mozambique, I was finishing teacher training at the university. Neighbors, relatives, friends of those who were kidnapped, and people who fled from war zones brought back news of the war and the suffering.

By the end of 1987, UNICEF estimated that 250,000 children had been orphaned or separated from their families. A high percentage was involved in the war as active combatants, forcibly trained and forcibly engaged in fighting. I was shocked by pictures of child soldiers who had been captured by government forces and others who were shot in combat. Something wrong was going on. I couldn't keep going to my classes, teaching students, while all these things were happening in my country. I decided to do something.

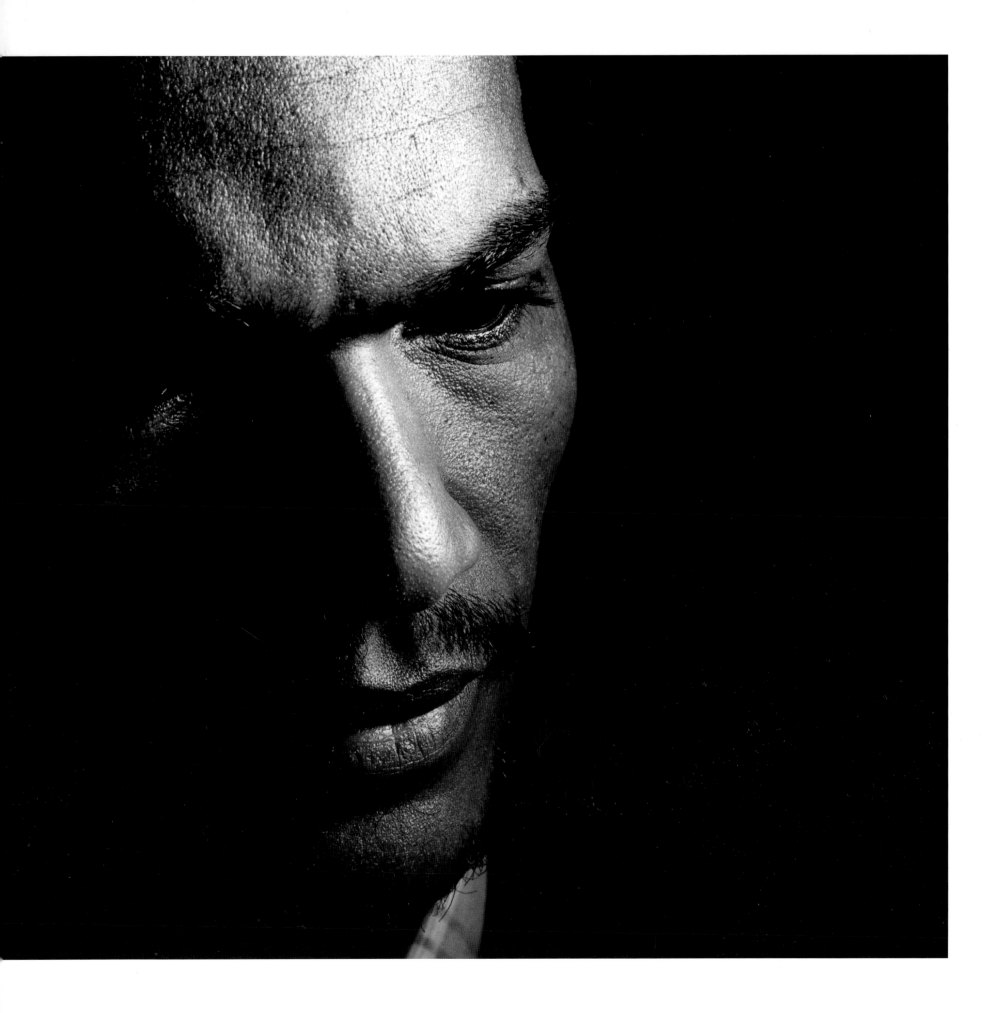

Around that same time, a local orphanage took in thirty-five kids captured in combat. A psychiatrist and a social worker interviewed these children, and what they heard was truly horrifying: entire families kidnapped, taken into the bush, forced to carry heavy loads to military base camps, and subjected to all kinds of abuse. Children were beaten, sexually violated, and compelled to witness killings and beatings, pressed into combat and urged to commit murder. These were common practices. Many of these children had been physically injured, and most of them were traumatized.

One particular seven-year-old boy who had been kidnapped changed my life. When I arrived at this orphanage, he was completely withdrawn from the world. He would be calm one day and cry continuously the next. Finally he started speaking. He said he was living with his family when a group of rebel soldiers woke him up at night, beat him, and forced him to set fire to the hut where his parents were living. And when his family tried to escape from the hut, they were shot in front of him and then cut into pieces. I will never forget his feelings, because I kind of went inside him and he shared with me the worst moments of his life. The images, the bad images I had from my childhood of small things that hurt me, all came alive. And sometimes I tried to put myself into his position and tried to live his experience. His was just one story among many others.

In conjunction with Save the Children (U.S.), we developed a program to gather information about children who had been separated from their families by the war. While the point of this program was to provide the victims with psychological and social help, it soon became obvious that we did not have the necessary resources. We were mostly left with the mission of helping the children leave the war areas and return to their families. We went into the war zones every day, documented as many children as possible, and tried to trace them to communities of displaced people inside the country, and to refugee camps in neighboring countries. Whenever possible we took children to safer environments.

Most of these kids were on the front so that's where we went. In some cases we didn't have permission from the government to go there, and furthermore, we never had permission from the rebels, since we didn't have any contact with them. Among the most basic needs we wanted to provide for the kids was access to water, food, and to simple medicine in order to fight the spread of malnutrition, malaria, cholera, and other diseases. But if a kid was injured with bullets in his body, or had been maimed by land mines, you had to address that before you could start doing your real work. Our lives were thus in permanent danger, too.

There were no safe roads in the country then, and the only way to reach those areas was by plane. On several occasions, we were almost shot down. We landed on airstrips that had been heavily mined. We had several plane accidents. Whenever we got too frightened, we tried to remember how lucky we were even to be alive.

The conflict in Mozambique was unique in the sense that it targeted only civilian populations. Direct combat between the government and rebel forces was very, very rare. In most cases, they would just go into the villages and into the huts and loot everything and kill everybody, or kidnap people and steal everything. In this process girls and boys were taken and indoctrinated as soldiers. At the end of the war we had evidence that many girls were used as maids and as sexual partners to the soldiers. After a few years of indoctrination, these kids became perfect killing machines. They would do exactly what their perpetrators had done to them: cold-blooded killing.

> "The struggle is far from being over,
> and despite the end of the war,
> there is an ongoing war to improve
> children's rights and welfare."

Everyone who promoted this war was to blame. There was a real psychology of terror. People risked being killed if they dissented from whatever they were forced to do. Either you killed or you were killed. That's what made people do what they did. Even life in the rebel camps was so bad and so difficult that the only people who had access to food or to the basic necessities were the soldiers. Being a soldier, in that context, meant that you would survive. It was as simple as that.

The camps no longer exist today. They were dismantled as part of the peace agreement. But the problem is that many of the kids were left behind as part of the demobilization process. The United Nations provided resettlement to adult soldiers but since the former fighting armies denied they had children in their forces, resettlement was not available to them. We tried to follow up but we were only able to provide support for something like eight hundred kids. We don't know what happened to the majority of them. They just went to a place where they felt safe and often the only place that they considered home was the place where they lived during the war.

Many times I asked myself why I chose this work. I had two kids and until they reached the age of four or five, I didn't spend more than two or three days a month with them. I finally came to realize that I was hurting my own family. They were always worried about my safety. And yet, there was something strong within myself that responded to saying I was a human being and there were other human beings out there in danger. And if those who are close to you are in a better position than those who suffer, you need to sacrifice some of your own privileges. It's hard to explain. It's perhaps a kind of gift that you have inside yourself. Part of the explanation lies in religion (I am a practicing Muslim) and part in education. Yet, there are many other people like myself who never considered doing what I did. Hence, it must be something deeper, something inside.

And though our program succeeded in reuniting about twenty thousand children with their families, when you consider that over a quarter million children were orphaned or lost during the war, our efforts seemed almost insignificant. We had the constant feeling that we were spending too much money to help only a few hundred children, even though I had worked as hard as I could.

Now that the war is over, the country is finally recovering and slowly making its transition into economic development and democracy. It's become clear to me that those who were suffering at the time of the war were the same as those who were most affected when the war was over: the ones who still lack basic resources. They are the ones who continue to be maimed by land mines in the country. The girls in the rural areas are the ones who have limited access to education, and who are still subjected to all kinds of abuse. It also became apparent to me that programs of education and health continue to focus on urban areas, where people are mostly safe, whereas in all those former front-line territories, there is nothing going on. Children continue to die of diseases that in other parts of the country can be easily treated. The struggle is far from over, and despite the end of the war, there is an ongoing war to improve children's rights and welfare.

I hope that some day we will have a world in which children can be treated like children again and in which they can be given all the opportunity they deserve as human beings. I imagine a world in which "humanness" would be the guiding principle behind rules and laws. I hope that someday we will reach this ideal.

You see, once you give people the opportunity to express their potential, many problems can be solved. My country is an example in which people were able to use their own resources in the most extreme and difficult circumstances. People really are resilient, and in countries like mine, that has an important meaning. And in that you must believe.

JULIANA DOGBADZI

GHANA

SEX SLAVERY

"I was a kid, seven years old, when my parents took me from our
home to captivity in a shrine where I was a sex slave to a fetish priest."

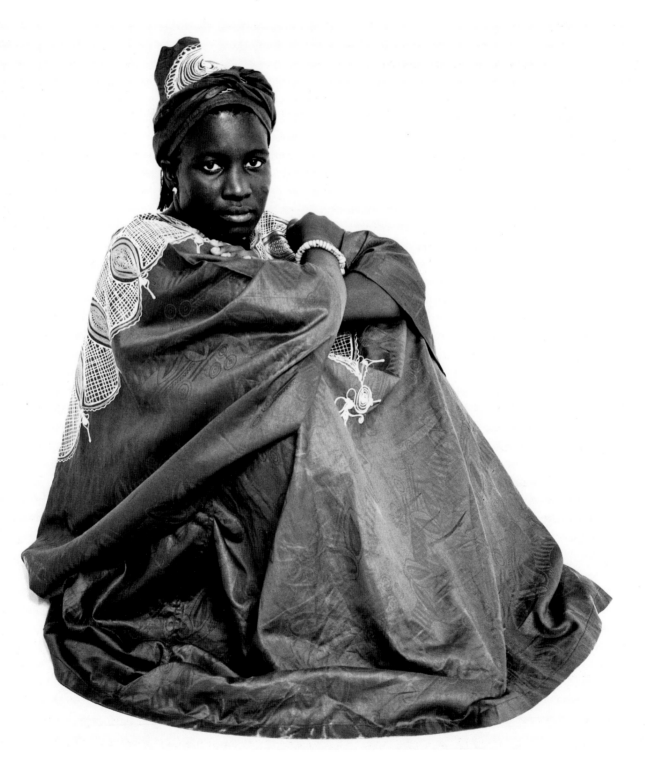

Juliana Dogbadzi, enslaved in a shrine in her native Ghana as a young child under a custom known as Trokosi, was forced to work without pay, without food or clothing, and to perform sexual services for the holy man. She was able to escape seventeen years later, after several failed attempts, at the age of twenty-three. Trokosi comes from an Ewe word meaning "slave of the gods," and is understood as a religious and cultural practice in which young girls, mostly virgins, are sent into lifelong servitude to atone for the alleged crimes of their relatives. In 1997, it was estimated that approximately five thousand young girls and women were being kept in 345 shrines in the southeastern part of Ghana. Through Juliana Dogbadzi's daring escape and her subsequent efforts to denounce the system, the Trokosi practice was banned in Ghana; however, law enforcement against Trokosi is still lax. Dogbadzi speaks out against Trokosi, traveling the country, meeting with slaves, and trying to win their emancipation; and increasingly, she is not alone in her courageous stance.

I have never been in a classroom. I have never been to school. When I was seven years old, my parents took me from our home and sent me to a shrine where I was a slave to a fetish priest for seventeen years. My grandfather, they said, had stolen two dollars. When he was suspected of the crime and asked to return the money, he defended his innocence. The woman who had accused him of the crime went to the shrine and cursed my grandfather's family, at which point members of my family began to die. In order to stop the deaths, a soothsayer told us that my grandfather would have to report to the Trokosi shrine. The priest told my family that it must bring a young girl to the shrine to appease the gods. A sister was sent to the shrine at Kebenu some six hundred miles away, but she died a few years later. Since I had been born just after my grandfather's death, I became her replacement.

I lived and worked in the priest's fields and kept the compound clean. While doing so, I was raped repeatedly by the priest on torn mats on the cold floor of windowless huts. The other female slaves and I received neither food nor medical care. We had to find time after working on the priest's farm to burn charcoal or to sell firewood in the nearest town in order to make enough money to buy food. There were times we lived on raw peppers or palm kernel nuts to stay alive.

Because I was just a kid, I didn't know what to do. There was an elder woman who was a slave and took care of me. She couldn't help me much because she had so many kids as a consequence of being raped by the priest. She said, "Look, little girl, take care of yourself or you will die." There used to be a hundred women slaves in my shrine, but the priest sent about ninety of them to work on his farms in other villages. Collectively, they had about sixty-five children and would have to work to look after the children.

Twelve of us, four women and eight children, lived in a one-room, thatched-roof house. It was built of mud and lacked both windows and doors. The rain got in. The snakes got in. The room was twenty feet long and twelve feet wide. The ceiling was low, just shy of our heads, and we all slept together on a mat on the floor. This is not everything that I can remember, but saying it brings back pains of old and it's difficult to go back through all those experiences.

You see, in the shrine you have no right to put on shoes or a hat to protect yourself against the hot sun. If it is raining or cold, you have only a small piece of cloth around yourself. A typical day in the shrine was as follows: you wake up at five o'clock in the morning, go to the stream about five kilometers away to get water for the compound, sweep, prepare meals for the priest (not eating any yourself), go to the farm, work until six o'clock, and return to sleep without food or to scrounge for leftovers. At night, the priest would call one of us to his room and would rape us. I was about twelve when I was first raped.

There was favoritism even in slavery. The priest liked girls who would readily give in to his sexual demands and hated those who would always put up a fight. Consequently, these girls were beaten. The ones he liked always said they were being wise because they wanted to avoid being beaten, while some of us maintained that they were foolish and were enjoying sex with a man they didn't love. When I saw people who came to the village to buy food wearing nice dresses, I started to think that I had to do something for myself. I had to get freedom.

JULIANA DOGBADZI

I had to do something that would change my life. I escaped several times. The first time I escaped, I went to my parents. I told them I was suffering in the shrine, but they were scared to keep me. They said that if they did, the gods would strike them dead. They brought me back to the priest to suffer the same pain again. I thought, no. This is not going to happen again. I had to find a way to free myself and free the other women, too.

The second time I escaped, I went to a nearby village. A young man fed me and took me to himself. He took advantage of me and made me pregnant. When the priest found out, he sent young men around the village to get me. They beat me endlessly and I had lots of cuts on my body. I collapsed and nearly died. The child's father had wanted to take care of us, but the priest threatened him with death. The young man who was taking care of me was asked to pay some bottles of hard liquor and a fowl and warned to stay away from me or die. I haven't seen him since and he hasn't seen our child.

The third time I escaped, I resolved that I would never again go back to the shrine. By this time, I was three months pregnant as a result of another rape that I had suffered from the priest. I was not feeling very well. For a number of days I had starved. I was pregnant and needed to get some food. Otherwise, I was going to die. I decided to go to a nearby farm owned by the priest to get

an ear of corn from the crop which the other slaves in the shrine and I had planted. I was caught stealing the corn and the priest ordered the young men around the village to beat me until I fell unconscious. When I came to, I saw all the bruises and wounds on my body and nearly lost the baby I was carrying. I decided I had to leave or I would be killed. But it was not to be. I was scared and I went back to the shrine again. Yet, that was the turning point. I was about seventeen or eighteen at the time and resolved that I was going to do something to help other people in the shrine.

One day, a man representing a nonprofit organization called International Needs–Ghana came to the shrine to talk to the priest. This was my chance. I don't know where my sudden confidence came from, but all my fear had disappeared. I was no longer afraid of death and was prepared to die for others. Thank God I had that feeling! I did not escape immediately because I was very weak, my pregnancy was well advanced and I could not walk a long distance. Luckily, I had the baby a few weeks later. With the baby strapped to my back and the first child, Wonder, in my hands, I escaped through the bush to the major street where I was given a lift to Adidome and to the site of International Needs–Ghana.

The members of the organization taught me a lot of skills and kept me away from the priest. They trained me in bread baking and other vocations. Nonetheless, I

"The shrine is a crime against children. The child of a slave shares his mother's plight. When the mother has food to eat, the child eats. If she has no food, the child will starve."

thought, "There are more women who remain in the shrine who need help. No one is going to represent them better than someone who has been in the shrine and who has gone through the pain, someone who can tell the world what happens in the shrine. If no one stops this practice, we will all have to die in pain." Against all odds, I decided to take the responsibility of addressing the issue and have been doing so ever since. I went to the shrines and spoke to the inmates. I told them that they needed to gather courage like I had and to get out.

The shrine claims powers it does not have in order to instill fear in the slaves and to stop them from escaping. The practice is a deliberate attempt by men to subjugate women. A man commits a crime and a woman has to pay for it. That is unacceptable. Likewise, the shrine is a crime against children. The child of a slave shares his mother's plight. When the mother has food to eat, the child eats. If she has no food, the child will starve. If she has clothing, the child will likewise have some. If not, that is it. If she goes to the farm, the child goes along. There are thousands of women *Trokosi* slaves with children who need to be helped. Those who have been liberated also require help in order to recover from the suffering endured in the shrines.

Unlike most of the other girls and women, I got over the fear instilled by the *Trokosi* system. This was my weapon. Now that I have escaped, I help to dimin-

ish the women's fears by telling them my story. I tell them what I am presently doing, that I am still alive, not dead, as they have been made to believe. I try to help the priests to understand the pain that the women have endured. Some do not allow me to enter their shrines any longer. When I am in the city, I educate people about life in the shrines and advocate for an end to the practice.

What I do is dangerous, but I am prepared to die for a good cause. People send threats by letter and others confront me openly. Thank God that those I work with are very strong and give me encouragement. At the moment, eight girls have joined me in my work with the organization. My next step to disbanding *Trokosi* is to ensure enforcement of the law and to get allied organizations in the Republics of Togo and Benin to stop this practice in their respective countries.

I do believe I have a calling because it is strange to be alive and sane and working after going through what I went through. The help that I have received from International Needs and my own confidence have made all the difference. I have totally forgiven my parents because I know that what they did to me was done through ignorance and fear. I don't want them to feel guilty so I avoid telling them about my experiences. I don't, however, see them often. I am glad to say that I am now happily married and have just had my first planned baby with the man I love. My life today is like the life of any other young woman.

BRUCE HARRIS

GUATEMALA / UNITED KINGDOM

CHILDREN'S RIGHTS

"Why are the children hungry?
Why are they being abused and murdered?"

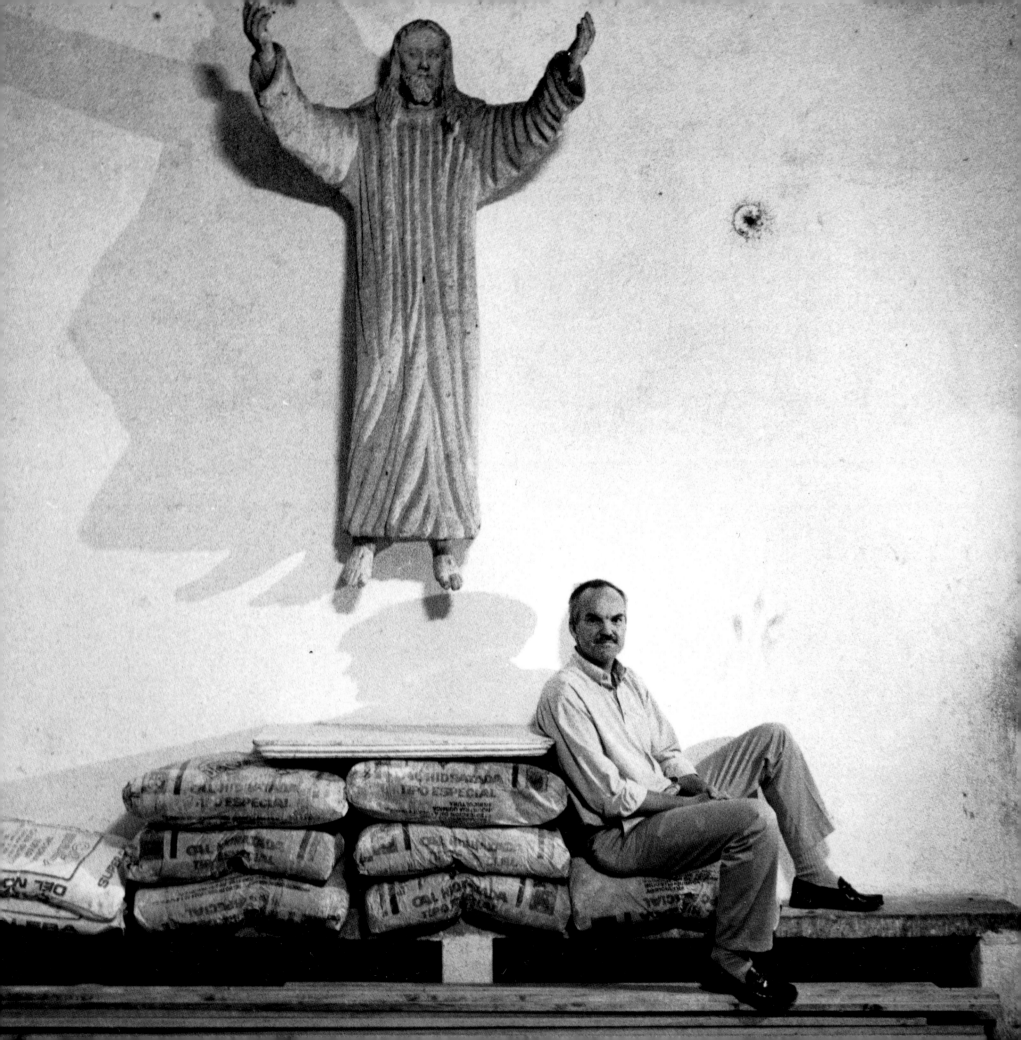

Throughout Latin America, homeless children are beaten, tortured, raped, and murdered with virtual impunity. Bruce Harris is Central America's foremost advocate for "street kids." Since 1989, Harris has been the director of Casa Alianza, in Guatemala City, which provides food, shelter, medical care, drug rehabilitation, counseling, skill training, legal aid, and other services to forty-four hundred homeless children abandoned to the streets. His investigations have led to 392 criminal prosecutions where children were the victims, and he was the first person in the history of Guatemala to successfully sue police for the murder of a street child. At the request of the attorney general, Harris investigated and exposed a baby-trafficking ring where poor women were tricked into giving up their infants for adoption. Bound for the United States, these infants yielded a hefty twenty-thousand-dollar fee each for unscrupulous middlemen. One alleged perpetrator (married to the president of the Guatemalan Supreme Court) then filed criminal charges against Harris for defamation. In Guatemala, truth is no defense in a defamation suit, and defamation is a criminal offense. Despite the danger of imprisonment (with some of the fifteen law enforcement personnel he helped land in jail), Harris forges ahead.

I'm not fully sure of what my reason for being is, but a lot of it is to protect children who have nobody to protect them. We are the sum of the parts of people who have had an impact on us in our own lives. We all have our heroes. Mine is Nahaman.

Soon after I joined Casa Alianza, I befriended Nahaman, a thirteen-year-old boy. One day, Nahaman's best friend, Francisco, came to the crisis center and shouted through the gate for him to get high, and by midnight seven or eight kids were huddled around with their faces submerged in plastic bags of glue, two blocks from the main police station. When the shift changed, five policemen emerged. One pointed his gun at the kids and told them to freeze. The kids ran and the cops caught a few, grabbed the bags of glue and literally started to pour it over their heads and into their eyes. Why? Because the kids would have to shave their heads to get the glue off and a shaved head indicates that you're a criminal.

Nahaman pushed the policemen's hands away, and they took this as an affront. They grabbed him and threw him to the ground and they kicked the dickens out of him—a thirteen-year-old boy against four grown men. He doubled over, screaming, and they kicked him unconscious. He lost control of his bladder. He had six broken ribs. There was bruising over 60 percent of his body. His liver had burst.

Meanwhile, Francisco was hiding underneath a car watching, and when the cops took off, he called an ambulance. But the ambulance never arrived—they didn't believe the kids. The kids thought Nahaman was dead. And to show you that part of their reality is to accept death as part of life on the street, they just went off to a park and went to sleep for a few hours.

When they woke up, they flagged a police car, who called an ambulance. They thought the boy was just intoxicated, so they put him under observation. By coincidence one of our social workers was in the hospital when Nahaman happened to regain consciousness and he told her what happened. She called the doctor and they found one and a half liters of blood in his abdomen and evidence of brain damage. He went into convulsions, suffered for ten days, and then he died.

Looking back on it, I realize Casa Alianza was in bed with the wrong people. We started out just offering food and shelter—but that was naive. I keep thinking of

> "When you see a kid who's been beaten or has a black eye or bullet holes in him, and he's not crying, then serious emotional damage has happened."

a priest in Brazil who said, "When I feed the hungry, they call me a hero; when I ask why the people are hungry, they call me a Communist." It is a noble task to feed the hungry (and quite honestly it would be more comfortable just to feed them!) but as an agency we have matured into asking why the children are hungry and why they are being abused and murdered.

When Francisco said the men who killed Nahaman were policemen, our first reaction was we've got to do something, but then the brain starts to rationalize all the reasons why you shouldn't: it's very dangerous, this is Guatemala, people get killed, there's a certain moral dilemma. But then you see Nahaman laying out there, and the path is so clear. Or is it?

We spoke with ten other children's advocacy groups and decided we should call for a meeting with the police: but only two groups showed up. It was the beginning of the realization that this was going to be a long, lonely road. And while I can understand why people didn't want to raise their voices, it would have made it a damn sight easier if they did. When it's just one organization that's crying out, then you become very vulnerable. We started getting phone calls and death threats. And as we started pushing more and more, the crisis center itself was attacked.

It was mid-morning when a BMW with no license plates and polarized windows came to the crisis center in the middle of Guatemala City. Three men with machine guns went to the gate, asked for me by name, and said, "We've come to kill him." The guard was terrified, and said I wasn't there. They got back in the vehicle, and came back down the street and opened fire with machine guns. Thank God none of the kids was shot. When something like

that happens, you call the police—funny in this case. So the police came very quickly and they took away all the bullets. They took away all the evidence. It shows how naive we were. When Covenant House in New York heard about the incident, they sent me a bulletproof jacket. It had a money-back guarantee, if for any reason it didn't work!

One of the greatest favors the perpetrators of this violence did for us was to spray our building with machine-gun fire because it was tangible evidence that we were doing something that affected interests. We were protecting children but there was something more here than met the eye. We were challenging the status quo, the way Guatemala had for decades operated, challenging the assumption that if a man had the gun and the uniform, he could get away with murder—literally.

Street kids aren't easy. When you see a kid who's been beaten or has a black eye or bullet holes in him, and he's not crying, then serious emotional damage has happened to that kid. If you start to show your feelings, you start to show what they perceive to be weakness. But when they assume the risk to love you, that's very personal.

The proof of it is that the most difficult thing for kids when they come into our program is a hug. Often it's the first time there's an honest sign of affection—with nothing expected in return. What we're trying to do is give children back their childhood—if it's not too late.

I truly dream of a world in which children will not have to suffer. We may not reach that between today and tomorrow, but at least there will be fewer kids on the street.

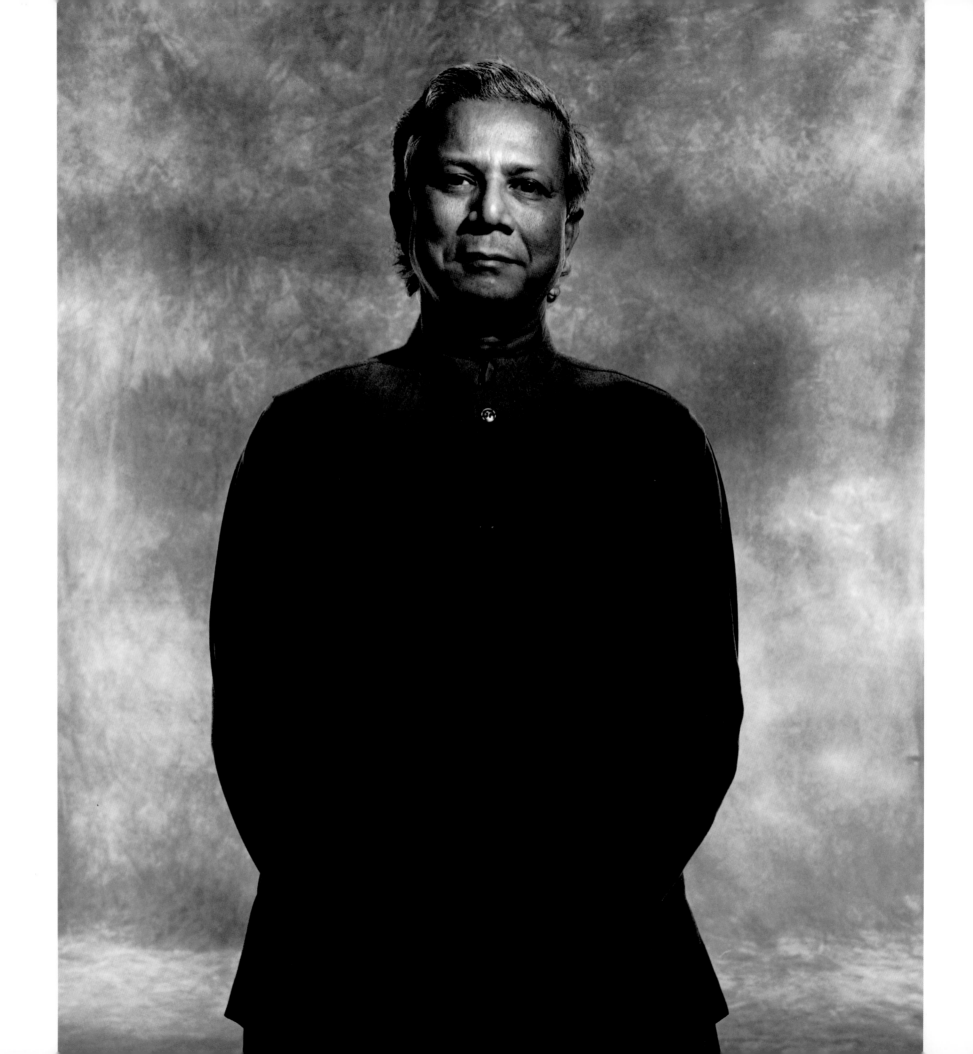

MUHAMMAD YUNUS

BANGLADESH

MICROCREDIT

"And she struggles to pay that first loan and then the second installment due the following week. And when she has paid completely, she can say, 'I did it!' It's not just a monetary transaction that has been completed, it is nothing less than the transformation of that person."

Founder of the Grameen Bank, the world's largest and most successful microcredit institution, Muhammad Yunus was born in one of the poorest places on earth, the country (then part of Pakistan) of Bangladesh. As a professor of economics, he was struck by the discrepancy between the economic theory taught in universities and the abject poverty around him. Recognizing the poor remained poor because they had no access to capital, no collateral for loans, and borrowing requirements so modest that it was not cost-effective for large banks to process their needs, Yunus started experimenting with small collateral-free loans to landless rural peasants and impoverished women. In 1983, he founded the Grameen Bank. Its rules were strict and tough. Clients find four friends to borrow with. If any of the five default, all are held accountable, building commitment and providing community support. Initial loans are as little as ten dollars, and must be repaid with 20 percent interest. Nearly twenty years later, this revolutionary bank is flourishing, with more than 1,050 branches serving 35,000 villages and two million customers, 94 percent of them women. Ninety-eight percent of Grameen's borrowers repay their loans in full, a rate of return far higher than that of the rich and powerful. More importantly, the clients are transforming their lives: from powerless and dependent to self-sufficient, independent, and politically astute. The real trans-formation will be felt by the next generation: a generation with better food, education, medication, and the firsthand satisfaction of taking control of their lives, thanks to Yunus's vision, creativity, and confidence.

When I started the Grameen program to provide access to credit for the poor, I came upon two major obstacles. First, commercial banks were institutionally biased against women. Secondly, they had absolutely blocked credit to the poor by demanding something no poor person has access to: namely, collateral.

After overcoming the second issue, I addressed the first. I wanted half of the borrowers from banks in my program to be women—a challenge. At first, women were reluctant to accept loans. They said, "No, no, I have never touched money in my life. You must go to my husband. He understands money. Give the money to him." So I would try to explain why a loan would benefit her family. But the more I tried to approach women, the more they ran away from me. My colleagues and I worked hard to come up with a way we could build trust in women so that they would accept loans from men. We slowed down our work just to include more women, since this trust-building took time.

Six years later, proud that half our loans were to women, we began to see something very remarkable. Money that went to families through women helped the families much more than the same amount of money going to men. Unlike men, women were very cautious with money and passed benefits on to their children immediately. They had learned how to manage with scarce resources. And women had a longer vision; they could see a way out of poverty and had the discipline to carry out their plans. Perhaps because women suffer so much more from poverty than men, they are more motivated to escape it.

In contrast, men were looser with money. They wanted to enjoy it right away, not wait for tomorrow. Women were always building up things for the future, for themselves, their children, their families. We saw a number of such differences between men and women.

We decided to make a concerted effort to attract women clients because we got much more mileage out of the same amount of money. So I created incentives for our loan officers because they had such a hard time convincing women to borrow money from the bank. Today, 94 percent of our loans go to women.

It has worked in ways we never anticipated. For instance, women borrowers decided to commit themselves to a set of promises that they called the "sixteen decisions." These are commitments to improve the welfare of the borrowers and their families above and beyond the loans. They agreed to send their chil-

dren to school, they decided to maintain discipline, to create unity, to act with courage, and to work hard in all their endeavors. They agreed to keep their families small, to send their children to school, to plant as many seedlings as possible, even to eat vegetables. These are some of the resolutions created by the women, not imposed by the bank. These aspirations were critical to their lives. Listening to them, you see what a difference women make.

A typical initial loan is something like thirty-five dollars. The night before a woman is going to accept that money from the bank, she will be tossing and turning to decide whether she is really ready for it. She is scared that maybe something terrible will happen to her. And finally in the morning her friends will come over and they will try to persuade her: "Let's go through with it. If you don't go, we can't. We can't always worry. It was not easy coming to this point. Let's go." And finally, with their encouragement, she will come to the bank.

When she holds that money, it is such a huge amount in her hands, it is like holding the hope and treasure that she never dreamt she would achieve. She will tremble, tears will roll down her cheeks, and she won't believe we would trust her with such a large sum. And she promises that she will pay back this money, because the money is the symbol of the trust put in her and she does not want to betray that trust.

And then she struggles to pay that first loan, that first installment, which is due the following week, and the second installment, which is payable the following

"As women become empowered, they look at themselves, and at what they can do. They are making economic progress and alongside that, making decisions about their personal lives."

week, and this goes on for fifty weeks in sequence, and every time that she repays another installment she is braver! And when she finishes her fiftieth installment, the last one, and she has now paid in full, she can say, "I did it!" She wants to celebrate. It's not just a monetary transaction that has been completed, it is nothing less than a transformation of that person. In the beginning of it all, she was trembling, she was tossing and turning, she felt she was nobody and she really did not exist. Now she is a woman who feels like she is somebody. Now she can almost stand up and challenge the whole world, shouting, "I can do it, I can make it on my own." So it's a process of transformation and finding self-worth, self-esteem. Proving that she can take care of herself.

You see, if you only look at the lending program of Grameen, you have missed most of its impact. Grameen is involved in a process of transformation. The sixteen decisions is an example: we found that Grameen children attend school in record numbers because their mothers really take that commitment seriously. And now many of the children are continuing in colleges, universities, going on to medical schools, and so on. It is really striking to see young boys and girls go on to higher levels of education. The program has been so successful that we now foresee a big wave of students needing loans, so we recently came up with another loan product to finance higher education for all Grameen children in professional schools. Now they don't have to worry about whether their parents will be able to pay for their higher education when tuition is so expensive.

A recent study in Bangladesh showed that children in Grameen families are healthier than non-Grameen children. *Scientific American* did a study of population growth in Bangladesh showing that the average number of children per family twenty years back was seven, but now it has been reduced to three. What happened? Why did it happen? *Scientific American* has spurred controversy by claiming the change is due to our program. As women become empowered, they look at themselves and at what they can do. They are making economic progress and alongside that, making decisions about their personal lives and how many children they choose to have. And of course Article 16, Decision 1, says that we should keep our families small. So this is an important part of the equation. At the population summit in Cairo all the sessions spoke of the Grameen model, because the adoption of family planning practices of women in our program is twice as high as the national average. Now, we are not a population program, but this is a beneficial side effect.

There are other side effects. Starting seven years back we encouraged Grameen borrowers to participate in the political process by voting. Their first reaction was negative. They said, "The candidates are all devils, so why should we vote for them?" It was very depressing that people looked at their electoral process in that way.

So we replied, "Okay, yes, they are all devils, but if you don't go and vote, the worst devil will get elected. So go sit down in your centers, discuss who could

be the worst, what could happen if he gets elected, and if you find this prospect terrible, then you have an opportunity to choose among all the devils, the least evil." People immediately got excited, and we had almost 100 percent participation in that first election.

It was very well organized. All the Grameen families met the morning of the elections, and went to the voting place together, so the politicians would take note of their large numbers, so that they were taken seriously. In the next elections we organized Grameen families to vote themselves and also to bring their friends and neighbors to vote, particularly the women.

The result was that in the 1996 election in Bangladesh voter participation was 73 percent, the highest percentage ever. And what shocked everybody was that across the board more women voted than men. In fact, women waited for hours, because when the voting arrangements were made, the authorities had expected only half the number to show up.

The outcome changed the political landscape. In the previous parliament, the fundamentalist religious party had seventeen seats; in the 1996 election, their number was reduced to three, because women found nothing interesting in the fundamentalist party's program. So that was very empowering, very empowering indeed.

Then, in last year's local elections, we were shocked to see that many Grameen members themselves got elected. So I went around and talked to those people,

and asked why they chose to run for office. They said, "You told us to select the least of the devils, and we tried, but it was such an ugly job that we got fed up, and we started looking at each other, thinking, 'Why are we looking for the least devil, when we are good people here? Why don't we run ourselves?" And that started the snowball effect which ended with more than four thousand Grameen members elected into local office. That's amazing. And the way they talk is completely different. I never heard women in Bangladesh talking like this. They are challenging the government. They say, "The government can't tell us how to vote. We made commitments to our electorate." This is the kind of thing that happens. So in health care, in political participation, in the relationship between mother and child and between husband and wife, there are transformations of society.

Now you can open up, you can do things, you can discover your own talent and ability and look at the world in a very different way than you looked at before. Because Grameen offers a chance to become part of an institution, with some financial support to do your own thing. Our customers are in a kind of business relationship, but one that makes such a difference to their lives.

Of course there is resistance. The first resistance came from husbands who felt insulted, humiliated, threatened that their wives were given a loan and they were not. The tension within the family structure sometimes led to violence against the women. So we paused for a while and then came up with an idea. We started meeting with the husbands and explaining the program in a way where they could see it would be beneficial to their family. And we made sure

"You can open up,
you can do things,
you can discover your
own talent and ability
and look at the world in
a very different way."

to meet with husbands and wives together so everyone understood what was expected. So that reduced a lot of initial resistance by the husbands.

Neighborhood men also raised objections, and cloaked the fact that they felt threatened by women's empowerment in religious trappings. We carefully examined whether our program was in some way antireligious. But they were hiding behind religion instead of admitting that they felt bypassed. It was the male ego speaking in religious terms.

Our best counterargument was just to give it time. It soon became clear that our borrowers were still attending to their religious duties, at the same time earning money and becoming confident. Women started confronting the religious people. They said, "You think taking money from Grameen Bank is a bad idea? Okay, we won't take any more—if you give the money yourself. We don't care who gives it to us, but without money we cannot do anything." And of course the religious advocates said, "No, no, we can't give you money." So that was the end of that.

We also received criticism from development professionals who insisted that giving tiny loans to women who do not have knowledge and skill does not bring about structural change in the country or the village and therefore is not true development at all. They said development involves multimillion dollar loans for enormous infrastructure projects. We never expected opposition from the development quarter, but it happened, and became controversial. Because what we do is not in their book. They cannot categorize us, whether right, left, conservative, or liberal. We talk free market, but at the same time we are pro-poor. They are totally confused.

But if you are in a classroom situation, you wander around your abstract world, and decide microcredit programs are silly because they don't fit into your theoretical universe. But I work with real people in the real world. So whenever academics or professionals try to draw those conclusions, I get upset and go back and work with my borrowers—and then I know who is right.

The biggest smile is from one of those women who has just changed her existence. The excitement she experienced with her children, moving from one class to another, is so touching, so real that you forget what the debate was in the ballroom of the hotel with all the international experts, telling you that this is nothing. So that's how I've got the strength—from people.

Grameen Bank is now all over Bangladesh, with 2.4 million families. Even in hard times, like this year's terrible flood, people are willingly paying and we're getting really good loans. That demonstrated the basic ability of the people to do something that they believe in, no matter what others say. People ask, what is the reason that we succeeded, that we could do it, when everybody said it couldn't be done. I keep saying that I was stubborn. So when you ask if it took courage, I would instead say it took stubbornness. No matter what kind of beautiful explanation you give, that's what it takes to make it happen.

RANA HUSSEINI

JORDAN

HONOR KILLINGS

"The only way to rectify the family's honor
is to have a wife, daughter, sister killed.
'Blood cleanses honor,' the killers say."

Journalist, feminist, and human rights defender, Rana Husseini broke the silence and exposed the shame of Jordan when she unveiled the common but unspoken crime of honor killings there. Honor killings happen when a woman is raped or is said to have participated in illicit sexual activity. Across the globe, women who are beaten, brutalized, and raped can expect police, prosecutors, and judges to humiliate victims, fail to investigate cases, and dismiss charges. Imagine what it means in Jordan, where women who are raped are considered to have compromised their families' honor. Fathers, brothers, and sons see it as their duty to avenge the offense, not by pursuing the perpetrators but by murdering the victims; their own daughters, sisters, mothers. Honor killings accounted for one-third of the murders of women in Jordan in 1999. Husseini wrote a series of reports on the killings and launched a campaign to stop them. As a result, she has been threatened and accused of being anti-Islam, antifamily, and anti-Jordan. Yet, Queen Noor took up the cause, and later, the newly ascended King Abdullah cited the need for protection of women in his opening address to parliament. The conspiracy of silence has been forever broken thanks to this young journalist who risks her life in the firm faith that exposing the truth about honor killings and other forms of violence against women is the first step to stopping them.

I never imagined that I would work on women's issues when, in September 1993, I was assigned as the crime reporter at *The Jordon Times*. In the beginning I wrote about thefts, accidents, fires—all minor cases. Then, after about four or five months on the job, I started coming across crimes of honor. One story really shocked me and compelled me to get more involved.

In the name of honor, a sixteen-year-old girl was killed by her family because she was raped by her brother. He assaulted her several times and then threatened to kill her if she told anyone. When she discovered that she was pregnant she had to tell her family. After the family arranged an abortion, they married her off to a man fifty years her senior. When he divorced her six months later, her family murdered her.

An honor killing occurs when a male relative decides to take the life of a female relative because, in his opinion, she has dishonored her family's reputation by engaging in an "immoral" act. An immoral act could be that she was simply seen with a strange man or that she slept with a man. In many cases, women are killed just because of rumors or unfounded suspicions.

When I went to investigate the crime I met with her two uncles. At first when I questioned them about the murder they got defensive and asked, "Who told you that?" I said it was in the newspaper. They started telling me that she was "not a good girl." So I asked, "Why was it her fault that she has been raped? Why didn't the family punish her brother?" And they both looked at each other and one uncle said to the other, "What do you think? Do you think we killed the wrong person?" The other replied, "No, no. Don't worry. She seduced her brother." I asked them why, with millions of men in the street, would she choose to seduce her own brother? They only repeated that she had tarnished the family image by committing an impure act. Then they started asking me questions: "Why was I dressed like this? Why wasn't I married? Why had I studied in the United States?" They inferred that I, too, was not a good girl.

From then on I went on covering stories about women who were killed in an unjust, inhuman way. Most of them did not commit any immoral, much less illegal, act, and even if they did, they still did not deserve to die. But I want to emphasize two things. One is that all women are not threatened in this way in my country. Any woman who speaks to any man will not be killed. These crimes are isolated and limited, although they do cross class and education boundaries. The other thing is a lot of people assume incorrectly that these crimes are mandated by Islam, but they are not. Islam is very strict about killing, and in the rare instances where killing is counseled, it is when adultery is committed within a married couple. In these cases, there must be four eyewitnesses and the punishment must be carried out by the community, not by the family members involved.

Honor killings are part of a culture, not a religion, and occur in Arab communities in the United States and many countries. One-third of the reported homicides in Jordan are honor killings. The killers are treated with leniency, and families assign the task of honor killing to a minor, because under Jordanian juvenile law, minors who commit crimes are sentenced to a juvenile center where they can learn a profession and continue their education, and then, at eighteen, be released without a criminal record. The average term served for an honor killing is only seven and a half months.

> "Honor killings are part of a culture, not a religion. One-third of the reported homicides in Jordan are honor killings."

The reason for these killings is that many families tie their reputation to the women. If she does something wrong, the only way to rectify the family's honor is to have a wife, daughter, sister killed. Blood cleanses honor. The killers say, "Yes, she's my sister and I love her, but it is a duty."

I undertook this issue not just because I am a woman, but because most people fight for human rights in general—political agendas, prison conditions, children's rights—but nobody is taking up this issue. And isn't it important to guarantee the right of a woman simply to live before fighting for any other laws?

Related to this is the practice of protective custody. If a woman becomes pregnant out of wedlock, she will turn herself in to the police, and they'll put her in prison to "protect her life." Anywhere else in the world you would put the person who is threatening someone's life in prison, but in my country and elsewhere in the Arab world, it is the opposite. The victim goes to jail. Most of these women are held there indefinitely. They are not charged, and they cannot make bail. If the family bails them out, it is to kill them. So these women remain, wasting their lives in prison.

Since I started reporting on the honor killings, things have started to change for the better. When King Hussein opened the Thirteenth Parliament, he mentioned women and their rights—the first time a ruler had emphasized women and children. And now King Hassan is following in his father's footsteps, with a new constitution where he put in two new sections, one on women. And he asked the prime minister to amend all the laws that discriminate against women. What was not included was a solution; we could begin with a shelter for women. Instead of putting women who seek haven from their families in prison, the government could have programs to rehabilitate them.

Of course this kind of human rights work has its critics. People have accused me of encouraging adultery and premarital sex. Once I had this man threatening that if I didn't stop writing, he would "visit me" at the newspaper. What upsets me the most is that people want to stay away from the subject by using these excuses. One woman said, "So what if twenty-five women are killed every year; look at how many illegitimate children are born every year?" So sad. People try to divert the main issue by accusing the victim and portraying evil women as the main cause of why adultery takes place. Women are always blamed in my country, and elsewhere in the world. Everywhere in the world, they are blamed. We are talking here about human lives that are being wasted.

It is important to realize that people who commit the killings are also victims. Their families put all the burden and pressure on their back. If you don't kill, you are responsible for the family's dishonor. If you do kill, you will be a hero and everyone will be proud of you.

While I was studying in the United States, I felt that there were good people who were trying to work for other people who were in need of help. I came to believe that if you want to do something or change something, you could do it. But in Jordan many people are passive. They don't care. Many believe that whatever they do will not affect anything in society. But I am convinced this is wrong. Because we can't say, "Okay, I won't do this because nothing will change." If you adopt this attitude, then it's true: nothing *will* ever change. I hope the day will come when I will no longer need to report on these crimes. This will happen when Jordan modernizes, not only materially, but in its awareness of human rights for women. And I am sure that day will come; and it may be closer than we think.

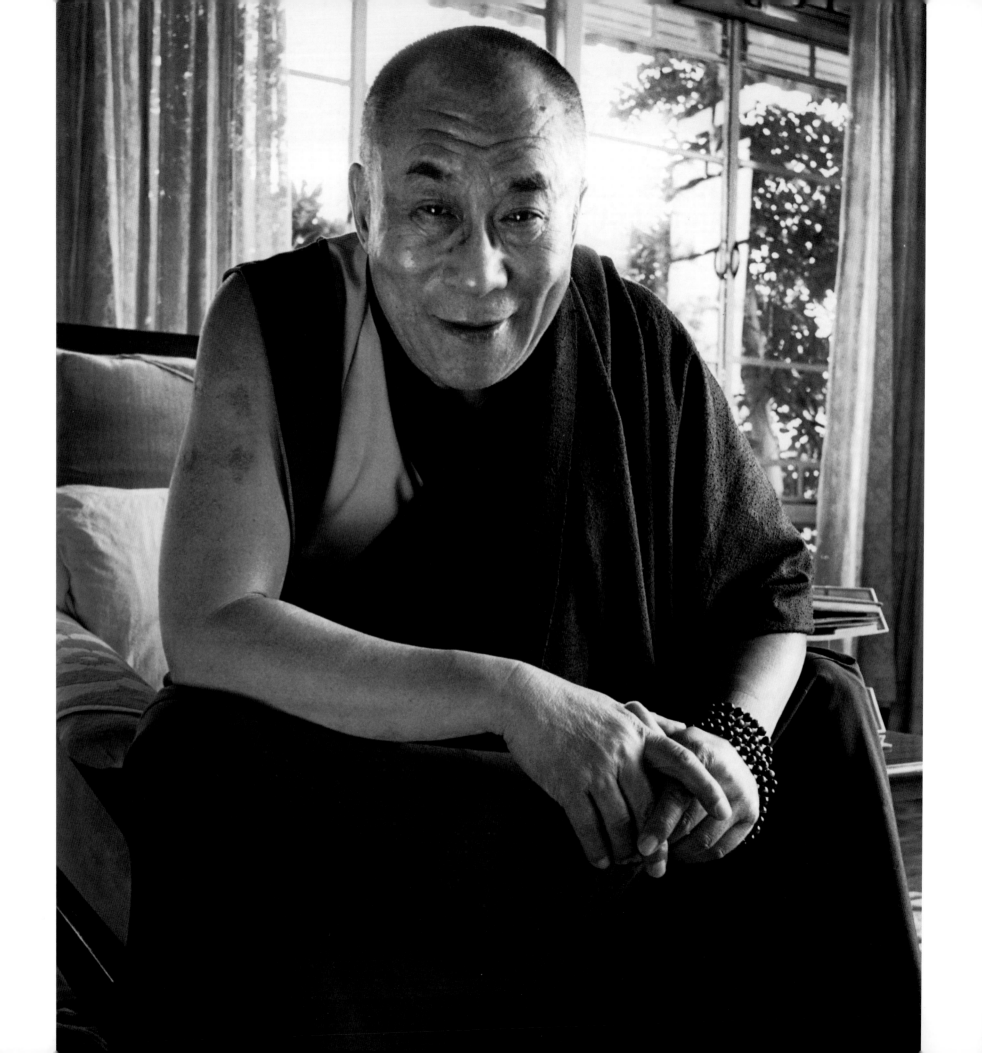

THE DALAI LAMA

———

RELIGIOUS FREEDOM

"Unless the world community tackles the
Tibetan issue, the human rights violations will continue."

The ninth child born to a farming family in the Chinese border region of Amdo in 1937, two-year-old Lhamo Thondup was recognized by Tibetan monks as the fourteenth reincarnation of the Dalai Lama, considered a manifestation of the Bodhisattva of Compassion. Renamed Tenzin Gyatso, he was brought to Lhasa to begin a sixteen-year education in metaphysical and religious texts to prepare him for his role as spiritual leader. The Chinese invasion of Tibet in 1949, and its aftermath, introduced brutal repressions in which thousands of Tibetans were executed in prisons or starved to death in prison camps, and hundreds of monasteries, temples, and other cultural and historic buildings were pillaged and demolished. In their effort to eradicate Tibetan culture and identity, the Chinese forced Tibetans to dress like Chinese, to profess atheism, to burn books, and to condemn, humiliate, and kill their elders and teachers. His life in jeopardy, the Dalai Lama fled into exile in northern India along with eighty thousand Tibetans in 1959; he has never returned. Meanwhile, new waves of repression erupted in the 1960s and 1980s that continue in the present. To date, the Chinese government has murdered, massacred, tortured, or starved to death over one million Tibetans, one-fifth of the population. In the face of this state oppression, where do Tibetans gather strength to continue the struggle? His Holiness the

Dalai Lama inspires Tibetans to embrace their beliefs and hold fast to their dreams. He has demanded that we think of those who have stolen his land and massacred his people, not as murderers and thieves, but as human beings deserving of forgiveness and compassion.

ON COMPASSION

When I visited the Nazi death camps of Auschwitz, I found myself completely unprepared for the deep revulsion I experienced at the sight of the ovens where hundreds of thousands of human beings were burned. The sheer calculation and detachment to which they bore horrifying witness overcame me. This is what happens, I thought, when societies lose touch with feeling. And while it is necessary to have legislation and international conventions in place to prevent such disasters, these atrocities happen in spite of them. What of Stalin and his pogroms? What of Pol Pot, architect of the Killing Fields? And what of Mao, a man I knew and once admired, and the barbarous insanity of the Cultural Revolution? All three had a vision, a goal, with some social agenda, but nothing could justify the human suffering engendered. So, you see it all starts with the individual, with asking what the consequences are of your actions. An ethical act is a nonharming act. And if we could enhance our sensitivity to others' suffering, the less we would tolerate seeing others' pain, and the more we would do to ensure that no action of ours ever causes harm. In Tibetan we call this *nying je*, translated generally as compassion.

ON SUFFERING

All human beings desire happiness, and genuine happiness is characterized by peace. A sentient being experiences suffering as well. It is that experience that connects us to others and is the basis of our capacity for empathy. Many in Tibet have experienced the suffering of having what we want taken away from us. As

refugees, we have lost our country, and have been forcibly separated from our loved ones. When I hear bad news from Tibet my natural reaction is one of great sadness. By the late seventies and early eighties there was an influx of large numbers of Tibetans who came to see me in India and spoke about how their fathers or their parents or their brothers or sisters were killed and how they themselves had been tortured or suffered. I often wept. Now, after hearing so many cases, my eyes have become dry. It's like the soldier who is scared when he hears the first shot, but after many shots becomes familiar with the sound.

And when the Chinese lost their temper with me, and they took it out on the Panchen Lama, that was very sad, and I accept some responsibility for what happened. Yet, what could I do? When these things occur there is no point in being discouraged and sad. Feelings of helpless anger do nothing but poison the mind, embitter the heart, and enfeeble the will. I take comfort in the words of the ancient Indian master Shantideva's advice, "If there is a way to overcome the suffering, then there is no need to worry. If there is no way to overcome the suffering, then there is no use in worrying." We must place this in context and remind ourselves that the basic human disposition toward freedom, truth, and justice will eventually prevail. It is also worth remembering that the time of greatest difficulty is the time of greatest gain in wisdom and strength. A great Tibetan scholar who spent more than twenty years in prison enduring terrible treatment, including torture, wrote letters during his confinement and smuggled them out—and they were acclaimed by many as containing the most profound teachings on love and compassion ever heard.

ON ETHICS AND ENVIRONMENT

It is no exaggeration to say that the Tibet I grew up in was a wildlife paradise. Animals were rarely hunted. Immense herds of *kyang* (wild asses) and *drong* (wild yak) roamed the plains along with shimmering *gowa* (gazelles), *wa* (fox), and *tsoe* (antelope). The noble eagles soared high over the monasteries and at night the call of the *wookpa* (long-eared owl) could be heard. Now, because of loss of habitat and hunting, the wildlife of my country is gone. In addition,

Tibet's forests have been clear-cut by the Chinese, and Beijing admits that this is at least partly to blame for the catastrophic flooding in western China. Sensitivity to the environment must be part of realizing the universal dimensions of our actions, and restraint in this, as in all, is important.

ON NONVIOLENCE

Chairman Mao once said political power comes from the barrel of a gun. But I believe that while violence may achieve short-term objectives, it cannot obtain long-lasting ends. I am a firm believer that violence begets violence. Some may say that my devotion to nonviolence is praiseworthy, but not really practical. I am convinced people say that because engaging in it seems daunting and it is easy to become discouraged. But where once one only spoke of peace in one's land, now world peace is at stake—the fact of human interdependence is so explicit now. And we must recognize that nonviolence was the principal characteristic of the political revolutions that swept the world during the 1980s. I have advanced the idea that Tibet, among other places, become a Zone of Peace, where countries like India and China, which have been at war for a long time, would benefit enormously from the establishment of a demilitarized area, saving a considerable portion of their income, which is presently wasted in maintaining border troops.

On a personal level, violence can undermine greater motivations. For example, I feel that hunger strikes as a vehicle of protest are problematic. The first time I visited the Tibetan hunger strikers (on April 2, 1988, in New Delhi), they had been without food for two weeks, so their physical condition was not yet too bad. Right from the beginning they asked me not to stop them. Since they undertook the hunger strike for the Tibetan issue, which is also my responsibility, in order to stop them I had to show them an alternative. But sadly there was no alternative. At last, Indian police intervened and took the strikers to the hospital, and I was immensely relieved. Yet the strikers acted with courage and determination, which is remarkable, and fortunately they did not have to die, not because they changed their minds, but because they were forced to live by the

because they changed their minds, but because they were forced to live by the Indian government. The strikers did not consider self-sacrifice to be a form of violence, but I did. Although they realized that our cause was a just one, they should not have felt that death at the hands of the perceived enemy was a reasonable consequence for their actions. This is a distinction and an important one.

ON HUMAN RIGHTS

Human rights violations are symptoms of the larger issue of Tibet, and unless the world community tackles the Tibet issue, the human rights violations will continue. Meanwhile, the Tibetans suffer, the Chinese are embarrassed, and general resentment increases. The Chinese authorities are concerned about unity and stability, but their method of dealing with Tibet creates instability and disunity. It's a contradiction and does not work.

ON THE VALUE OF LIFE

I realize that being the Dalai Lama serves a purpose. If one's life becomes useful and beneficial for others, then its purpose is fulfilled. I have an immense responsibility and an impossible task. But as long as I carry on with sincere motivation, I become almost immune to these immense difficulties. Whatever I can do, I do; even if it is beyond my ability. Of course, I feel I would be more useful being outside government administration. Younger, trained people should do this, while my remaining time and energy should concentrate on the promotion of human value. Ultimately, that is the most important thing. When human value is not respected by those who administer governments or work on economic endeavors, then all sorts of problems, like crime and corruption, increase. The Communist ideology completely fails to promote human value, and corruption is consequently great. The Buddhist culture can help to increase self-discipline, and that will automatically reduce corruption. As soon as we can return to Tibet with a certain degree of freedom, I will hand over all my temporal authority. Then, for the rest of my life, I will focus on the promotion of human values and the promotion of harmony among the different religious traditions. I will continue teaching Buddhism to the Buddhist world.

ON GOALS AND IMPERMANENCE

There are no inherent contradictions between being a political leader and a moral leader, as long as you carry on political activities or goals with sincere motivation and proper goals. Proper goals mean not working for your own name, or for your own fame, or for your own power, but for the benefit of others.

Within another fifty years I, Tenzin Gyatso, will be no more than a memory. Time passes unhindered. The Chinese authorities and the Tibetan people very much want me to continue my work, but I am now over sixty-four years old. That means, in another ten years I will be seventy-four, in another twenty years I will be eighty-four. So, there is little time left for active work. My physicians say that my life span, as revealed by my pulse, is one hundred and three years. In this time, until my last day, I want to, for the benefit of all, maintain close relationships with those who became Tibet's friends during our darkest period. They did it not for money, certainly not for power (because by being our friends they may have had more inconvenience dealing with China), but out of human feeling, out of human concern. I consider these friendships very precious. Here is a short prayer that gave me great inspiration in my quest to benefit others:

May I become at all times both now and forever

A protector for those without protection

A guide for those who have lost their way

A ship for those with oceans to cross

A bridge for those with rivers to cross

A sanctuary for those in danger

A lamp for those without light

A place of rugs for those who lack shelter

And a servant to all in need.

WANGARI MAATHAI

WOMEN AND THE ENVIRONMENT

"When you start doing this work, you do it with a very
pure heart, out of compassion.... The clarity of what you ought to
do gives you courage, removes the fear, gives you the courage
to ask. There is so much you do not know. And you need to know."

Throughout Africa (as in much of the world) women hold primary responsibility for deciding what to plant, for tilling the fields and harvesting the food. They are the first to become aware of environmental damage that harms agricultural production: if the well goes dry, they are the ones concerned about finding new sources of water and those who must walk long distances to fetch it. As mothers, they notice when the food they feed their family is tainted with pollutants or impurities. Wangari Maathai, Kenya's foremost environmentalist and women's rights advocate, founded the Greenbelt Movement on Earth Day, 1977, encouraging the farmers (70 percent of whom are women) to plant "greenbelts" to stop soil erosion, provide shade, and create a source of lumber and firewood. She distributed seedlings to rural women and set up an incentive system for each seedling that survived. To date, the movement has planted over fifteen million trees, produced income for eighty thousand people in Kenya alone, and has expanded its efforts to over thirty African countries, the United States, and Haiti. Maathai won the Africa Prize for her work in preventing hunger, and was heralded by the Kenyan government and controlled press as an exemplary citizen. A few years later, when Maathai denounced President Daniel arap Moi's proposal to erect a sixty-two-story skyscraper in the middle of Nairobi's largest park (graced by a four-story statue of Moi himself), officials warned her to curtail her criticism. When she took her campaign public, she was visited by security forces. When she still refused to be silenced, she was subjected to a harassment campaign and threats. Members of parliament denounced Maathai, dismissing her organization as

"a bunch of divorcees." The government-run newspaper questioned her sexual past, and police detained and interrogated her, without ever pressing charges. Eventually Moi was forced to forego the project, in large measure because of the pressure Maathai successfully generated. Years later, when she returned to the park to lead a rally on behalf of political prisoners, Maathai was hospitalized after pro-government thugs beat her and other women protesters. Following the incident, Moi's ruling party parliamentarians threatened to mutilate her genitals in order to force Maathai to behave "like women should." But Wangari Maathai was more determined than ever, and today continues her work for environmental protection, women's rights, and democratic reform. From one seedling, an organization of empowerment and political participation has grown many strong branches. In 2004 Maathai received the Nobel Peace Prize in recognition of her efforts.

The Greenbelt Movement in Kenya started in 1977 when women from rural areas and urban centers, reflecting on their needs at organized forums, spoke about environmental degradation. They did not have firewood. They needed fruits to cure malnutrition in their children. They needed clean drinking water, but the pesticides and herbicides used on farms to grow cash crops polluted the water.

The women talked about how, a long time ago, they did not have to spend so much time going out to collect firewood, that they lived near the forest. They spoke of how, once, they ate food that sustained their health. Now, while the food does not require much energy to grow, it does not sustain them. The women feel their families are now very weak, cannot resist diseases, and that their bodies are impoverished because of an environment that is degraded.

The National Council of Women, a nongovernmental organization, responded by encouraging them to plant trees. In the beginning it was difficult because the women felt that they had neither the knowledge, the technology, nor the capital to do this. But, we quickly showed them that we did not need all of that to plant trees, which made the tree-planting process a wonderful symbol of hope. Tree-planting empowered these women because it was not a complicat-

ed thing. It was something that they could do and see the results of. They could, by their own actions, improve the quality of their lives.

When we said we wanted to plant fifteen million trees, a forester laughed and said we could have as many seedlings as we wanted because he was convinced that we could not plant that many trees. Before too long, he had to withdraw that offer because we were collecting more trees than he could give away free of charge. But we didn't have money. We decided that we could produce the seedlings ourselves. We would go and collect seeds from the trees, come back and plant them the way women did other seeds: beans, corn, and other grains. And so the women actually developed forestry management techniques, using "appropriate technology" to fit their needs. Here is the basic method: take a pot, put in the soil, and put in the seeds. Put the pot in an elevated position so that the chickens and the goats don't come and eat the seedlings.

This method worked! Some day we will record all the inventive techniques that the women developed. For example, sometimes trees produce seeds carried by the wind. These germinate in the fields with the first rain. It was very interesting to see a woman cultivating a field with a small container of water. But, she was cultivating weeds! She had learned that among these weeds were also tree seedlings, and that she could pick the seedlings and put them in a container. In the evening, she went home with several hundred seedling trees! These techniques developed by the women became extremely helpful. We planted more than twenty million trees in Kenya alone. In other African countries, we have not kept records.

Trees are alive, so we react to them in very different ways. Quite often, we get attached to a tree, because it gives us food and fodder for our fires. It is such a friendly thing. When you plant a tree and you see it grow, something happens to you. You want to protect it, and you value it. I have seen people really change and look at trees very differently from the way they would in the past. The other thing is that a lot of people do not see that there are no trees until

they open their eyes, and realize that the land is naked. They begin to see that while rain can be a blessing, it can also be a curse, because when it comes and you have not protected your soil, it carries the soil away with it! And this is the rich soil in which you should be growing your food. They see the immediate relationship between a person and the environment. It is wonderful to see that transformation, and that is what sustains the movement!

We have started programs in about twenty countries. The main focus is how ordinary people can be mobilized to do something for the environment. It is mainly an education program, and implicit in the action of planting trees is a civic education, a strategy to empower people and to give them a sense of taking their destiny into their own hands, removing their fear, so that they can stand up for themselves and for their environmental rights. The strategy we use is a strategy that we call the "wrong bus syndrome," a simple analogy to help people conceive what is going on. People come to see us with a lot of problems: they have no food, they are hungry, their water is dirty, their infrastructure has broken down, they do not have water for their animals, they cannot take their children to school. The highest number of problems I have recorded at a sitting of about a hundred people is one hundred and fifty. They really think we are going to solve their problems. I just write them down, but I am not going to do anything about them. I just write them down in order to give the people a feeling of relief and a forum where they can express their problems.

After we list these problems, we ask, "Where do you think these problems come from?" Some people blame the government, fingering the governor or the president or his ministers. Blame is placed on the side that has the power. The people do not think that they, themselves, may be contributing to the problem. So, we use the bus symbol (because it is a very common method of transportation in the country). If you go onto the wrong bus, you end up at the wrong destination. You may be very hungry because you do not have any money. You may, of course, be saved by the person you were going to visit, but you may also be arrested by the police for hanging around and looking like you

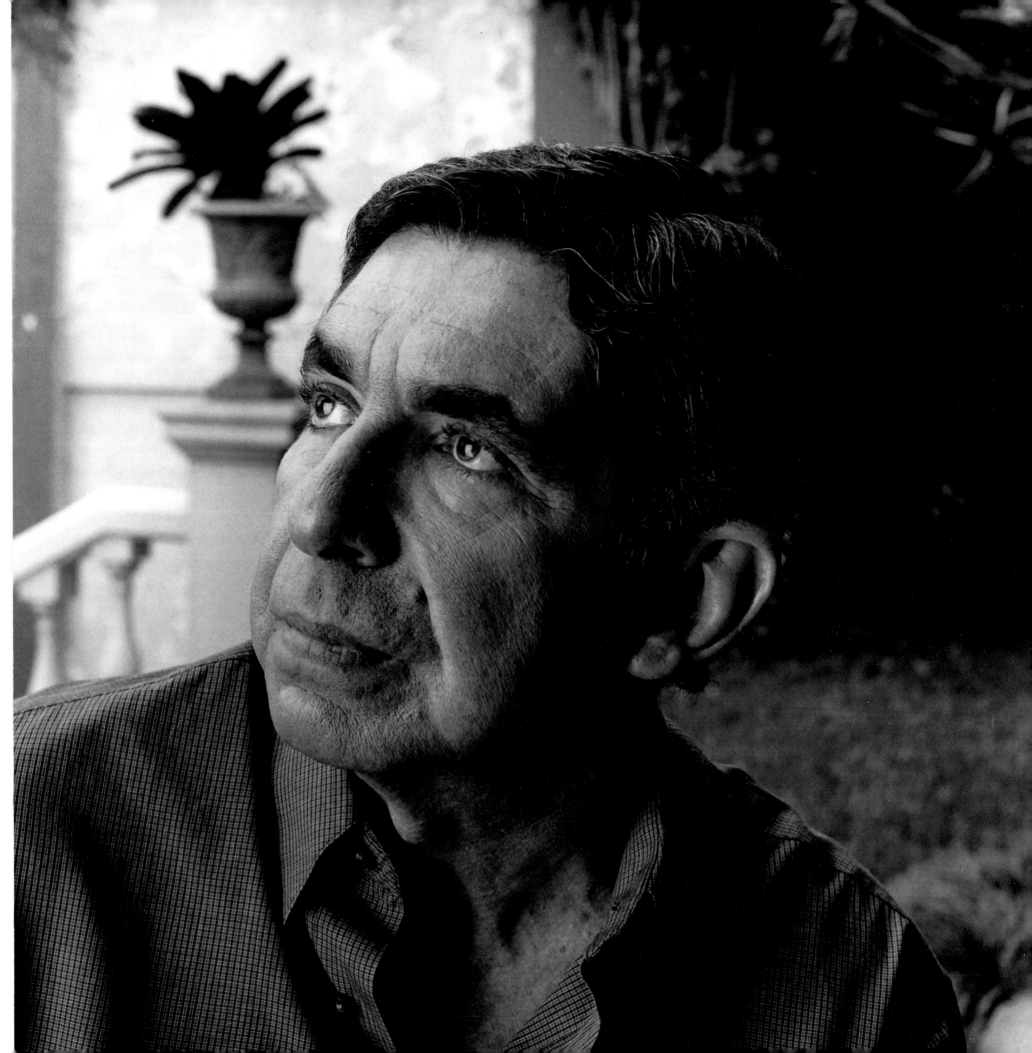

DIANNA ORTIZ

GUATEMALA / UNITED STATES

TORTURE

"To this day, I can smell the decomposing of bodies, disposed of in an open pit. I can hear the piercing screams of other people being tortured. I can see the blood gushing out of the woman's body."

Dianna Ortiz is an Ursuline nun from New Mexico who journeyed to Guatemala in the early 1980s as a missionary, teaching Mayan children in the highlands. After months of receiving threats, Ortiz was abducted and brutally raped by armed men in November 1989. One of the men overseeing the torture appeared to be American. The Inter-American Commission on Human Rights concluded that: "Sister Ortiz was placed under surveillance and threatened, then kidnapped and tortured, and that agents of the government of Guatemala were responsible for these crimes…including violating Dianna Ortiz's rights to 'humane treatment, personal liberty, a fair trial, privacy, freedom of conscience and of religion, freedom of association and judicial protection.'" Ortiz's ordeal did not end with her escape. Her torment continued as she sought answers from the U.S. government about the identity of her torturers in her unrelenting quest for justice. Ortiz's raw honesty and capacity to articulate the agony she suffered compelled the United States to declassify long-secret files on Guatemala, and shed light on some of the darkest moments of Guatemalan history and American foreign policy.

I want to be free of these memories. I want to be as trusting, confident, adventurous, and carefree as I was in 1987 when I went to the western highlands of Guatemala to teach young indigenous children to read and write in Spanish and in their native language and to understand the Bible in their culture. But on November 2, 1989, the Dianna I just described ceased to exist. I tell you this story only because it reflects the suffering of hundreds of thousands of people in Guatemala, a country ravaged by a civil war that began in 1960 and lasted thirty-six years. Most of the victims, like me, were civilians targeted by government security forces.

As I sat reading in the garden of a convent, where I had retreated to think about my options after receiving increasingly violent death threats, I heard a man's deep voice behind me: "Hello, my love," he said in Spanish. "We have some things to discuss." I turned to see the morning sunlight glinting off a gun held by a man who had threatened me once before on the street. He and his partner forced me onto a bus, then into a police car where they blindfolded me. We came to a building and they led me down some stairs. They left me in a dark

DIANNA ORTIZ

GUATEMALA / UNITED STATES

TORURE

"To this day, I can smell the decomposing of bodies, disposed of in an open pit. I can hear the piercing screams of other people being tortured. I can see the blood gushing out of the woman's body."

Dianna Ortiz is an Ursuline nun from New Mexico who journeyed to Guatemala in the early 1980s as a missionary, teaching Mayan children in the highlands. After months of receiving threats, Ortiz was abducted and brutally raped by armed men in November 1989. One of the men overseeing the torture appeared to be American. The Inter-American Commission on Human Rights concluded that: "Sister Ortiz was placed under surveillance and threatened, then kidnapped and tortured, and that agents of the government of Guatemala were responsible for these crimes…including violating Dianna Ortiz's rights to 'humane treatment, personal liberty, a fair trial, privacy, freedom of conscience and of religion, freedom of association and judicial protection.'" Ortiz's ordeal did not end with her escape. Her torment continued as she sought answers from the U.S. government about the identity of her torturers in her unrelenting quest for justice. Ortiz's raw honesty and capacity to articulate the agony she suffered compelled the United States to declassify long-secret files on Guatemala, and shed light on some of the darkest moments of Guatemalan history and American foreign policy.

I want to be free of these memories. I want to be as trusting, confident, adventurous, and carefree as I was in 1987 when I went to the western highlands of Guatemala to teach young indigenous children to read and write in Spanish and in their native language and to understand the Bible in their culture. But on November 2, 1989, the Dianna I just described ceased to exist. I tell you this story only because it reflects the suffering of hundreds of thousands of people in Guatemala, a country ravaged by a civil war that began in 1960 and lasted thirty-six years. Most of the victims, like me, were civilians targeted by government security forces.

As I sat reading in the garden of a convent, where I had retreated to think about my options after receiving increasingly violent death threats, I heard a man's deep voice behind me: "Hello, my love," he said in Spanish. "We have some things to discuss." I turned to see the morning sunlight glinting off a gun held by a man who had threatened me once before on the street. He and his partner forced me onto a bus, then into a police car where they blindfolded me. We came to a building and they led me down some stairs. They left me in a dark

rule of law, and civilian control over the military and security forces. Its government must not engage in gross violations of internationally recognized human rights. The International Code of Conduct would not permit arms sales to any country engaged in armed aggression in violation of international law.

Many say that such a code is impractical—impractical because it puts concern for human life before a free-market drive for profits; impractical because it listens to the poor who are crying out for schools and doctors, rather than the dictators who demand guns and fighters. Yes, in an age of cynicism and greed, all just ideas are considered impractical. You are discouraged if you say that we can live in peace. You are mocked for insisting that we can be more humane. I often question the relationship between the International Code of Conduct on Arms Transfers and the free-market concept of supply and demand. If a country's leaders want arms, some might ask, who are we to say that they shouldn't have them?

This question merits two responses. First, since the end of the Cold War, arms manufacturers have been aggressively promoting sales to the developing world, in order to compensate for the drastic reduction in arms purchases by most industrialized countries. Furthermore, when we assert that a "nation" desires arms, to whom exactly are we referring? Is the single mother in Indonesia or the street orphan in Egypt pressuring government leaders to buy tanks and missiles? Or is it a dictator—who sees arms purchases as the only way to maintain power? The poor of the world are crying out for schools and doctors, not guns and generals. Another argument to justify the sale of arms is that if one country does not sell arms to a nation that wishes to buy them, someone else will. That is precisely why all arms-selling nations must agree to certain common restrictions. We can no longer say business is business and turn a blind eye to the poverty and oppression caused by arms transfers. Just like slavery and the drug trade, the arms trade reaps profits tainted with blood.

Demilitarization is the goal—and it has proven to be an attainable one. Truly the progress made in Panama and Haiti, to name two countries, give us much reason to hope. The U.S. invasion of Panama in 1989 dissolved that country's armed forces. Subsequently, the Arias Foundation for Peace and Human Progress pushed for the constitutional abolition of Panama's military. We com-

missioned an opinion poll to gauge the Panamanian people's support for a demobilization process; not surprisingly, the poll found substantial support for such a measure. We also began a public education campaign to promote the value of demilitarization. These efforts, and the resolve of the millions of Panamanians who stood for disarmament, came to fruition in October 1994 when Panama's legislature amended the Constitution to abolish their armed forces.

Similarly, the army of Haiti was in considerable disarray following the U.S.-led interventions in 1994. At this time I encouraged President Aristide to consider demobilizing his armed forces. Meanwhile, many civil society groups held meetings to promote demobilization. The Arias Foundation launched a public opinion poll campaign akin to that of Panama's and documented similar support among the Haitian public for the abolition of their armed forces. In April 1995, Aristide publicly announced his intention to seek the elimination and constitutional abolition of Haiti's armed forces. Then in February 1996, the Haitian Senate presented a resolution stating their intent to pursue the constitutional abolition of Haiti's armed forces.

Courage begins with one voice—look at all the people who have come forward, as individuals and groups, to support the Code of Conduct. Clearly, much work remains to be done. People must continue to organize, so that their voices will be heard. Political leaders must be convinced that demilitarization is a practical and desirable goal. And if they cannot be convinced, then people must elect new representatives. Conviction itself is only talk, but it is important talk, because it motivates action. So while I recognize the hard work of bringing people together in democratic movements, of policy formation, and of diplomacy, I think it is important to affirm that change in consciousness is a crucial first step in making social change—the step from which action grows.

Courage means standing with your values, principles, convictions, and ideals under all circumstances—no matter what. If you stick to your principles, you will often have to confront powerful interests. Having courage means doing this without fear. It means having the courage to change things. I often say that Costa Rica is not now an economic power, but that we want to be some day. Costa Rica is not a military power, and we do not ever want to be. But Costa Rica is already a moral power. This is why we must always be sure to have the courage to do what is right.

beast, offering unimaginable prosperity to the most well educated and well born, while doling out only misery and despair to the world's poor. For some, the new economic system means minimizing labor costs and maximizing profits; for many others, it means facing the end of job security, and at the same time witnessing the reappearance of "sweatshops." The most vulnerable and economically insecure populations bear the miserable brunt of the impact of an economic system based on greed and speculation, rather than on human need. While the world as a whole consumes twenty-four trillion dollars worth of goods and services each year, the planet holds 1.3 billion people who live on incomes of less than one dollar a day. The three richest countries in the world have assets that exceed the combined gross domestic product of the poorest forty-eight countries.

The question is not whether you will be involved in the ethical challenges of globalization, but what your contribution will be. Will you, in your apathy, be complicit in the injustices I have described? Or will you, with your action and your example, bolster the ranks of those fighting for human security? Today we must accept the fact that the evils of environmental destruction and human deprivation, of disease and malnutrition, of conspicuous consumption and military buildup, are global problems—problems that affect us all.

Military spending is not merely a consumer excess; instead, it represents a huge perversion in the priorities of our civilization. We're talking about enormous sums of money that could be spent on human development. But also, we're talking about vast investment in instruments of death, in guns and fighters designed to kill people. The creation and proliferation of arms bolsters the power of the military, impedes the process of democratization, destroys economic advances, perpetuates ethnic and territorial conflicts, and creates situations in which even the most basic human rights are endangered. Moreover, we increasingly find that women and children are forced to endure a disproportionate share of the hardships of armed conflict and the poverty it worsens.

Since the end of the Cold War, many industrialized nations have reduced their defense budgets. As a result, those countries' arms merchants have turned to new clients in the developing world, where the majority of today's conflicts take place. The United States stands out as an extreme case. Currently, the United States is responsible for 44 percent of all weapons sales in the world. And, in the past four years, 85 percent of U.S. arms sales have gone to nondemocratic governments in the developing world.

At the end of 1997, weapons manufactured in the United States were being used in thirty-nine of the world's forty-two ethnic and territorial conflicts. It is unconscionable for a country that believes in democracy and justice to continue allowing arms merchants to reap profits stained in blood. But ironically, vast amounts of taxpayer money goes to support this immoral trade. In 1995 the arms industry received 7.6 billion dollars in federal subsidies—this amounts to a huge welfare payment to wealthy profiteers.

War, and the preparation for war, are the two greatest obstacles to human progress, fostering a vicious cycle of arms buildups, violence, and poverty. In order to understand the true human cost of militarism, as well as the true impact of unregulated arms sales in the world today, we must understand that war is not just an evil act of destruction, it is a missed opportunity for humanitarian investment. It is a crime against every child who calls out for food rather than for guns, and against every mother who demands simple vaccinations rather than million-dollar fighters. Without a doubt, military spending represents the single most significant perversion of global priorities known today, claiming 780 billion dollars in 1997. If we channeled just 5 percent of that figure over the next ten years into antipoverty programs, all of the world's population would enjoy basic social services. Another 5 percent, or forty billion dollars, over ten years would provide all people on this planet with an income above the poverty line for their country.

Military officials simply try to marginalize and downplay disarmament proposals as much as possible. They call these ideas "impractical" and "idealistic." They use backroom political tricks to impede disarmament legislation. And they have a whole array of arguments to rationalize the production and sale of arms. I have worked to advocate an International Code of Conduct on Arms Transfers, a comprehensive international effort to regulate and monitor weapons sales. This agreement demands that any decision to export arms should take into account several characteristics pertaining to the country of final destination. The recipient country must endorse democracy, defined in terms of free and fair elections, the

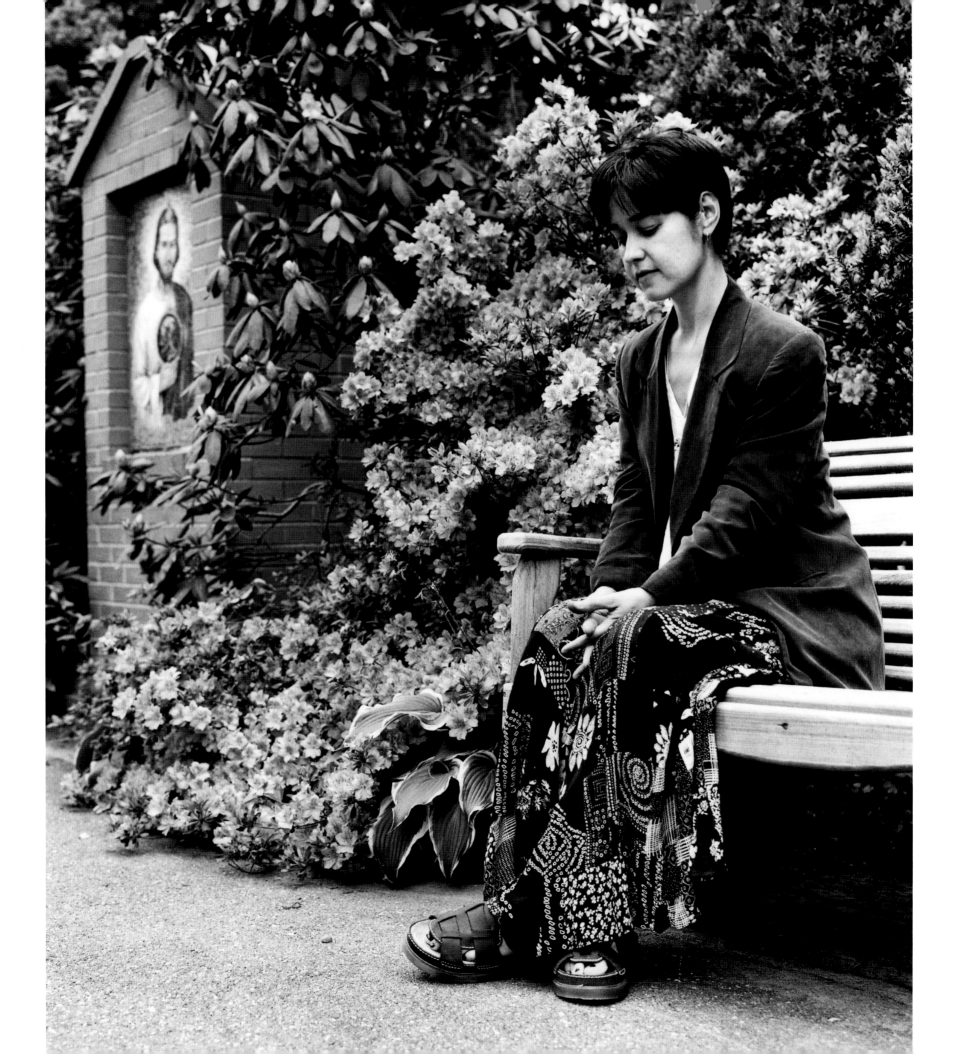

cell, where I listened to the cries of a man and woman being tortured. When the men returned, they accused me of being a guerrilla and began interrogating me. For every answer I gave them, they burned my back or my chest with cigarettes. Afterwards, they gang-raped me repeatedly.

Then they transferred me to another room and left me alone with another woman prisoner. We exchanged names, cried, and held onto each other. "Dianna," she said in Spanish, "they will try to break you. Be strong." When the men returned, they had a video camera and a still camera. The policeman put a machete into my hands. Thinking it would be used against me, and at that point in my torture wanting to die, I did not resist. But the policeman put his hands onto the handle, on top of mine, and forced me to stab the woman again and again. What I remember is blood gushing—spurting like a water fountain—droplets of blood splattering everywhere—and my cries lost in the cries of the woman.

The policeman asked me if I was now ready to talk, and one of the other torturers, the man who had threatened me on the street, mentioned that they had just filmed and photographed me stabbing the woman. If I refused to cooperate, their boss, Alejandro, would have no choice but to turn the videotapes and the photographs over to the press, and everyone would know about the crime I'd committed. This was the first I had heard of Alejandro, the torturers' boss. But soon I would meet him.

I was taken into a courtyard and interrogated again. The policeman wanted me to admit that I was Veronica Ortiz Hernandez. Earlier he had shown me a photograph of a long-haired, indigenous woman. "That's you," he'd said. "You are Veronica Ortiz Hernandez." She looked nothing like me. He was still insisting on this, and asking me the name of a man in another photograph he had shown me.

The policeman raped me again. Then I was lowered into a pit full of bodies—bodies of children, men, and women, some decapitated, all caked with blood. A few were still alive. I could hear them moaning. Someone was weeping. I didn't know if it was me or somebody else. A stench of decay rose from the pit. Rats swarmed over the bodies and were dropped onto me as I hung suspended over the pit by the wrists. I passed out and when I came to I was lying on the ground beside the pit, rats all over me.

The nightmare I lived was nothing out of the ordinary. In 1989, under Guatemala's first civilian president in years, nearly two hundred people were abducted. Unlike me, they were "disappeared, gone forever." The only uncommon element of my ordeal was that I survived, probably because I was a U.S. citizen, and phone calls poured into Congress when I was reported missing. As a U.S. citizen, I had another advantage: I could, in relative safety, reveal afterwards the details of what happened to me in those twenty-four hours. One of those details: an American was in charge of my torturers.

I remember the moment he removed my blindfold. I asked him, "Are you an American?" In poor Spanish and with a heavy American accent, he answered me with a question: "Why do you want to know?" Moments before, after the torturers had blindfolded me again and were getting ready to rape me again, they had called out in Spanish: "Hey, Alejandro, come and have some fun!"

And a voice had responded "Shit!" in perfect American English with no trace of an accent. It was the voice of the tall, fair-skinned man beside me. After swearing, he'd switched to a halting Spanish. "Idiots!" he said. "She's a North American nun." He added that my disappearance had been made public, and he ran them out of the room.

"I know what few U.S. citizens know:
what it is to be an innocent civilian, and to be accused, interrogated, and tortured,
to have my own government eschew my claims for justice and actively destroy
my character because my case causes political problems for them."

Now he was helping me on with my clothes. "*Vamos*," he said, and he led me out of the building. He kept telling me he was sorry. The torturers had made a mistake. We came to a parking garage, where he put me into a gray Suzuki jeep and told me he was taking me to a friend of his at the U.S. embassy who would help me leave the country.

For the duration of the trip, I spoke to him in English, which he understood perfectly. He said he was concerned about the people of Guatemala and consequently was working to liberate them from Communism. Alejandro told me to forgive my torturers because they had confused me with Veronica Ortiz Hernandez. It was an honest mistake.

I asked him how they could have mistaken me for a woman who did not resemble me in any way. And why were the threatening letters I had received addressed to Madre Dianna and not to Veronica Ortiz Hernandez? He avoided my questions and insinuated that I was to blame for my torture because I had not heeded the threats that were sent to me. I asked him what would happen to the other people I had heard screaming and saw tortured before my eyes. He told me not to concern myself with them and to forget what had happened.

In English again, he made it clear that if I didn't "forgive" my torturers, I would face consequences. "We have the videotapes and the photographs," he said. Soon the jeep stopped in traffic. We were near an intersection and up ahead was a red light. I took advantage of the opportunity, jumped out of the jeep, and ran.

I thought that was the end of my torture. It was only the beginning. Because I didn't "forget" about the other people being tortured, because I filed suit against the Guatemalan security forces instead of forgiving my torturers, and because I revealed

that they were supervised by an American, I faced consequences. The Guatemalan president claimed that the abduction had never occurred, simultaneously claiming that it had been carried out by nongovernmental elements and therefore was not a human rights abuse. Only one week after my abduction, before any true investigation had been conducted, the U.S. ambassador suggested that I was a political strategist and had staged my own kidnapping to secure a cutoff of U.S. military aid to Guatemala.

Two months later, after a U.S. doctor had counted 111 cigarette burns on my back alone, the story changed. In January 1990, the Guatemalan defense minister publicly announced that I was a lesbian and had staged my abduction to cover up a tryst. The minister of the interior echoed this statement and then said he had heard it first from the U.S. embassy. According to a congressional aide, the political affairs officer at the U.S. embassy, Lew Anselem, was indeed spreading the same rumor.

In the presence of Ambassador Thomas Stroock, this same human rights officer told a delegation of religious men and women concerned about my case that he was "tired of these lesbian nuns coming down to Guatemala." The story would undergo other permutations. According to the Guatemalan press, the ambassador came up with another version: he told the Guatemalan defense minister that I was not abducted and tortured but simply "had problems with [my] nerves."

During this time, the United States was working arm in arm with the Guatemalan army to achieve a secret foreign policy objective—defeating the Guatemalan guerrillas. And my case was bad publicity for the army. Because I had mentioned the American boss, it was also bad publicity for the U.S. government, whose overt foreign policy objectives in Guatemala were promoting democracy, stability, and respect for human rights. In the ambassador's words, my case could "damage U.S. interests." In a letter urging State Department officials not to meet with me to take my tes-

timony, the ambassador put it this way: "If the Department meets with her…pressure from all sorts of people and groups will build on the Department to act on the information she provides…I'm afraid we're going to get cooked on this one…."

The Organization of American States, after completing a four-year investigation of my case, found in 1997 that I indeed was abducted and tortured by agents of the Guatemalan government, that the details of my testimony were credible, and that the Guatemalan government had "engaged in repeated unwarranted attacks on [my] honor and reputation."

The Guatemalan justice system was not so forthcoming. I made three trips to Guatemala to testify against the government, something no torture survivor had ever been able to do. Again, my passport opened up possibilities for me that Guatemalans would never have. Pressing charges would mean certain death for a Guatemalan who managed to survive torture. I identified the place where I was detained and tortured, and participated in a reenactment of my abduction.

On my return to the United States, I received intimidating phone calls and anonymous packages. One contained a dead mouse wrapped in a Guatemalan flag. I suspect that Guatemalan military intelligence agents or members of a U.S. intelligence agency were behind these attempts to intimidate me.

The intimidation did not end with anonymous threats, but carried over into the courtroom. As I sought justice, I was cast as the criminal, much as women who file charges of rape are presumed guilty until proven innocent. The lawyers' accusations against me and their aggressive interrogations triggered flashbacks. The case languished in the Guatemalan court system. No suspects were ever identified.

In 1996, I held a five-week vigil before the White House, asking for the declassification of all U.S. government documents related to human rights abuses in Guatemala since 1954, including documents on my own case. A few days into my vigil, I was granted a meeting with First Lady Hillary Clinton. Mrs. Clinton admitted what no other U.S. government official had dared to concede during my seven-year search for the truth behind my abduction and torture in Guatemala: she said it was possible that the American in charge of my Guatemalan torturers was a "past or present employee of a U.S. agency."

I ended my vigil and fast when the State Department declassified thousands of documents. But the documents contain no information about the American boss, and they do not identify my Guatemalan torturers. They do contain several interesting points of information. For example, Americans employed by various government agencies were in fact working within the Guatemalan security forces at the time of my abduction; and the U.S. ambassador at the time of my abduction admitted that the embassy had contact with members of a death squad.

Documents also show that the Guatemalan defense minister in office at the time of my torture studied counterinsurgency tactics at an army school in Georgia. Course manuals advocated the torture and execution of civilians ("terrorists operating within the democratic system") whose "political, social, and economic activities" could cause "discontent." The manuals urged internal intelligence agencies to "obtain information on the substance of [these] nonviolent attacks." It is no surprise that the Guatemalan army targeted me, as all civilians trying to help the poor were considered potential subversives.

> "My torturers were never brought to justice. It is possible that, individually, they will never be identified or apprehended. But I cannot resign myself to this fact and move on."

After escaping from my torturers, I returned home to New Mexico, so traumatized that I recognized no one, not even my parents. I had virtually no memory of my life before my abduction; the only piece of my identity that remained was that I was a woman who was raped and forced to torture and murder another human being. I still have little memory of my life before my abduction at thirty-one. Instead I have memories of the torture. You may think this strange, but even at this moment, I can sense the presence of my torturers. I can smell them. I can feel their monstrous hands on my body, I can hear them hissing in my ear that I am the one who killed the woman. I want to be free of these memories. I want freedom for myself and all the people of Guatemala. The key is the truth. I want to know who Alejandro was. Was he a CIA agent? Why is the U.S. government protecting him? How many other Alejandros are there out there, supervising torture?

Efforts to obtain information through U.S. government investigations also led nowhere. The Department of Justice interviewed me for more than forty hours, during which time their attorneys accused me of lying. They interrogated my friends and family members and generally made it clear that I was the culprit, I was the one being investigated, not the government officials who acted wrongly in my case. During the interview, I reentered that clandestine military prison and relived my torture it in all its horror. After I had given the majority of my testimony, I felt compelled to withdraw from direct participation in the Justice Department investigation. The investigators had the sketches I had made with the help of a professional forensic artist, delineating the characteristics of each torturer, including Alejandro, and the investigators had my testimony, in detail. The responsibility for finding answers lay with them. The Department of Justice came up with a two-hundred-page report to protect sources and methods and, ostensibly, to protect my own privacy.

In an attempt to get the report declassified, I then had to violate my own privacy. Afraid that the Department of Justice investigators might leak information I had given them if I pressured for the release of the report, I went public with that secret information myself: I got pregnant as a result of the multiple gang rapes. Unable to carry within me what the torturers had engendered, what I could only view as a monster, the product of the men who had raped me, I turned to someone for assistance and I destroyed that life.

Am I proud of that decision? No. But if I had to make the decision again, I believe I would decide as I did then. I felt I had no choice. If I had had to grow within me what the torturers left me I would have died. In 1998, after going public with this information, I filed a Freedom of Information Act request to obtain the Department of Justice report. My request was denied in full.

But to this day, I cannot forget those who suffered with me and died in that clandestine prison. In spite of the humiliation that demanding answers has entailed, I stand with the Guatemalan people. I demand the right to a future built on truth and justice. My torturers were never brought to justice. It is possible that, individually, they will never be identified or apprehended. But I cannot resign myself to this fact and move on. I have a responsibility to the people of Guatemala and to the people of the world to insist on accountability where it is possible. I know what few U.S. citizens know: what it is to be an innocent civilian, and to be accused, interrogated, and tortured, to have my own government eschew my claims for justice and actively destroy my character because my case causes political problems for them. I know what it is to wait in the dark for torture, and what it is to wait in the dark for the truth. I am still waiting.

HAFEZ AL SAYED SEADA

EGYPT

—

POLITICAL RIGHTS

"The government didn't accept our report documenting the abuses so they targeted our organization. But what I wrote are facts. Hundreds of the people were arrested. Hundreds were tortured in the police stations."

Established in 1985, under Hafez Al Sayed Seada's leadership, the Egyptian Organization for Human Rights investigates, monitors, and reports on violations of the Universal Declaration of Human Rights. Seada defends victims; strives to create understanding of, and popular support for, the defense of human rights; and works to change laws and government practices that violate international instruments. He has launched numerous campaigns against specific violations, including torture, female genital mutilation, inhumane prison conditions, and religious persecution. Due process in Egypt is hampered by emergency decrees, military and state security courts where due process rights are suspended, a judiciary beholden to the executive, the routine use of torture by security agents, and the deep divisions and suspicions among the many religious and ethnic minorities in the country. Although there are many news outlets, press self-censorship is common, and dissent from the official party line is dangerous. Sexual discrimination is rampant, and women are at a severe disadvantage in family law and access to legal literacy. Seada's early life as a student activist landed him in prison, where he was mistreated and thrown through a window in an effort to deter him. Instead the experience transformed a university demonstrator into a man with a lifelong commitment to protection of human rights. Today EOHR is Egypt's foremost human rights organization.

The police first arrested me in 1979, at university, because I participated in a demonstration against the government to uphold the rights of students to free association and to work on political issues. They beat me, gave me electric shocks, and tortured me for one month. They kept telling me to reveal who was supporting me, what country or leader was backing me. These scars across my face are from when they pushed me through a window. I was hurt so badly they had to take me to a hospital where I was operated on and remained for nineteen days. That was the end of the torture, but they kept me in jail for another four months.

A decade later, I decided to work as a human rights lawyer. I joined the Egyptian Organization for Human Rights, working without pay, from 1990 until 1993, documenting cases of abuse throughout Egypt and helping to build the organization. In 1997 the board appointed me director general. My country had been suffering since the Emergency Law had been declared in 1981. The Emergency Law annuls all constitutional rights—any rights—under international conventions. The press is restricted, independent newspapers and television are banned, and all the other newspapers are owned by the government. The police, security, and intelligence forces enforce this by regularly employing all kinds of torture. We had a very narrow space in which to operate. You can't even talk about corruption. You can't talk about the transition to democracy in Egypt or the rigging of elections: not in a place where the government chooses not only the candidates running from the state party, but those of the opposition party as well!

There are now twenty thousand detainees in prison. They have had no trial, and no charges have been pressed. Recurrent detention is widely resorted to. The emergency law gives the authorities (upon the approval of the minister of the interior) the right to detain someone without charge or trial for thirty days. But this often extends to six months or more, because the authorities have the right to reject the appeal of the detained person twice. Then, when the duration is over, another ministerial order is issued, keeping the detainee as long as the authorities wish. It amounts to endless detention.

Even when trials do take place, civilians are often referred to the military courts (and you can imagine the military courts). The latest case, involving over one hundred people from Albania, included four thousand pages of documents, and the defense was given only one week to prepare for the hearing. In most cases the outcome is predetermined. Military trials continue to be a source of serious concern for the Egyptian Organization for Human Rights due to the absence of any constitutional or international guarantees for a fair and a just trial. These trials demonstrate the lack of independence of the judiciary system in Egypt. There is another issue that represents an enormous challenge: securing respect for women's rights. Fewer than 2 percent of parliamentarians are women, and those are appointed by the state. Our group works with the UN Commission for Human Rights, which condemns the abuses in Egypt. Their support helps, though we know that we will have to pay the cost of this struggle. Look at what happened to me: I went to prison for writing about the torture of the Copts. The government didn't accept our report documenting the abuses so they targeted our organization. But what I wrote are facts. Hundreds of people were arrested. Hundreds were tortured in the police stations. We couldn't remain silent and call ourselves human rights defenders. So we published this report and then the government accused me of spying for a foreign country, Britain. They accused me of receiving money from the

British Embassy to make the report. This indictment is still pending—I am out on five hundred dollars bail.

When I was under investigation, they asked me if I was responsible for managing everything here at the Human Rights Organization. I told them I was. The investigators didn't believe me, saying, "No, the president shares responsibility with you." I told them publishing the report was my decision alone. I was responsible for everything. I wrote the report, I read it, I reviewed it, and I decided to publish it and issue it in a newspaper—to uphold human rights. I personally sent it to all the news agents. Sure, if I had told the investigators that I was not responsible, they might not have arrested me. But this is not my moral code. I felt I should take my responsibility and bear the consequences.

It may never come to trial but they have made it clear that if I write any more reports, they will restart the investigation and prosecute. But this is our job, as human rights advocates, to point the finger at government errors. If we don't do this, who will? These are our rights; we should fight for them. No government recognizes rights without a struggle. Look at America's Civil War and the agony of Europe's battles for democracy. We, too, must demand our rights. Winning democracy will involve sacrifice. So far we haven't paid heavily, or sacrificed ultimately. But we know that at some point, we'll either pay or be forced to accept this corrupt regime. If we are not willing to sacrifice, then we cannot complain when we are thrown in jail without reason, without any charge, and without any due process. We can expect no better. Because the fact is that this government doesn't respect the UN Conventions on Human Rights. They don't respect the democratic system. They want only to continue retaining sole political power.

I am not frightened. I think of the future, of my son. I face this challenge for him, for all our children, and for all their future. If we don't start now, the next generation will inherit our failure to bring about change.

My father and my mother always said, "Look at the facts and then make things right." When my father came to visit me in jail, he said: "Good or bad, your destiny is in the hands of God. God has planned whether you stay in prison or are released back to us. No one can change that." This encouraged me to always confront what I knew was wrong.

I know that the future will see an Egypt becoming more democratic, with respect for human rights. But this is the future only if the people demand their rights and they struggle. With mass communications, satellite dishes, and the internet, people cannot be kept in the dark any longer. And with the prosecution of Pinochet in Spain and Milosevic in Serbia before the International Criminal Court, those in power now know they will, someday, be held accountable for their wrongdoing. Things are in a state of change—there is no looking back.

My country has tremendous potential. It is rich in resources. We have the infrastructure of industrialization and a vast host of Egyptians abroad who work in the field of technology. If my countrymen believe that Egypt now respects human rights and that corruption is limited, they will invest. If we create systems for transparency, for democratization, for accountability, and for tolerance, this will protect our country from any threat, fundamentalist or terrorist, domestic or foreign. I believe in our future—and I know it will be better than now.

DESMOND TUTU

RECONCILIATION

*"We have a God who doesn't say, 'Ah…Got you!' No. God says, 'Get up.'
And God dusts us off and God says, 'Try again.'"*

Archbishop Desmond Tutu's work confronting the bigotry and violence of South Africa's apartheid system won him the Nobel Peace Prize in 1984. Born in 1931 in Klerksdorf, he graduated from the University of South Africa in 1954 and was ordained as a priest in 1960. He studied and taught in England and South Africa, and in 1975 he was appointed dean of St. Mary's Cathedral in Johannesburg, the first black South African to hold that position. In 1978 he became the first black general secretary of the South African Council of Churches. Outspoken against the evils of apartheid, he was vilified by friend and foe, press and politicians, yet through his extraordinary patriotism and commitment to humanity, his vision, and ultimately, his faith, he persevered. After South Africa's first democratic, nonracial elections in 1994, effectively ending eighty years of white minority rule, the new parliament created the Truth and Reconciliation Commission, appointing Tutu as its head to lead his country in an agonizing and unwavering confrontation of the brutality of the past. His faith in the Almighty is exemplified by his belief in the Word made flesh; that the battle for the triumph of good will be won or lost, not by prayers alone, but by actions taken to confront evil here on earth.

There's a high level of unemployment in South Africa that helps fuel a serious level of crime. These things feed off one another because the crime then tends to make foreign investors nervous. And there aren't enough investors to make a significant impact on the economy so the ghastly legacies of apartheid—deficits in housing, in education, and health—can be truly addressed.

If you were to put it picturesquely, you would say this man and this woman lived in a shack before April 1994. And now, four years down the line, the same man and woman still live in a shack. One could say that democracy has not made a difference in material existence, but that's being superficial.

There are changes of many kinds. Things have changed significantly for the government, despite the restrictions on resources. The miracle of 1994 still exists and continues despite all of these limiting factors that contribute to instability. They are providing free health care for children up to the age of six and for expectant mothers. They are providing free school meals and education through elementary school. But the most important change is something that people who have never lived under repression can never quite understand—what it means to be free. I am free. How do I describe that to you who have always been free? I can now walk tall with straight shoulders, and have this sense of pride because my dignity, which had been trodden underfoot for so long, has been restored. I have a president I love—who is admired by the whole world. I now live in a country whose representatives do not have to skulk around the international community. We are accepted internationally, in sports, etcetera. So some things have changed very dramatically, and other things have not changed.

When I became archbishop in 1986, it was an offense for me to go and live in Bishopscourt, the official residence of the Anglican archbishop of Cape Town. Now we live in a village that used to be white, and nobody turns a head. It's as if this is something we have done all our lives. Schools used to be segregated rigidly, according to race. Now the schools are mixed. Yes, whites tend to be able to afford private schools. But government schools, which in the past were segregated, have been desegregated. Now you see a school population reflecting the demography of our country.

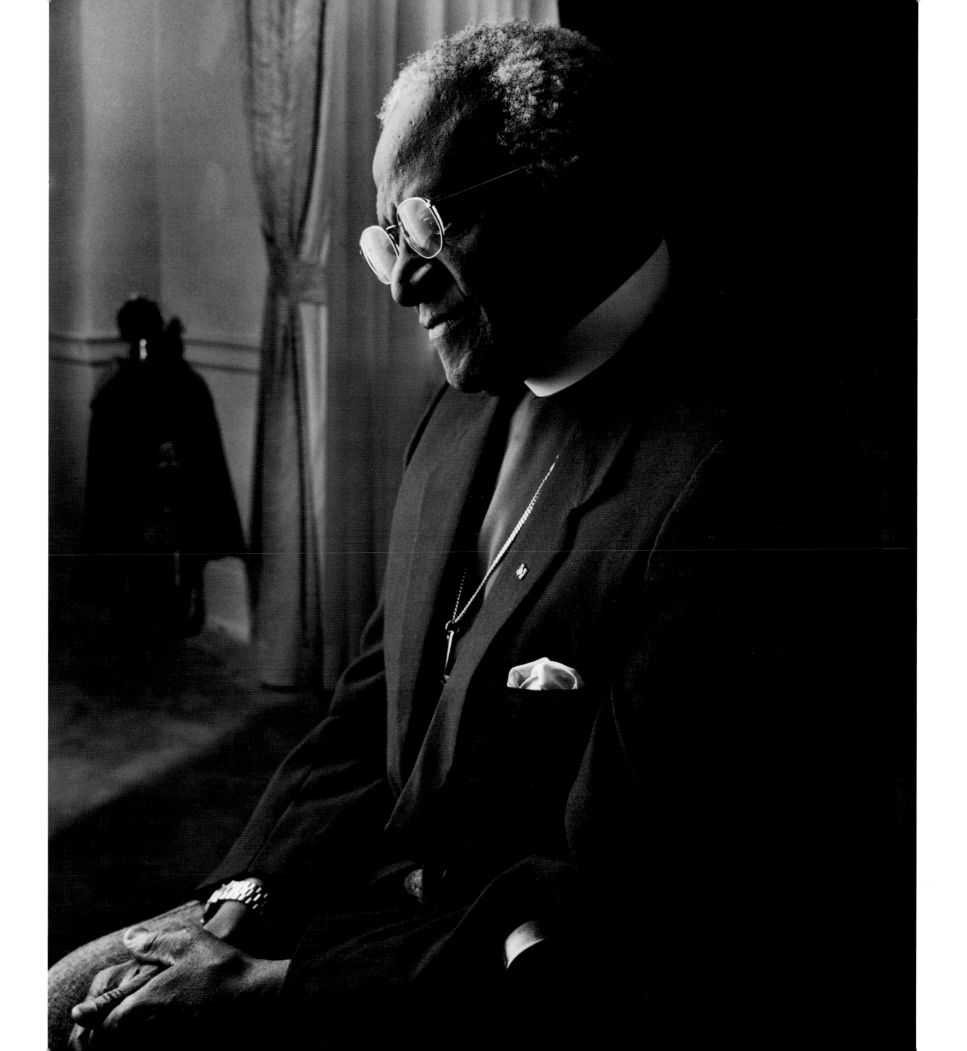

DESMOND TUTU

I was an advocate for sanctions and as a result, most of the white community regarded me as the man they most loved to hate. They would say, "Sanctions are going to hurt blacks." Yet South Africa was prosperous largely on the basis of cheap labor, using the iniquitous migratory labor system, where black men lived in single-sex hostels for eleven months of the year. Even my constituents were ambivalent about me. And so you had graffiti like: "I was an Anglican until I put Tu and Tu together." Some were really quite funny, like "God loves Tutu" adding, "The gods must be crazy." If looks could kill, they murdered me many times over. When I got on a plane in Johannesburg, or a train in Cape Town, the looks that I got were enough to curdle milk.

I received death threats, but that was not unexpected. If you choose to be in the struggle, you are likely to be a target. There are casualties in a struggle. Of course, it isn't nice to have threats and things of that sort. But it is par for the course.

When they threatened my children, that really upset me, that really got my goat. If somebody is intent on threatening me, that's okay. But they didn't have a modicum of decency. They could hear it wasn't me, it wasn't my wife, it was only a child on the telephone. They could have either dropped the telephone, or said, "Can you call your father, or call your mother?" But they didn't.

One threat came from a group called the "White Commando." They said that either I left the country by a certain date, or they were going to dispense with me. We told the police, who showed a sense of humor. One said, "Archbishop, why don't you do us a favor and stay in bed that day?"

I think my family would have felt that they were disloyal if they pressured me to change. I asked Leah, my wife, once, "Would you like me to keep quiet?" I have never been more wonderfully affirmed than when she said, "We would much rather be unhappy with you on Robben Island (the South African island prison where black political prisoners were jailed), than have you unhappy thinking you were free (in the sense that I had been disloyal to what I believed was God's calling to me)." Anything else would have tasted like ashes. It would have been living a lie. There is no reason to live like that. I suppose I could have been maybe part of a struggle in a less prominent position. But God took me, as they say, "by the scruff of the neck," like Jeremiah, who for me is a very attractive character because he complained: "God, you cheated me. You said I was going to be a prophet. And all you made me do is speak words of doom and judgment and criticism against the people I love very much. And yet if I try not to speak the words that you want me to speak, they are like a fire in my breast, and I can't hold them in."

Now you can't believe it's the same country. The pleasures of conforming are very, very great. Now it's almost the opposite. I mean on the street, they stop to shake hands and talk. When we found out that I had cancer, I was getting cards from the most unlikely quarters. At least on one occasion a white woman wanted to carry my bags and her family gave up their seats for me. It's a change, yes, it's almost like we are in a different country.

Our country knew that it had very limited options. We could not have gone the way of the Nuremberg trial option because we didn't have clear winners and losers. We could have gone the route of the blanket amnesty and say wipe the slate clean. We didn't go either way. We didn't go the way of revenge, but we went the way of individual amnesty, giving freedom for truth, with people applying for forgiveness in an open session, so that the world and those most closely involved would know what had happened. We were looking particularly to the fact that the process of transition is a very fragile, brittle one. We were saying we want stability, but it must be based on truth, to bring about closure as quickly as possible.

We should not be scared with being confrontational, of facing people with the wrong that they have done. Forgiving doesn't mean turning yourself into a doormat for people to wipe their boots on. Our Lord was very forgiving. But he faced up to those he thought were self-righteous, who were behaving in a ghastly fashion, and called them "a generation of vipers."

Forgiveness doesn't mean pretending things aren't as they really are. Forgiveness is the recognition that a ghastliness has happened. And forgiveness doesn't mean trying to paper over the cracks, which is what people do when they say, "Let bygones be bygones." Because they will not. They have an incredible capacity for always returning to haunt you. Forgiveness means that the wronged and the culprits of those wrongs acknowledge that something happened. And there is necessarily a measure of confrontation. People sometimes think that you shouldn't be abrasive. But sometimes you have to be to make someone acknowledge that they have done something wrong. Then once the culprit says, "I am sorry," the wronged person is under obligation, certainly if he or she is a Christian, to forgive. And forgiving means actually giving the opportunity of a new beginning.

It's like someone sitting in a dank room. It's musty. The windows are closed. The curtains are drawn. But outside the sun is shining. There is fresh air. Forgiveness is like opening the curtains, opening the window, letting the light and the air into the person's life that was like that dank room, and giving them the chance to make this new beginning. You and I as Christians have such a wonderful faith, because it is a faith of ever-new beginnings. We have a God who doesn't say, "Ah…Got you!" No, God says, "Get up." And God dusts us off and God says, "Try again."

In one instance, I was preaching in a posh church of some of the elite in the white Afrikaner community, a Dutch Reformed church, and I was probably the first black person to have done so. I spoke about some of the things we had uncovered in the Truth and Reconciliation Commission. For instance, the previous government had had a chemical and a biological warfare program which was not just defensive, and had been looking for germs that would target only black people. They wanted to poison Nelson Mandela so that he didn't survive too long after he was released from prison. One of the ministers in the church came and joined me in the pulpit, and broke down, saying he had been a military chaplain for thirty years and didn't know these things. He hoped he'd be forgiven and I embraced him. There are others who have been less than forthright, but generally you have had people say, "We are sorry." Most of our people are ready to forgive.

There are those who are not ready to forgive, like the family of Steve Biko. That demonstrates that we are dealing with something that is not facile. It is not cheap. It is not easy. To be reconciled is not easy. And they make us so very aware of that.

One of the extraordinary things is how many of those who have suffered most grievously have been ready to forgive—people who you thought might be consumed by bitterness, by a lust for revenge. A massacre occurred in which soldiers had opened fire on a demonstration by the ANC (African National Congress), and about twenty people were killed and many wounded. We had a hearing chock-a-block full with people who had lost loved ones, or been injured. Four officers came up, one white and three black. The white said: "We gave the orders for the soldiers to open fire"—in this room, where the tension could be cut with a knife, it was so palpable. Then he turned to the audience and said, "Please, forgive us. And please receive these, my colleagues, back into the community." And that very angry audience broke out into quite deafening applause. It was an incredible moment. I said, "Let's keep quiet, because we are in the presence of something holy."

SENAL SARIHAN

TURKEY

─────────

POLITICAL RIGHTS

"When prisoners told me of the tortures that they were suffering,
I could barely stand it. The prison was far from the city, and when I returned
every day from it, I felt like I was going to another life. I felt that I didn't
have the right to hug my husband after hearing all these things that were
happening. I had become a mother, but by then I didn't think I even
had the right to hug my children."

Mother, lawyer, feminist, wife, playwright, director, teacher, union organizer, editor, advocate, leader, Senal Sarihan has challenged the status quo her entire life. As a member of the teachers union's cultural unit, she wrote and directed plays. She joined the Executive Committee of the newly founded Turkish Teachers Association in 1967, where she wrote pro-union articles for their monthly newspaper. Those articles led to her imprisonment in 1971 when the military regime sentenced Sarihan to twenty-two years for her writings. When the newly elected government released her in 1974, Sarihan studied for her law degree and in 1976 began defending intellectuals, union leaders, and human rights defenders. In 1980 she was again arrested and held for thirty-five days for her articles "espousing antistate views." She founded the Contemporary Lawyers Association in 1986 and served as its president, advocating legal reform and the defense of human rights. As the editor of the CLA's monthly magazine, she has became the most influential critic of Turkey's antiterrorism law and violations of the rights of free expression. Sarihan is known for her dogged defense of prisoners, women, and children. In the course of her work, fundamentalists and supporters of the status quo alike have threatened her life. In spite of ever-present danger, Sarihan marches on. Forming an alliance of women's groups called the Contemporary Women's Association she organized thirty-five thousand women to rally for their rights in 1996, the largest such demonstration in the history of Turkey. The dispossessed are well represented by Senal Sarihan.

I began as a teacher in the 1970s, working in a very poor section of Istanbul. There was a cholera epidemic and a lot of my students died and around the same time we had our first military coup. They started to imprison a lot of intellectuals, and I thought I would be imprisoned as well. I was expecting it, actually. At that point I was helping a professor who had been tortured in the prison. They released her, and I was helping her to recover. The government claimed that she was in league with an organization (she was not) and I really didn't have anything to do with any illegal organization. But nevertheless I was detained and tortured for forty days.

Obviously I didn't know anything. They thought I was being silent. They used electrical shock on my ears, tongue, and sexual organs. At the time I was very thin, with long hair separated in the middle, and I had pimples. I learned that they were looking for a woman who was the daughter of a colonel and I looked very much like her. That's why they imprisoned me and tortured me—mistaken identity.

I always heard about violence and torture in the prisons but never dreamed it would be so bad. They transferred me from Istanbul to Ankara—ten hours of transport. And said in Istanbul that I was lost, that I was killed, that I was dead. My parents didn't have any information—I simply disappeared for three months. Then another prisoner who had just been transferred from Istanbul to Ankara saw me

as she was led in, and was shocked because everybody thought that I was dead. That's how people finally learned I was alive.

On October 3, 1971, I was put on trial with a group of intellectuals. I had never seen these people before, but officials claimed that we were part of underground organizations. We decided together that we weren't going to say anything during this trial, to protest that they were not prosecuting the people who tortured us. The court then said this was "a movement decision," proving we were in league with each other, and gave me twenty years of imprisonment, claiming I was the leader of the group. Today I'm laughing, but at the time I was dumbfounded—I really had nothing to do with that group.

I was twenty-three and had been a leader in student organizations. Just before I was seized I had taken the exams for law school, though I was more inclined towards studying sociology. But after prison, I decided that I actually needed to be a lawyer, to be prepared to defend other people's rights so they didn't have to go through what I did. In 1974 the new government passed an amnesty law and all of us in the Ankara jails were freed three years after. It was a lucky period. The government and all society accepted that what they'd done to us was unfair, so we were able to go back to our professions. I became a teacher again and got married. I decided to

get married really fast because I was trying to get out of the house. Even though my father was very democratic, after all that had happened he started to be very careful about me. But I knew that I wanted to get married with somebody who would understand, who had the same point of view as I had. I met my husband in prison; he was also a teacher and the head of a student organization.

While in prison, my students went on a series of strikes to call attention to my situation. That was really important and very moving for me—they were putting themselves in danger and could have been imprisoned as well. So I wanted to return to work as a teacher to support them as they had me. After my husband and I got married we were both sent by the government to teach in a small village by the Black Sea. The day after we arrived, the government decided to send my husband to another city, hundreds of miles away. Our life became work. There were many ultranationalist, almost fascist groups spread throughout Turkey who made a point of finding out where people like me (who had been imprisoned) were, and leading propaganda campaigns against us. In the village where I was teaching, I started to receive death threats. We were publishing a magazine on education and teaching and I was continuing to do plays, folkloric dances, and discussion sessions with the parents of the students. We had excellent relations with teachers, students, and parents, but nevertheless the fascist groups did everything

"I was put on trial with a group of intellectuals. I had never seen these people before, but officials claimed that we were part of underground organizations. The court gave me twenty years of imprisonment, claiming I was the leader of the group. Today I'm laughing, but at the time I was dumbfounded—I really had nothing to do with that group."

they could to destroy this. Finally I couldn't take it anymore. I contacted my husband and said that we just had to go to the same city and live together. We found a way; but again they didn't leave us alone. They said I only had a special amnesty and therefore had to go to a city called Tocat to teach, but would be under detention there. After that the police officers were after me all the time—I couldn't work. So I decided to come to Ankara and sue them in court—and I won. Meanwhile I had finished law school. One of the cities nearby where I was trying to do an internship wouldn't accept me, saying I was a Communist. My husband and I moved again to Ankara, working as teachers while I applied to an Ankara law office for my internship; this time I was accepted, although at that time there were very few lawyers who were interested in cases involving freedom of expression.

But the lawyer that I was working with was famous, and always helping intellectuals and ordinary people. He was a great teacher and a big influence. The year after I started, another military regime seized the government. So there were more and more political cases and I became a lawyer in the courts where once I was a prisoner. I could actually feel the problems that these prisoners were having, in my body, could feel their emotion because I knew that they were also tortured, and they shouldn't have been. So even though it was hard, I started to fight back against the torturers. We simply had to put them on trial. That was

1980. A year later, another coup. This time, all the workers' advocates and teachers unions groups were closed by the government, and the number of lawyers dealing with political cases decreased significantly. There were maybe seven or eight lawyers total in Ankara—that's it, because they were scared. In that period Turkey had a lot of problems: thousands were killed in prison, torture was common. (And of course people say anything under torture.) For up to two years many others remained in prison awaiting trial—even though they weren't guilty. They had to perform hard labor there, could barely see their families. I started to work to improve the situation and was the first to bring a case against the prisons.

Personally, it was very hard. When prisoners told me of the tortures that they were suffering, I could barely stand it. The prison was far from the city, and when I returned every day from it, I felt like I was going to another life. I felt that I didn't have the right to hug my husband after hearing all these things that were happening. I had become a mother, but by then I didn't think I even had the right to hug my children. I gave birth and then forty days later went to work immediately. One judge knew that I had to nurse my baby so he would wait until midnight to start my cases, to help me. I wanted to take flowers from the garden and give them to the children who were in

detention. I wanted to make them feel close to nature. While we waited for our trials—long hours—I would write stories about what was happening to these children. And at that point I started to work with mothers to create a human rights organization. There was a lot going on in these prisons we couldn't do anything about. But we always tried to help. In 1990 we recreated the Contemporary Lawyers Association, which was closed down since 1980 along with all the groups that had been banned then.

All these years of struggle made me well known in the public eye—the press and the media covered me constantly. I was known as a human rights lawyer, not as part of a militant group. I wasn't afraid of being in prison or any other reprisals, but whereas as an underground group leader I was circumscribed, as a lawyer I knew that I could do a lot. Even though I was in danger most of the time, struggling gave me a lot of strength, and made me stronger. The act itself creates a mechanism to allow you to defend yourself even better. In 1985 I had my second child; in 1986 I was in prison again. This time the charge was that eleven years ago (when I was in that little village by the Black Sea) I had been engaging in Communist propaganda by publishing those education magazines. The statute of limitations is normally five years in Turkey, so this certainly had no legal basis, but my activism bothered them to such an extent that they were trying to find any way possible to put me in prison again. My baby was ten months old then and the fact that I couldn't give him milk was very, very hard for me. Since it was very obvious that what they were doing was illegal, a lot of people supported me, which was really nice. And after thirty-five days we were released.

But I want to make clear that the struggle that I am living today is also my struggle, not just something I do for others. There were elections in our lawyers association recently, and my lawyer friends cautioned me that I was getting too involved with work and not giving enough attention to my children and family (my son had been depressed at this time). And I said to them, "My son is also your son. Anybody's child could have been sick. I am struggling so that all of our children will benefit."

The work that we're doing in the Contemporary Lawyers Association has had absolutely good, extremely positive results. There is now solidarity among lawyers and we have grown in numbers. We've tried to deal with the legal aspects of all the organizations that are trying to democratize Turkey and the intellectual organizations who are trying to help them. We did significant work to end torture and to improve the conditions in the prisons, to improve freedom of expression. But at the same time, bad things still happened in the nineties. There were fewer cases of torture, but many

> "But I want to make clear
> that the struggle that I am living
> today is also my struggle,
> not just something I do for others."

people were killed by extrajudicial executions, or disappeared. In 1991 they passed another amnesty law, but failed to free people who were imprisoned because of the Kurdish situation—all those intellectuals were still in prison, definitely a double standard. This was part of the antiterrorism statute that we were also against, which allowed the government to fight terror by terror. There were a lot of disappearances at this time of Kurdish lawyers. I am Turkish, and have a Turkish ethnic background, but for years we Turks lived as brothers and sisters with Kurdish people. The Kurdish situation became really incendiary because Ocalan (the leader of the Kurdish terrorist group KPLA) started to get support from outside countries, like Iraq, and then the government blamed terrorist activities in the southeast on civilians living there. Since then there have been a lot of human rights violations against the Kurds and we have fought that. For instance, during a meeting of the Kurdish political party someone lowered the Turkish flag, so they decided to arrest and detain all the deputies for that. But only one stupid person did that—the rest had nothing to do with it—and I wasn't scared of defending them because I knew that they weren't against Turkey, the nation, as such. Now they are free.

In 1993 there was a meeting of thirty-five intellectuals in the town of Sirvas and the fundamentalists set the hotel on fire and killed all of them. I repre-

sented their families and because of that received a lot of death threats. During that time in Diyarbakir where Sezgin Tanrikulu was living, there was a disappearance of a man called Sherif Afszhar. The family found the person who took him—the first time anyone had. But no lawyer was able to accept the case because they were scared, so they asked me. I went back and forth to Diyarbakir in really difficult conditions. Somebody put a gun to my head and they told me that if I came back again they were going to break my legs. I knew that the secret police were planning to capture me—they told me. Next day I went to the judge and made a complaint. The judge just said that the threat could be from a private underground organization or the fundamentalists—how could he know? He could do nothing.

Courage is a way of life. Working and struggling is how you become happy. When you look back on your life, you should have changed the world somehow. Of course humans are scared; being scared is a very human feeling. But you can't live being scared. You have to overcome. And you know that those who are against you are really scared of you. You are not doing this because of courage, you're not ever thinking about courage. It has simply become your way of life. Sometimes I am really scared—for my children. But how nice it will be if they have a mother that they can be proud of. So I struggle, until the end, so that they can be proud of me.

VAN JONES

UNITED STATES

POLICE BRUTALITY

"This guy is beaten, he's kicked, he's stomped, he's pepper-sprayed,
gagged (because they didn't want him bleeding on them),
and then left in a cell. Well, that's the sort of stuff you expect in
Guatemala, but it happened just fifteen or twenty minutes from here."

Van Jones is the founding director of the Ella Baker Center for Human Rights. Named for an unsung civil rights heroine, the Center has challenged abuses in the U.S. criminal justice system since 1996. A project of the Center, Bay Area Police Watch is committed to stopping police misconduct and protecting victims of abuse. Police Watch takes a multifaceted approach, combining advocacy with education and community organizing. Staff work directly with individuals who have suffered from police harassment, intimidation, and brutality. Jones efforts effect establishment of civilian oversight, and required transparency and accountability within disciplinary proceedings. His efforts to ban the use of pepper-spray helped launch a nationwide campaign against the chemical weapon. The Police Watch Hotline documents complaints and refers victims to lawyers who are trained by Police Watch in handling misconduct cases. Police Watch then helps victims and lawyers during legal proceedings, organizes community support, and advocates on their behalf to public officials and the media. Jones' work illuminates egregious abuses of human rights that take place even within the protection offered by the democratic laws of the United States.

The Ella Baker Center for Human Rights is a strategy center for documenting and exposing human rights violations in the United States-particularly those perpetuated by law enforcement. A project of the Center, Police Watch has a hotline that opened in 1995 here in the San Francisco Bay area and in 1998 in New York City where people can call and report abuses. We designed a computer database, the first of its kind, that allows us to track problem officers and precincts and prac-

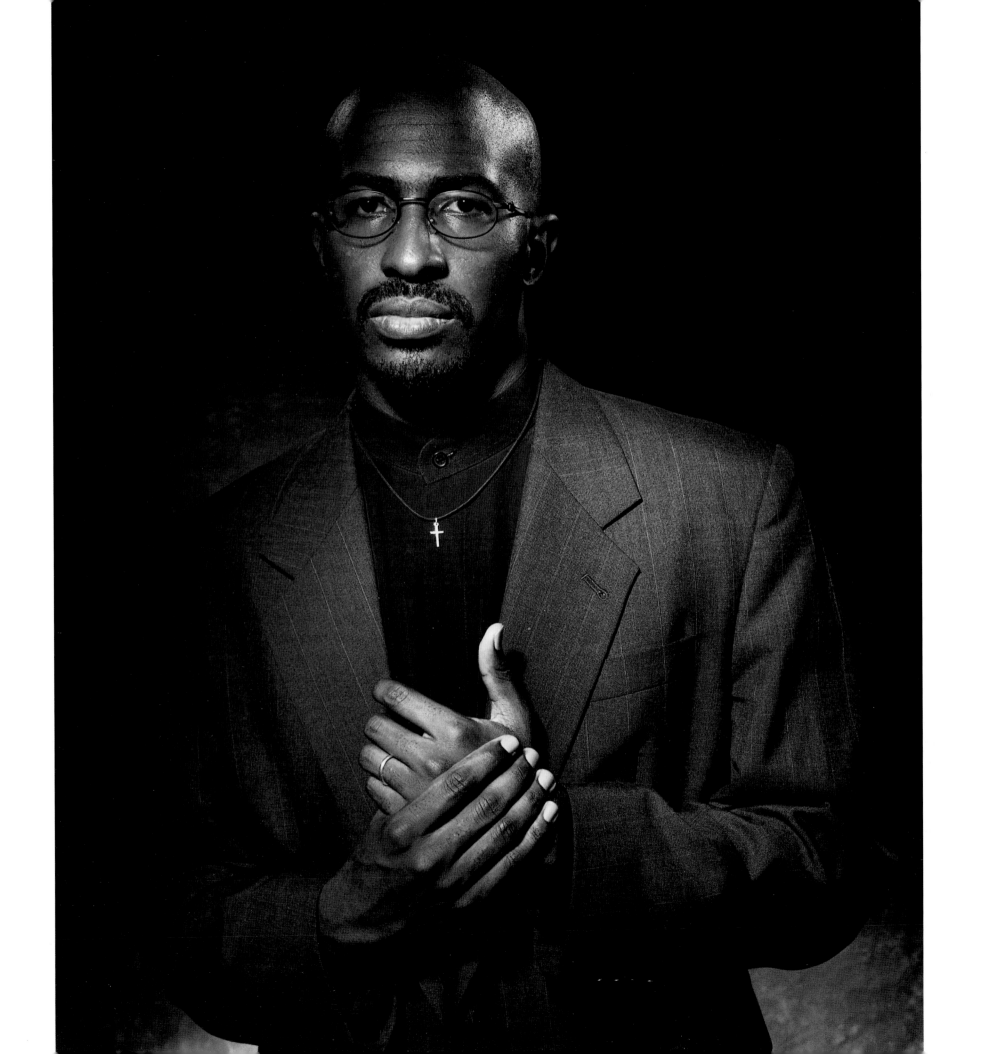

tices, so at the click of a mouse we can now identify trouble spots and trouble-makers. This has given us a tremendous advantage in trying to understand the scope and scale of the problem. Now, obviously, just because somebody calls and says, "Officer so-and-so did something to me," doesn't mean it actually happened, but if you get two, four, six phone calls about the same officer, then you begin to see a pattern. It gives you a chance to try and take affirmative steps.

We also try to expose abuse by doing a lot of public education. This is something we've really pioneered. Sometimes when people who suffered abuse at the hands of the police tried to engage the mainstream media, they would do it in a way that made them seem shrill, alarmist, or racially divisive. Instead, we thought it was important to interact intelligently with the media in a way that let them know that we were credible and interested in moving this issue forward in a responsible way.

Look, we get ten phone calls a day here from survivors of police misconduct and violence. Some of it is, "Officer so-and-so called me a boogerhead," or something minor like that, but it also goes as far as wrongful death. We see the full gamut here. We try to spend half an hour to an hour with every person who calls. We have people who call because their children have come home with a broken arm or broken jaw or their teeth shattered or because the child has been held in jail for four or five days with no charges. What we do when

people call is that we let them tell their story and then we write the story into the computer. We don't try to rush them.

Then we tell them about their rights and their remedies. We tell them if you want to file a complaint with this officer in this municipality, here's the number you call, here's how to get the form to fill out, here's the process. We tell them if you want to bring a lawsuit or file a claim of some sort for money damages, here's what that process looks like.

If a caller has evidence of police brutality, then we have a couple dozen cooperating attorneys that we refer those cases to. Those attorneys rely on us to screen to a certain extent—to ask enough questions about the incidents so that if somebody calls and says, "Police Watch told me to call," then they can be relatively confident that there's at least something to work with here.

We started out in January 1995 at the Lawyers' Committee for Civil Rights. Even though police issues were not a part of their docket (they usually focus on employment, discrimination, and other issues), they saw a need.

That need became clear, after we had been doing this project for a while, in the Aaron Williams case. This was the African-American man who died in police custody. We had a really close relationship to the process. Sometimes you have

> "This case became a question of not letting the authorities get away with this level of wholesale disrespect and disregard for human life and for the rule of law."

to have a certain amount of professional distance, but this case was not like that at all. Here the family and Police Watch volunteers merged efforts and spent those two years literally arm-in-arm. We went through three separate disciplinary hearings for the same officer on the same case within eight months, and we lost the first two times and we finally won in 1997. I'll never forget the look on the officer's face. It had gone beyond Aaron. This case became a question of not letting the authorities get away with this level of wholesale disrespect and disregard for human life and for the rule of law. Community witnesses, several dozen of them, all said that after Aaron was down on the ground and hand-cuffed, the policeman was kicking him in the head with cowboy boots, and that he was identifiable because he was the only officer in plainclothes.

Aaron had been sprayed in the face with pepper-spray, which is not a gas, like mace—it's a resin. The resin sticks to your skin and it burns and it continues to burn until it's washed off. The police never washed the resin off Aaron. And so this guy is beaten, he's kicked, he's stomped, he's pepper-sprayed, gagged (because they didn't want him bleeding on them), and then left in a cell. Well, that's the sort of stuff you expect in Guatemala, but it happened just fifteen or twenty minutes from here.

All of this was illegal and inhumane and yet it was going to be sloughed under the rug. This case was definitely a turning point in my life. I knew what kind of officer this was; I knew what the family was going through and I just made a commitment inside myself that I was not going to walk away. Win or lose, this family was not going to fight by itself. Every resource that I had, every bit of creativity that I had, all of the training in criminal law and community organizing that I had, I was going to put to work until we got justice.

As a result, I began to get threats. "Who do you think is protecting you?" or if something were to happen to you, talking about "People like you don't deserve to live"; "People like you don't deserve to be in this city." It just went on and on.

But 99 percent of the cases don't end as dramatically as Williams's. We have this one African-American father who bought a sports car for his son. On the boy's sixteenth birthday, he was driving him home in this new sports car and the police pulled him over—two black guys in a sports car. Now they put them on the hood of the car, they frisked them, they went all through the car. There was no physical violence but the guy wound up with a severe emotional and nervous breakdown. Small business went under. He just couldn't recover from it because he was so humiliated in front of his son.

My point is that this sort of stuff just shouldn't be happening. It doesn't make our world any safer, doesn't make law enforcement's job any easier. It increases the level of resentment against law enforcement. And it's plain just wrong.

KA HSAW WA

MULTINATIONAL CORPORATE RESPONSIBILITY

"Sometimes, the military walks across the path just in front of us, so close we can touch them. We have to be very careful."

Ka Hsaw Wa is the founder of EarthRights International, a nongovernmental organization that filed a precedent-setting lawsuit against a U.S. corporation for torture committed by its agents overseas. The suit charges that Burmese government agents hired by Unocal, a U.S.-based oil company, to provide security, transportation, and infrastructure support for an oil pipeline, committed extortion, torture, rape, forced labor, and extrajudicial killings against the local indigenous population. Ka Hsaw Wa knows about the abuses committed by the military regime firsthand. He has spent years walking thousands of miles through the forests of Burma, interviewing witnesses and recording testimonies of victims of human rights abuses. He has taught hundreds of people to investigate, document, and expose violations of international human rights. As a student leader in the 1980s, Ka Hsaw Wa organized pro-democracy demonstrations in Rangoon. He was seized and tortured by agents of the Burmese military regime, in power since 1962 (and renamed SLORC (State Law and Order Restoration Council) in late 1988). When police opened fire on peaceful demonstrators, one of Ka Hsaw Wa's best friends died in his arms. Ka Hsaw Wa fled into exile along the Thai border. To protect family members he took a new name, Ka Hsaw Wa, which means "white elephant." Ka Hsaw Wa's meticulously compiled documentation of systemic rape and forced labor is relied upon and cited by Amnesty International, Human Rights Watch, and other international organizations. He has collaborated on several books about the abuses, including School for Rape *(1988): "Take over 300,000 men, many of them under the age of seventeen and largely uneducated. Force some of them to enlist at gunpoint and promise all of them a salary they never receive entirely. Give them guns and bombs. Train them to shoot, to crawl through the jungle at night, to ambush. Convince them that*

their enemies are ethnic minorities, students, women, anyone who disagrees with the government, and that these millions of people are traitors or infidels. Starve them. Withhold their mail and don't allow them to send any letters. Forbid them from visiting their families. Force them to beat each other for punishment. Abandon some of them if they are too sick to walk. Abuse them verbally and physically every day. Allow them plenty of alcohol and drugs. You have just created the army of Burma's ruling military regime." Ka Hsaw Wa's work, at tremendous personal risk, continues in the jungles of Burma.

I've been doing this for eleven years. Most of the time I coordinate fieldwork, collect information, conduct fact-finding missions, and train my staff to do the same, specifically in the pipeline area of the U.S. oil company Unocal. We currently have a lawsuit pending against Unocal. The crux of the case is that a U.S. company is using human rights abuses to further their profit margins.

We interview people inside Burma and ask questions about human rights violations perpetrated by the military government. We hear cases of torture and forced labor, forced portering and rape, and extrajudicial killings. Sometimes I collect information outside of Burma along the Thai border and at other times I collect it in the refugee camps.

The villagers who support us keep in touch secretly or by code. We use radios and GPS (Global Positioning Systems) to find our way through the jungle. It is extremely dangerous. There are a lot of military bases. We listen to the radio in order to track the military's movements and to avoid being caught. I wear black clothes and carry a backpack. We travel with a maximum of three people at a time. Sometimes, the military walks across the path just in front of us, so close we can touch them. We have to be very careful. I have been shot at twice.

We make our decisions based on the movement of the troops. Normally, we don't go into the villages because it's so dangerous. Instead, we ask the people to come secretly to the jungle because we don't want to expose ourselves to them and also because we might put them in jeopardy. Among the villagers, there are spies for SLORC, the local military organization. Therefore, we must be very, very careful.

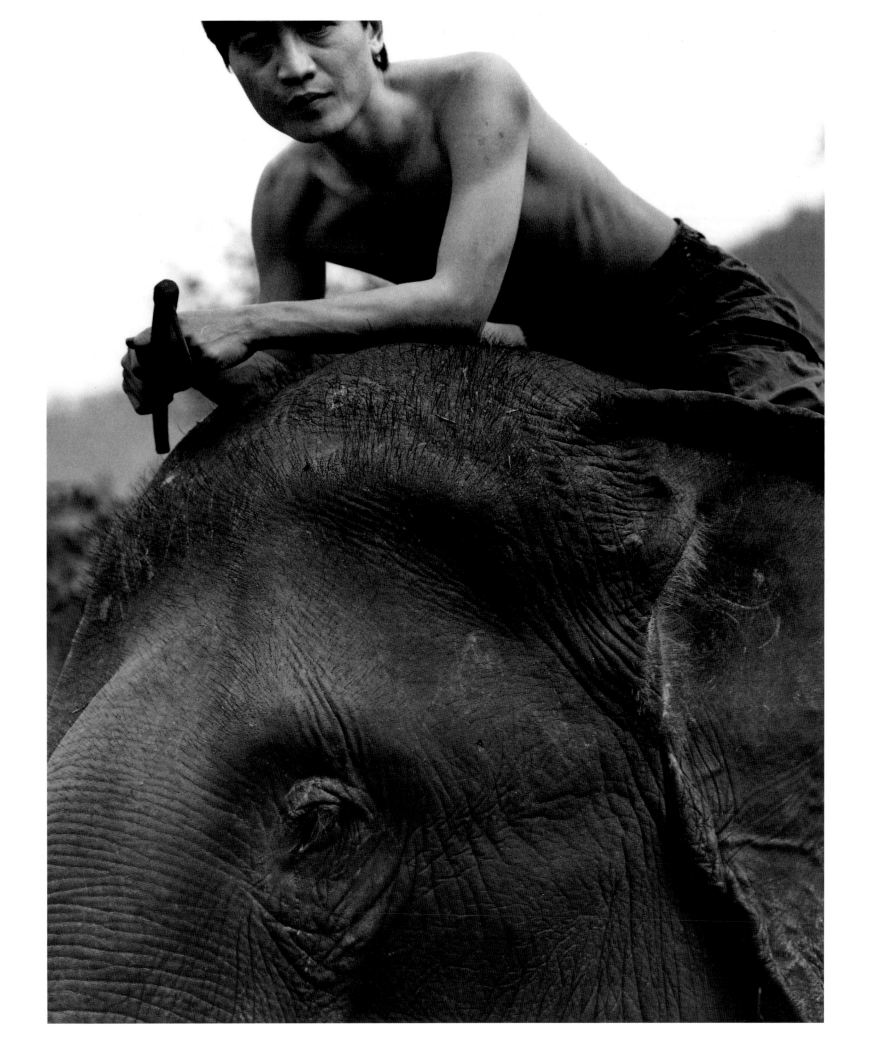

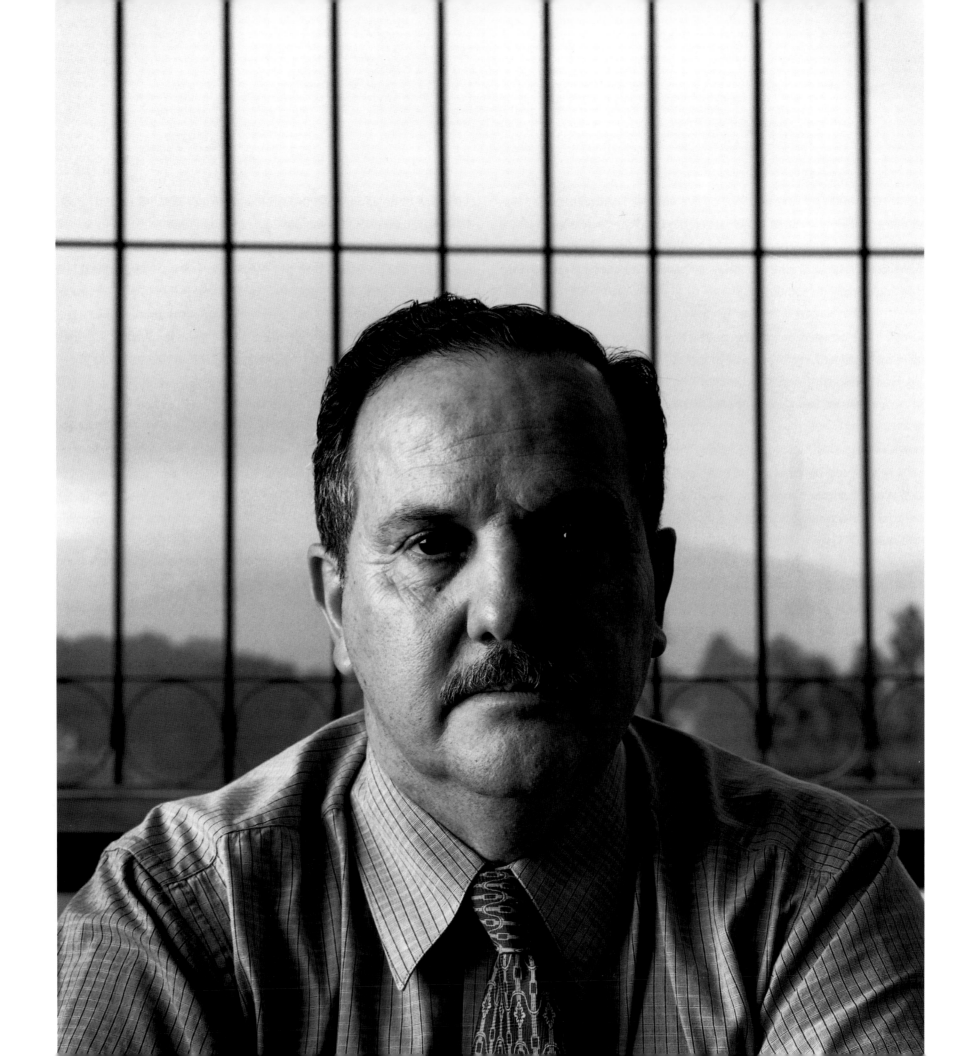

JUAN MÉNDEZ

ARGENTINA

HUMAN RIGHTS AND RECONCILIATION

"Is it morally defensible, after twenty years of searching, that individuals still cannot find their relatives, when there are people walking around who know the location of the bodies?"

From the time that he worked as a lawyer in Argentina in the early 1970s helping to build the modern human rights movement, Juan Méndez created a road map for others to follow in defending political cases. When he was detained by the brutal Argentine security forces, his family moved quickly to demand his whereabouts, and when his captors realized they had a limited period of time to "elicit" the information they sought, Méndez was subjected to particularly harsh torture. Méndez became one of Amnesty International's first Prisoners of Conscience in Argentina, and advocates and diplomats alike pressured the junta, forcing Argentina to release him in 1977. In exile, Méndez continued his human rights work, pioneering advocacy tools that are the bases of much international human rights work today. Méndez spent fifteen years at Human Rights Watch, heading its Latin American division, and later becoming Human Rights Watch's general counsel. He has recently left the advocacy arena to become executive director of the Inter-American Institute for Human Rights and now runs the human rights program at the University of Notre Dame. He is currently second vice president of the Inter-American Commission on Human Rights of the Organization of the American States.

In the late 1960s, I was a university student in Argentina. It was a time of upheaval and student activism throughout the world: in Prague, in Paris, and in Latin America. At the time, we were under a military regime that exploited the schism between the poor and the wealthy. Many of us got involved politically; some took up arms, some joined organizations, and others, like me, tried to use their legal skills to defend political prisoners, to fight against cases of torture, and to protect human rights. I thought of that as my contribution to the struggle.

The first time I was detained was in 1974, before General Juan Perón's death, in my hometown, in front of the law school I had attended, where I was teaching at the time. They let me go in two or three days. But that signaled to me that I was being watched, that I had enemies. So, my family and I moved to Buenos Aires where nobody knew me. Little by little, I went back to teaching, to practicing law, and to political activism in shanty towns and poor neighborhoods. A while later, in August 1975, I was arrested again. At the time, Isabel Perón, who had succeeded her husband after his death, was in power and her regime conducted many political murders.

Terror was everywhere. A lot of people were caught painting political graffiti and the next day they would appear dead and tortured. And there were others, followed and picked up in their houses or their offices and killed. Like me, a lot of people were thrown in jail and, if they weren't charged with something, they were placed under administrative detention.

The most repressive military dictatorship in our history started in March 1976. I was in prison at the time and though I was about to be allowed to go into exile, the military held me for another year, still without charges. An Amnesty International mission came to Argentina in November 1976, met my family, and reviewed my case. It was clear that the state didn't have any evidence against me, except that I was defending political prisoners. I qualified neatly under the category of Prisoner of Conscience for Amnesty, one of the first to be adopted in Argentina. Three months after, I was allowed to leave. There were maybe eight thousand people in similar situations, who spent an average of four years in administrative detention, whereas I was lucky to get out after a year and a half.

In Argentina they had no mercy. Those eight thousand were the "legal" prisoners. Ninety percent were tortured, and tortured heavily with electric shocks,

beatings, near drownings, and mock executions. It was very mechanized, very routine, and very brutal because they wanted to get a lot of information out of you, and even if that information was of no value in court, they didn't care. They just wanted intelligence. After the 1976 coup d'état, it all became worse, because they knew they didn't have to worry about producing you alive. In the early seventies, they had only a few days to get information out of you. One, because your friends immediately protected themselves and moved, in case you were forced to say where they lived; and two, because sooner or later they would have to arraign you before a judge. If you were in really bad physical shape then the judge would probably be on their case. And because they worked very fast, they were also very brutal. They would take you to the edge of killing you in torture, and then, if they couldn't get any more information out of you, might leave you alone. A lot of my friends spent a week in torture sessions. In my case, it was only three days. I was fortunate that my family mobilized very fast to get a writ of habeas corpus and talk to judges. My torturers knew that they had even less time than normal with me. So, instead of two, I had five torture sessions in two days. Pretty brutal, but at least it was short.

After my second arrest, I spent eighteen months in prison. Eventually, I was expelled. I wasn't even allowed to go back to my family and my house in Argentina. I was, literally, put on a plane and sent into exile. Once my family had rejoined me and we established ourselves in the United States, I had to decide whether I wanted to go back illegally. Many of my friends in exile returned clandestinely to Argentina and, while I admired them for it, I thought it was suicidal, quite frankly, because in the end they couldn't do much. At this point I decided to stay in exile and I began to work from the outside with NGOs and local groups.

It wasn't so dangerous when I started. You didn't know whether the repression was going to be transitory and maybe next month it would be all right, or at least a little better. You always have hope that, even if it's dangerous for a lot of people, it's not that dangerous for you, because you're not that well known. So you live. It's not that you're incredibly courageous, you just think that maybe it's not going to be as bad as it looks. In fact, I think we only realized the tragedy of Argentina when we went into exile and observed it from the outside looking in. When you're in the middle of it, obviously, you have a sense of duty. You know you have this prisoner that you have to file a brief for, or there's this friend who's just been caught and his mother is asking you to do something about it. There's a sense of being needed, and also a feeling that this will pass and, hopefully, we sail through it. Unfortunately for many of my friends, that optimism was a serious mistake.

The front line of lawyering can be done very effectively as long as you have a halfway independent press. For example, if we would go to court and the judge wasn't inclined to do anything about it, one way of putting pressure on him was to go simultaneously to the press with a copy of the habeas corpus writ. If, in the morning, there was a little article that said that a habeas corpus on behalf of so-and-so had been filed with Judge so-and-so, then the judge knew that he must do something within the week. If not, there was going to be another article saying, "He didn't do anything." Unless you have all those things in place, the system breaks down. In the present period in Latin America, even under constitutional rule, those conditions are not always met. We can't call it democratic quite yet. There are many other things that must be done, more on the preventive side of things such as human rights education, or building independent, impartial, courageous, and professional press organs, or making sure that human rights activists are better known through the media. We learned hard lessons from the dictatorial past and, even when democracy isn't what we hoped it would be, at least we're building the fences against the future breakdowns of the rule of law.

What passes for reconciliation in Latin America is really another word for impunity. It's not so much because of how I feel about the people who did

"It is important to ask for reconciliation. But it's a different thing to ask the victim of abuse to reconcile with his or her torturer or the killer of his or her child. Especially when the torturers and the killers don't want to offer anything in return."

wrong to me. I don't really care any more if I could identify them, or send them to prison. But taking the position of the communities affected, I feel very strongly that reconciliation has to happen through a process. It cannot be imposed by public policy. How do we get from here to there? Not with state-imposed amnesties that pretend that reconciliation has happened by fiat. In fact, all they're doing is letting the torturers and the murderers go free. Some say, "Peace and justice are not the same thing and to have peace you can't have justice." I don't deny that one priority in places like Sierra Leone today or El Salvador in the early nineties is to silence the guns; but you cannot raise that to the level of good policy. When you say let bygones be bygones you actually give an incentive to murderers and torturers to come back and to do it again. Or worse. Now democracy has taken hold, but you still don't have military elites or police bodies that are accountable. They have not had to account for anything and, although they don't torture political enemies anymore, instead they torture suspected common crime offenders. What kind of democracy is that? If there is one great thing about the detention of Pinochet, it is that it has forced this issue in Chile. And it has forced it in a good way because there is no risk of a coup d'état. People in Chile, Argentina, and other countries with similar episodes are frankly asking, "Is this reconciliation fair?" Is it morally defensible, after twenty years of searching, that individuals still cannot find their relatives, when there are people walking around who know the location of the bodies? The victim has a right to know. And he or she has a right to have the state tell him or her. And if the violation was serious enough, the state also has the obligation to restore justice by prosecuting those responsible.

Moral leaders have to lead the way by clarifying roles, by calling on the military to disclose the information that they have, and by asking that the government not pass spurious amnesty laws. Likewise, moral leaders must tell the people that once they have been shown in good faith that the new democratic government

has done everything possible, they must reconcile. It is important to ask for reconciliation between warring factions when people go to war over political differences, to say that we are still members of the same national community, who should look to the future and forget the past. But it's a different thing to ask the victim of human rights abuse to reconcile with his or her torturer or the killer of his or her child. Especially when the torturers and the killers don't want to offer anything in return, they don't want it discussed, and they don't want any information revealed. They pretend that they should be given some kind of medal for what they've done. The military is quiet now, but it doesn't accept that it did anything wrong and fights tooth and nail any effort to disclose the truth or to hold itself accountable. In those terms, there is no reconciliation possible.

I feel very privileged that I have been able to work in this field for a long time and to have seen the front lines in Argentina, to work from the international advocacy perspective at Human Rights Watch, and now from the academic perspective at the IIHR (Inter-American Institute of Human Rights), and the University of Notre Dame. This has given me a sense of the place and the purpose of each of these different types of organization in the overall human rights movement. All of them are effective in their own way. Domestic human rights groups are essential because they are in the front line. But without the possibility to go to international organizations and, eventually, in appropriate cases, to intergovernmental organizations (like the Inter-American Commission, the Inter-American Court, or the European Court on Human Rights), their ability to change things on the ground is limited. By the same token, without academic organizations that can train and professionalize activists in different parts of the world, the movement cannot continue to grow and improve, bringing in new generations of people doing the work as effectively as they can. All that is knowledge. And knowledge has to be transmitted. We have much to teach and much to learn.

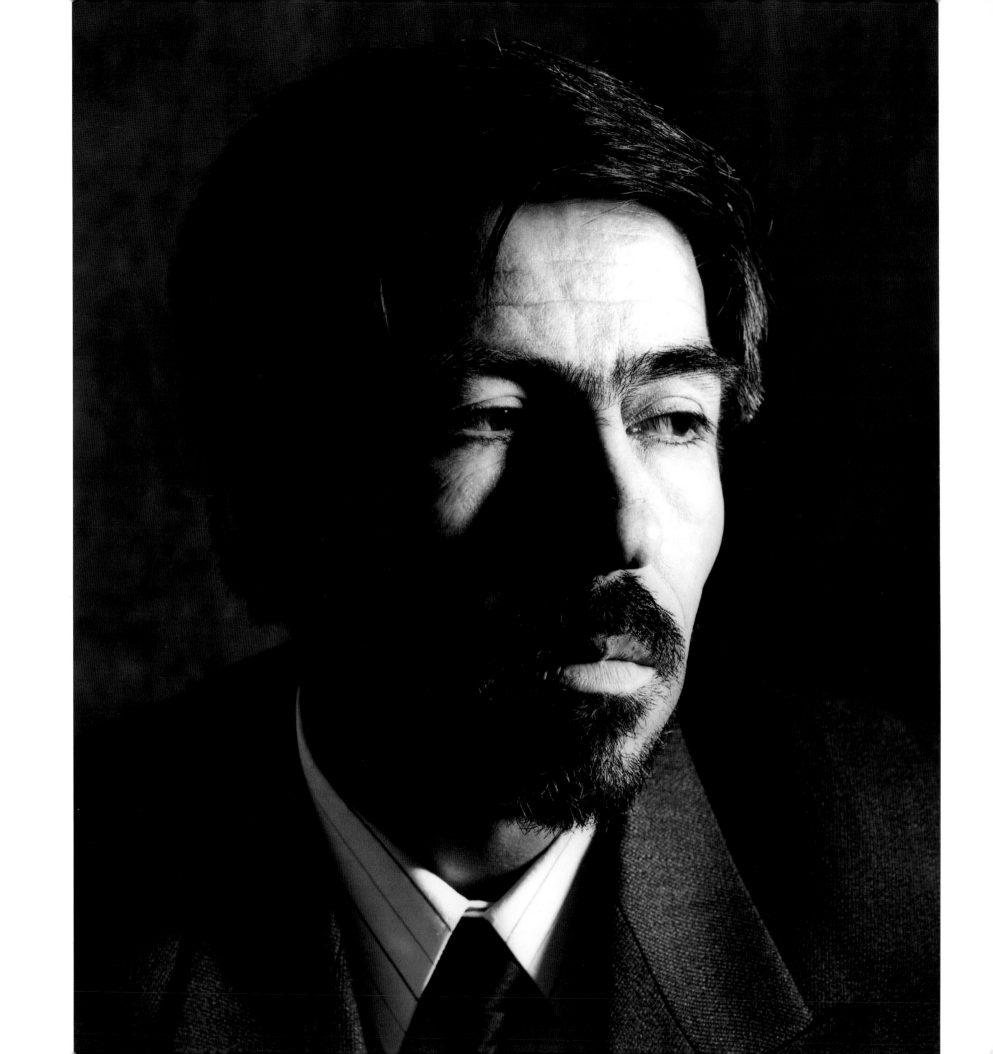

JAIME PRIETO MENDEZ

COLOMBIA

POLITICAL RIGHTS

"For victims knocking at our door, awaiting a response,
we need to convert our moments of despair and impotence into
a creative capacity to always find at least some space,
then we should stretch our arms and open up that space."

Jaime Prieto Mendez is one of the leading figures in the Colombian human rights movement, serving from 1990 to 1998 as executive director of the Committee in Solidarity with Political Prisoners, the most effective advocates in the country for those imprisoned for political beliefs. For most of the past fifty years, Colombia has been under a state of crisis in which civil rights have been suspended and thousands imprisoned after military proceedings where due process rights are largely ignored. The committee has defended hundreds of clients; denounced arbitrary arrests, torture, and disappearances committed by state security agents; and sought the release of detainees. Because of their work, committee staff have been harassed, threatened, forced into exile, and murdered. Prior to joining the committee in 1976, Prieto worked as an educator in an impoverished neighborhood of Bogotá, and later, in a rural community. Prieto recognized that the conditions of poverty, exacerbated by people's lack of knowledge about their rights, made people vulnerable to abuse, so he established a human rights education program. In retaliation for his work, Prieto was threatened and imprisoned by local authorities. After joining the Committee in Solidarity with Political Prisoners, Prieto continued his human rights literacy work in impoverished communities. He focused on using legal mechanisms to protect and defend human rights. Prieto took the initiative to establish a dialogue between human rights groups and government entities, which sought to bring government practices into line with international law. Prieto recently stepped down as director of the Committee. He teaches at a university in Bogotá, and is internationally regarded as a founder of the modern Colombian human rights movement.

For me, it all began when one day the police entered the national university campus in Bogotá during a student protest. By the end of the day one student was assassinated, and many others were arrested. A campaign of solidarity was organized for the students who were detained, I joined in, and we won their release. After that first success, the Committee in Solidarity with Political Prisoners asked that we collaborate with them. That was 1976—and I have been working in human rights ever since.

In the early seventies, I spent four years in the eastern plains regions with Catholic youth groups, doing literacy work. We accompanied peasants in their struggle for land and against economic depression, sometimes helping create unions among the workers. Perfectly legal and normal, but still the local authorities accused us of being Communists. We were merely teaching the workers their rights as set out in the law, but, as you know, lawful rights are not always allowed to be disseminated. The existing laws make it appear that we have a democratic state, while exercising those rights is something else entirely. My perception of the Catholic Church during those four years was that they were turning their backs on the poorest of the poor; this ended up distancing me from religion, though it was this spiritual foundation that had originally animated my activism.

Initially our work at the Committee focused on national mechanisms for protecting and promoting human rights. By the 1980s, the discussion also embraced international law, in an effort to increase our effectiveness. We thought it was important that those communities most hard-hit by violations knew the mandates of the different authorities and how they could protect their own rights. At the same time, we acted when people were detained. We tried to learn why they were detained, what the conditions of the detention were, and we attempted to prevent any torture and to facilitate legal counsel. We did this from the time I came into the Committee and continue to do so today. In the early 1990s, when political changes were taking place in Colombia, we also opened a dialogue with the authorities about the violations.

JAIME PRIETO MENDEZ

But the pressure against human rights defenders today makes you wonder whether there is enough political space to continue this defense work. People I have been very close to have disappeared and been assassinated. We had to get people from our organization out of the country. And that gives rise to pressure, causes grave concern within a family over personal security. You see, many people who have been assassinated did not have prior threats against them. So when I say I haven't been threatened I am not saying there isn't any risk. Yet I obviously feel much more at ease when the perceived risk is not that high.

I stepped down from the leadership of the committee for a variety of reasons. Over the past ten years it has involved carrying a tremendous amount of responsibility, and, in one way or another, this was impeding other leaders from rising. I also wanted to contribute to the defense of human rights from another perspective. Now I am a professor at the National University. I teach a course on human rights, a course on political economy, and one on international humanitarian law. In addition, I have been trying to write a memoir about the work we have done. I certainly have not stopped working to defend human rights; I have only put aside a specific responsibility.

While I am ready to struggle for the cause of human rights in every way necessary, I am not willing to risk my life irresponsibly. It is often possible to gauge a risk

and know when to step aside, to choose to remove oneself in order to be able to continue one's work. I can accept the latent risk on the front line, but it is a risk I have never pushed the limits of. This is my way of being responsible to myself, to my family, and to the cause itself. There are some circumstances where people need to offer their life, but basically it is no good to foster the idea of a heroic defense that doesn't allow for the possibility of hiding, leaving the country, lowering your profile—because we are much more useful alive than dead.

Combining human rights work with my responsibility as a father or husband has more to do with the risk or transformations of daily life. Serious violations of human rights by the state might make you forget that human rights are also experienced in a day-to-day way. This needs to be reiterated because while the state has a tremendous responsibility to regard and respect a citizen's rights, it is necessary that everyone respects those rights. My children have taught me this. They pointed out that I can't be authoritarian in the home, telling me, "You're a human rights defender and now you are acting like some jefe in the house." Let's just say that they are a good point of reference, and credibility begins in the home, no?

That said, it is possible that the work of "frontline" human rights defenders is overestimated. What work we have done is important, but others have also done vital work. Many people, including some actually within the government,

> "Serious violations of human rights by the state might make you forget that human rights are also experienced in a day-to-day way."

have made a tremendous contribution and helped prevent death or avoid torture. Others have made a tremendous contribution to disseminating the general spirit of human rights. The right to life, the right to personal integrity, the right to liberty are where we concentrated our efforts under difficult circumstances marked by violent attacks. But we must not lose perspective on the overall economic, social, cultural, or environmental rights or on the rights of certain sectors of the population, such as women and children. We must look beyond those affected by violence, and those suffering from discrimination within a patriarchal society or from a society that doesn't even recognize children's rights. Without those considerations, the notion one might have of human rights would be limited. We at the committee have carried out a very particular function. It is necessary, but very limited, perhaps somewhat overestimated. Instead, now, we need to lift up the work of others.

We need to create trust in civil society. People need to believe that even under the most difficult circumstances we can succeed. Seeing the international community becoming increasingly interested in our situation is a source of strength. We don't have a right to lose hope. For victims knocking at our door, awaiting a response, we need to convert our moments of despair and impotence into a creative capacity to always find at least some space. Then we should stretch our arms and open up that space.

Tremendous emphasis needs to be placed on amplifying the voices of the victims until the authorities begin to hear you, and once they begin to hear you, to ensure that the victims' voices, their words, actually become a reality. We need to actually create forums of interlocution that make it possible to accelerate the social force, to create greater legitimacy in public opinion, since this is how the authorities recognize changes must be made. Despite all of our efforts in these adverse circumstances we have succeeded in opening up some political room. Even today a necessary interaction to change the will of the authorities to stop the array of abuses must take place. Though there are still many accusations against human rights defenders, high-level government officials have had to sit down and talk with us. Even though the media for a long time tried to silence our voice, today they take our positions into account. It depends a great deal on having earned credibility, and making sure our information is true and just, on collecting that information carefully and procedurally, on working closely with the victims so that we can argue their petitions with authority. We cannot simply brandish our status as human rights defenders or as victims suffering from aggression by the state as an excuse for arguing our cause. We have a duty to be serious, rigorous, and extremely creative in coming up with formulas that make it possible to overcome human rights problems, wherever we find them. This is the challenge before us.

VERA STREMKOVSKAYA

BELARUS

LAW AND DEMOCRATIC CHANGE

"I requested that the defendant go free on bail
because he was very old and quite sick. In response, the court claimed
that my appeal was making the man nervous—that this
was the reason for his deteriorating health. Then, they censured me."

Belarus was formed in 1988 after the fall of the USSR. As a founding member and former president of the Center for Human Rights in Belarus, Vera Stremkovskaya is one of that country's most respected legal practitioners, known for her willingness to take up the defense of politically unpopular clients. In retaliation, she has been harassed, threatened, and charged with libel. In March 1999, the Collegium of Advocates (the government-controlled bar association) issued a "stern reprimand" to Stremkovskaya because of her outspoken advocacy for human rights, threatening disbarment if she continued her work. The Soviet-style regime maintains strict control over the media, restricts circulation of the independent press (when it is not banned altogether), and controls all broadcast media. Street demonstrators can expect mass arbitrary arrests, beatings, and long prison terms, while plainclothes state security agents carry out threats and kidnappings in the street with total impunity. In the Belarus police state, this courageous woman seeks justice for the few who dare speak out against injustice—Vera Stremkovskaya's bravery and courage are exemplary.

VERA STREMKOVSKAYA

The Belarussian authorities started a wave of harassment against me. Upon my return from the United States, where I had spoken to different audiences about the human rights situation in Belarus, the authorities tried to revoke my license to practice law. I was told to appear before the chairman of the Supreme Court of Belarus and the deputy minister of justice. I was also told to present myself before the Minsk Regional Committee of Advocates, a professional organization. They argued that criminal defense work and human rights activities were entirely separate and told me to choose between being a lawyer or being a human rights activist. At every meeting, they threatened to revoke my license to practice law, citing my speeches, meetings in the United States, and human rights activities as inappropriate to the profession. Strong reaction in my defense from foreign countries, notably the U.S. and German embassies, saved my license to practice law. However, the Belarussian authorities still issued a censure.

I received a second censure after an appeal to change a pretrial detention order. After my request that the defendant go free on bail while on trial because he was very old and quite sick, in response, the court actually claimed that my appeal was making the man nervous—that this was the reason for his deteriorating health. Then, they censured me.

The case was against a fellow by the name of Starovoitov. He had transformed a Soviet type of agricultural institution into a new, market-oriented company in which workers were given shares. President Lukashenko rejected these changes and, in order to squelch his activities, falsely charged the man with embezzlement.

When they threatened to revoke my license, I was very upset. If I were to lose my license, I would lose my job and the opportunity to earn a living for myself and my family. This was my profession and I loved it. I was shocked and it was a terrible time for me, but I wanted to continue to defend human rights. Belarussian law implies that the lawyer be a professional human rights defender. Only Belarussian authorities could come up with the idea that these are two separate roles.

In fact, most of my clients are people charged in political cases. They are prisoners of conscience and feel apologetic for causing me to suffer from the threats and suppression of the government. The most moving moment took place after the trial of Starovoitov. I went to see this old, skinny, gray-haired man and he fell on my shoulder. He put his head against me, cried, and said, "I am so sorry that I have caused so many troubles for you." Other clients went to meetings with me and would defend me in front of the officials. Their support, along with my own moral convictions, kept me going. Had I decided to forego my obligations, necessary changes in Belarus would not have been possible. Likewise, I understood that I had a personal cross to bear. I felt very strongly that I had been destined to practice law and, therefore, should continue to do so.

In another sense, I see the world as a consistent creation of which I am a part. I know the history of our country well and the developments of different civilizations throughout time. This has been precious, important, and useful knowledge in shaping my view of the world. I am a poet and I love poetry. People who write poetry perceive the world a little bit differently. My view of the world is sensitive and emotional.

I feel an obligation as a member of society. I turn to the Bible and to Jesus Christ and question why he did what he did for human beings, even those who didn't believe in him. There is a line from a Russian poem, "Go alone and help the blind to face at the moment the repression, the indifference of the crowd and the sarcasm of the crowd." In my opinion, this is everyone's obligation. This is the meaning of life for me.

> "They told me to choose between being a lawyer or being a human rights activist. At every meeting, they threatened to revoke my license to practice law, citing my speeches, meetings in the United States, and human rights activities as inappropriate to the profession."

I am a single mother. My parents died and I am bringing up my child alone. We are a family unit. We feel and think the same way and view life in a similar manner. Since I have a lot of friends and my home is a meetinghouse, my son is always meeting creative people. At the same time, he sees how tired I am when I come home from work. He realizes what I am doing, and, more and more often, asks me very particular questions about my cases.

Life for me is one process. I cannot be one person with my kids and another at work. These worlds overlap. My clients often become my friends. They visit my house and my son meets them and sees who they are. He is attracted to this type of person. I think that I am happier than those who work from nine to five and pretend to do something important, when in fact they just exist.

In my opinion, courage comes from doing something despite the difficulty of the circumstances. You do it because you feel it is right, because you should. The feeling of inner strength is like a metal cord inside of you that helps you to go forward. It originates from a vision of the future, from the belief in God, from a consciousness of destiny, and from knowledge of history. Likewise, it comes from the people who surround you, like my friends and my son. In the United States and other countries, people understand and support me. This gives me a great deal of strength.

People in Belarus are no longer afraid. The fear that once gripped them has begun to dissipate and they have become creative in their protests. These protests may be local and small but are a sign of resistance. One inmate organized a protest against the rats in his cell. Although a prisoner, he defended his dignity and protection of his rights. In another incident, he hung his underwear and dirty clothes out the window so that the people working on the streets could see it. In doing so, he hoped to pressure the warden for more sanitary conditions.

At times these protests are quite funny. An artist by the name of Pushkin put a pile of manure in front of the presidential palace. In it, he placed President Lukashenko's campaign slogans, along with a sign reading, "Results of your presidency."

There is also a newly formed presidential youth organization called the Belarussian Patriotic Youth Union. Once, on AIDS Prevention Day, the Democratic Youth Movement formally presented the pro-Lukashenko Presidential Youth Organization activists with dozens of condoms on which the analogous message was written, "So that there will be no more like you." The idea was to stop the group from spreading.

I am sure that the democratic process in Belarus will prevail. I am sure of it. We don't have any other choice. Belarus is a European country in the very center of Europe. Just as changes have taken place elsewhere, so they will happen in Belarus. I see our history as part of the development that is happening throughout the world. The history of the world proves that humanity is the whole union of people. We are united in moving toward democracy, toward justice, and toward a more open society. I believe that these democratic changes will take place in Belarus because there is a plethora of smart, industrious people who devote themselves to this cause on a daily basis. With particular regard to elections, there is additional support from the international community. The United States reacted strongly to the elections and Amnesty International continues to condemn the Lukashenko regime for detaining prisoners of conscience. This has helped Belarus to envision itself as a part of the international community. In fact, I had the opportunity to speak to President Clinton in Atlanta at the American Bar Association ceremony for international human rights lawyers where I was given an award. On behalf of the Belarussian people, I expressed my gratitude to the United States and our continued hope for democratic change.

BOBBY MULLER

UNITED STATES

THE INTERNATIONAL BAN ON LAND MINES

"There is an organization for just about every conceivable issue you can come up with. What makes a difference is getting political leadership behind you. And we got a powerful senator who went nuts."

In 1969, Lieutenant Bobby Muller led an assault up a hill in Vietnam until a bullet hit his back and severed his spinal cord. Miraculously, Muller survived. But the real misery didn't begin until Muller returned to the United States and was confined to a decrepit veteran's hospital. During his first year, eight people on his ward committed suicide. His experiences there led him to become a leading advocate for veterans' rights. Years later, as head of the Vietnam Veterans of America Foundation, Muller traveled to Cambodia where he witnessed the devastating impact of land mines on the local population. He launched himself into this new cause with characteristic energy and determination and in 1997, his efforts, along with cofounders at the Campaign to Ban Land Mines, won the Nobel Peace Prize. Despite his success, Muller is the first to point out that the most daunting task, still to be accomplished, is removing the land mines already planted. Antipersonnel land mines kill or wound twenty-six thousand women, men, and children each year, often years after the conflict has ended and combatants have gone home. Today, Muller continues to focus worldwide attention on war's impact on civilians.

We have an extraordinary capacity to deny our reality. Each and every one of us knows we are going to die. But it probably would be too terrifying for most people to live their lives with the daily awareness of the fact that this could be it. So we deny that. When I was twenty-three I got shot and was conscious long enough to recognize what had happened—to feel the life ebbing out of my body. I was losing consciousness and saying, "I don't believe it, I'm going to die. On this shitty piece of ground, I'm going to die." When I woke up, I was on a hospital ship, in intensive care. I had so many tubes sticking out of me that I couldn't believe that I hadn't died. They wrote in my medical record that had I arrived a minute later I would have—the bullet had gone through my lungs and both had collapsed. I was lucky—the ship right off the coast was the farthest north it ever went up and it was turning around to go back south, back toward Danang. So I had this miraculous series of things happen. When you really face your mortality the way I did, it changes you. My reaction was joy to be given a second chance. And I'll never forget when the doctor came and said, "We've got good news and bad news. We're pretty confident that you're gonna live—but you're gonna be paralyzed." And I just absolutely remember saying, "Don't worry about that. That's okay. I'm here. I'm here."

I had been an officer with the marines, infantry. I was God: I would decide who went on point, who was first out, this, that, and so on. And to go from being God to a piece of shit—it was kind of overwhelming. The first time I ever cried was when I got to the veteran's hospital. It was a dilapidated facility—overcrowded, understaffed, stinking—it had been an orphanage in the late 1800s.

In these kinds of situations you ultimately get to critical matters. You either say no and push back or you get overwhelmed and crushed. Everybody handles it differently. A lot of vets got injured in ways that were never a question of their life. It was just a question of their loss. Eight on my ward committed suicide. If you are eighteen years old and you have never expected to do anything except manual labor in some capacity, a disability denies you that future. You give up or you get pissed and you start to fight. Once you cross that line and you start to be an activist, you don't get easily intimidated. When people start to push back at you, well, you continue to march and you lean into it a little bit more.

I am amazed at where I started. I kept waiting for somebody to make things right for Vietnam vets and nobody was doing it. So in 1978, nine years after I returned from Vietnam, I said, "I'll go tell the story." I believed that if somebody could get the story out and focus attention on the injustice, the government would make it right. I still naively believed that if you simply got the story out, a caring and values-based society would respond. That's when I learned that things don't happen simply because of arguments that are based on equity and justice. You need more than that. You need political engagement. That was an important lesson. But then you also learn that in the democracy that we have, you still do have opportunity

and the mechanisms are still there. It's like with the land mines campaign. Once I came to understand land mines, I recognized how truly devastating the consequences of this weapon were, not just for the lives of the victims, but for the countries they were used in, a major destabilizing factor. Then I really had no doubt that we could ultimately get this weapon banned internationally, put on the list with poison gas, dumb-dumb bullets, the weapons the world community says no to. But it was a difficult process to get the U.S. to say no.

We reached out to the retired military leadership and got Schwartzkopf, the former chairman of the Joint Chiefs, General Jones, and General Galvin to sign an open letter to the president—a full-page ad in *The New York Times*. You don't necessarily have to have grassroots to move mountains. That's a lesson I learned from the early days. So when we came back in '92 we said, we're going to make something happen here on land mines. We went to the most powerful member of Congress that we knew, Senator Patrick Leahy of Vermont. He was the chairman of the appropriations committee on foreign operations, and Leahy single-handedly ensured that the United States outlawed traffic in land mines. Leahy was even able to use his influence with the president so that Clinton addressed the UN General Assembly and said, "We've got to outlaw these weapons."

This illustrates the importance of political leadership. We can put out a moral call. But you know, there are a lot of moral calls, there are a lot of injustices out there, and there is an organization for just about every conceivable issue you can come up with. What makes a difference is getting political leadership

> "I have killed people and I would do it again if it was necessary. But there's a difference between engaging an enemy soldier and killing civilians. Conflict has fundamentally transformed. Now it is the vulnerable, the innocent, that are the target of violence, instead of the military."

behind you. And we got a powerful senator who went nuts. I knew a lot of guys in the Senate who said, "Look, Bobby, I only signed that goddamn bill to get Leahy off my back; he wasn't leaving me alone." These guys don't give a shit about antipersonal land mines—it was Leahy's persistence that made them say, "All right already, I'll sign the bill."

One of the things that really pissed me off when we were awarded the Nobel Peace Prize was there was such a romanticized treatment in the media, to make people feel good—inspired. It was horseshit. People think because of Princess Diana, the fact that there was an international treaty, a Nobel Peace Prize, that it's done, the job's over. We need to wait a second—we have not universalized this treaty.

Land mines have totally fallen off the screen for everybody. We still need the United States to sign the treaty because all these other countries that need to be on board are not going to get on board ahead of the United States: China, Russia, India, Pakistan.

Courage for me means swimming against the tide. To go on in the face of adversity. To be willing to expose yourself to failure and ridicule. You have to be conscious of the fact that you're at risk and aware of what you can lose—to then go forward is a courageous act. To just act blindly, that's not courageous. Loss is not only reputation and money, it's security and possibly your life. And if you go in and face those risks and threats I think that's greatness. You're doing it not because you're gonna get applauded at some point down the road or rewarded, but because it's right.

My dream for the future is to make a real contribution in containing conflict. I am not a pacifist. I have killed people and I would do it again if it was necessary. But there's a difference between engaging an enemy soldier and killing civilians. Conflict has fundamentally transformed. Now it is the vulnerable, the innocent, that are the target of violence, instead of the military. That is absolutely unacceptable. If we can't ultimately get people to be outraged over the slaughter of the innocent that's going on, then chances of getting people to engage the concept of conflict is even more remote. Because with most people, conflict is still defined more along the terms of *Saving Private Ryan*. It's a bitch, but it's still military on military. This is the fiftieth anniversary of the Geneva Convention following the Second World War. Those aren't laws of war—they're suggestions. Laws require punishment for those who violate them. There has to be accountability. Antipersonal land mines, since 80 percent of their victims are innocent victims, serve as a good way to illustrate what conflict has become—violence that cannot discriminate between soldiers and civilians.

Look, we live our lives largely insulated from the depth of despair of pain and anguish and everything else that is going on out there. That's why I feel so strongly in going after laws and making them real—the belief that you cannot allow the genocides, the Cambodias, the Rwandas of the world to play out. Allowing innocent people to be slaughtered on the scale that we're witnessing around the world is just degrading the basic level of human conduct that we need to have. The world community has to say that conduct won't be tolerated. Because if we do allow it, then it's a breeding ground and sows the seeds of destruction. One day, that degree of madness is going to walk up the block and come into your neighborhood.

RAJI SOURANI

GAZA

———

HUMAN RIGHTS AND SELF-DETERMINATION

"The world may think that peace is on the way here,
 but the reality on the ground is very different…never before has
 the overall human rights situation deteriorated as dramatically."

*Raji Sourani is Gaza's foremost human rights lawyer, and the founder and direc-
tor of the Palestinian Center for Human Rights and former director of the Gaza
Center for Rights and Law. In the 1980s, Sourani was widely recognized for his
effective defense of Palestinians before the Israeli military courts. In connection
with his defense work, Sourani was four times held in detention by the Israelis,
beaten and subjected to mental and physical abuse. Sourani has represented
Palestinians facing deportation and closely monitored detention and prison con-
ditions. Reaching out to Israeli human rights organizations, he formed links
regarded with suspicion by fellow Palestinians but which proved to be effective in
the pursuit of human rights. He was detained by the Palestinian Authority in 1995,
following statements critical of their establishment of a state security court. Since
the signing of the Declaration of Principles by the Government of Israel and the
PLO, and the establishment of limited Palestinian self-rule, Sourani has advocat-
ed strict adherence to international standards for the Israeli government and the
Palestinian Authority. And despite the danger of repercussions, he is an outspo-
ken critic of human rights violations committed by both sides. In his bold and prin-
cipled stance, Sourani has won wide respect, and has been recognized by numer-
ous international organizations for his courageous work.*

We Palestinians are living in a highly complicated situation, which is unprecedented in modern history. Six years after the signing of the Oslo Accords, what we are experiencing in the occupied territories is a system of de facto apartheid, developed under the auspices of peace. We are nearly a forgotten people, consigned to a second-class existence. We are far from practicing our right of self-determination and independence.

After fifty years of conflict, and thirty years of occupation in the Palestinian Territories, the Oslo Accords were signed nearly seven years ago by the government of Israel and the PLO. These accords were intended to provide a transitional interim arrangement for a period of five years as a means of moving towards a final resolution of the conflict. The basic philosophy behind the accords was that they were designed to serve two main purposes. The first was to develop a setting in which trust could be built between the two sides; the second was to develop a framework in which to resolve the final status negotiations within five years. It is clear that trust between the two sides has not improved, and in fact, in some areas are at an all-time low. Furthermore, the final status negotiations did not even begin within the five-year interim period, which ended on May 4, 1999.

Policies since the signing of the Oslo Accords include aggressive settlement expansion, fragmentation of the Palestinian Territories by the construction of settler bypass roads, military installations, and the establishment of new settlements, and unprecedented levels of land confiscation. Furthermore, the Israeli policy of closure over the entire Palestinian Territories has not only severely restricted the right of freedom of movement, but has dislocated families from different areas. Closure has also cut the Palestinian Territories off economically and socially, both from the rest of the world, and from the other parts of the Occupied Territories themselves. This has led to further economic deteri-

oration and dependence on Israel. In Jerusalem, Israeli policy has been to eject Palestinian residents, through house demolitions, the imposition of Israeli domestic law over Palestinian residents of East Jerusalem, withdrawal of residency permits, harassment, and settlement activity.

House demolitions provide one example of what Palestinian families face in their encounters with Israeli occupation authorities. Homes are demolished as a form of illegal collective punishment against families of whom one member may be suspected of an offense. Alternatively, homes are demolished simply because they were built without the necessary building permit from the occupation authorities—a permit which in many cases is practically impossible to obtain. The outcome of these demolitions is to impose collective punishment and to "ethnically cleanse" the Palestinian population. Palestinian families are often given only twenty-four hours notice to remove their belongings when Israel moves to clear certain areas for settlement. These families suddenly find themselves out on the street, their home demolished in minutes before their very eyes.

Of course, I have to talk about torture. Under international law, torture is absolutely illegal, and we cannot be selective. We have to have one standard for all people, Israeli or Palestinian, regardless of race or religion. But for decades the Israeli General Security Service has been torturing Palestinian detainees with impunity. Recently, a report released by the Israeli Special Controller confirmed what we have been asserting to the world community for years—torture has been widely and systematically used by Israeli interrogators against Palestinian detainees.

After twenty years of struggle against torture, we—Palestinian and Israeli human rights organizations and lawyers—received a decision from the Israeli High Court

> "The Israeli occupation, in its legal and physical form, has remained a very real part of our daily lives. The world may think that peace is on the way here, but the reality on the ground is very different."

of Justice in September 1999, finally recognizing that torture is systematically practiced. The Court, however, went on to find that the reason torture is illegal in Israel is simply because there is no law to legalize it. The Court, scandalously, went as far as to suggest that if the government of Israel should decide that they wanted to allow the use of torture, they should pass a law to that effect.

The Palestinian people are impatient to have their state in the West Bank, Gaza, and East Jerusalem, a combined area that composes only a scant 18 percent of historical Palestine. Even so, the current Israeli government has gone even further and has clearly stated its intentions: the complete annexation of East Jerusalem, no return to the 1967 borders, no right of return for refugees, and the continuing existence of Israeli settlements.

Clearly this does not meet the minimum level of Palestinian aspirations. This has become a situation leading nowhere. Some time ago, Israel had a choice between divorce or marriage. Israel chose divorce, represented by the two-state option, in order to preserve the Jewish nature of the state of Israel. But the most basic requirement of the two-state option is that the Palestinian people have their own state. This minimal requirement has yet to be fulfilled. The one-state option (with equal rights for all citizens regardless of race or religion) was rejected by Israel. Instead all we have are fragmented Bantustans of Palestinian control, with the Israeli military occupation continuing over the Palestinian Territories as a whole.

It must be stressed that in the past six years, the Israeli occupation, in its legal and physical form, has remained a very real part of our daily lives. The world may think that peace is on the way here, but the reality on the ground is very different. I can assure you that never before has the overall human rights situ-

ation deteriorated as dramatically. The Gaza Strip has a total area of around 165 square kilometers, of which Israel continues to control around 42 percent. Twenty Israeli settlements have been established in the Gaza Strip, housing some five thousand settlers. In the remaining 58 percent of the Strip, 1.2 million Palestinians live in some of the most cramped conditions in the world.

In the year 2000, with the fall of the Berlin wall and the end of the apartheid regime in South Africa behind us, this situation cannot be tolerated. In fact, if the situation continues it will inevitably lead to a renewed cycle of bloodshed and violence. We observe with deep disappointment that the fruits on the ground of the Oslo process could not be further from the stated intention of building confidence between the parties and resolving a final agreement for a just and lasting peace in the region. We also affirm our belief that there can be no possibility of real, just, and lasting peace without respect for human rights.

The Oslo Accords were signed between the government of Israel and the PLO, the legitimate representative of the Palestinian people, expressing their aspirations and having led their legitimate resistance against the occupation. We, the Palestinian human rights community, believed from the very beginning that it was essential to both our self-respect as a people, and for the ultimate achievement of our goal of a democratic state, that the practices of the Palestinian Authority, in the very limited areas in which it was granted jurisdiction under the Oslo Accords, be closely monitored. We were, from the outset, committed to the development of a society that would respect the rule of law, democratic principles, and human rights.

We believe that the particular experiences of the Palestinian people, and the consequent development of a strong Palestinian civil society, can enable us to

develop a unique state in the region—namely, a truly democratic state. We still hope to succeed in this goal, and many Palestinians remain steadfast in working towards this end.

As local human rights organizations, we thought that the struggle for the development of this democratic society and the strengthening of Palestinian civil society would be easier than the struggle against the Israeli occupation. Now we see we were wrong; it is a deeply complex process and much more difficult than we imagined. We are deeply concerned by certain practices of the Palestinian Authority which violate human rights standards, including restrictions on the freedom of expression and assembly, undermining the independence of the judiciary, and the establishment of state security courts.

Without in any way offering this as an excuse for those practices, we nevertheless deem it necessary to express our concern at the role played by both the Israeli and American administrations in promoting these violations of human rights by the Palestinian Authority. This role is particularly perplexing since the stated strategic interest of both these parties is real and lasting peace in the region. The development of a genuinely democratic system in the Palestinian Territories not only promotes the necessary stability for such peace, but is in fact an essential prerequisite for any kind of true peace. For fifty years Israel has complained that it should not be expected to make peace with dictators. This only makes Israeli and American obstacles to the development of a genuine democratic society in the Palestinian Territories all the more perplexing, while raising serious questions as to their genuine intentions.

No one needs peace—a just peace—more than those who are oppressed. The fact that the Palestinian people have become the victims of those who were once victims themselves only shows how important it is to remember this point.

In terms of both political and human history, it is deeply saddening when the victim becomes the victimizer of people who are guilty of nothing except existing in their homeland. The Palestinian people have suffered for the past century, and for the past fifty years have been the victims of Israeli human rights violations. We must all acknowledge the lesson of history—that reconciliation cannot begin without recognition and apology.

True peace must be between people, not simply between leaders. The possibility of this materializing is severely undermined by the Israeli policy of closure, which, as well as violating the basic human rights of Palestinians, also creates a division between peoples by preventing any meaningful contact between Palestinians and Israelis.

We used to have an excellent relationship with our Israeli counterparts, human rights groups and lawyers. They used to come to us, we would go to them. They would invite us to lecture or speak at public meetings. We would work alongside each other on particular cases and causes. This created wonderful chemistry. But now, after more than five years of the closure policy, we are totally disconnected from our Israeli friends. We still cooperate, by telephone, E-mail and fax, but we are no longer able to have the human contact, because we can no longer come and go as we please.

I believe deeply in the need for peace, but my own life taught me that there can be no peace, no justice, without human rights. Witnessing massive and violent human rights violations on a daily basis makes quite a mark on a young mind and heart. In my youth I saw many people killed, arrested, or beaten before my eyes—including my brother, who was arrested, in early 1968. He was in prison for three years. As a kid, at school, I saw the army beat students for participating in demonstrations. Our daily life was really hell. My family is deeply

rooted in this place—I'm not, by definition, one of the many refugees in Gaza. But everybody felt like strangers in our homeland. Our lives were totally controlled by the occupation. When you are as young as I was and see all this happening, it leaves a strong impression. You begin to ask: What's going on? Why is this happening? Why are these unfair things happening? Why was our neighbor's house demolished? Why was my brother imprisoned? Of course anyone who feels and begins to understand what is going on wants a better future, a better life, and you want to express it in one way or another.

For me the next stage came after my arrest and imprisonment. I saw the other side of the moon. All I had seen before did not prepare me for the hell I found myself in, even if I, as a lawyer, was treated to the "VIP" hell. When you are being subjected to torture, you want to die ten times a day. And I saw how torture was being used systematically, even on kids as young as twelve.

I thought: all these prisoners, their miserable conditions, the systematic torture and abuse, and nobody knows anything about it. And then I thought of the house demolitions, the land confiscations, the daily beatings. I said to myself: I'm a lawyer, can't somebody be a witness to these crimes? Can't we reduce the suffering even minimally, some way or another? I thought that surely it was possible, through sustained human rights work, to let the world know about the practices of the Israeli occupation, and in doing so to help these victims. So that is what I decided to do. And I've been doing it for twenty years now.

I'll never forget one time after being released from administrative detention, having been detained simply because of my human rights work, the Israeli officer said to me, "Raji, this is your last arrest, and I hope you know what that means." It was a threat, but we believed in our work, in our struggle, in human rights. I hate to speak about our own suffering as human rights activists. We have to be strong enough to make people feel, and know, that we can defend them. We have to be strong enough to take care of the real victims.

I simply believe that human rights, democracy, and the rule of law are not luxuries. They are crucial necessities—the oxygen of meaningful life. We see the violations on a daily basis. We see the victims, we know them, we live with them. What keeps us going is the belief that you can do something, even if it is just a little something. And even if we cannot improve the situation, at least we can stop it from deteriorating further.

I believe we must continue to struggle to defend the rights of the victims, we must continue to reject all forms of human rights abuses. We must believe that it is worth it to make even small changes. For the sake of the victims of these abuses and injustices, we must carry out our work professionally. We must be vigorous in our defense of the persecuted and bold enough to never stop opposing their victimizers, no matter who they may be.

I don't believe in violence, and I don't think it is a solution. Nor do I believe that Palestinians are the only ones whose blood is sacred. All human life is sacred, no matter which nationality, race, or religion. But we cannot accept the situation as it is. We must do something.

I don't want to see more suffering. Whatever we do today may bear its fruits tomorrow. Like Martin Luther King Jr., we too have a dream—a dream and a very legitimate agenda, to get rid of the occupation, to determine our own destiny, and to have an independent state—a state where democracy, human rights and the rule of law prevail. As I have said, the obstacles we are now facing are very complicated, much more so than pre-Oslo. But we are determined to go on with the struggle—all the way.

MARTIN O'BRIEN

NORTHERN IRELAND

HUMAN RIGHTS IN THE MIDST OF CONFLICT

"The worst thing is apathy—to sit idly by in the
face of injustice and to do nothing about it. There is a real
responsibility to challenge things that are wrong."

As the executive director of the Committee for the Administration of Justice (CAJ), Northern Ireland's foremost human rights organization, Martin O'Brien has played an important role in bringing a cessation to the conflict which has divided Northern Ireland for decades (some would say centuries). The last thirty years of unrest, starting with the suppression of civil rights protests in the North in the late 1960s have claimed more than three thousand lives. At the heart of the conflict is the failure to assure quality justice and the rule of law for all sectors of society. A long history of religious persecution and discrimination, economic disparity enhanced by the devastating economic consequences of war, and emergency decrees which suspended civil rights, exacerbated the violence. Nongovernmental, nonpartisan, and nonsectarian, CAJ is one of the very few entities trusted by both Loyalists (loyal to British rule) and Nationalists/Republicans (advocating closer alliances with the South of Ireland) alike. Founded in 1981, CAJ offers hands-on support to victims of abuse and provides human rights lawyers with support and legal resources. As executive director of CAJ, O'Brien played a key role in drafting the strong human rights provisions in the Good Friday Peace Agreement, signed in 1998 by all parties, that set forth a timetable and a structure to end sectarianism and created a new power-sharing government in the North. CAJ is the only nongovernmental organi-zation actively engaged in monitoring compliance with the accords. O'Brien is a pacifist, and for him, the commitment to peace requires an action agenda and a deep understanding of every point of view. The optimism and determination shown by O'Brien and those like O'Brien have prevailed over violence, and their will to resolve these conflicts will be needed in the years to come.

I started working at the Committee for the Administration of Justice in Northern Ireland in 1987. The committee has three jobs. First, it publishes and disseminates information on citizens' rights, such as how the police should behave when conducting an arrest, or how prisoners are treated. Northern Ireland is a very segregated society—so much so that it is quite possible to reach the age of eighteen without ever having met someone from a different political background. In an effort to tackle this segregation there are a range of groups that organize different activities designed to bring Protestants and Catholics together, perhaps by sponsoring activities, talking about sports, or discussing a number of uncontroversial topics. Over time, more controversial issues arise within these groups. Tension, for example, might be created within the group if someone has a family member in prison. At this point, CAJ might be invited by the group organizers

to facilitate a discussion about prisoners' rights or have a general discussion about human rights: why are rights important and where do our ideas about rights come from? CAJ publishes materials about abuses and gets that information into the press. As an extension of this, the committee acts as an informational resource for students, journalists, community groups, church people, members of the public, politicians, international delegations, and others.

Secondly, CAJ offers legal advice and assistance to people whose rights have been violated. The committee either acts as their lawyers (as in the five cases presently in the European Court of Human Rights), or helps victims and their families manage a case beyond the court proceedings. For instance, members might help the family in a miscarriage of justice case by identifying sympathetic politicians and attending meetings between the two parties. Likewise, members meet with people from Amnesty International or the Lawyer's Committee for Human Rights to enlist their support.

Lastly, the committee is involved in lobbying for changes to laws and practices that violate human rights. For example, it has worked to secure laws prohibiting racial discrimination in Northern Ireland. This has provided protection for minority groups like the Chinese and Indian communities in Northern Ireland. Another example would be our work to secure safeguards to prevent the ill-treatment of detainees. Lobbying and campaigning are critical to ensure that the government lives up to its commitment to international human rights law. Over the last few years our work centered on getting strong human rights protections written into the Good Friday Agreement. CAJ was very successful in this regard. The challenge for us now is making sure that these protections are fully implemented.

I got involved in this kind of work in 1976 when I was twelve years old. A group of people knocked on the door of our house and said, "Do you want to go on a peace march to demonstrate against the violence?" My older brother and sister went and I said I would go with them. We marched every weekend in different parts of Northern Ireland and, in doing so, formed a local group that brought together diverse people. The Peace People won the Nobel Prize in 1977. With demonstrations drawing approximately twenty to thirty thousand people, a popular movement developed. It was exciting. A number of us went to a summer camp in Norway designed to bring together Catholics and Protestants from different backgrounds and locations throughout Northern Ireland. We had discussions about politics, about religion, about violence, and life in Northern Ireland. We discussed nonviolence as well. At the summer camp, I met a Norwegian woman who came to work in Belfast after the summer camp. With the help of an American, we formed a group called Youth for Peace.

About twenty of us organized a three-day fast on the steps of city hall to highlight hunger around the world and to call for peace. We were all sitting there and fasting for peace when a bomb suddenly went off a few streets away. It was discovered that the IRA had planted it in a car. It was pouring rain and we went around to see if there was anything we could do. Nobody had been killed, but there were a lot of passers by covered with glass from the windows. Glaziers arrived and life quickly returned to normal. It was impossible to see, it was so wet, blood was dripping off the pavement, but life was proceeding as normal, and yet this dreadful thing had just happened.

I had been learning about nonviolence, hearing what Gandhi and Martin Luther King were saying. It was wrong that people should mess up the lives of others

for some political ideology, for a flag, over who should govern this particular place. That night, it became very clear to me that violence was inhumane and that we didn't have the right to use it. In my family we were brought up with a strong sense of right and wrong, that people were to be treated well and not abused. The sanctity and the preciousness of life was emphasized.

In every case, the impact of the violence is terrible. In Northern Ireland, people get categorized either as innocent victims or "other" victims. If you haven't been involved in anything, you are an "innocent" victim. On the other hand, if you are in the IRA and you are out doing something and end up getting shot, you are not categorized as innocent. In this case, there is a sense that you do not deserve any sympathy and, by extension, neither does your family. This is in spite of the fact that everyone's grief is the same.

There is a hierarchy of victimhood. If you are involved in politics, for example, you are not considered innocent. Whenever somebody is killed in Northern Ireland, media interviews with the relatives are conducted. The first thing asked is, "Was your husband involved in anything? Why would somebody have done this?" People rush to say, "He was a very quiet person. He just lived for his family. He wasn't involved." But if you are involved in public life, somehow a violent death seems to be understandable.

The worst thing is apathy-to sit idly by in the face of injustice and to do nothing about it. There is a real responsibility to challenge things that are wrong. I believe that nonviolent tactics are right and effective. Though nonviolence is a backdoor approach to combating human rights abuses, it is both morally and pragmatically right. If you believe that a greater world exists beyond this one, then it is more important from a larger standpoint to do the right thing rather than to be effective or to survive. There is a bigger frame of reference.

I have been afraid a couple of times. When I was very young and we were going on the peace marches, some of the marchers were attacked with bricks and bottles and a number of people were beaten. At those times, I remember being frightened. When Pat Finucane, a defense lawyer doing a lot of work on human rights, was killed, it became clear that he had received threats beforehand and that there was official collusion by elements within the police and army. I and other people working on human rights were frightened. And on March 15, 1999, Rosemary Nelson, a lawyer and member of the CAJ's board and a friend, was killed by a bomb left under her car. That was truly terrible. But you can't live your life in fear and give people power over you who want to create fear. At the end of the day, it is very important that these people are not allowed to do that. It would be better to die early than to refrain from doing things because you are fearful about the consequences.

I am afraid for other people as well. I worry about the people who work with me. It is important that people know what they are getting into. If you step on somebody's toes, before you know it you are getting threatening letters or phone calls saying, "You will end up dead," or "We will get you, we know where you work, we can wait outside your office and follow you home." Mind you, it's not a regular occurrence. Of course, when you get the phone call at home, this is a bit more disconcerting.

DOAN VIET HOAT

VIETNAM

POLITICAL RIGHTS AND IMPRISONMENT

"I wanted to send a message to the people who wanted to fight for
freedom that the dictators could not win by putting us in jail.
I wanted to prove that you cannot, by force, silence someone who
doesn't agree with you."

Doan Viet Hoat is known as the Sakharov of Vietnam for his intellectual range and outspoken role as leader of the democratic movement, even from the prison cell. Hoat protested the South Vietnamese government's suppression of Buddhists in the 1960s while still a student. In the United States, he received a Ph.D. in Education in 1971. Returning to Vietnam, he concentrated on upgrading Van Hanh University (a Buddhist private university in Saigon) to the world level of institutions of higher learning. In 1976, when North Vietnam took over South Vietnam, the new authorities embarked on mass arrests of intellectuals and Hoat spent the next twelve years confined to a cramped cell, shared with forty others. Upon his release, Hoat began publishing Freedom Forum *(Dien Dan Tu Do) underground. He was detained without trial for two years, then in March 1993, sentenced to twenty years for "attempting to overthrow the people's government." Hoat continued to issue statements on democracy and criticisms of the regime that were sent out of the prisons clandestinely. To silence him, the government transferred Hoat from one detention center to another, but everywhere he went, Hoat's charismatic temperament won over prisoners and guards alike, who sought his counsel and carried out his letters. Finally, Hoat was sent to the remote Thanh Cam Labor Camp, Thanh Hoa province, and prisoners were removed from the adjcent cells. He spent four and a half years in solitary confinement until, in September 1998, after international pressure, Doan Viet Hoat was released, then exiled. He now lives in the United States, and continues his movement for human rights and democracy for Vietnam.*

DOAN VIET HOAT

I spent twenty years in Vietnamese prisons, and was in isolation for four years. I was forbidden all pens, papers, and books. To keep my spirits up I practiced yoga and Zen meditation. I did a lot of walking. I had access to a small yard from 6 A.M. till 4 P.M., so I gardened—small cabbages mostly. I sang, I talked to myself. The guards thought I was mad, but I told them if I did not talk to myself I would go mad. I tried to take it easy, to think of my cell as home, as though I had entered a religious way of life, like a monk. My family was Buddhist and I had many good friends who were monks. I learned yoga as a student. In isolation as I had no books, I just had to use my mind. Zen meditation helped—with it you turn inside. You have to be calm, to make your mind calm, to think this was just a normal way of life. During the first one or two years this was very difficult, but I got used to it. Every day passed, like every other day. I wrote and recited a lot of poems I had learned by heart. This was a way to keep my mind alert, and helped to clarify my thoughts. As soon as I was released, one of the first things I did in America was to write down the poems from my mind that I recited in prison—now they have published a second volume of them.

The knowledge that it could have been worse in solitary confinement helped. I knew that others survived more severe treatment, and their resilience was an important source of courage. If they could persevere, so could I. Here's one ironic example. When I first came there, the first day, they asked me if I wanted to buy any necessary things, and they gave me a piece of paper to write a list. And I wrote down many things, including a fan. I had in mind a small, handmade fan. But they thought I had asked for an electric fan, unheard of in prison. So they were very angry. I didn't understand why they were angry, when I asked for just a fan. Eventually, word arrived from the minister, or the ministry officials, who had agreed to let me buy an electric fan. And one official came in and he said, "Your electric fan—made in China or Japan?" Well, I was very surprised, but knew by this incident how they were going to treat me—not so badly. But about one week later everything became clearer. One day it was terribly hot. I turned on the fan, and it did not work. I asked the official and he told me that to save energy, from now on, power would be cut off during the daytime. I observed that there was still power in the entire camp, except in my area. And every year, once or twice, they came into my cell to videotape me, sitting there, reading some newspaper, one month outdated, and with the electric fan always vividly behind me.

The common criminals clandestinely listened to illegal radio broadcasts from abroad on the BBC, or RFI (Radio France International) about me and about my cause fighting for human rights. Prison conditions were unbearable, They were

"I spent twenty years in Vietnamese prisons, and was in isolation for four years. I was forbidden all pens, papers, and books. To keep my spirits up I practiced yoga and Zen meditation. I did a lot of walking. I had access to a small yard from 6 A.M. till 4 P.M., so I gardened—small cabbages mostly. I sang, I talked to myself."

beaten almost every day. So they asked for my help. I secretly wrote a report about the conditions at the camp, and the other prisoners smuggled it out to my family in Saigon. The officials found out about that because my friend sent a letter back to me in a piece of pork, and the officials (who check everything very carefully) found the letter. They knew therefore that I had written about the camp, so they quickly sent the letter to the minister of interior affairs, who in turn sent inspectors to the camp—and finally life improved. They stopped beating the prisoners, they removed the officials who liked beating prisoners, they improved meals, and now they even have musical groups who sing every day to make the camp very lively! I realized that our voice had been heard by the international community. I felt more inspired.

I had been writing other essays criticizing the regime, and fellow prisoners in all the camps I had gone through got them out for me. After I wrote the reports the officials increased their efforts to isolate me. They removed prisoners from the cells all around me. They blocked up the window of my cell so that no one could get in touch with me. It became unbearably hot because no air could circulate. I developed high blood pressure. They put in a new door so I couldn't see out and for the two last years it was very bad for me.

Still, I felt that if I kept silent in jail, then the dictators had won. And I wanted to send a message to the people who wanted to fight for freedom that the dictators could not win by putting us in jail. I wanted to prove that you cannot, by force, silence someone who doesn't agree with you. That's why the prisoners, both political and criminal, tried to circulate my writings. Without their help I could not have sent my messages out. We united to continue our fight for freedom and democracy, even from within the prison walls.

My dream for the future is a dream of Vietnam. Our country has a long history of people who fought against aggression and injustice. Our highest calling is love of country, as has been demonstrated by many Vietnamese patriots in the past. I, too, have been moved by the love of my country and also by the greatness of my country's future and the world's future. I believe in a very bright future for Vietnam and for the whole region of Southeast Asia. Time has passed too slowly for my country and my people, and left a long history of suffering. So these thoughts make me unable to keep silent—my knowledge, vision, and love of country urge me to speak. And I always believe that truth, justice, and compassion will prevail, no matter how strong the dictators are, no matter how bad the situation might be.

NATASA KANDIC

SERBIA

HUMAN RIGHTS IN TIME OF WAR

"In 1991, many of my friends decided to leave the
country, but I felt I had to stay and fight the policies of war itself."

In 1991 the cessation of Slovenia triggered the disintegration of the former Yugoslavia into the republics of Serbia, Croatia, Bosnia and Herzegovenia, Montenegro, Macedonia, and Kosovo. Led by the Croatian dictator Tudjman and the Serbian Milosevic with their policies of ethnic cleansing, efforts to consolidate territory along ethnic lines were systematized and enforced, using concentration camps, rape camps, and other gross violations of human rights. With the NATO bombings of Bosnia and later of Kosovo, the armed conflict ground to a halt. Physical bravery is rare on the battlefield; rarer still is the bravery it takes to stand up against one's own government, or against one's own community, including family, friends, and professional colleagues, all in the pursuit of justice. Natasa Kandic is among a small minority of Serbs who have dared this, as she investigated wrongs committed by her own and other ethnic groups. Serbs, Croats, Muslims, Kosovar Albanians, and Romas have, in turn, labeled her a traitor for her unbiased and unrelenting struggle for human rights. Born in 1946, and first working in housing issues for the Trade Union Organization, in 1992 Kandic formed the Humanitarian Law Center, Yugoslavia's premier human rights organization. Known for meticulous investigative work despite the extreme danger, HLC has been relied on by the War Crimes Tribunal to research human rights abuses in wartime. HLC also represents victims before tribunals, and is a legal pioneer in bringing claims against the Serbian and Montenegran governments. HLC provides legal assistance to refugees for land claims, citizenship, right of return, pension payments, and property ownership rights, among others. Kandic also has used her own considerable organizing skills to mount popular support for peace, initiating the Candles for Peace campaign in 1991, where citizens stood with flames alight outside the Serbian presidential building nightly for sixteen months, reading the names of those killed during the war. Kandic also organized a thousand volunteers to collect 78,000 signatures protesting forced conscription of Serbians into the war in Croatia. In 1992, the Black Ribbon March saw 150,000 Belgraders demonstrate against the suffering of civilians in Sarajevo. That same year, Kandic's weekly column (wherein eighty intellectuals called for peace) appeared in Borba, Belgrade's first independent daily newspaper. Natasa Kandic has consistently spoken out against repression and bigotry in all its forms, and her work for peace and tolerance in the former Yugoslavia will be remembered long after the last guns sound there.

Before the war years I was involved in political actions in the former Yugoslavia without any knowledge about existing international powers for the protection of human rights. And when the war started in 1991, many of my friends decided to leave the country. I understood their choice, but I felt I had to stay and fight the policies of war itself. I began to travel throughout Yugoslavia, in the beginning to

the region of Croatia. I investigated human rights abuses and tried to protect activists, including intellectuals and political parties. When the war later began in Bosnia I focused on minorities and Muslims and their position in Serbia.

In 1992 I decided to formally establish an organization to gather information about the violations of humanitarian law. The idea was to gather evidence, to investigate cases, and to speak out about abuses based on the testimonies we had heard. First we developed a methodology, then established a database. We wanted to be absolutely sure that every allegation was true.

We succeeded in documenting the abuses, but of course we failed to stop the war, or to establish peace. When I documented abuses against the Croats, the regime called me a traitor. When I documented abuses against the Muslims, the regime called me a traitor. When I documented abuses against the Serbs in Croatia, the regime said—nothing. I documented crimes against the Albanians, and of course the regime said that I was a traitor. Lastly, I documented abuses against the Serbs and minorities, much of it against the Roma after the Kosovo war, and the government continued to call me a traitor.

So you see, I don't agree with human rights activists who claim that human rights issues are not political issues. They are crucially important political issues, with serious implications for the future of society. Without respect for human rights and implementation of human rights standards, there won't be democratic changes. Human rights is, in fact, the ultimate political question.

To describe what the last nine years have been in the former Yugoslavia would take days, weeks, months. So let me tell you one or two stories from the recent past. In 1999, I went to an international meeting in Paris and returned on the last flight to Belgrade, just before NATO started to bomb. Three days into the bombing, I decided to go to Kosovo. The war was on; there were certainly no buses there. So I got in a cab and asked the driver to take me to a town about a hundred kilometers from the border between Serbia and Kosovo, and he agreed. When

we finally got there, I asked if he would drive me further, all the way to Pristina. Well, at first he was so afraid. A Serb, he thought the Kosovo Liberation Army was there, that he might be killed. And I then explained to him that only the Serbian police and the Yugoslav army were there. So he decided to do it.

Our first impression of Pristina was really awful. The only people on the streets were the police and military, only men brandishing weapons, no women at all. I tried to find my office and staff to see what to do. It was so dangerous that we decided to collect everyone and go to Macedonia. But when people heard that I was in Pristina and that I planned to go to Macedonia, there was a big panic. The word spread like a fire and thousands and thousands of cars followed us to the border. Within ten minutes caravans of cars were all around us. But by the time we got to the border it was closed. We told the soldiers that some of us in the cars were Serbs and some Albanians; they were taken aback to see mixed company. But one young soldier warned us to go no further, "Because very strange police are here." We were very afraid, and I thought we'd better return immediately to Pristina.

We traveled through empty roads without cars or civilians. Everything was abandoned: the fields, the houses, the villages. Police were hiding because NATO was targeting police forces and military forces. It was very dangerous to travel. But for me it was very important to go out. Based on my experience in Croatia and Bosnia, I know that every effort made in a difficult time will bring some hope. Again, whatever police were there were surprised to see us. Our taxi driver was brilliant. The police checked his identity cards and he began to speak about the situation with the police, always calling them "my brother." The police suspected nothing. This driver was just an ordinary man, without links to human rights organizations or anything. But he courageously just kept driving us through this war zone, never asking why we were there or what we were doing. He knew I was a Serb and he saw that we were sleeping in Albanian houses shared by Albanians and Serbs. He was confused, but he thought that's okay for Albanians and Serbs to be together. And he wanted to

understand, asking my lawyers, "What's happening? What is her job, anyway? Why are you going to Macedonia? What's happened to the Albanians?" And this incredible driver, whom I didn't know before, felt he was safe with me. He said, "I will travel always with you because you are so sure of what you are doing, I don't believe we will ever have trouble."

But I wasn't sure—not really. But I knew it was important to go to Kosovo just to be with the people. I saw their fear and I cannot describe it. They were sitting in their houses without moving. Only a few women had the courage, the strength to go out to buy food. All the men were shut in their apartments, scared of the police, in terror of the paramilitaries, horrified by what might happen to them tomorrow.

I couldn't afford to feel fear because I saw their fear. They kept asking me, "When will you return?" They were completely isolated and I was virtually their only contact with the outside world. I couldn't share my fear because I had an obligation. I spent nights with them, talking about the situation, what to do. I tried hard to convince them to stay, because after war they would need to have a house, to have property, to have their computers, their books. And I think a majority of the people in Pristina who decided to stay did so because of the ten days I was there, talking to people in their houses. It was very important to them that somebody from Belgrade visited, because they knew the danger that effort represented. They knew someone cared, that they were not alone.

After my trip, I returned to Belgrade. I was so surprised to see that people weren't even talking about what was happening in Kosovo. They saw the refugees on CNN, on BBC, but it was unreal to them—nobody even asked me about Kosovo. The level of denial was high.

Then, on March 26, 1999, civil police and military forces had expelled all Albanians from the city of Peje and the refugees fled to Montenegro. So I continued on to Montenegro with my staff to open a temporary office there. I asked

my good friends who were Albanian lawyers in Montenegro to work in the office, to begin to interview these expelled Albanians about the expulsions and what happened in Peje, and they accepted.

One stayed to investigate abuses, and two continued on to Albania. And I was happy to see them working in the office, instead of a refugee camp without books, without food, in awful conditions. I left again for Pristina, saying to myself, "Don't think about the police, everything will be all right." I always traveled with the same incredible driver and each time the police stopped us he said, "We are going to Kosovo to pick up some children from our family. How is the situation?" We tried to convince the police that we were Serbians just like them. And they let us go. I was always traveling: Kosovo, Montenegro, Belgrade, and back again, always the same circle.

We talked with people all day and all night, and thousands came to our office, because all of them, as Albanians in Kosovo, were listening to the radio station, Free Europe, which talked about us and the work we were doing. Free Europe was a famous station among Albanians, because they could get objective information from it about events in the former Yugoslavia. When I was in Belgrade, Free Europe always called me about the situation in Kosovo, which was very important, because nobody had any information about what was really happening there. The first time they interviewed me, they prefaced it by asking, "Are you afraid to talk?" I said, "No, I am not afraid. Because I am a fighter. And every step is important."

And you know, after the NATO military intervention, when the troops began to reach the villages, people recognized my voice, not my face, from those broadcasts. Once that saved me in a terrible situation. I was with my Albanian lawyers in a village where sixty people from one family got killed. When all these people came up to us I said "Good afternoon," in Serbo, and people were first shocked, and then very, very angry. It was—menacing. Suddenly, one of them said, "Wait, I recognize your voice. You're the one from the radio." And then all of them came over to me and began to speak of what they had seen and what they suffered.

FAUZIYA KASSINDJA

TOGO/ UNITED STATES

FEMALE GENITAL MUTILATION AND IMMIGRATION ABUSE

"On Thursday they said I'd be married. On Friday they told
me they'd cut me. At midnight I escaped."

Fauziya Kassindja narrowly escaped female genital mutilation by fleeing from her remote village in Togo under cover of night and making her way to the United States where, in December 1994, she sought political asylum. Instead of receiving this seventeen-year-old orphan with understanding and humanity, U.S. officials proceeded to strip her naked, put her in chains, imprison her, and send her through the Kafkaesque nightmare known as the U.S. immigration system. After extensive advocacy by a law student at American University and an appearance on the front page of The New York Times, *Kassindja became the first person to receive political asylum from the United States based on the threat of female genital mutilation. Up to 130 million women worldwide, the vast majority concentrated in twenty-six African nations, have been subjected to female genital mutilation, and 2 million annually confront it. The procedure involves cutting off the clitoris. No anesthesia is used. Often other parts of the external genitals are also excised, and the entrance to the vagina is commonly sewn almost completely shut. Infection, scarring, infertility, excruciating intercourse, complex childbirth, and almost unbearable pain are common side effects. Many women die in the aftermath of the procedure, which is performed with razor blades, sharp rocks, knives, and in some instances, scalpels. Despite the trauma she suffered, Kassindja has spoken actively against the practice and about the difficulties she faced in the U.S. immigration system.*

I have four sisters and two brothers; I was the sixth child, the last girl. I was a mischievous one, very close with my father—he was my best friend. All my sisters were encouraged by him to do whatever we wanted with our lives. Our parents didn't decide for us. They always said, "It's your decision. If it's a positive one we're going to help you make it come true. If it's negative, we're going to advise you not to do it, but if you think that's what you want, go ahead. Later on you have yourself to blame. You can't say your parents forced you." My father sent all of us to school, so that we could learn English and help with his business. This was unusual for girls in Togo.

When I was sixteen my father died and everything changed. My aunt and my uncle, my father's siblings, hated my mom right from the beginning because Mom was from Benin and they thought she didn't fit in—she's not from their tribe. They tried to force my father to divorce her, but he didn't listen. They said my mother was behind all of us going to school. They thought she poisoned my father's mind.

After Father's death, Aunt moved into our house. She told us that my mother had decided to go live with her family in Benin, which was untrue. She and my uncle made my mother leave, and my aunt became my new guardian. I was allowed to go to school until the end of that year. When I turned seventeen she

told me that I wasn't going back to school because there was no need to waste money and time, and besides, all my sisters had gone to school and had just ended up married. I had lost my father, I had lost my mom, and now school. I thought, "Oh my God, what is going to happen next?"

Shortly after a gentleman started coming to the house. I thought maybe my aunt wanted to get remarried, so whenever he left I said, "Oh I think he's a great guy." She kept going on, praising him, how rich he was, how famous, how nice he can be. I thought she was in love. I didn't know that she was really saying that to get me interested. She didn't tell me that she wanted me to marry him until one time she mentioned, "I told him that you weren't going back to school." I was surprised. "Why would you have to tell him I'm not going back?" So she said, "Remember how you always say he's a nice person? He wants to marry you."

I thought she was kidding. She told me that he was forty-five years old. I said, "Forty-five!!!" And she kept going, "Don't worry. He has three wives and they will help take care of you." I said, "I don't want to do this." So after that it was a huge fight in the house all the time. Then one day she said, "I know you don't love him now but once you get *kakiya* [genital mutilation], you will learn to love him."

Soon after I woke up and she called me into her room and I saw all this beautiful clothing on the bed—dresses, jewelry, shoes—and she said, "This is all from your husband. He wants you today. So tomorrow will be the day of *kakiya*." I said, "What! I am going to get married today?" I had no idea what to do. The marriage proceeded and, after, they gave me the marriage license to sign, but I refused. My older sisters and brothers came, and we talked about it. They apologized for not doing anything to prevent things so far. My older sister was so upset. She told me not to cry—everything would be okay. She would make sure that nobody would do *kakiya* to me. But I didn't believe her because there was nothing that she could do. I was somebody else's wife now. She says, "Don't worry. Amaray and I will disguise you." Amaray is what we call my mom; it means "bright."

She told me not to sign the marriage license, told me not to worry. Everything would be fine. She came back in the middle of the night and we left the house and crossed the border to Ghana. The next available plane was to Germany. My sister gave me three thousand dollars, all the money she had. I got on the plane from Germany to the United States by purchasing a passport. When the immigration officer at Newark Airport said, "Do you have any money?" I showed her the little money I had left and then told her that I wanted asylum. She said go sit over there, and she would be with me shortly. So I sat waiting until she

"I felt just like the criminals
I had seen in movies. I started
crying. I said, 'Please,
don't take me to prison.'"

checked everybody and came to me. She said, "Okay, tell me what you want from the United States." I told her I wanted asylum. She told me I had to tell her what is the problem. So I told her everything. Well, not everything, because it is so embarrassing. How could she understand? I didn't know the words even to say it in English. I didn't know what it was called. I told her my father was dead and my mother had vanished, and my aunt wanted me to marry somebody I don't want to marry and that I wanted to go back to school. That basically summarized everything—I didn't mention *kakiya* because I knew she probably couldn't understand and she would also think I was crazy. Whether I got asylum was up to the judge, she said, so I would go to prison, then see the consular official from my country, and then I could go home and be with my family.

I started crying and screaming—telling her that I was only seventeen, and I didn't do anything wrong, I didn't want to go to prison. Then they brought the cops to the waiting area where I was sitting. Her supervisor said if I didn't want to stay, then I either had to go back to Togo or to Germany. I didn't know anyone in Germany, and Togo was the last place I wanted to go. They took my fingerprints and everything. A woman in uniform called me into her room, where she asked me to take off my clothes. I said, "Please, I am menstruating, can I keep my underwear on?" And she said to take it off. It was the most humiliating moment in my life. I took

it off and just wished I could disappear into the wall. She gave me back my pants and my sweater and then she started putting the handcuffs on me. I felt just like the criminals I had seen in movies. I started crying. I said, "Please, don't take me to prison." She ignored me and she put the chain around my waist. I couldn't walk very fast with the chains, but she kept pushing my back, saying, "Let's go. Let's go." So I was taken to this detention center in Elizabeth, New Jersey.

That's where the nightmares really began. I was strip-searched again, and left in this huge cold room and this man came in and stared at me, as I was standing there naked. Then I was taken to this prison in Hackensack where I was sexually harassed by an inmate. I think she was a drug addict. They put me in the maximum security part, with a cellmate convicted for I don't know what. She smoked, and I had terrible asthma. I told the doctor that I couldn't stay in that room and he just said, "I am sorry, ma'am, I can't help you." I started coughing and throwing up blood. But I was denied any medicine because of my immigration status.

Then I had to go to Lehigh County Prison in Pennsylvania. A girl from Tanzania and I were handcuffed together. During all this process of transferring from one prison to another, we were chained, like criminals. First they sent us for a medical evaluation, where they thought I had tuberculosis. As a result, I was

put in isolation. They kept me in this room for eighteen days, and I lost thirty pounds. Before I could talk to anybody I had to put on a face mask, like the one doctors use for operations. When I needed something I had to stand in the other corner of the room, turn to the wall, and yell for a guard. The door had this small window in the middle where they passed my food. I couldn't come near the door. They treated me like an animal. I needed soap. I needed a toothbrush. I called and called—most of the time, nobody would come.

I met Cecelia Jeffrey, another prisoner, in a detention center in New Jersey. She treated me like a daughter. When I'd go to bed, she would come and tuck me in. She has always been there for me ever since we met. When I started feeling sick again—stomach, heartburn—they ignored me and wouldn't give me any medicine. So I thought, "If I'm going to die, why don't I go back." I wrote the request form to the INS [Immigration and Naturalization Service], and wrote Cecelia a letter, telling her how much I really appreciated the way she took care of me and that I would never forget her.

She got really upset, because she knew about my situation back home. She got furious. She wrote to the counselor that I was her daughter and that they should please transfer me to minimum security, because she could persuade me not to go back.

They were so overcrowded they put a bunch of us in the maximum security part of the prison. The prison guards asked me, "Is Cecelia your mom?" and I said, "Yes." So I was transferred to minimum security, where she was, and she was so upset with me. She said, "Are you crazy? Do you know what you're going back for?" And I said, "I just can't take it anymore." Next day she was in the shower and called, "Sweetheart, come here." (She always called me sweetheart.) I went to the bathroom and she was standing in there, and she opened her legs apart and said, "Look. Is this what you want to go back to?" I didn't know what I was seeing.

It was so scary—terrible—I didn't know how to explain it. I just saw it and ran away from the bathroom. And she screamed, "Come back here! You want to be stupid? Come back here! Come and look!" So I went back and she said, "Do you know what this is?" I didn't know. It didn't look anything like female genitalia. Nothing. It was just like a really plain thing like the palm of my hand. And the only thing you could see was a scar, like a stitch. And just a little hole. That's it, no lips, nothing. I said, "You live with this?" And she said, "All my life. I cry all the time when I see it. I cry inside. I feel weak, I feel defeated all the time."

I look at her and I see the strongest woman on earth. Outside you can't really tell that she's suffering or in pain. I know she's not happy, but you couldn't tell

> "If I hadn't been through
> all these things, the case wouldn't have
> reached the many people that it has today.
> This is the work of God."

from her appearance or the way she treated others. She's the most loving person I've ever met. After she said, "Well, if you want to go back, I'll help you write the request form. It's your stupidity. Fine." I introduced her to Karen [Masalo], my lawyer, and together they made me stay.

At my first hearing, the judge was so rude, so mean to both Layli and me. Layli Miller Bashir was a law student from American University Law Clinic who had taken my case. Layli asked me a question and before I could answer the judge said, "It's not necessary, the court doesn't want to know this." And he asked me a question and before I answered, he answered for me. I couldn't talk at all in the courtroom. He didn't believe that my mother couldn't protect me from the genital mutilation. And he didn't believe that my father protected my other four sisters, but not me. It was so scary. He yelled a lot and he said my name and my country's name wrong and when I corrected him, he got so upset. And he said something, and I spoke out, "No, that's not what I said." And he yelled, "This will be the last time you interrupt the court." From the way the hearing was going, I knew he wasn't going to grant my asylum. Even before he came into the court, he had made up his mind not to grant it. Layli told me that I shouldn't worry, that no matter what happened, she would make sure that justice was done. She begged me not to go back.

I was in prison when I met with the reporter from *The New York Times*. At first I didn't want to do the interview. I had already done several, but none helped me get out of prison. So I said, "What's the use? I feel like I'm exposing my family. And who knows, I might be sent back to my country and that is going to be really terrible for me." They sent a list of the congressmen who signed a petition to the district attorney to have me paroled—it was denied. If twenty-five congressmen couldn't get me out of prison, could an interview help?

But I finally agreed to talk to the *Times,* and to our surprise the story appeared on the front page. It was the eleventh and I got out the twenty-fourth. They said that the media was very powerful here in this country. More powerful than the Congress? It was scary, and I couldn't understand it.

Everything happens for a purpose and whatever happens is destined. So I got out because it is God that made this possible. At that time I was going through all this suffering, I couldn't see it that way. I thought, "Why me, why doesn't it happen to somebody else?" But now when I look back I know that if I hadn't been through all these things, the case wouldn't have reached the many people that it has today. This is the work of God. And it is truly unbelievable.

ELIE WIESEL

ROMANIA / UNITED STATES

THE POWERLESS

"What I want, what I've hoped for all my life, is that my
past should not become your children's future."

*Elie Wiesel was brought up in a closely knit Jewish community in Sighet,
Transylvania (Romania). When he was fifteen years old, his family was herded
aboard a train and deported by Nazis to the Auschwitz death camp. Wiesel's
mother and younger sister died at Auschwitz—two older sisters survived. Wiesel
and his father were then taken to Buchenwald, where his father also perished.
In his autobiography, Wiesel writes: "Never shall I forget that night, the first
night in camp, which has turned my life into one long night, seven times
cursed and seven times sealed. Never shall I forget the little faces of the chil-
dren, whose bodies I saw turned into wreathes of smoke beneath a silent blue
sky. Never shall I forget those flames which consumed my faith forever. Never
shall I forget that nocturnal silence which deprived me, for all eternity, of the
desire to live. Never shall I forget these things, even if I am condemned to live
as long as God himself. Never." Wiesel has devoted his life to ensuring that the
world does not forget the atrocities of the Nazis, and that they are not repeated.
After the war, Wiesel became a journalist in Paris, ending his silence about his
experiences during the Holocaust with the publication of* Night *in 1958. Translated
into twenty-five languages, with millions of copies in print around the world,* Night
*was a searing account of the Nazi death camps. Wiesel has written over forty
books, and won numerous awards for his writing and advocacy. He served as the
chairman of the President's Commission on the Holocaust, and was the founding
chairman of the U.S. Holocaust Memorial Council. In 1986 he won the Nobel Peace
Prize. Wiesel teaches at Boston University and travels the globe advocating for
human rights and the discussion of ethical issues.*

KERRY KENNEDY Why don't you give in to futility, the sense that there's nothing one person can do in the face of the world's ills? What keeps you going?

DR. WIESEL When you think of the other you realize that something must be done. If I think of myself, I probably wouldn't have done many of these things. But what else can they do to me that they haven't done already? I think of the children today who need our voices, possibly our presence, possibly all our help, but at least our emotions. I think of the minorities—social minorities, ethnic minorities, religious minorities, or health minorities, the victims of AIDS or the victims of Alzheimer's. Then you have no right to say: "Since I cannot do anything. I shouldn't do anything." Camus said in one of his essays (and it's a marvelous thing), that one must imagine Sisyphus happy. Well, I don't imagine Sisyphus was happy, but I imagine the other is unhappy. And because the other is unhappy, I have no right not to diminish his or her unhappiness.

KK How did you, as a child, survive after your father died?

DR. WIESEL A few months after his death came the liberation. In those months, I could have died any day, any moment. There was no will to live. And even if I were to say today I wanted to live to testify, it wouldn't be true.

KK Do you believe God gave you a special gift to bear witness to the atrocities, or was your survival arbitrary?

DR. WIESEL It was arbitrary. I don't want to call it a miracle because it would mean that God performed a miracle for me alone. It means he could have performed more miracles for others who were worthier than I, probably, or at least not worse than I. I don't think so. It was sheer luck. I happened to be there, and there were people standing ahead of me. And just as they left, the gate closed. Every single day I was there and at the last moment, the quota was filled. If I had been five rows ahead, I wouldn't be here.

KK Do you think there's a Divine plan?

DR. WIESEL No, I don't believe it. I don't know how to react to that. I don't accept it. I go on questioning God all my life.

KK Could you talk about the relationship between courage and love in your experience? From where do you derive your sense of hope?

DR. WIESEL It's very simple. Only another person can give me hope, because only another person can take hope away from me. It's not God. It's a person, a human being. Ultimately all this, our relationship with others affects our own destiny, and surely our own moral attitude and destiny (call it love, call it friendship, call it conviction), is related to the other. Whatever it means, this relationship with someone else doesn't mean my relationship with God. All the laws, morality, are about human relations. In my tradition, my life, there was no animosity, no resentment, no fear in my family. It was a source of strength, of faith, with both my mother and father. Maybe I was too young when I left them.

KK Fifteen?

DR. WIESEL Yes. Maybe if I had lived longer with them I would have developed the same problems that children today have with their parents. I don't know. Maybe.

KK How about your own son?

DR. WIESEL He is the center of my life. The center of my center. He's now twenty-six. I am a crazy father. But he doesn't like me to speak about him.

KK You wrote that you were inspired by the Jews' courage and determination to remain committed to their faith, even in the face of evil and absolute powerlessness against it. Talk about your sympathy for the powerless.

DR. WIESEL The powerless, for me, are the most important, the weak and small. For me, that's why in every book of mine, in every novel, there's always a child, always an old man, always a madman. Because they are so neglected by the government and by society. So I give them a shelter. And therefore in my childhood, I liked these Jewish people—and do to this day. Years and years ago, I used to go and spend the whole afternoon with old Yiddish writers, whom nobody read because they were marginalized, to make them feel that somebody reads them.

KK It's important to reach out to people who are marginalized—

DR. WIESEL Yes, to those who feel nothing is worth it, who feel that one is forgotten. And in fact, with human rights abuse, with prisoners, nothing is worse for a prisoner than to feel that he or she is forgotten. Usually the tormentor, the torturer uses that argument to break the prisoner, saying, you know, nobody cares. Nobody cares. This is why, for instance, at a conference in Washington on the

looted artwork and monies, I asked, "Why so late? Why the pressure now?" The main thing is we forget that most of the victims were not rich. The enemy stole our poverty and nobody speaks about it. They speak only about the fortunes and the galleries of those who were rich. But what about the poverty of the poor? At times, when I speak, people listen, but they don't hear.

I owe something to these people who were left behind. We who are so life-oriented, who celebrate youth, who celebrate strength—it's enough to see the commercials on television of only beautiful girls, healthy young men to know that somehow it is a kind of rejection of those who are not young, who are not healthy, who are not rich. Therefore I feel I owe them something. That's also why I write. That's what I write. I've written more than forty books, but very few deal with the war. Why is that? Because I believe in sharing. I learn so I have to share that learning. I have a great passion for learning and for teaching. So many of my books are about learning—from the Bible, from the prophets, from mysticism.

KK How do people become cruel, talk about hate?

DR. WIESEL At least we are in a situation where we realize the consequences. What a hater doesn't understand is that in hating one group, actually he or she hates all groups. Hate is contagious, like a cancer. It goes from one cell to another, one root to another, one person to another, one group to another. If it's not stopped, it can invade the whole country, the whole world. A hater doesn't understand, therefore, that actually, in destroying others, he then destroys himself. Show the outcome, show the ugliness. There is no glory in killing people, and there's no glory in degrading people. There is no glory in persecuting. That's a very important lesson.

KK One taught over and over again. Is there a point in repeating it?

DR. WIESEL I know what you're saying. Of course there is. But to come back to what I said earlier, I know I don't manage to persuade people to change, but I do it anyway. A story: a just man decided he must save humanity. So he chose a city, the most sinful of all cities. Let's say it is Sodom. So he studied. He learned all the art of moving people, changing minds, changing hearts. He came to a man and woman and said, "Don't forget that murder is not good, it is wrong." In the beginning, people gathered around him. It was so strange, somewhat like a circus. They gathered and they listened. He went on and on and on. Days passed. Weeks passed. They stopped listening. After

many years, a child stopped him and said, "What are you doing? Don't you see nobody is listening? Then why do you continue shouting and shouting? Why?" And the man answered the child, "I'll tell you why. In the beginning, I was convinced that if I were to shout loud enough, they would change. Now I know they won't change. But if I shout even louder, it's because I don't want them to change *me*."

KK After all that shouting, do you think you have made a difference?

DR. WIESEL Here and there, maybe. I get letters, at least a hundred a month from children who read my books. I answer every one of them. My first book came out forty-two years ago. I know that some are moved. I know they are.

KK Is it possible to have courage, the determination to make a difference in other people's lives, without suffering yourself?

DR. WIESEL Of course, by studying the suffering of others. And you can do it in an elegant way, a discrete way. If a person suffers, you cannot reduce his or her suffering, but one thing you can attain is that the suffering should not become a source of human nature.

KK What does courage mean to you?

DR. WIESEL You know, for me, courage is the way you define it. I don't even make U-turns. I remain a refugee at heart. I'm afraid of the police. So if I do run into them, I stop and move away. I let my wife handle it. I'm afraid of uniforms. Generals frighten me. It wasn't courageous for me to tell Ronald Reagan not to go to Bitburg, it was just natural. For me, prophets were courageous because they had no constituents, nobody protected them.

KK Wasn't there one very powerful guy watching out for them?

DR. WIESEL Prove it. Do you have a paper identity card, saying, I, the God of the universe, appointed you? It's only the prophet who said, "God sent me." Go and prove it. And nevertheless, because of the personality, because of the words, he spoke through God. And that is courage to speak the truth. Power may be that of a president or a king. Power may be a destroyer of the individual. And power may be something you must address with courage, which is the truth. The problem is how do you find it? . . . What I want, what I've hoped for all my life, is that my past should not become your children's future.

SAMUEL KOFI WOODS

LIBERIA

———————

POLITICAL RIGHTS

"I saw a society yearning to be convinced about the essence
of conviction. I saw a society where there was a vacuum.
I saw a society that required more sacrifice and understanding.
There is a universal contest betweengood and evil.
And I believe that eventually good will triumph over evil.
But good cannot triumph over evil by retreating from
evil—good must confront evil."

*Founding director of the foremost human rights organization in Liberia, the
Catholic Justice and Peace Commission, Sam Woods managed on a shoestring
budget to write and distribute to the international community reliable reports of
abuses in the midst of a brutal civil war. His work led to the liberation of more
than fifty inmates at the Central Prison in Monrovia, many of whom were held
without charges after arbitrary arrests. The human rights radio program he
established broadcasts reports of arrests and extrajudicial executions, and edu-
cated tens of thousands of Liberians about their rights. Woods, his family, and
his staff were under threat from government authorities, and he was forced into
hiding and exile on several occasions. Though many of his colleagues were mur-
dered, Woods returned again and again to his work for justice and peace.
Woods's lifelong commitment to human rights began with student activism lead-
ing to his first arrest in 1981. In 1986, as a member of the National Student
Union, he was forced into hiding, then banned from employment and travel. He
later became director of the YMCA, where he organized citizens. After civil war
broke out in 1989, he fled to Ghana, but returned to work with the Catholic
Church and in 1991, with the support of the courageous Archbishop Michael
Francis, he founded the Justice and Peace Commission. At the height of the war
in 1996, Woods was evacuated by the U.S. embassy, only to return to Liberia a
few months later. In 1998, he was declared an antigovernment activist and was
threatened with sedition for exposing forced child labor in the country. Today
Samuel Kofi Woods continues to fight for justice in the face of terror.*

I was born in a zinc shack in a suburb of Monrovia; a place called Bushrod Island.
It is a place of squalor as a result of migrants from the rural areas coming to seek
job opportunities. I was one of twenty or so children of my father—that alone cre-
ated difficulties—no educational opportunities, no housing. And those conditions
imposed upon me a perception of the world—the perpetual conflict between
good and evil as expressed through political, social, and economic systems.

Liberia comes from the word "Liberty." Our capital city is Monrovia, named after
one of the American presidents, James Monroe. Our first president was Joseph
Jenkins Roberts. I am told he has a monument in Virginia. There is a deep link
between the United States and our country. We have always been an American
protégé. Back in 1821, a group of freed slaves entered Liberia's shores and settled
on a place called Providence Island. Most of those people were mulattos, products
of relationships between slave masters and slaves of the households sent back to
Liberia by a group called the American Colonization Society, a philanthropic
organization in the abolitionist movement. Our constitution, our laws, our way of
life, everything that we attempted was modeled after American society. The hope
of these freed slaves was to create a paradise in Africa for all people seeking free-
dom and liberty. As a result, we've had a number of different settlers in Liberia,
which in fact is part of the problem. Those from North America were considered
skilled politicians, because they were related to the slave master and had the
opportunity to be close to the family. Those from South America were basically

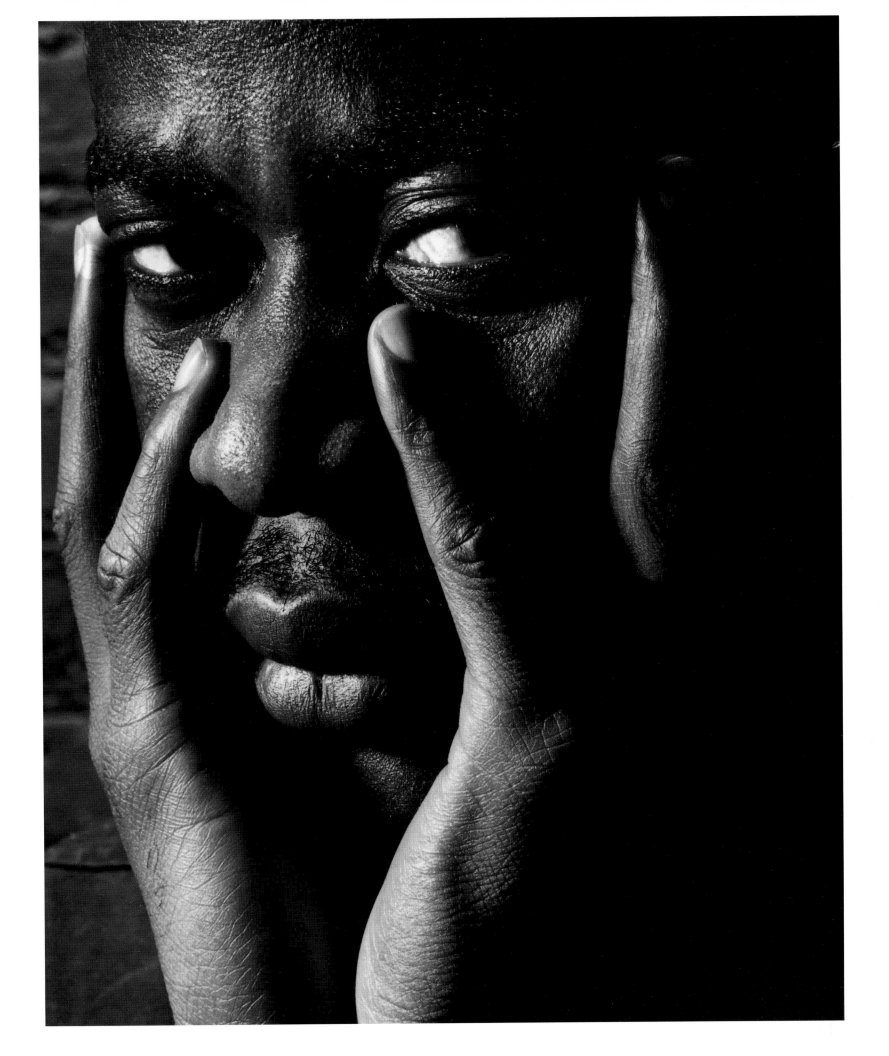

unskilled plantation workers. There were those from the West Indies, from the Congo, and others recaptured by the British warships and American ships when the abolitionist movement was very strong. Within that group there were contests for power while at the same time erecting a political and social system that marginalized the vast majority, who were indigenous. Add this to the racial crisis: if you had lighter skin you were considered superior to those of darker skin, which was reflected in the social relationships and in the political relations.

Not until the 1870s did the first dark-skinned black president emerge in Liberia. His name was Edwin James Roye. After a few years he was overthrown and allegedly murdered. The Liberian crisis has roots in the problem of identity, of those who came into the country, those whom they met in the country, and those who felt marginalized by the legal, political, and social processes. Legitimacy was an issue and the government tried to assert its authority in the rural areas by imposing rule by force. In that process, a lot of violations occurred: a lot of internecine wars where so-called indigenous people were killed. This division grew over the next century.

In 1980 there was a coup in which the president was killed, and a leadership of the so-called indigenous came to power. Those who carried out the coup were from the army. The military in our country was generally illiterate, and for ten brutal years Liberia submerged into violence, chaos, and anarchy.

When the coup occurred I was still in high school, agitating for change. We thought it had finally come. Within a year, we students called for the government to estab-

lish a timetable to return the country to democratic elections—we became the enemy. In time, student leaders were arrested. A campaign of intimidation, harassment, and arrests followed that period. We also began a campaign for academic freedom and social justice. I personally participated in a number of demonstrations between 1981 and 1985, until I was elected student president of the university, and a leader of the national student organization in 1986. I was hunted on many occasions for my position on national issues. I went into hiding many times for my life. In November 1995, the first military invasion of Liberia occurred. It was brutally crushed by the late Samuel K. Doe. An orgy of killings and disappearances ensued. He used the opportunity to pursue his perceived enemies. A group of armed men stormed my home in search of me. I miraculously escaped. When I completed my university degree in economics and management, I was arrested two days after graduation. The government unofficially banned me from employment and travel. I couldn't find a job. I was denied the right to travel. I was virtually a noncitizen. It was difficult to get jobs from the private organizations, because they were all afraid. My documents from the university were censured. I remained in Liberia in spite of repeated calls to leave the country for exile. I totally rejected this idea.

I decided to take the government to court. I felt that my situation should be pursued in the court of law. I consulted many law firms. No one wanted to represent me. Everyone was afraid. I was compelled to enroll at the law school with the intent to defend those who would face a similar predicament in the future. In March of 1986, I got arrested and went to prison. That experience opened my eyes to the horrible situation in the prison. I encountered people who were detained illegally, without charge, without due process, without the right to

"For the past ten years, I have slept in a different place every night, for security reasons. I have been moving from place to place, often sleeping only two hours at a time for well over a decade."

lawyers, with nobody to represent them. I was seriously motivated. When I got out, I went right to law school. By 1989, we had a civil war on our hands, and I was continuously harassed to join one of the many factions because I was a student activist. I refused to believe that violence was the solution.

In November 1991, I met Mike Posner of the Lawyers' Committee for Human Rights. He had just had a discussion with the archbishop, Michael Francis, who is a very committed man, about trying to institutionalize the idea of respect for human rights. He asked me to start the Justice and Peace Office of the archdiocese. I had no road map, no training, just a desk and a typewriter. It was a difficult situation. Liberia was experiencing war, and the concept of human rights was new to the population in general.

Upon reflection, after seven years, I am proud to say that ours has become one of the strongest Catholic Justice and Peace Commissions in Africa and probably internationally. We have been able to provide free legal service to indigents—people who cannot afford legal fees for their defense. We represented journalists and political prisoners. We represented factional leaders who were detained illegally, people who were killed or reported missing. We ran radio programs on human rights and reconciliation. We have now been able to conduct training for journalists on conflict resolution, human rights, and peace building. We have been able to do it for youth, for women's organizations, the police, and the law enforcement institutions. And more than that, we have served as a central link in civil society. Because of that I have suffered a lot of attempts on my life.

In April 1996 during street battles among factions for the city, I was pursued by some of them. My hideout was ransacked twice one night. By God's guidance, I was not in. The American marines subsequently evacuated me from Liberia. A month later, after fighting subsided, I returned—much to the astonishment of many. I had been warned by friends and relatives not to return. For the past ten years, I have slept in a different place every night, for security reasons. I have been moving from place to place, often sleeping only two hours at a time for well over a decade.

It doesn't feel good because it doesn't make you a normal person. But you are propelled because you are doing a good deed. You are trying to sacrifice so that other people can survive, so they see hope and meaning in living. In June 1998, last year, the Liberian Information Ministry declared me an antigovernment agent while on a visit to Europe and I was told by my European friends not to go home. I went back. And strangely enough, when I arrived at the airport, there were citizens waiting for me to work on their cases and to stop any attempt to have me arrested. It was said that the government intended to charge me with sedition for statements that I have made against forced child labor in the southeastern parts of our country. The purported charge was never effected.

In September, government troops reportedly killed some people while attempting to arrest a former warlord. I condemned it and called for an investigation. The statement was issued on October 9, 1998. I had to travel for a three-day meeting in Brussels. While I was away, the police impounded my office vehicle and the driver was flogged. It was reported that I would be

arrested for treason upon my return based on official allegations levied against me by some officials of government. Everyone advised me not to return again. I said I would return and plead my case if there was any. And I went back to Liberia after about a month. When I went home, my mother (my father died a few years ago) was shocked to see me. She couldn't believe I was in the country—she had written me a letter saying not to return, that even if she died, I should not return for her funeral. My office, the entire leadership, wrote me a letter too, also urging me not to return to Liberia. My colleagues, my friends, everyone wrote to advise of the potential danger of my return.

But I saw a society yearning to be convinced about the essence of conviction. I saw a society where there was a vacuum. I saw a society that required more sacrifice and understanding of my conviction. I wasn't frightened because I believe that life means nothing if the pursuit of the truth cannot be achieved. We don't want to be heroes or to be foolish. We want to be normal people. And to be normal people is to pursue the truth, though it's very difficult. There is always a universal contest between good and evil. And I believe that eventually good will triumph over evil. But good cannot triumph over evil by retreating from evil—good must confront evil.

At some point in your life you are confronted with the fear of death. You walk into the corridor of death and you know this moment might be your last. And everything about life leaves your body—yet you survive. It takes time but then life returns and you see how meaningless you are as a human being—how much you can gain by sacrificing for others. I went through this.

I went to prison one time and while in prison one of the guards came to me and threatened my life. He pulled out his gun and put it in my mouth. And he said to me, "Who do you think you are?" It was late and this guy was drunk. I didn't have

clothes on. I was powerless. The gun was already in my mouth. I could have died and each time I reflect on it, it's like—I was gone, gone. My life has always been, at every moment of the day, every moment, a surprise. I walk to different places and people hold my hands and can't believe that I am still living. Because all that was heard about me was that I would be killed in a moment. Society needs people who can help by their sacrifice, by their conviction. Because when you confront evil you provide a moral alternative for society. When a nation is so consumed in evil, it's difficult to see alternatives, unless people of conviction stand up! Sometimes you can even convince other people to join the struggle. You can even convert those of evil heart to good. I have seen that happen.

In July 1997, Charles Taylor was elected president. In November, a former ally who had broken away from him (along with his wife, his cousin, and his bodyguard) was killed on the highway. Everyone was afraid. It happened on a Friday when he disappeared. This man had been one of the most serious critics of the Justice and Peace Commission, of my work, and of the archbishop. And his family could go nowhere else but to me. His children were afraid to say that he was arrested and subsequently killed by agents of the government. They needed a voice. And I became their voice. We filed a case against the government to produce the bodies. We provided evidence that it was the security forces that arrested this man. We launched a sustained international campaign. We insisted on investigation. We went to court. I personally led the defense until President Taylor was forced to admit that the man was actually killed at the hands of the security forces. In this man's death, he was confronted with the truth: in his grave he was confronted with a reality that we have no malice against anyone.

We also sent a signal that we will stand up for anyone's right to due process. And this is what motivated us. This is what keeps us going. We do it with a clear conscience. President Taylor didn't understand why I would take the gov-

> "My daughter had to deny that she was my daughter. A young girl of about eleven had to say, 'I don't know that man.' And you call your son on the phone and he says, 'Don't come home, the police are looking for you.'"

ernment to court. I told him, "Mr. President, I am doing this because I want you and many others to know that human rights are universal. Everyone is entitled to them, no matter how high or low she or he is. And we must be here to ensure that those guarantees exist. So even you, Mr. President, if you are arrested in this country, we will defend you." Taylor couldn't understand it. He offered me a job on the National Human Rights Commission set up by the government. In some cases, I was offered money. I said no. I have said to many people that he has been able to defeat a lot of people because they have sold their souls, they have compromised their convictions.

I became Catholic in 1992. But I have never been a good churchgoing Catholic. I have seen religion as my relationship with God and my fellow man—for me this is religion. And I believe that the divine mystery is how I have been delivered many times. How I have decided to sleep in one place one night, and I stayed until about midnight and decided to change all of a sudden. And then that very night it was attacked. There's no answer. I don't have any special powers that lead me to understand how I survive these things without arms, without violence, without security protection. But I have a deep and abiding confidence and faith in God.

My life has a toll in terms of keeping the family going. At some moments you almost feel that you are sacrificing them in pursuit of your conviction. Sometimes it appears as if you are being very selfish, for these young children have not developed enough to have convictions of their own. The instability in their lives, the movement from one country to another: they were in Ghana and they went back to Liberia and now they are in The Hague. They had to leave Liberia, using different travel documents. My daughter had to deny that she was my daughter. A young girl of about eleven had to say, "I don't know that man." How painful it is for children to

go through this! And you call your son on the phone and he says, "Don't come home, the police are looking for you." My fiancée has been with me for a long time. She suffered a similar fate. She has been a driving force in trying to propel me in what I have to do. She is convinced that it is right. She has motivated me in that direction. She has been helping me to understand where the children are involved. They are growing in understanding and are helping me, too. They have been so molded by this experience that, rightly or wrongly, they too have been consumed by this conviction. There were times that we were not able to be so close because I was always on the run, always away from them. But we have become very close and even closer now. My friends, coworkers, relatives, Liberian people, and the international community have been of great inspiration, too.

You are not motivated because you are a decent person, no. Sometimes it is a calling. And when there is a calling, there is no explanation for what motivates you. There is no explanation for your action, or what propels you. It has to be a vocation. Every one of us has been born into this world with a mission. It has to be fulfilled. Whether I like it or not God intended to use me in society in this way. I hold no malice against anyone. I believe hatred blurs the human sensibilities and diminishes the spirit. Those who hate me, criticize me, and vilify me, purify my conviction and strengthen my courage.

We all live in different societies. We all have to face our different circumstances and challenges. But we must find our common ground. We must work together. And I think we can all make this world a better place. When I attend funeral ceremonies and have to say something, this is my favorite quote by Etienne de Grellet: "I know I shall pass this way but once. And if there is anything I can do, any kindness I show, any good thing I can do, let me do it now, for I shall not pass this way again."

BALTASAR GARZÓN

SPAIN

INTERNATIONAL LAW

"The world's problems seem to be only problems that you watch
on TV, then you go on having dinner, and then you go to sleep …
We cannot say that 'I only take account of what happens in my country,
and whatever is not happening in my country, what happens
beyond the borders does not affect me.'"

Judge Baltasar Garzón has made an illustrious career taking on powerful enemies, specializing in cases against government corruption, organized crime, terrorists, state antiterrorism units, and drug lords. In 1973 Augusto Pinochet led a bloody military coup against democratically elected socialist President Salvador Allende of Chile. Pinochet's seventeen-year reign of terror was characterized by human rights violations on a truly massive scale, including widespread disappearances and extrajudicial killings. In October 1998, Garzón made history when he seized the opportunity to indict Pinochet in Europe, when the general visited London. Garzón carefully and boldly pursued the general legally, despite furious pressures both abroad and at home. While Pinochet was eventually released to Chile because of failing health, following the decision of U.K. Home Secretary, Jack Straw, Garzón's campaign for justice had set a precedent that heads of state may now be tried for crimes such as torture and genocide, that no person is above the law, and that sovereign immunity does not extend to crimes against humanity. Other countries quickly followed Garzón's lead, and there are currently extradition requests against Pinochet with other countries (Belgium, France, and Switzerland also submitted extradition requests) while the former dictator of Chad is now being held for trial in Senegal. Dictators across the globe have canceled trips abroad for fear of the long arm of justice. Garzón's work has given hope to thousands of victims of Pinochet's regime, and of the military juntas in Argentina (1976–1983), and, indeed, to all oth-

ers who suffered at the hands of dictators around the world. Most importantly, it reminds us that when a government persecutes its own people, that betrayal is of universal concern. With the Pinochet case pending, Judge Garzón is conducting enquiries against military officials in Argentina and others have taken his lead, bringing charges against former General Rios Montt in Guatemala. The world will never again be quite so safe for dictators.

The combination of the responsibility I was taught in the seminary, which was a responsibility learned through discipline, and the work I was taught at home, through freedom, was a wonderful combination. My family is Catholic, and they thought I was too naughty to be a priest. But I was stubborn and went to the seminary anyway from eleven to seventeen. I wanted to be a missionary, and to work for social justice, for the benefit of other people, but after a time, I realized that I might not be able to cope with all the restrictions of being a priest. So I opted to study law instead. Although my family was a well-to-do middle-class family and I didn't have to work to study, I thought I should work as well so that all my brothers and sisters could study, too. So I worked in construction, waited tables, and pumped gas. My father was diabetic and also worked at the gas station. I would work nights so he could go home—he had already had one diabetic attack. I studied at night and in the morning I would go to the law uni-

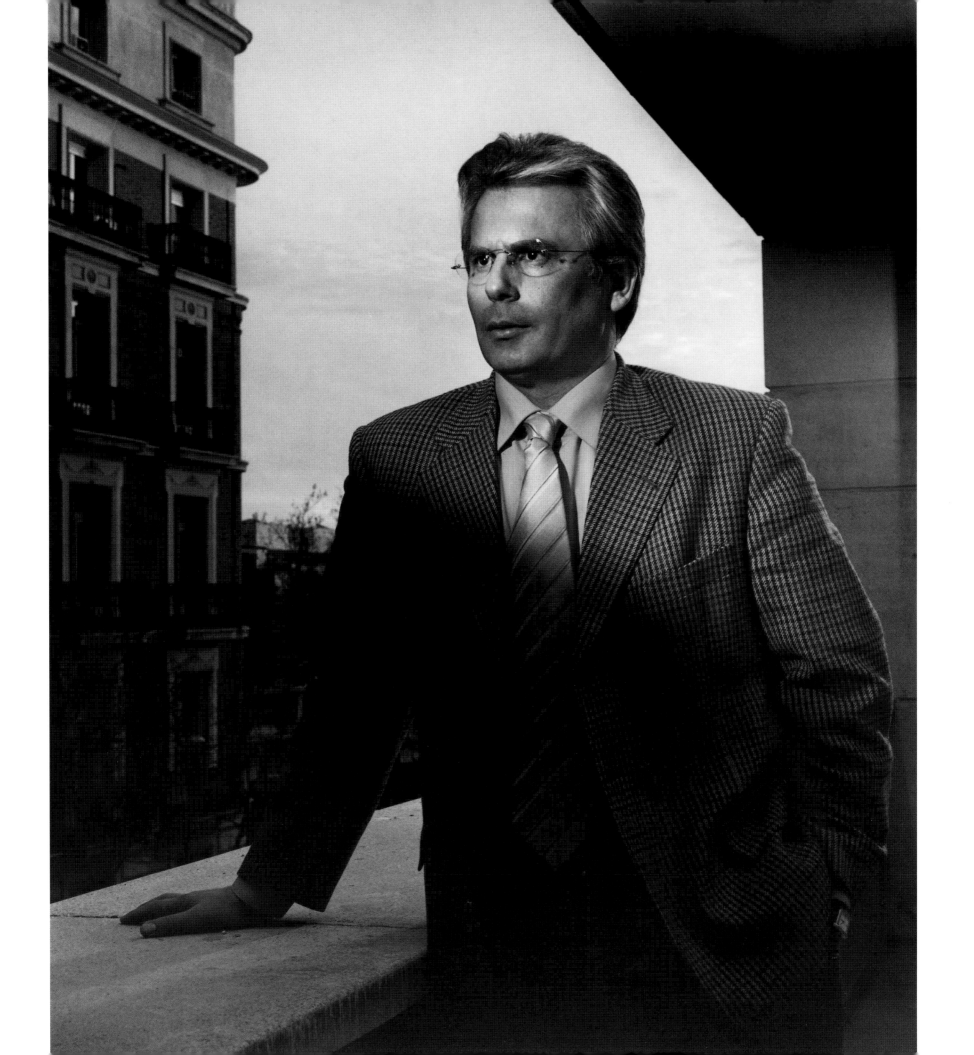

versity, and in the afternoon I would sleep a bit. Of course, working was also for me a way for seeing my girlfriend. (The girlfriend I had at that time is the woman I'm married to now.) I wasn't sleeping much. Actually I do not sleep much now either (three hours a day), so I have time to do more things.

To become a judge in Spain, you have to study five years of law. And then you have to take a special examination, where you're tested on 438 topics, followed by judge's school. On December 1, 1980, just after my twenty-fourth birthday, I became a judge. I've been in the national court for twelve years now. I deal with organized crime, terrorism, drug trafficking, extraditions, counterfeiting, corruption, crimes committed outside Spain, but where the Spanish are competent to try them—such as genocide and torture, as in the cases of Argentina and Chile—crimes committed against international organisms and national organisms such as the king or the government. I was also a politician for a year, in 1993, and I served as a head of The National Program Against Illicit Drug Trade.

My work is dangerous mostly in matters of terrorism, and also counterterrorism, meaning state terrorism, or death squads, against organized terrorism. I've had to order the vice minister of the Interior taken into custody, along with the heads of the antiterrorist police. I've also prosecuted cases against the leaders of the antidrug police, of the civil police, because there were many cases of bribery. My work regarding Spanish problems is mostly dedicated to cases of terrorism, political terrorism, pro-independence terrorist acts, Islamic terrorism. But mostly, ETA terrorism, which is the Basque organization from northern Spain.

I have received many death threats, but you get used to it. Threats have never changed my mind. Threats mainly come when I investigate cases of drug trafficking, from Colombia or Turkey, with heroin. One time when I felt a great deal of pressure was when I opened up the cases of counterterrorism, death squads. People broke into my house and left a banana peel on top of my bed. At the time, accusations appeared charging me with misuse of government funds. They had all these receipts, some real, others bogus. Luckily I was able to prove the accusations were false. (Ever since then I keep meticulous records of every single thing I purchase.) But such accusations continued until I went to the attorney general and asked that he investigate me, so everything would be clear. That's when the banana appeared. The banana peel was a sign to me that they could do whatever they wanted with my family; a Mafia-style warning. If they had access to the most intimate room in my home, my bedroom, that meant they could go anywhere undetected. On that Saturday, our family was out of the house, but our home is under surveillance by television cameras and a policeman twenty-four hours a day. A week later, a journalist phoned me. Since nothing had happened, nor had I said anything, or denounced anything, somebody had phoned this journalist and told the journalist the story that somebody broke into our home and left a banana peel on the bed. So the journalist phones me and says, "Did you see a banana peel on top of your bed a week ago?" I answered, "No, what are you talking about? I haven't seen anything." That evening, while having dinner with my wife and kids, I said to my wife, "It's such nonsense, this journalist pretends a week ago there was a banana peel on our bed." And my wife became pale. I said, "What's wrong, aren't you feeling well?" And she said that on that same Saturday, when she and her sister came

> "Politicians keep writing international conventions. But then when the time comes to apply one of those laws that have been ratified, they say 'the problem is, economic stability, or political stability, could be threatened by the application of this rule.' So what's the point?"

back from shopping, they found this banana peel on the bed. But they didn't give any importance to it, because they thought one of the kids had left it. They threw it in the garbage and thought that was it. So we realized it was true, that they had broken in, they had broken the key lock of the house, the cameras were broken, they were not working, and yes, we were frightened.

Despite the pressures, it is very clear to me that I have a job to do. The rest is peripheral. I can't allow these things to change my life. I am voluntarily where I am. These problems are included in the job description. I'm not cavalier. I take precautions. I'm aware there's a risk. I do my best to stay at home as much as possible. I don't go to public places very often. When I go with one of my kids to the cinema, I never follow the same route. So I have a measures that are almost ingrained after twelve years and I do my best so that this does not affect me. I'm lucky because my wife has always supported me. And even when I have had doubts about myself, it has been my wife who has stopped me and said, "You can't have doubts about anything, you can't be weak, you must go on." We have both talked a lot to the kids about this commitment that we feel, that our life is this way, and that there are risks, but we have to take them. When I abandoned politics as an independent deputy, to return to being a judge, my eldest daughter came and embraced me, saying, "Daddy, I support you and I like you more as a judge." One of the things we've made clear to our children—as I was taught as a kid in my family—is that this is a job, that somebody has to do this job, and that I have decided to take this job with total freedom and absolute responsibility. I explain that I could earn much more somewhere else, but money isn't everything. This job is something that society needs, and I have to do it. For me, social commitment is very important, almost vital.

All my education stressed that in good times or in bad times you always have to face problems, not run away from them. Sometimes you can be wrong, you can make mistakes. But I accept the responsibilities of my actions. Because what you cannot do is what many people do, you cannot pretend that these problems are not your problems. I believe that a judge must live in society, must deal with the problems in society, and must deal directly with the problems of society, must face them. We have good, strong laws both domestic and international. Yet nobody seems to apply them. They say, "Well, this is something that is maybe different from what I'm used to." The world's problems seem to be only problems that you watch on TV, then you keep on having dinner, and then you go to sleep. This does not mean that I feel I am Mother Teresa—I wish I were! But it does mean that if a case comes to me, I must apply all the laws and extend the application of law to benefit the case. We cannot say that, "I only take account of what happens in my country, and what happens beyond the borders does not affect me." That would be a nineteenth-century approach. The key issue is that the victims, those massacred as a result of those crimes against humanity, need protection.

Argentina and Chile are situations where international laws that have been ratified by Spain are being applied. These are cases like those of Guatemala, Rwanda, Yugoslavia, where the fact that those crimes happened inside those countries does not mean they can only be judged inside those countries. Mass violation of international human rights must be universally persecuted. International human rights have universal jurisdiction. The issue is whether you want to apply international law or not—you can either apply the law or shy away from it.

It has always amazed me that politicians keep writing international conventions. But then when the time comes to apply one of those laws that have been ratified, they say "the problem is, economic stability, or political stability, could be threatened by the application of this rule." So what's the point? Do we ratify the laws in order to apply them or not? What is amazing is that there are no inconveniences when we're talking about violating human rights. Yet, there are many incoveniences when we talk about judges, or taking people to trial who have committed human rights violations. We must respect the law and the autonomy of judges and politicians who complain that judicial action will affect the stability of a country, but who do not respect the rule of the law. If those in political power would support transparency, then democracy, political systems, and also the economy would be fortified. But they are fearful of being called into court, so they do not want an international judiciary with real power. That's why the United States, for example, will not ratify the International Criminal Court. World leaders should have no fear of accepting jurisdiction for a court which will only prosecute crimes against humanity or other international crimes. They have no problem accepting economic globalization, or the free circulation of people among European states. Europe has no problem in accepting a common law restriction to immigration. They acknowledge some crimes are transnational and that they affect humanity in general. So what is the problem with judging these crimes? We laud ourselves for setting up norms and structures and then we claim these laws do not apply to us. Since Nuremberg we have gone out of our way not to apply the laws. In Cambodia they were not applied because of China. In South America they were not applied because of the United States, and in South Africa they were not applied because the United Kingdom. Now, finally, a new consciousness is being created in the wake of awful atrocities in Bosnia and Rwanda. The denunciations and activities of non-governmental organizations like Amnesty International and Human Rights Watch have contributed to this consciousness. So when cases dealing with these issues have come before people like me, we have thought we have the means, why not use them? An independent judiciary can take advantage of the legal instruments, and develop them, and thereby help society.

International principles must be applied. It is possible to hold perpetrators of mass human rights violations accountable. The president of Chad has been detained in Senegal for torture. Italy was opening investigations for the crimes committed when the attempt to murder Bernardo Leighton occurred in Rome. There have been spectacular advances, like the decision of the House of Lords that Pinochet is not immune from prosecution. The international community has now accepted, thanks to this case in England, that the principle of universal jurisdiction is valid. Four years ago, when I started these cases, jurisdiction was a formidable obstacle. We were actually creating that path. Now in universities and international forums people recognize that we can use all these laws that had been passed but never used before. Now we know we can use them. When interpreting a law, a judge can develop the law or be conservative about it. We have been able to open up progressive interpretations of the law. When you face one of these problems what you must do is see beyond the end of your nose. You must determine who the victims are and how international law can be used to hold the perpetrators responsible, and protect the victims efficiently.

When this is all in the history books, the way such cases were conducted will be standard practice for applying the principle of universal justice and prosecuting crimes of genocide, terrorism, torture, or forced disappearances. It will simply be an issue of victims, perpetrators, and application of the law. Today

> "Political leaders claim to be concerned with upholding the law and meanwhile they insist on compromise when it comes to human rights."

some people say that it is a political and economic problem and that relationships between one country and another may be harmed. But in very few years everybody will say what this is; it is evident that it was only an issue of law.

Political leaders claim to be concerned with upholding the law and meanwhile they insist on compromise when it comes to human rights. So it seems it's always the crazy mothers of the Plaza de Mayo, or the crazy students of Tiananmen, or women in Morocco or in Jordan who ask for equal rights with men, or women in Iran who don't want their faces covered, who are responsible for advancing human rights. The leaders forget their own responsibilities very quickly, along with the victims.

Being a judge is not a calling; its something much simpler. The only thing is that you just have to do your job right, that's it. If a case comes to you, you can ask some simple questions and apply the law—and you are doing legally what a judge must do. But of course you know that if you start asking more questions, then the case gets complicated. So you will not be able to go home early. You will have to stay late. But I believe that's actually the difference: you must ask more questions until you get to all single points in a case, and not only to the minimum legal points of the case, which is another way of seeing this job.

Courage means to be honest with yourself and to be able to overcome the fear that you have. When you're doing this work, you have so many responsibilities it is hard for outsiders to understand how you can manage with such a weak infrastructure. You have so many things to do that actually you have no time to think of courage. You just have to do those things. Perhaps the biggest fear is the fear of making mistakes. Or of damaging people. But that is part of the job of a judge and you have to make decisions. And sometimes decisions are very, very hard to make. I always suffer when I have to send anybody to prison because I am always aware that I can be mistaken.

Some people may think that I am a very tough person but I am actually not. Sometimes it is very hard to continue when you are convinced that somebody is guilty but the legal system has not been able to prove guilt, thus he is innocent. It is most difficult to maintain this stance when one of your colleagues is murdered. The next day you have to go to the office and keep on working. And then you have to have the author of the murder in front of you. And if there are not enough legal proofs to sentence him, you have to accepted it, and release him. But then, with the same rigor, when the legal proof exists, you have to condemn him.

There was a Sicilian judge, Giovanni Falcone, who for me was the personification of judicial independence. He was assassinated in 1992 for his commitment to justice. It was then that the Italian government realized that they had to fight the Mafia. When you see people of such courage, you understand how important the rule of law is. You have to give something to society in exchange for that which society gives to you. This is a way of thinking, a life philosophy. It is very demanding and difficult, too.

Before dying, my father said, "Son, you must have broad shoulders." Our family has broad shoulders. You always have space to bear a bit more load. But you have to make sure that other people don't notice it. What does this mean? You always have to have your tie on. You have to go into the office smiling and then if you want to cry, you have to wait until you go home. That's what you have to do. Sometimes, it is difficult to bear.

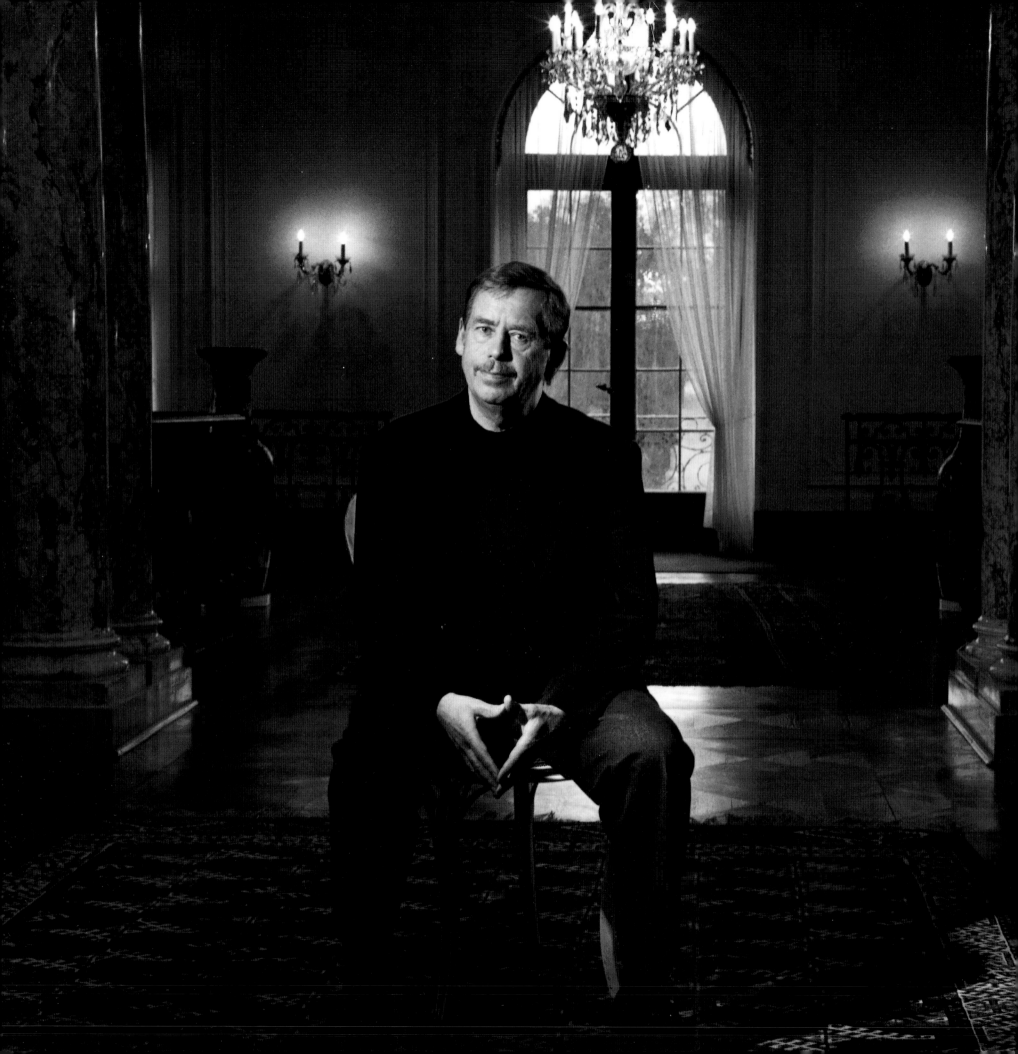

VACLAV HAVEL

CZECH REPUBLIC

FREE EXPRESSION

"You don't want to become involved with the dirt that is around you and one day, all of a sudden you wake up and realize that you are a dissident, that you are a human rights activist."

Vaclav Havel is one of democracy's most principled voices. Armed with a moral compass that points true north, and an eloquence unsurpassed in the political arena, Havel speaks with the honesty of a dissident from the halls of the presidential palace in Prague. Czechoslovakia's leading playwright and a perennial victim of state repression under Communist rule, he is cele-brated for his absurdist plays including The Garden Party, The Increased Difficulty of Concentration, The Memorandum, Largo Desolato, *and* Temptation. *Havel, who was born in 1936, was a founder of Charter 77, a human rights and democracy organization that challenged the Soviet takeover. He wrote compelling texts on repression and dissent, and his 1978 work,* The Power of the Powerless, *is one of the best political essays ever written. In 1979, in retaliation for his human rights activism, Havel was sen-tenced to four and a half years at hard labor, during which he wrote* Letters to Olga. *As chief spokesperson of Civic Forum, which he cofounded in 1989, Havel's leadership, political savvy, and moral persuasion helped bring Communism to its knees, and enabled him to negotiate a peaceful transition to democracy. Out of the ashes of Soviet control emerged a new state, based on free expression, political participation, civil society, and commit-ment to the rule of law. In 1989, Havel was elected the first non-Communist president of Czechoslovakia in over forty years.*

ON LEADERSHIP AND COURAGE

The crisis of authority is one of the causes for all the atrocities that we are seeing in the world today. The post-Communist world presented a chance for new moral leaders, because at that time of transition in these countries there were no profes-sional or career politicians. This gave intellectuals an opportunity to enter into poli-

tics, and, by entering, to introduce a new spirit into the political process. But gradually people were suppressed—the mill ground them down—and much of that opportunity was lost. There are certain leaders that one can respect, and I do certainly respect, leaders like the Dalai Lama. I appreciate the fact that, although very often they have no hope, not even a glimpse of success on the horizon, they are still ready to sacrifice their lives, to sacrifice their freedom. They are ready to assume responsibility for the world, or at least for the part of the world they live in. I have always respected these people and appreciated what they do. Courage in the public sphere means that one is to go against majority opinion (at the same time risking losing one's position) in the name of the truth. And I have always strongly admired historic personalities who have been capable of doing exactly this.

ON BECOMING A DISSIDENT AND THE DIVINE

Becoming a dissident is not something that happens overnight. You do not simply decide to become one. It is a long chain of steps and acts. And very often during this process, you do not really reflect upon what is happening. You just know that you want to avoid any debt that would put a stain on your life. You don't want to become involved with the dirt that is around you and one day, all of a sudden you wake up and realize that you are a dissident, that you are a human rights activist. With me the story was rather similar. It was only much later, while I was in prison, that I started reflecting on the process and why I had done what I had done. There must be some, call it "transcendental," source of energy that helps you overcome all these sacrifices. Now some people may disagree with this idea of a transcendental source, but I feel it. While I was in prison, I often thought about why a man decides to remain decent, a man of integrity, even in situations when he or she is on his own, when nobody knows your actions and thoughts—except you yourself. Even in these situations, a man can feel bad, can have a bad conscience, can feel remorse. Why is this? How is it possible? And my answer to this is that there must be another eye looking on—that it's not just the people surrounding you that make the difference. I have no evidence of the existence of such an eye, but am drawing on the archetypal certainty of such an existence.

ON FEAR

I have experienced, and still experience, a whole spectrum of fears. Some of my fears have had greater intensity than the fears of the others. But my efforts to overcome these fears have also been perhaps more intense. The major fear is

"There must be some, call it 'transcendental,' source of energy that helps you overcome all these sacrifices. Now some people may disagree with this idea of a transcendental source, but I feel it."

imagining I might fail somebody, that I might let somebody down and then have a very bad conscience about it. For example, when I am thrown into an unknown Latin American country, I could be asked to speak, to address the parliament. I give a talk, I try to be flowery, impressive. I deliver. But once this is over, I always turn to somebody and say, "What was it like? Was it good? Did I deliver?" I have always felt this uncertainty; I have always been a person suffering from stage fright, from fear. Fear is with me, but I act in spite of it.

ON HUMOR

When a man or woman is ready to sacrifice everything for very serious matters, what happens in the end is that such a person takes himself or herself extremely seriously. His or her face then becomes very rigid, almost inhuman, and such a person becomes a monument. And as you know, monuments are made of stone or of plaster and it is very difficult for monuments to move. Their movements are clumsy. If one wishes to retain humanity, to stay human, it is important that you keep a certain distance. To keep this distance you need to be able to see that there is a certain element of absurdity, even ridicule, in one's deeds.

ON HOPE

Often people confuse hope with prognostics. Prognostics is the science of studying whatever happens around you in the world. With it either you will make a positive prognosis (because you are an optimist) or a negative prognosis (which would have a pessimistic impact on the people around you). But it is very important to differentiate. Hope is not prognosis. Hope is something that I see as the state of the spirit. If life had no sense, then there would be no hope, because the very sense of life, the meaning of life, is closely linked with hope.

ON FREEDOM AND RESPONSIBILITY

Freedom without responsibility is perhaps something that is a dream of almost everybody to do whatever you want to do and yet not to assume any responsibility for what you did. But of course, that would be a utopian life. And also, life without any responsibility would not make sense. So I think the value of freedom is linked with responsibility. And if freedom has no such responsibility associated with it, then it loses content, it loses sense, and it also loses weight.

JOSÉ ZALAQUETT

CHILE

POLITICAL RIGHTS, TRUTH, AND RECONCILIATION

"I no longer took notice of fear, much in the way
a surgeon becomes accustomed to the sight of blood."

José Zalaquett began his career as a founder of the modern human rights movement worldwide, campaigning while a law student for Salvador Allende. Upon Allende's election as president of Chile in 1970, Zalaquett served a two-year term as cabinet minister, which he left for a post at the university. Shortly thereafter in 1973, General Augusto Pinochet launched a bloody coup which forcibly ousted the elected government. Thousands were arrested, imprisoned, tortured, and killed. Many more went into exile. In the aftermath, the Catholic Church, one of the only entities remaining with a degree of political space, approached Zalaquett to create a Committee for Peace to help the victims of the coup. Under Zalaquett's leadership, the committee, later known as the Vicaria de la Solidaridad, was the foremost human rights organization operating in Chile throughout the dictatorship, from 1973 to 1990. The Vicaria defended hundreds of detainees and helped family members of the disappeared file habeas corpus documents demanding the whereabouts of their loved ones. In retaliation for his work, Zalaquett was imprisoned in 1975 and 1976, and expelled in 1976. In exile he continued his human rights work at Amnesty International, serving as chair of its executive committee. Ten years later, he returned to Chile. In 1990 Zalaquett was named as a member of the National Commission on Truth and Reconciliation, and with his nine colleagues wrote a report on the fate of the victims of the Pinochet regime. As such, he became an internationally respected authority on truth and reconciliation, and has since advised similar commissions on three continents.

In the 1970s, I was an official in the Allende government. After a couple of years, I left politics and went back to the university, serving as deputy vice president for academic affairs. Then the coup occurred. The Palace of Government, a symbol of our freedom, was bombed. It was a devastating blow, a strategic move to take power and to paralyze the opposition.

The military immediately began to round up people. Because the prisons were not large enough to accommodate the many thousands taken prisoner, they were put into a soccer stadium. Congress was dissolved and the military burned the electoral rolls, forbade political parties and trade unions, and established a curfew, which lasted for twelve years.

There was nothing left in this barren institutional land in 1973 except for the government and the churches. Those who knew that I was a lawyer approached me and asked for my help in finding their imprisoned or disappeared relatives. Learning that the churches were organizing to provide some relief, I joined them. When I say "churches," I am referring to the Catholic Church (the largest in any Latin country), five Protestant denominations, and the rabbi of the Jewish community in Chile.

They organized the Committee for Peace that would later be transformed into the Vicariate of Solidarity, a human rights organization which became interna-

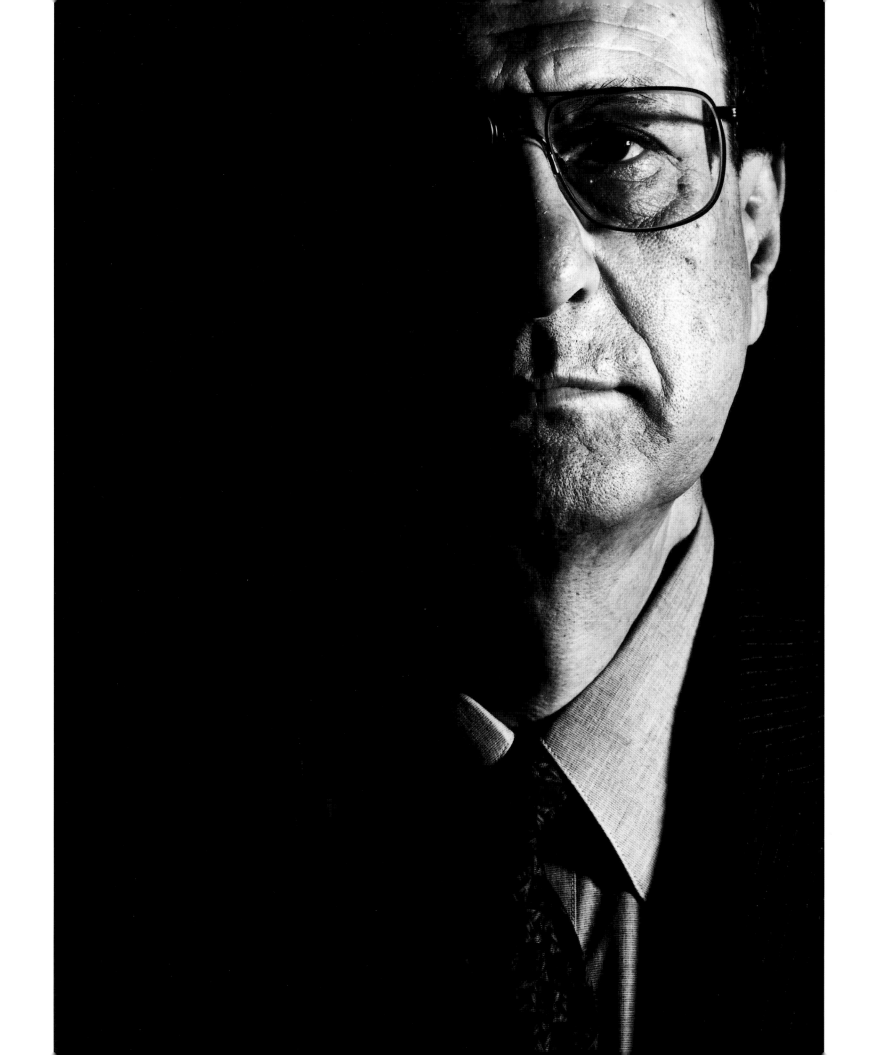

tionally famous. My first task was to go around the country—a country as long as the U.S. is wide—checking out the situation, visiting prisoners, and trying to establish branches of the nascent committee.

At that time, the Catholic Church was well respected by the military because Chile is a Catholic country. I carried credentials issued by Cardinal Silva, from Santiago. This opened many doors. Local bishops would receive me and put me in contact with the local military commander. Because of this, I was able to visit several prisons and camps.

When I returned to Santiago, I was asked to form a proper legal department to defend the prisoners. We soon had a staff of more than seventy people and began to establish legal strategies, mainly habeas corpus writs. Although we lost virtually every case, we knew that we had to continue. The process itself was important.

Under normal circumstances, a case can be won if the law is on your side and the lawyer is competent enough. This was not the case in Chile. The Supreme Court proved itself to be fearful of, and subservient to, the military junta from the outset. The junta kept it in place, to be able to claim that it was respecting the independence of the judiciary. Yet it was obvious that legal proceedings were merely cosmetic: the courts would invariably rule in favor of the government.

Despite this, we could still use such legal proceedings to help people and to denounce what was going on. For the families of victims it was important to have a lawyer by their side. Also, through the legal process we could second-guess the secret police's intentions. If they told the courts they had never arrested the person in question, we knew they probably intended to make him dissapear and we had to mobilize all the national and international pressure we could muster to try to stop that. The legal ritual also helped build a historical record. Since we kept copies of all transcripts, we had thousands of official files which we photocopied and sent to the United Nations, the OAS, or Amnesty International. Foreign correspondents from *The New York Times*, *The Washington Post*, or *Le Monde* could examine them. In addition, we had recorded eyewitness accounts that proved to have tremendous documentary value. Seventeen years later, this information served as the cornerstone of the Truth Commission's work.

However, our work did not go unnoticed by the military junta. By the end of the seventeen-year period, more than fifty of us had spent time in prison. One committee worker was killed and many more were exiled.

Yet compared to the fate suffered by others, we faced lesser risks. The secret police followed a certain rationale. Those who posed the greatest threat to the regime were the well-trained and ideologically conscientious left-wing militants; they were marked for death or torture. Their lawyers, instead, could be subject to imprisonment or exile. Had I been at greater risk, I don't know if I would have proceeded as I did. I had a commitment to justice but I do not claim to have innate bravery. Rather, I'm very normal and try to shun danger when possible. In the end, whatever courage I displayed was an exercise in learning how to live with fears. After a while, I no longer took notice of the fear, much in the way a surgeon becomes accustomed to the sight of blood. The important thing

"The important thing is not to let your heart grow cold while keeping your head cool. If you let your head become as impassioned as your heart, you run unnecessary risks and do not serve people well."

is not to let your heart grow cold while keeping your head cool. If you let your head become as impassioned as your heart, you run unnecessary risks and do not serve people well. Finding this balance requires a good deal of time.

The authorities arrested several of us in 1975, although they never charged us. The junta then asked Cardinal Raúl Silva Henríquez to disband the Peace Committee, and when the cardinal complied, those of us who had been arrested were released. Then Cardinal Silva reorganized our group under the Vicariate of Solidarity. I went back to work in this new office and was arrested again. I was taken directly from prison to the airport where the guards even buckled my seat belt and sent me into exile.

Where did my impulse for this come from, you ask. Since I can remember, I have rebelled against the misuse of power, as have others in my family. Although my father and mother were both loving and just people, in their time they did not have to wrestle with situations of political emergency. However, all four of my sisters have. One was in Lebanon serving as a war nurse, two married Nicaraguans and fought against Somoza, and the youngest was part of the Chilean underground working to oppose Pinochet. After her husband was killed, this sister spent a year in prison. I hold in the highest moral regard those who do not conform to arbitrary power and are always humane and never cruel. Mean-spirited people are obsequious with power and are tough with the meek.

Of the seventeen years of military rule, I spent ten in exile. In 1986, the ban was lifted and I was allowed to return to Chile. Before this time, my passport bore

the letter "L," indicating that I was to be arrested if caught trying to reenter the country and sent back to the place from where I had come.

When I returned to Chile, I continued to work on questions of political transitions and past human rights violations. I had started addressing these issues in 1984, when I visited Argentina on behalf of Amnesty International. I talked to President Alfonsín and his government, and met with the mothers of the disappeared and with the Truth Commission that President Alfonsín had set up to account for their fate. I was in Uruguay the following year, to talk to President Sanguinetti, lawyers, judges, and relatives of the victims. In 1987, I went to Uganda and in 1988 to the Philippines. When, in 1990, there was a change of government in Chile, President Aylwin asked for my advice. He established a Truth Commission and I became a member of it. The commission produced a voluminous report in 1991, accounting for nearly three thousand people killed and disappeared. I have continued to work in this field, writing, teaching, and advising human rights organizations or governments on questions of political transition and human rights.

We call democratic transition a process by which the country attempts to build a just political system after a period of civil war or dictatorship which has left a legacy of war crimes, human rights violations, and deep divisions in society. Every step of this transitional process takes on symbolic value and has lasting effects. Truth is important. Justice is important. Forgiveness is, too—but not blanket impunity.

I believe that there are two levels of forgiveness. On the individual level, a person may forgive his offender. This is a very intimate process in which govern-

mental policies can not intervene. Personal reconciliation or forgiveness is a heart-to-heart matter. Community clemency, which refers to laws of amnesty or pardons, is altogether different.

Community forgiveness is legitimate when it contributes to reaffirm the community laws and values which have been broken or violated. This is the rationale behind the doctrine of forgiveness in all major religions—Christian, Jewish, Islamic. They place a higher value on pardon than on punishment. But community pardon requires that some steps be taken. In the Christian tradition, absolution is not granted unless there is an admission of wrongdoing. The individual must atone for sins that have been committed and make reparations. In this manner, it is as if the sinner is putting back the brick he took from the moral building. This reaffirms the community values and the process of moral reconstruction and the culprit may be forgiven. But if the individual refuses to acknowledge his guilt, then punishment is necessary to subdue his stubborness. On the contrary, a blanket measure of amnesty, without acknowledgment, only serves to validate human rights abuses. There is no truth, no repentance—just cynicism.

South Africa helps to demonstrate this point. After several decades of apartheid, involving countless politicians, judges, or policemen, tens of thousands of people were potentially liable for prosecution. Prosecution of this magnitude was impossible and it could jeopardize the goal of the democratic transition, that is, to achieve a united, reconciled society. However, if nothing was done, the transition would have condoned the past and insulted the memory of all who suffered for

so long. Given this situation, South Africa chose to grant amnesty to those who disclosed the truth about the crimes and their involvement in them.

Concerning the acknowledgment of misdeeds, it's not possible to peer into the hearts of people and discover whether their contrition is genuine or whether it is calculated. This does not really matter. Acknowledgment is not a subjective question, but rather a civic ritual. The important thing is the external, solemn manifestation of acknowledgment. A record is thus established which is left in the annals of the nation to enlighten future generations. This is the meaning of forgiveness at the social level. At the personal level, of course, it is a very intimate affair.

As a member of the Truth Commission, I went throughout the country interviewing thousands of people. Although I rarely heard a call for sheer, absolute vengeance, many people demanded that their violators suffer the full weight of the law. This was fair enough. The commission consistently heard that Chile should never again allow these abuses against humanity to happen. Many people said that they didn't want revenge or to create a situation in which more children would be orphaned. Most wanted to know who to forgive. Anonymous forgiveness, you see, is not very human. The victim needs to know who committed the crime so that he or she may forgive and live in peace.

For me, courage signifies the determination to act according to your values. It is a daily exercise in addressing the natural trepidation that we have to confront and to learn how to live with fear. In the Peace Committee we had shared a

> "I was taken directly from prison to the airport where the guards even buckled my seat belt and sent me into exile."

sense of togetherness, we supported and encouraged each other. Heroism is something different. I reserve this word for those who brave any danger in the pursuit of their ideals, even without the support of others.

I cannot claim to have suffered inordinately in prison. Rather, I suffered mostly while in exile because I was only able to see my two daughters twice a year. My daughters understood that despite my circumstances, they remained the most important part of my life. At one point or another, both have told me they are very proud of me. This is very important for me. However, at times I wished that I would have done things differently, knowing what I now do about the reality and consequences of being exiled. I am still torn apart and wish that I could have been more a part of their early lives. Sometimes I feel I should have spared myself for them rather than run the risks I faced. But then again, I could not have done otherwise. This has been an emotionally wrenching question for me, one that has been a constant until this very moment.

After returning to democracy, Chile had to face the question of moral reconstruction. Although transition was difficult, the country did not have to build democracy from scratch. Rather, it could rely on traditions of justice and the rule of law that had been established in the past.

The Truth Commission was able to accomplish a great deal. By accounting for the disappearances and deaths of nearly three thousand people, it exposed the Chilean system of human rights abuse and established a global truth. It is no longer possible to deny that these people were unjustly killed. This is very important. Justice has been done in a number of cases involving key people. Compensation was provided and society acknowledged the truth.

Yet there are some unfinished tasks. They are now being addressed by a government-sponsored series of roundtable discussions involving eighteen people. Participants include high-level military officials, human rights lawyers, religious leaders, and community leaders. The debates have been highly publicized in the press and have been closely followed by civil society as a whole. This initiative was made possible after the arrest of Pinochet in London. Two main issues are being dealt with: how to find the remains or account for the fate of nearly one thousand disappeared prisoners; and how to get the armed forces to publicly acknowledge the wrongdoings of the military regime, so as to prevent the abuses from ever happening again.

Chile has yet to complete its transition to democracy. Nonetheless, the country has learned something in the process, namely that everybody is endowed with fundamental human rights which override all differences. Politics remain contentious. However, the sharp polarization that characterized the old system has dissipated. There is no longer a sense that individuals, whether they be suspected subversives or members of the bourgeois class, can be eliminated to serve a greater purpose or ideal. It has taken Chile many years to come to this consensus. The memories of human rights abuse are still vivid and it often seems that old hatreds will be reignited, but a fundamental degree of political and social tolerance has begun, at least, to prevail.

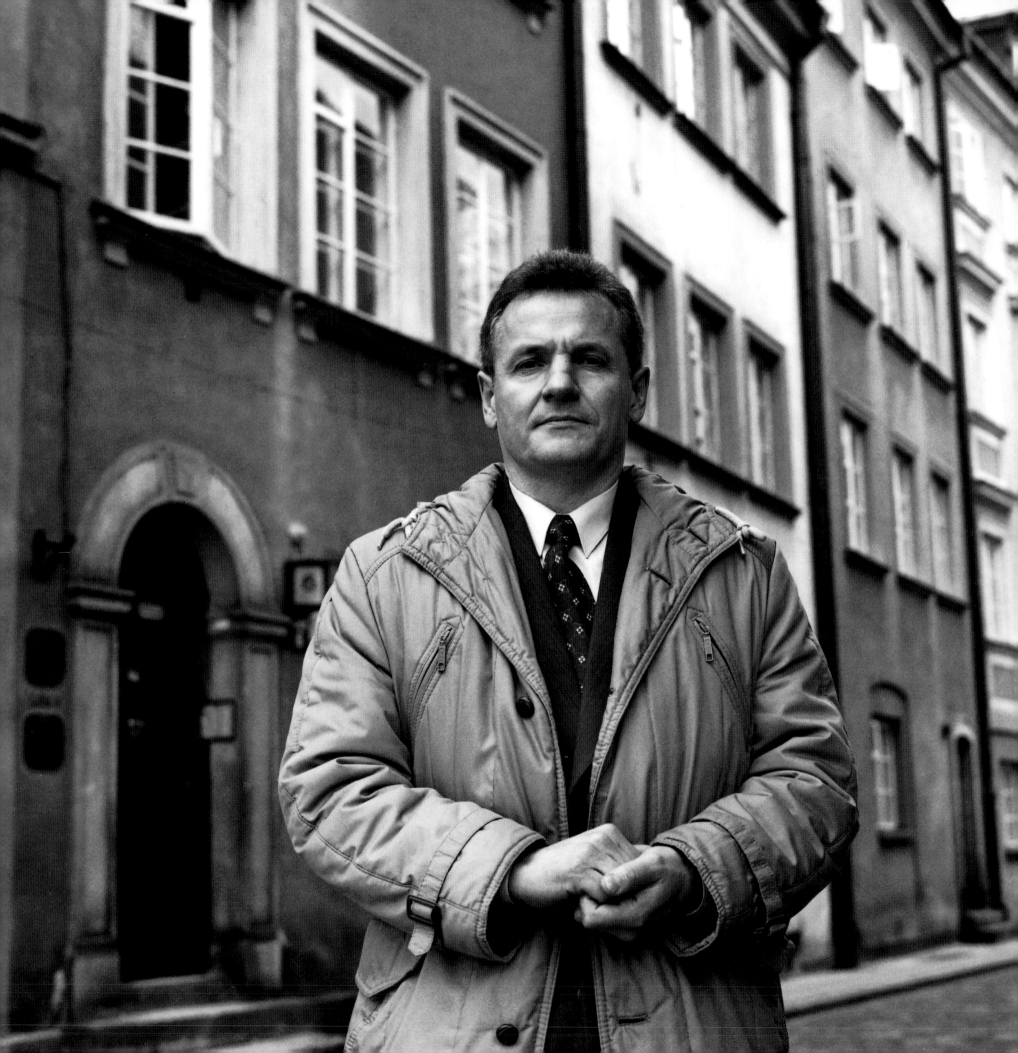

ZBIGNIEW BUJAK

POLAND

POLITICAL PARTICIPATION AND LIFE UNDERGROUND

"'Let's not get caught' was our slogan."

Zbigniew Bujak (b.1954), currently a cabinet minister in Poland, led the Solidarity underground in the Warsaw region from the imposition of martial law in 1981 until his arrest in 1986. Trained as an electrical technician and soldier, Bujak became active in the opposition in 1978 while he was working at the Ursus tractor factory. After organizing a strike in 1980, Bujak became the leader of the Warsaw (Mazowsze) region of Solidarity in 1981. Escaping capture in Gdansk on the night martial law was declared, Bujak traveled underground back to Warsaw where he set up one of the most elaborate and effective underground operations ever known. After his release from prison in a general amnesty, Bujak continued to lead Solidarity for the Mazowsze region until 1989. He was one of Solidarity's leading negotiators in the "Round Table Negotiations," during which he and his colleagues negotiated a peaceful compromise with the communists and set the stage for the rise of democratic governance in Poland. The wave of democracy that started in Poland inspired change in Hungary, East Germany, Czechoslovakia, and eventually throughout the entire region. Bujak decided not to run for office in this electoral contest, instead choosing, like Lech Walesa, to stay focused on the trade union movement. He also worked on the political arena, and helped to found the Citizens' Movement-Democratic Alternative, later the Democratic Social Movement, and the Union of Labor. Elected to Parliament in 1991, he served until 1997. There he spoke eloquently on behalf of women's rights and against anti-Semitism, incurring the wrath of many who were once his ardent supporters. He currently serves as Minister of Customs, one of the most important posts in the Polish government.

In the Solidarity Movement, though we didn't realize the army would be used on such a scale, we knew there would be some sort of martial law introduced. We prepared—hiding the money, all the machines, the files—we hid it all. On December 12, 1981, on the very day when the Solidarity Trade Union held a national meeting at Gdansk shipyard, news was coming in that ZOMO, a special unit of military police used in street fighting, was mobilizing. We thought, "This is it. Even if there is very little we can do at this point, we just have to go. We have to finish the meeting of the national committee."

This particular meeting was being very closely monitored by the secret service. Entering the Gdansk shipyard and arresting us there could have been dangerous because it was a big factory, with a lot of people around and it could have turned into a direct confrontation—with consequences. It was clear from the very beginning that General Jaruzelski was trying to avoid that. He used a tremendous number of police and army units to intimidate us. He wanted to paralyze us with this massive force. Tactically speaking, he did it all very well. They decided to wait and arrest us in our hotels, which was much easier to do. We could see the Monopol Hotel being surrounded, and people being taken away. When we got there, the receptionist told us that Janusz Onyskiewicz, the Solidarity spokesperson, had been arrested. The moment had come. Zbyszek Janus, another activist, and I went directly from the shipyard to the railway station. From there Zbyszek went to his friends in Gdansk, and I stayed that first night in a monastery; then, the next day, I moved to a private apartment. From the windows I could see the tanks, one after another, entering the shipyard. We managed to get in touch with the people of the strike committee inside to figure out whether we should join them, but they suggested that we should stay out,

that all the leadership should scatter to different hiding places. I got an engineer's uniform and rode the train back to Warsaw.

In Warsaw, the most important problem was figuring out who was in hiding, and how to get in touch with them. I had a very clear-cut strategy. I went to my friend's family and asked them to ask their neighbors to go to a very trustworthy priest named Father Nowak to ask for help in contacting others in the underground. Nowak already knew where my deputy, Wiktor Kulerski, was hiding in a private house. I met Kulerski the same day. Another priest from a neighboring parish helped us out. Wiktor then got in touch with Ewa Kulik and Helena Luczywo, and now we knew that our problems had been solved. With those two women, we would be able to build the entire underground network.

We organized three separate structures. The editorial committees published and distributed underground newspapers and leaflets—our most important function. A separate structure existed for all these people who organized Pularski's, Janus's, Zbigniew Tomaszewski's, and my activities. Every single one of us had to have a separate crew of people who organized safe houses for us where we could live, have meetings, and work. The others didn't know where we lived or which people were organizing for us. So if somebody got caught by the secret service, that person would know as little as possible—just one cell would be disrupted. Every month we had to change apartments and our appearance. The way the secret police did their surveillance was by compiling details about the kind of hat, coat, bag you carried. If you switched what you wore, you could easily lose the police. At one point I remember having this

jacket that was very light on one side and very dark on the other, so I could turn it inside out and unbutton it and it would look like a coat.

In one place, where we were for a month, we had about sixteen different apartments at our disposal to move to at any time, apartments of complete strangers. We avoided both our own families and those of other activists. We avoided our friends. That meant we had to completely put our trust in strangers. At the beginning we had this fear that these people would sell us out. The reward for doing that was huge: twenty thousand dollars and a permanent exit visa to leave the country. But only once was someone betrayed.

"Let's not get caught" was our slogan. The general belief in Poland was that the secret police were omnipotent. The whole system was based on the myth of their "terrible efficiency." When people were shown that a year had passed and the opposition was still not captured, was flourishing underground, the myth of efficiency began to show cracks. This was our conviction—that remaining free would compromise the system. And we were right. Today we still get calls from former secret police agents who say, "You know, you son of a bitch, if we had caught you then…" and you can see they are still angry.

There are two kinds of courage. I have a deep conviction that military struggle (though this is certainly a paradox) does not require that much courage. I myself was in the army and know it's easier to just point, shoot, and run. When I read about the dissidents in Russia, I realized "civilian's courage" is much harder. I don't know how to prove this, but when you have to make a decision—whether to sign a petition, or whether to participate in a demonstration—when

you know you can be put into jail, sentenced, or sent to Siberia for years, the way that the Russians have been, this is real courage. When you read about Mandela in South Africa, you can see that it requires a different courage to be ready for this type of activity.

In politics, you can call it courage to express your true opinions. It may turn out that you lose friends—that somebody in the family turns from you. I experienced it. I know I stopped being a hero to all Poles when I expressed my opinions aloud. A lot of people said, "You have disappointed us, you betrayed us. We thought you would be with us, the Nationalists, you would be leading us." And a lot of anti-Semites said, "We thought you would be a true Pole, and that we would deal with those Jews and Communists." Or all those people involved with the antiabortion movement, when I said I believed that it's the woman's decision to choose, turned me into enemy number one.

Look, I believe all of my dreams are coming true. I was afraid that my wife and I would be childless. Then we had a son and we are happy beyond belief. If he hadn't been born I think I would have been a frustrated, bitter person, thinking I'd wasted my family life for something abstract. But he came. And I have this feeling that what I am leaving for my son is the best Poland I could possibly have helped create. You know what we are doing now is going to become the stuff of legends, the same way as it was for us when we talked about our parents' lives. I have the sense of participating in a huge victory: the end of martial law, and later the roundtable, and then Tadeusz Mazowiecki's success. Our idea has won, in the sense of helping fulfill a big political vision, and I was part of it.

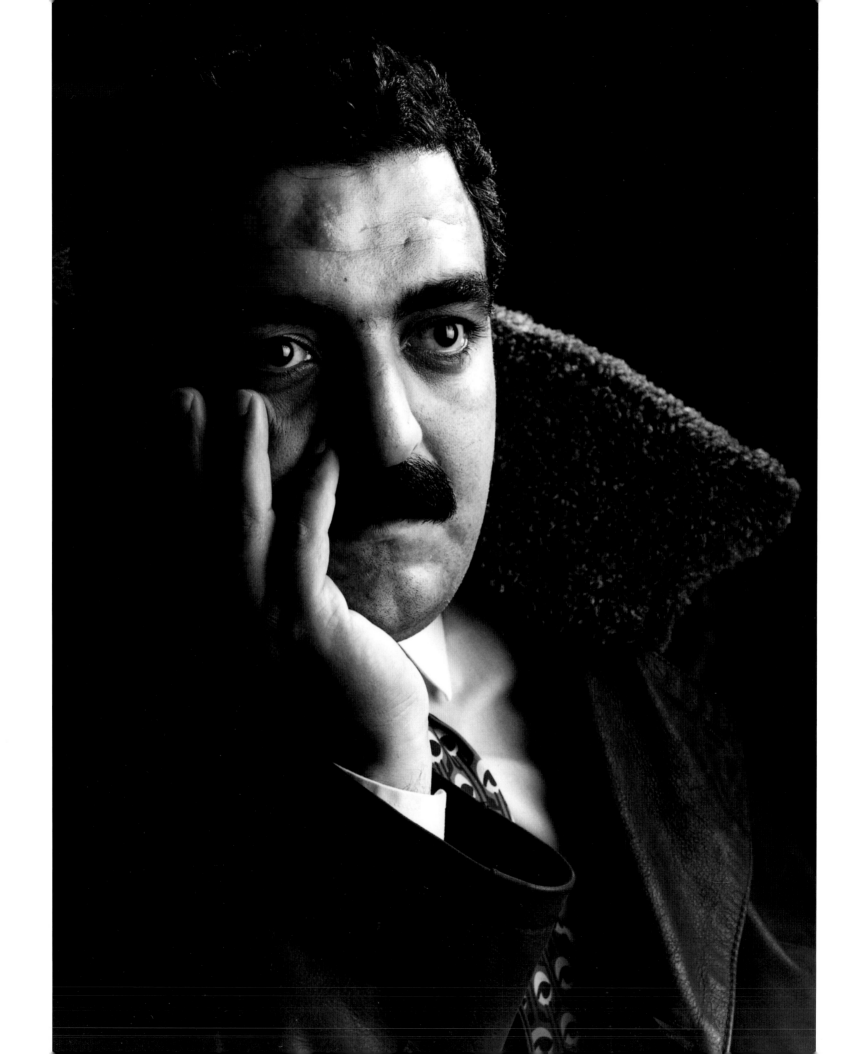

SEZGIN TANRIKULU

TURKEY

KURDS AND SELF-DETERMINATION

"When I am in court, eye to eye with people that I am
accusing of torture, be it soldiers or policemen, when they look
into my eyes and I don't look away, when I am not the first to
flinch, I feel that I have more courage than they do. In their eyes you
can see the hatred they have, their hatred of you, that they
want to kill you for what you are doing."

Sezgin Tanrikulu is the leading human rights attorney in Turkish Kurdistan, a strong advocate of legal reform and strengthening civil society. Co-founder of the Diyarbakir Human Rights Association, the Secretary of the Bar Association in Diyarbakir, and the regional representative of the Human Rights Foundation of Turkey, his work has taken him where few dared to go. For over a decade, the Kurdish region has been under a state of siege, including food blockades and curfews. Fighting between Turkish troops and the Workers Party of Kurdistan has caught civilians in the cross fire. Turkish forces have engaged in a systemic practice of targeting civilians, destroying villages, and forcibly evicting noncombatants. More than twenty-six thousand people have been killed and two million displaced since 1992. Extrajudicial killings, disappearances, arbitrary detention, and torture in police custody are commonplace. Freedom of expression is severely curtailed: until recently, Turkish law forbade the Kurdish language, Kurdish dance, Kurdish songs, and even the use of Kurdish names.

Throughout Turkey and particularly in the southeast region, lawyers avoid defending politically unpopular clients. In this climate, lawyers become victims of persecution themselves, and are routinely identified by prosecutors, police, and security agents as "terrorist lawyers." In Diyarbakir alone, more than thirty lawyers have faced criminal charges apparently based solely on their defense of clients in the courts. Even submitting complaints to the European Court of Human Rights or passing information to international human rights groups has been considered evidence of terrorist support and has resulted in prosecutions and prison terms. Tanrikulu has been indicted several times for his activities as a lawyer and in 1994 was charged with "insulting the judiciary" for appealing a decision to convict on the basis of a statement ruled inadmissible by another court because it was extracted by torture. Tanrikulu's commitment to stay and defend human rights in the face of state persecution reflects his tenacity and devotion to the rule of law.

When I graduated from law school in Istanbul in 1984, I returned to my native city, Diyarbakir, and started my practical training. The government had imposed emergency rule and there were at least three thousand political prisoners in jail, so tension was high in the city. It was very difficult to be indifferent to such a situation. The mayor of the city, Dr. Megdi Zana, who is the husband of Layla Zana, the Kurds' most famous political prisoner, was charged with separatism. He needed the energetic work of a young lawyer to help him full-time, so I started defending him. Once I got involved, I became a specialist in human rights. The scale of terror increased in the region, the war became bloodier, and it was impossible for me to take cases other than those involving human rights abuses.

Megdi Zana was an independent mayor, without any party affiliations. After the military takeover in 1980, he was alleged to be a member of a terrorist organization and had to spend from 1980 to 1991 in jail. He was dedicated to the Kurdish cause. In the 1980s the Turkish government banned the Kurdish language. However, every time he was in court defending himself against their charges, Megdi Zana spoke Kurdish to the judges. Because of his efforts the law was abrogated in 1991, and the Kurdish language was accepted by the Turkish central government.

Six of my friends, all of them lawyers of Turkish origin, were killed between 1990 and 1995, a time I call the nightmare period. They were killed for nothing else than their courage in defending human rights, killed because the authorities wanted to send a signal to people like us working for human rights. They were just the victims of our situation. We suspected they were politically planned assassinations involving military intelligence. Our suspicions were corroborated when an information officer asserted that one of the lawyers was assassinated by an agency linked to the military. This information officer was later murdered.

From 1992 to 1995 the situation in Diyarbakir was especially acute. At least two or three people were killed in Diyarbakir every day in extrajudicial political assassinations. It was a very tense period. I was followed from the moment I stepped foot outside my door every morning. There was nothing to do but find humor in the situation. Most of the time when people were killed they were assassinated with one bullet from behind. We joked at the notion of placing mirrors on our shoulders so we could see who was creeping up!

In 1988, with five of my colleagues, we decided to establish the Human Rights Association of Diyarbakir. By 1997, the Human Rights Association had six hundred members. But on May 22 that year, the government closed down the HRA after they allegedly found forbidden publications in the archives of the association. We weren't alone. Two other cities, Mardin and Urfa in southeast Turkey, also had human rights associations closed for the same reason.

I was detained for short periods of time. On my way back to Diyarbakir from Europe, the authorities stopped me at the airport and told me that I was on their list of suspects. I knew that if they took me to the police station bad things could have happened. But in Diyarbakir there are also some very honest judges

"Once you work for people, once they call you at two o'clock in the morning, once they come to your office and you see the suffering in their faces, you don't think about representing a case, you're representing people. Your job becomes a very human one."

and prosecutors, and one prosecutor who heard about my case immediately called and insisted that they had to interrogate me in court. He saved me.

In another instance, a state prosecutor who really believed me once he heard me—that I was not guilty on the charges of separatism and membership in a terrorist organization—said: "Why don't you just write up your defense and I will just sign it as if I had written it?" That was amazing—but it happens. That's why I have to say that although the picture is very bleak, there are pockets of hope.

My conscience is clear because I haven't done anything illegal; I am not in contact with any terrorist organization. Everything I do is on the record. I have no reason to fear security forces or state authorities. I would have no problem in court defending my case. All my fear is based on the fact that there are circles within the state that are beyond state control. These people can really be dangerous and that's why our job involves a certain risk.

There were times I was really concerned about my family but my wife says she's the one who is always scared. Something that I'm particularly afraid of is car bombing, because once you switch on the engine it's too late. A friend's car, a lawyer in Diyarbakir, was bombed like this.

The struggle for human rights is as old as human beings themselves. And I believe that if we do not stand up against injustice, nobody can help us. It's only people themselves who can change situations. To live under conditions in which there is no justice is worse than dying. So I do what I do in order to ensure a better future. On the other hand,

our region is a very backward one. The literacy rate is very low and there is a war going on. So for people who are ignorant but who are still suffering abuses of human rights, we are seen as people who can save them. We lawyers are considered demigods, which carries a lot of moral responsibility. Since there are so few lawyers in Diyarbakir, we really have to work hard to deserve the people's trust. That's why we feel, in our region particularly, that we have a special task. Once you work for people, once they call you at two o'clock in the morning, once they come to your office and you see the suffering in their faces, you don't think about representing a case, you're representing people. Your job becomes a very human one.

Let me offer a very narrow personal definition of what I think courage is. If I can represent someone who was tortured, if I can stand up to the police force, to the system that has tortured this person, this is courage. And this is my way of fighting. There are different ways of getting to the same end but representing people who have suffered is my way. When I am in court, eye to eye with people that I am accusing of torture, be it soldiers or policemen, when they look into my eyes and I don't look away, am not the first to flinch, I feel that I have more courage than they do. In their eyes you can see the hatred they have, their hatred of you, that they want to kill you for what you are doing. And as someone who is fighting for justice, you should not be ashamed of what you are doing. I have friends who keep telling me, "Why are you fighting so hard against the system? Why are you putting so much at risk?" But I think I am doing what I must do. I do something that someone has to do. And I have no second thoughts, no doubts about the rightness of what I am doing. If everybody was responsible in what they were doing, there would be no problems in this world.

MARIA TERESA TULA

THE DISAPPEARED

"We held a press conference telling the public about the work. . . .
As a result, a death threat appeared in the newspaper
threatening all members of Co-Madres that if people did not obey
they would be disappeared or decapitated one by one."

Maria Teresa Tula is a leader of the Co-Madres (Mothers of the Disappeared) of El Salvador, a group of impoverished, mostly illiterate women whose husbands or children were kidnapped or killed by death squads and government security forces during El Salvador's bloody civil war. The 1980s conflict pitted leftist organizations and campesino farmer-based guerrillas against an entrenched alliance of landowners and the military, with each side aided by different Cold War backers. In 1992, when a peace accord was signed by the government and the Farabundo Martí Liberation Front, the reign of terror that had ruled in El Salvador for over a decade finally ended. After Tula was threatened, abducted, and tortured, she returned to Co-Madres to continue her work for justice and for women's empowerment. A self-described feminist, Tula escaped to the United States, crossing the border as an illegal alien. She spent the next several years running the Co-Madres office in Washington, D.C., and fighting deportation for herself and all Salvadorans. She now lives in the U.S., fulfilling her dream of providing her children with a safe environment and a good education.

I was born on April 23, 1951, in the village of Izalco, in the Department of Sonsonate in El Salvador. My father was a bus dispatcher and my mother worked in a factory in Santa Ana nearby. I had eight brothers and sisters. Like most people in the village, we were poor. I received only a first-grade education. After that I began helping my mother in the house until the day I was married. My husband, José Rafael Canales Guevarra, was killed by the Salvadoran military in June 1980.

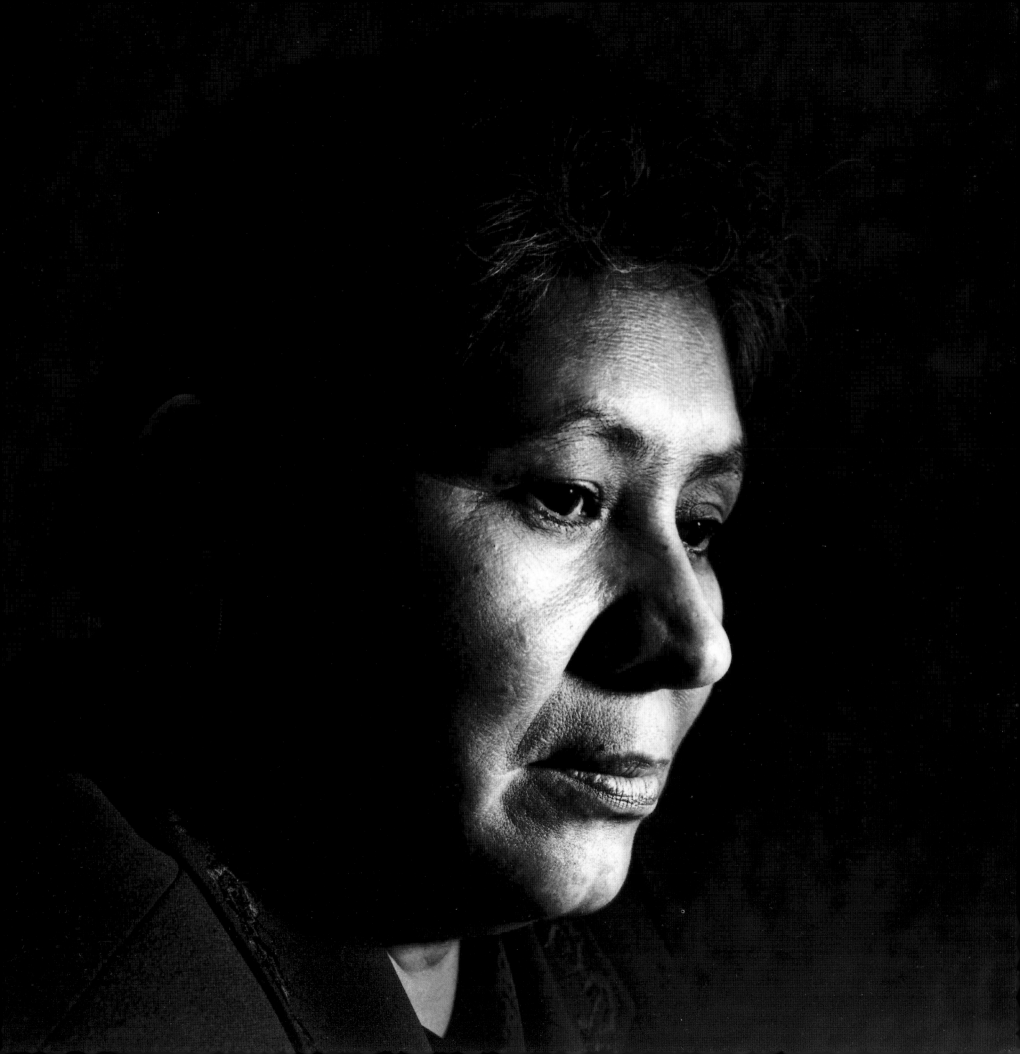

We had five children together. I also have a sixth child, Oscar Feliciano Tula, born on July 5, 1986, while I was being held in prison without charges.

Until 1978 I was never involved in politics in any way. My husband was working in the Central Azucarrero de Izalco (Izalco Sugar Company), owned by one of the richest families in El Salvador—and I was taking care of our children and taking in washing and ironing. Conditions at the company were very bad. There was no job safety, wages were low, and there were no health benefits. The seventeen hundred workers decided to go on strike and refused to leave the plantation. Some stayed inside the processing plant. Others guarded the gates of the hacienda to make sure no trucks could get in.

My husband was very active in the strike. On the second day I went to bring him medicine and food at 10:00 A.M., just as the security forces arrived and arrested everyone. Many ran into the sugar cane fields to escape. The police beat those who were caught, tied their hands behind their backs and told them to lie face down. All of us family members were there watching and waiting to see what they were going to do with our husbands and sons. They separated twenty-two people and let the rest go. My husband was one of those they kept. He was taken to the National Guard headquarters in San Salvador and held incommunicado for three days. On the fourth day, a military tribunal sentenced him to six months in prison. The only witnesses were Guard members. At first they wouldn't even tell me where he was, but I finally found out and visited him in Santa Tecla Prison. He told me how he had been tortured—beaten in the testicles, then hung from the ceiling and beaten all over, a torture described as "the airplane."

Then I started working with the Co-Madres—an organization of women formed in 1977 to fight for the release of husbands and other family members jailed or disappeared or assassinated and to demand that the government respect human rights. In June 1978, my husband was released from prison. We decided to move to Santa Ana, since it would have been dangerous for us to remain in Izalco. Once a person has been in prison they are in even greater danger of being assassinated or disappeared by the security forces or death squads.

In Santa Ana my husband got work as a bricklayer. He was not involved in politics. He worked and spent time at home with our children. I kept doing my work washing and ironing clothes, and kept working with Co-Madres, pressuring the government to respect human rights. During this time there were continual assassinations and disappearances. On the highway from Santa Ana to San Salvador you could see fifteen corpses in different places on any given day: students, workers, peasants, old people, women.

The Co-Madres would call press conferences when people were disappeared, or place ads in the newspaper announcing that someone was being charged and tried. I worked mostly with governmental organizations, international officials, and institutions and churches. I also distributed food to people who visited the office, visited political prisoners in jail and brought them supplies, and solicited food and other donations from international and domestic organizations.

Like other independent human rights organizations, we came under attack from the right wing. In October 1979 I was in San Salvador with a group when we learned that the body of one of these mothers' sons had been found on the streets; he had been disappeared. It was 7 P.M. and we were returning with the body in a minibus, when we were stopped by the police. They accused us of carrying arms and made all ten of us, including a child, lie face down with our arms stretched above our heads. The six policemen walked in single file around us, beating us on our backs with rifle butts and stepping on us. We were lying about three hours, while more police arrived, including a commander. Meanwhile it kept getting closer to the curfew time—midnight—when everyone had to be off the street. If anyone was on the street after midnight they could be machine-gunned. So they were detained until then—many people died this way.

Around 11:40 P.M. they started to let us go. Six women were released, but four of us—including me—they kept. They asked us questions—where were we from, our names, the names of our parents, what were we doing. Meanwhile, they kept on saying we were carrying arms, a complete lie, and joking that the boy whose corpse we were carrying had died of mosquito bites. Finally, at ten minutes to twelve, they told us to put our hands behind our head and start walking. Then they told us to stop, turn around with closed eyes, and then keep walking,

then stop again, and turn around. They kept doing this until at one moment we all felt rifles against our stomachs. They asked us if we wanted to die. We were silent. I felt complete terror and thought they were surely going to kill me. Finally, they told us we could leave. It was two minutes to twelve, which meant we had only two minutes to get off the street. They brought back the chauffeur, who had been taken a short distance away; he had been badly beaten. We all got into the bus with the corpse. Fortunately there was a funeral home nearby and we arrived there before the curfew began. This was my first personal experience of torture and the kind of tactics used by the security forces. I had heard many stories but this was the first time I had experienced it myself.

In 1980 I moved with my family to Sonsonate, where my husband had gotten a job building big houses. Barely a month later he was assassinated. On June 19 four men in civilian clothes, heavily armed, came to our house. They asked for my husband and said they were taking him to the municipal police station because he had been witness to a robbery. When he didn't return I inquired at the police station, but he wasn't registered there. The following day the newspaper had a picture of him saying he was a guerrilla who died in a confrontation with the armed forces in a clandestine house full of arms. This was a complete lie since he hadn't been involved with anything since the strike. When I went to get my husband's body, the judge who had identified it told me that it was the armed forces who had killed my husband, that his hands and feet had been bound and there was a bullet hole through his head. At the cemetery in Sonsonate, I saw his tied hands and feet and the bullet hole through his head.

My neighbors warned me that my house was "militarizado," with soldiers surrounding it and going through all our things. Once they kill one member of a family, they often kill others. So I never went back. Instead I went to San Salvador. I was pregnant at the time with my fifth child.

I continued to be very active with Co-Madres, which was under intense pressure from the right-wing death squads and security forces. In 1980 the Co-Madres office, which we shared with the nongovernmental Human Rights Commission (CDH), was bombed twice. The first bombing took place on March 13, 1980. Afterward the National Guard came, supposedly to investi-

gate, but did nothing. The second bombing occurred in September 1980, and several unknown decapitated bodies were left at the front of the office, as a further warning of what would happen to us. Several members of the Human Rights Commission were also assassinated during this period.

In the beginning of 1982, Archbishop Rivera y Damas recognized the work that we at Co-Madres were doing and he gave us office space along with the Human Rights Commission, Socorro Juridico, and Tutela Legal—the Archdiocese's own human rights and legal offices. To announce our move, we held a press conference, telling the public about the work we were doing and where they should come for help. As a result, a death threat from the death squad leader Maximiliano Hernandez appeared in the newspaper threatening all members of Co-Madres that if people did not obey they would be disappeared or decapitated one by one.

Fifteen days after this, a member of Co-Madres, Ophelia, was captured by members of the security forces dressed as civilians, and then taken to the National Police Station. We started paid advertising to get her released and to force a tribunal to investigate why she had been captured. The police confirmed that she was being held, "for investigation." We later learned that during those days she had been tortured and raped, and eighteen days after she had been captured, she was dumped near the Santa Ana–San Salvador Highway, about fifty kilometers outside of San Salvador, early in the morning. Some workers called us to say a woman had been found. Her hands were still tied behind her and her mouth was gagged. She was so disfigured that we didn't even recognize her. Her whole face was inflamed; she couldn't talk because her teeth had been broken inside her mouth, and she had cigarette burns on her arms and body. When we asked her who she was, and she managed to say "Ophelia," we couldn't believe it. We took her to a doctor, and after she had recovered she testified about what had happened to her. She said there were photos of all of us at the National Police Station, but they were asking her about a few people in particular. I was one of the people they were asking about.

It was shortly after this that men dressed as civilians started coming to my house, asking questions. Others were constantly watching the house and whenever I left they would come and talk to the children. The children were

nervous about what would happen to me. Around this time in the street the army and the security forces were also stepping up their street searches. They would make people get off buses and show their registration and they would physically search you and everything you were carrying, including diapers.

The terrorization of Co-Madres continued. In 1982, Elena Gonzalez was shot and killed by death squads in her home in Cuzcatancingo. Three Co-Madres mothers, Haydee Moran, Blanca Alvarado, and Carmen Sorto Ruano and her nineteen-year-old daughter, were taken one by one by National Police to the famous body dump, "Puerta del Diablo," where they laid their heads on a stone and told them their heads would be cut off with a machete if they didn't talk about Co-Madres. Haydee and Blanca were released; Carmen and her daughter were imprisoned until 1983.

It was clear to me that my life was in danger. I decided to flee El Salvador for Mexico. I left on August 4, 1982, taking four of my children, and leaving the eldest in San Salvador with my mother. I stayed in Mexico until 1984, and worked there with the Co-Madres office. Then my visa expired so I was afraid of being deported back. The United Nations Committee on Refugees recognized me as a refugee and they gave me papers to apply for political asylum in Mexico, and though I had a number of interviews I never received any response. This made me even more nervous since I knew other Salvadorans whose applications were granted; I might be on some kind of blacklist.

In 1984, after the Co-Madres received the Robert F. Kennedy Human Rights Award I decided to return to El Salvador as I believed that with international attention and recognition for our work, I would now be safer. Also, Napoleon Duarte had recently been elected president after a campaign in which he promised to respect human rights and initiate investigations into disappearances and assassinations. But when the four of us applied for our visas to travel to the United States for the RFK award, they were denied. An article appeared in *La Prensa Grafica* quoting a U.S. State Department declaration saying they were denied since we had Communist connections. To have our names printed in the newspaper linked to Communists was very dangerous. It was like giving permission for the death squads to come in and assassinate us.

A few days after, the U.S. Embassy told the public, the Kennedy Memorial, and a human rights delegation that the visas were denied because we were dangerous and terrorists and we had direct connections to guerrillas. We asked for an audience with the ambassador so he could provide proof, but he wouldn't see us. A visiting U.S. delegation also asked for proof, but nothing was forthcoming. From that moment we noticed an increase in surveillance, but luckily, around this same time, three of the four of us were invited for a European tour. We left on January 20, 1985, and spent three months touring Spain, Holland, Switzerland, England, Greece, West Germany, France, Italy, Norway, and Sweden. We met with Mrs. Mitterand, Mrs. Papandreou, and other prominent women; also with Willy Brandt in West Germany and with United Nations representatives in Geneva. We hoped this kind of international exposure would give us more protection, and on our return on April 20, 1985, we were accompanied by European parliamentarians.

Meanwhile, the assassinated body of a Co-Madres member, Isabel, who had disappeared some eleven months earlier, was found in her home. Only a few months later, Maria Ester Grande was detained by the Treasury Police and threatened; they picked up her son and tortured and interrogated him for fifteen days to get information about his mother and where she lived. (During this time, those of us who were active in Co-Madres never lived in one place. We moved around for fear of being picked up by the death squads or security forces). Finally, he told them and the Treasury Police went and picked her up; then they returned four times to her house, treated her children brutally and threatened to kill their mother and brother if they didn't tell where arms were hidden. They never found any arms. But they presented her with her son tied up and beaten, and said if she wanted her son to live she would have to go back to Co-Madres and get the names of all who worked there and their addresses. Then she was dropped off at our office. Instead of cooperating with them, she told us what happened. We immediately went to the Red Cross and finally her son was transferred to Mariona Prison until 1987.

Shortly after this, there was a break-in of the Co-Madres office and everything was taken—documents, testimony, tapes, photos, and money. As a result they had those lists of everyone involved with Co-Madres. From this

point on, there was constant surveillance and repression. In November 1985, Joaquin Antonio Caceres, of the Human Rights Commission, with whom we worked closely, was captured and held for forty-five days and later brought to prison and accused of being a guerrilla. Around the same time, Co-Madres was awarded the Bruno Krisky Human Rights Award. I traveled to Austria to receive it, visiting other European countries as well. I was away until March, and when I returned, all my movements were monitored by the police. I lived in constant fear.

On May 6, 1986, I was grabbed suddenly by a man at a bus stop, a pistol was pressed in my side and I was told to walk and not make any noise. Then I was pushed into a white car that was waiting with its doors open. They forced me to lie on the floor with my head down, so that I couldn't see outside, and then the car drove around in circles so I wouldn't know where I was being taken. Finally I was taken to a house with the three men who captured me. They blindfolded me and put me in a chair with my hands tied behind my back, and they started interrogating me about who I was, what was I doing in the neighborhood, and whether I knew people from Co-Madres. I was held for three days, during which time I was beaten and raped by the three men, all while blindfolded. I was seven months pregnant at the time. There was no way for me to know if it was day or night. They gave me no food and only a little water. Later they started carving my belly with a knife. They didn't make deep wounds but scrapes which left blood. They questioned me about Co-Madres and when I continued to tell them I knew nothing, they told me I would die. Then they left me for the night, blindfolded, with my hands tied to the chair.

The next day they asked me the same questions and again wounded me with the sharp object, but this time the wounds were deeper—I still have scars. Finally, they blindfolded me again, put me in a car, and told me not to look where we were going or they would shoot me in the head. Then they dropped me in the Cucatlan Park. It was nine in the morning. I was bleeding, disoriented, and my clothes were torn since they had sliced them with the sharp, pointed object. I was holding my wound to stop the bleeding. I had no money; they had taken everything from me. I asked a woman at a bus stop to help me, telling her that I had been robbed. She gave me some money. I didn't know if

I should go first to the hospital, my home, or the office. I decided the office and told them everything that had happened. Several days later we published a "denuncia" (an accusation).

The security forces' arrests of people connected with human rights organizations intensified. And on Friday, May 26, I was arrested again. They were dressed as civilians, heavily armed, but I later learned that they were members of the Treasury Police. I was tortured for four days, beaten all over, on my head, my back. At one point a towel was put over my head and one of my torturers sat on my head and neck. Ten days later I was visited by the International Red Cross and the Human Rights Commission who told me that I was accused of being a terrorist. Though I was never tried or sentenced, I was held in Ilopango Women's Prison until late 1986. I was able to find homes for four of my children. But my six-year-old daughter stayed with me in prison, along with my son, who was born there.

On September 22, I was ordered released by President Duarte, in a public ceremony. At that ceremony I pointed to a man there who had been one of my torturers. Following my release I was terrified to go to the Co-Madres office, I was scared at bus stops, and if any vehicle stopped, I was afraid someone would jump out and grab me. I was frightened that I would be machine-gunned on the street. My house continued under surveillance and attacks against the Human Rights Commission also continued. I knew that there was no way I could remain in El Salvador. I began planning my escape.

I learned that I was being invited to the United States in January to talk to members of Congress and other groups: this would be a good opportunity to find temporary safety. I was no longer safe in El Salvador or Mexico, which was no longer accepting Salvadorans for asylum. I was forced to leave three of my children in Mexico, living with different families. My two youngest children came with me.

There is another story to tell about my efforts to get asylum in the United States in the 1980s, when many in the U.S. government were supporting the regime in power, but that is for another time. I rejoice that peace has come to my country at last and that the human rights we fought for during those dark years now seem within our reach, not just in our dreams.

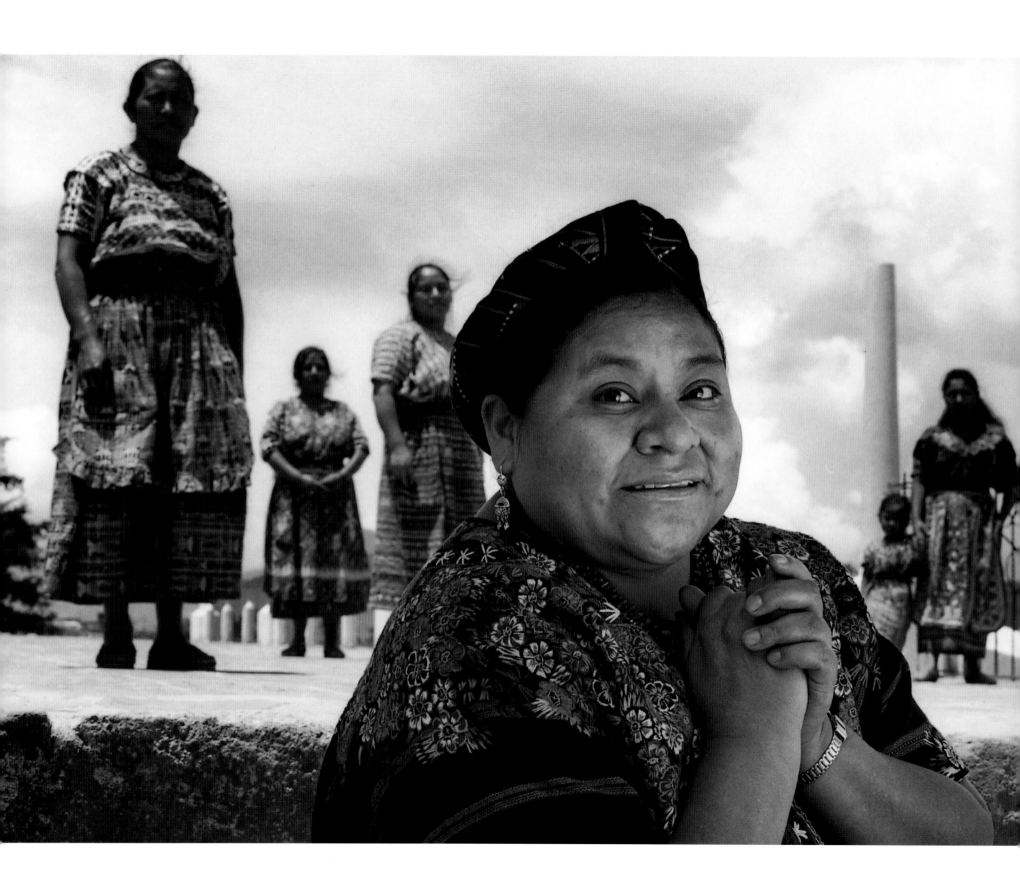

RIGOBERTA MENCHÚ TUM

GUATEMALA

INDIGENOUS PEOPLES' RIGHTS

"I was a militant woman in the cause of justice.
And for twelve years I did not have a home of my own or a family."

Rigoberta Menchú Tum is a heroine to Mayan Indians in Guatemala and indigenous peoples throughout the world. Born into an impoverished family in 1959, this daughter of an active member of the CUC (Committee of Campesinos [Agricultural Workers]), she joined the union in 1979, despite the fact that several members of her family had been persecuted for their membership. In the early 1980s, the Guatemalan military launched a "scorched earth campaign," burning over four hundred Mayan villages to the ground, massacring hundreds of children, women, and the infirm; and brutally torturing and murdering anyone suspected of dissenting from the policy of repression. The military killed up to two hundred thousand people, mostly Mayan Indians, and forced one million people into exile. Menchú's mother and brother were kidnapped and killed, and her father burned alive. While the Guatemalan army marched against its people, the rest of the world remained almost completely silent. In 1983, Menchú published her autobiography, an account of the Guatemalan conflict. I, Rigoberta Menchú *was translated into twelve languages, and was an influential factor in changing world opinion about support for the military. Fifteen years later, discrepancies were found about certain details of the work, but there is no dispute regarding its essential truth and the massive suffering of Guatemala's indigenous peoples at the hands of the hemisphere's most brutal military government. In 1992, Rigoberta Menchú Tum won the Nobel Peace Prize for her work. Menchú has been forced into exile three times for her advocacy within Guatemala, and despite the threats, continues her work today on human rights, indigenous rights, women's rights, and development.*

Struggles for the rights of poor people, for dignity, for human life, seem to be very, very dark tunnels, but one should always try, in that struggle, to find some light and some hope. The most important thing to have is a great quantity of positive feelings and thoughts. Even though one can easily be pessimistic, I always attempt to look for the highest values that human beings could possibly have. We have to invent hope all over again. One day, sadly, I said to myself with great conviction: the death of my parents can never be recuperated. Their lives cannot be brought back. And what can also never, never be recuperated is the violation of their dignity as human beings. Nothing will ever convince me that anything could happen to pay back that debt.

Now, I don't think this realization is a personal matter; rather, it is a social question. It's a question of a society, of history, of all memory. Those of us who are victims are the ones to decide what pardons are going to take place and under what sort of conditions. We, who have survived the crimes, are the ones who should have the last words, not those observing. I respect the opinions of those who say that a decree or an accord or a religious philosophy is enough to pardon others, but I really would like, much more than that, to hear the voice of the victims. And at this moment, the victims are really not listened to.

An amnesty is invented by two actors in a war. It's hardly the idea of the victims, or of the society. Two armed groups who have been combating each other decide that it is best for each to pardon the other. This is the whole vulgar reality that the struggle for human rights has to go through at this moment.

An agreement with real dialogue would bring war to an end as soon as possible. But I never could accept that two sides that have committed horrendous atrocities could simply pardon themselves. What the amnesties do is simply forget and obliterate, with one simple signature, all the violations of human rights that have taken place. Many of these abuses continue in the lives of the victims, in the orphans of that conflict. So even though there are amnesties in countries such as Argentina, Chile, El Salvador, and Guatemala, I can see that people do not forget the human rights violations that they have suffered, and they continue to live them. These are things that are not going to be forgotten.

A real reconciliation has to be based on the search for truth. We who are the victims of these abuses have a right to the truth. Finding the truth is not enough. What we also have to find is justice. And the ways, the processes, and the means by which this justice can be accomplished are through law and through the courts, through procedures that are legal.

This is why I now have a legal case in Guatemala against the military. We have a lot of corrupt judges, we know about bribery and threats. The military does not want to set a precedent for real justice, so they bribe the entire legal system. One of these days that system will become more fair. But we have to give time to the system of justice to improve.

Living in a country of such violence, of such a history of blood, no one, no one would want to bring a child into this world. I was a militant woman in the cause of justice. And for twelve years I did not have a home of my own or a family. I lived in refugee camps when I could. I lived in the homes of nuns in Mexico. I left behind many, many bags in many different countries, in many different buildings. Under those circumstances, what would I have done with a child? I was involved in all kinds of risks, and thought that maybe I would have to sacrifice my life for my people. When one says that, you understand, it is not just a slogan, but a real-life experience. I exposed myself to the most difficult kinds of situations.

I met my husband in 1992. When I met him, I really didn't think that it was going to be a longstanding relationship. How could it, when I was always going from one place to another, almost like a vagabond? My husband's family, in particular, helped me a great deal in stabilizing my life. It only happened because my future in-laws were really very persistent and just insisted—all the time—that we get married, even if it was only a civil wedding. They were worried about what the family, what the society, what the community, what everybody else would think, if we weren't married. For me, it didn't have any particular importance.

For me stability began with another wish: it was very important to find, once again, my sister Ana. She was the youngest of the family. She had decided that she was going to live with me, but I didn't have a home where she could live. I began to actually have the desire to have a home, a desire that coincided with the time when I was awarded the Nobel Peace Prize. Many friends, people who gave me counseling thought that it would be better for me, too. After all, you can't have a Nobel Prize winner wandering around the world semiclandestinely!

> "It's not true that it is only pain that motivates people to continue struggling to make their convictions a reality. The love of many other people, the support that one has from other people, and above all, the understanding of other people, has a lot to do with it."

I give thanks to Mexico—to the people of Mexico, and at that time, to the authorities, the officials of Mexico City—who offered me that sense of stability in a very short period of time. The office of the mayor gave me a house, and in that house we were able to construct for ourselves, once again, a very normal life. We were once again a family. I'd left Guatemala in 1981, but though I'd returned in 1988, I was detained, so I was forced to leave again. After that I would come and go in and out of Guatemala, but I could never stay for very long. Finally, in 1994, we went back, officially.

Home is important to me for another reason. I have two children now—one who I lost. It just changes around your life completely when you have a child, doesn't it? You can't be just moving around the world in any way that you want anymore. So you live life according to the circumstances that you are in. I can't say, though, that I ever had the intention of living my life, or any part of my life, quite the way in which I lived it! Things just happened. Suddenly I was caught up in the situation. And I tried to overcome it, with a lot of good will and not a whole lot of introspection. Now my son lives with my family, with my sister and my nephews; there are seven children in the house. There are two twins, two years old, a daughter of my sister-in-law, and four children who don't have a father. But we live in a large family, and that gives my son a great deal of satisfaction. He has a community every day.

My youngest son, whose name was Tzunun, which means hummingbird, was part of a very, very difficult pregnancy. It was risky from the very first day. It required a tremendous desire to be a mother, to carry it through, and I had decided to have this child. All my work, all my activities had to be stopped. Still, so sadly, he lived only three days. But when he died I thought that he had lived with me for many, many years. I talked to him, I understood him, we thought he could perceive things around him.

During this time, I was always thinking about the world and listening to the news and trying to find out what was going on. And when you really listen it has a very, very big impact on you. Because when you are going around to conferences and talking to people and people are applauding you, you really don't fully realize what a terrible situation that women and children are in. But being at home, in your own four walls, and knowing what is happening in the world, you really feel very limited in what you are doing and what you can do. My child gave me time to sit back and to think about the condition of women, and children, and children who don't have parents, and children who are abused by their parents. My situation, my condition as a mother is a great, great privilege: not just some kind of decree, or law, or desire, but something that, fundamentally, has transformed my life.

There have been a lot of successes in my life. And when you have success, it helps you to want to continue the struggle. You are not alone, for it's not true that it is only pain that motivates people to continue struggling to make their convictions a reality. The love of many other people, the support that one has from other people, and above all, the understanding of other people, has a lot to do with it. It's when one realizes that there are a lot of other people in the world that think the way you do, that you feel you are engaged in a larger undertaking. Every night when I go to sleep, I say a prayer that more people, more allies will support the world's struggles. That's the most important thing. That would be so good.

JOSÉ RAMOS-HORTA

EAST TIMOR

NATIONAL SOVEREIGNTY

"More courage is required to forgive than is required to take up arms."

José Ramos-Horta received the Nobel Peace Prize in 1996 for his uncompromising and indefatigable work on behalf of the people of East Timor, brutally invaded by Indonesia in 1975. Muslim West Timor became part of Indonesia in 1946, while East Timor, settled in 1520 by the Portugese with different language, religion, and customs, remained a colony until Portugal's withdrawal in 1975. Twenty-five-year-old José Ramos-Horta was named foreign minister of the newly formed government in November 1975, but only a month later, Indonesian troops massed around the capital city, Dili, and, as Ramos-Horta's plane touched down in Portugal, he was told that Indonesia had taken control of his country. In the years following the invasion, one-third of the population was to lose their lives to massacres, starvation, epidemics, and terror. Throughout the next two decades, Ramos-Horta traveled the globe speaking out against abuses, and, in 1992, he put forth a peace plan which called for a phased withdrawal of Indonesian troops culminating in a referendum in which the people of East Timor would vote for independence, integration into Indonesia, or free association with Portugal. When the September 1999 vote showed that 80 percent of Timorese had voted for independence, Indonesian armed forces and their militia allies went on a rampage. They massacred hundreds, burned to the ground 70 percent of the standing structures in the country, set fire to crops, killed thousands of farm animals, and destroyed major sewer systems and electric lines. Hundreds of thousands were forced into exile at gun-point. Ramos-Horta led the international charge against the slaughter, and, because of his appeals, the United Nations sent in troops to stop the violence. In December 1999, after twenty-four years in exile, José Ramos–Horta finally went home again to a free and independent East Timor.

I was born into a mixed family, with a Portuguese father who had opposed the Salazar fascist regime in Portugal, and therefore was exiled to East Timor in the thirties, and a mother from East Timor. We grew up in remote villages without electricity, running water, roads, or cars. Tetum, the main native language, was spoken in our home. I only learned Portuguese at the Catholic Mission school. We had very little: I remember getting my first shoes when I was a teenager and since I didn't want to ruin the shoes, I saved them to wear at Christmas. By the following Christmas they no longer fit me—I was so upset.

The Catholic Mission was also very poor. For almost ten years we had corn for breakfast, lunch, and dinner. They'd throw it in a drum, boil it, and then put it on your plate. It was old and hard and I have a tooth ruined because of that corn. We'd have meat maybe, oh, once a month. And the Catholic school was very conservative. You had to pray fifty times a day, and confess constantly because the priest used to tell us that even if you were young you could die at any moment, and if you died with sin, you'd go straight to hell. So I thought

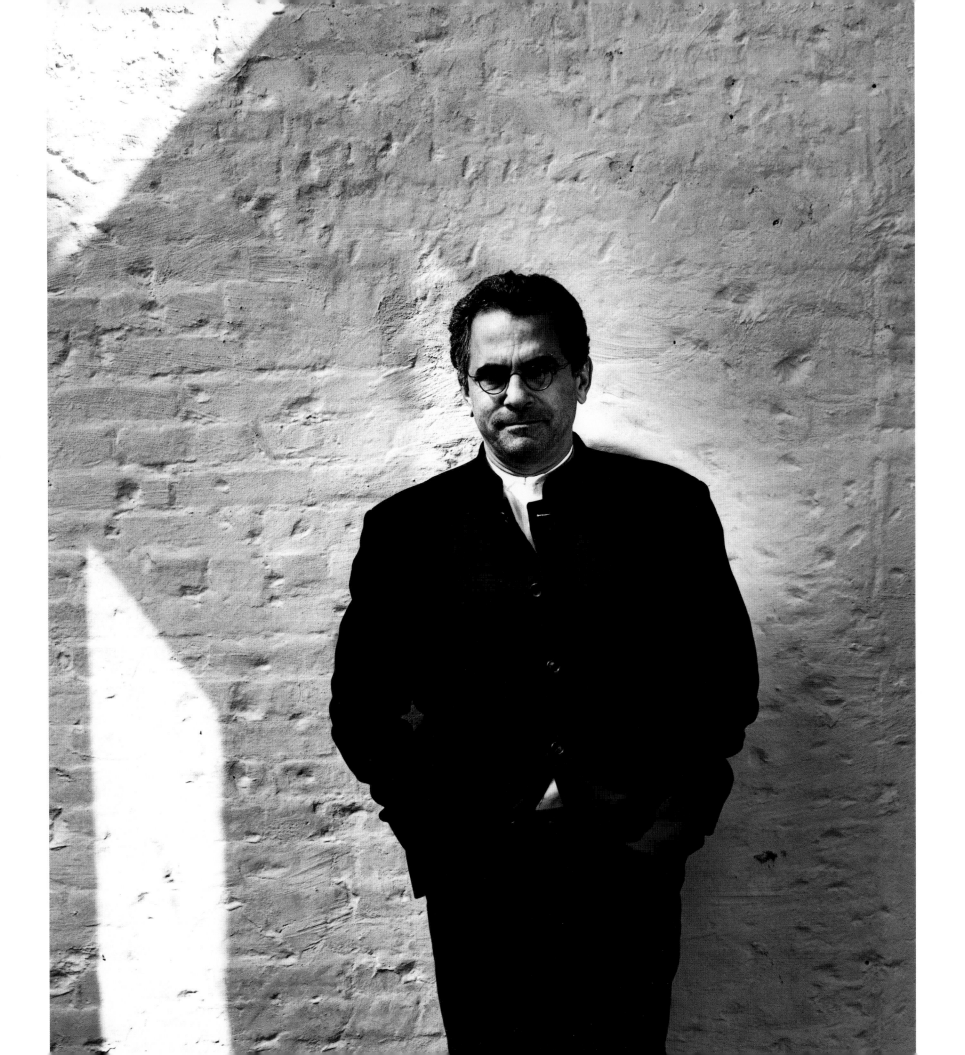

that if I prayed two acts of contrition instead of one then that would double my protection—even as a kid I was already covering all my bases!

I wanted to be a journalist. In my late teens I began working as a reporter in Dili, the capital, for a local newspaper, *The Voice of Timor*. I managed to get an extra job in radio presenting news, and a part-time job on Portuguese television, where I started to shoot news stories for them, and, afterwards, wrote the news myself. In the process, I became very pro-independence, very critical of the Portuguese colonial rule. (No offense to the Portuguese today who have done an outstanding job for East Timor. But the colonial Portuguese pre-1975 were so incompetent and lazy and did nothing to really develop the country.)

When I was only twenty I started working at the tourist information department, and made some outrageous remarks while having drinks with two guys, one from the U.S. The next day I was called in by the Portuguese political security police, the famous PIDE, notorious in Portugal and Africa for using torture against civilians. They repeated everything that I had said about them. I was impressed. Two days later I was again interrogated, for hours, lost my job, and left for Mozambique for two years. They did not torture me—just interrogated me and I left. I don't want to pretend that I was a hero. If I were not drunk, I would not have said what I said. That was my defense, also. To which they said, "It doesn't matter. You thought it. You actually believe it."

In 1974 I founded the first social democratic party in this country, which, within weeks, became the most popular, practically a revolutionary front for an independent East Timor. Some Marxist students who had just returned from

Portugal joined and took control. That is where it got its reputation as a Marxist-Communist organization. But it was never a Marxist group. It just had a lot of rhetoric in speeches. We used to call each other "Comrade," do stupid things, like salute with the clenched fist (why not just wave?).

And then in 1975 came a civil war. The Portuguese left and the city was like a ghost town. FRETILIN (Revolutionary Front for an Independent East Timor) was in control. Not one single house had been destroyed. Not one single thing was damaged. The Portuguese bank was intact. Even the cars that belonged to the Portuguese government were untouched. The Mercedes of the governor was not touched. There was respect, but the town was deserted. Thousands had fled. The war had ended. I did not see it because I was in Australia during the brief period of the civil war which lasted about two weeks. But when I came back I saw the consequences of the war, brief but vicious and stupid.

Then came the invasion on December 7, 1975. In November 1975 I was made foreign minister and on December 4, I was sent out of the country. A light aircraft came to take me to Australia and then on to Europe and the U.S. I arrived in New York two days after the invasion, which took place on December 7 when I was mid-air between Asia and Europe. Two days later I was on my way to New York to plead the case of East Timor at the United Nations.

I arrived in New York in the midst of the North American winter. I had never been to a major city in my life and had never seen snow. My task as the newly appointed minister of foreign affairs of East Timor was to plead our case before the UN. I was lucky to have been helped by the newly independent

"Five thousand young people went from a church to a cemetery to pay tribute to a young Timorese student…shot inside the church by the Indonesian army. It was a very peaceful procession. Suddenly Indonesian special troops arrived with machine guns and started shooting at the people."

nation of Mozambique. They set up appointments for me and introduced me to the members of the Security Council. At the age of twenty-five I was probably the youngest foreign minister ever, certainly the youngest ever to address the Security Council. Along with the first two factors is the reality that I was the least experienced and most naive. So when I say I was the youngest it was not necessarily as a tribute but a defense. And though Indonesia was a powerful regional leader, courted by the U.S. in the post-Vietnam, anti-Communist, Cold War world, we managed a stunning unanimous decision in the Security Council. But that was also my first lesson in international hypocrisy. The same countries that voted to condemn the invasion and demand that Indonesia withdraw were the same ones selling weapons to Indonesia, enabling Indonesia to pursue the war in East Timor for the next twenty-three years.

The only country that gave us money at that time was Mozambique. By 1981 they were broke, so Angola, which had a bit more money, although at war, supported me with sometimes five hundred dollars a month, or one thousand dollars a month. That was how I survived. I lived mostly in run-down sublets of friends or of people I knew. Occasionally I would do translations for a friend of mine who worked with a church, translating funding requests from Portuguese, French, and Spanish, at ten dollars a page. And if I double-spaced them, she didn't mind. Later I had a full-time job for the Mozambique government in Washington as an advisor on American politics, media, and congressional relations. In 1988, I went to Oxford as a senior fellow. After that I moved to Australia. The late seventies were the darkest years in East Timor's history: 200,000 people died because of weapons sold by the Americans. My own sister Maria was killed by a plane delivered to Indonesia two weeks before by the Carter administration. Those planes

caused huge devastation in East Timor—my two brothers were also among the thousands killed. By the end of 1976–77, the Indonesian army was at a standstill. Because they never had a truly professional, disciplined army, they never expected such a huge resistance. They took thousands of casualties. If the U.S. had not intervened massively the Indonesian army probably would have been defeated militarily by the Timorese resistance force. So the Carter policy made a difference with a massive injection of weapons to Indonesia that changed the balance of power and prolonged the war for twenty years.

I'm not sure of what kept me going in those dark decades. Some people fight because they believe in world revolution. But I am not an ideological person and I don't believe in world Marxism. Nor am I a fundamentalist Catholic who believes in the dominance of the faith. Instead I thought of the spirits of those in East Timor, telling me to fight on. I was totally isolated in the U.S. and could have gone and taken a job, like so many exiles do, defected and gotten on with my life. Instead I worked on the cause of East Timor as a full-time job, twenty-four hours a day almost. I had no money but I would get in the bus and go anywhere in the U.S. to talk. I got an invitation to go to Milwaukee—I went and spoke there. A friend of mine had the brilliant idea that I should speak in Birmingham—so I took the bus there and found an audience of twelve Eritreans listening to me. One day I went all the way to Chicago because a very kind activist managed to get my name included in a big conference in a fancy hotel. Sharing the talk with me was a university professor with a very loud voice, Roger Clark of Rutgers University. There were all old ladies in the audience, most of them half-asleep. I was so polite I didn't want to wake them, so I talked softly. When it was the professor's turn, I wondered whether the ladies would have a heart attack. He definitely woke them up.

On November 12, 1991, five thousand young people went from a church to a cemetery to pay tribute to a young Timorese student who died two weeks earlier, shot inside the church by the Indonesian army. It was a very peaceful procession. Suddenly Indonesian special troops arrived with machine guns and started shooting at the people. At least five hundred died that particular day. Many were killed in hospitals by Indonesian doctors in collaboration with the army: poisoned with toxic pills, their skulls crushed with rocks. We had witnesses. Two of them (both paramedics) survived and escaped. One of them took samples of the pill given to people. Those pills were tested by forensic experts in London and found to be a highly toxic substance usually mixed with water to clean toilets. There were soon many more massacres. The difference between this one and the others is that an incredibly courageous British cameraman was there and filmed the whole massacre. As the Indonesians kept firing, he kept filming and when they stopped, he took out the tape and buried it in the cemetery. They took away some of the pictures he had left, and that night he climbed back into the cemetery to recover the film and smuggle it out of the country. He was lucky he was a foreigner and the Indonesian army was careful not to harm him. But after this things began to change greatly.

In December 1996 Bishop Belo and myself received the Nobel Peace Prize, which gave me easy access to international media and world government leaders. As you can understand, Indonesia was not too terribly pleased. I then became the target of a vicious campaign of innuendoes and physical threats—even death threats.

The citation was for more than twenty years of work, and for a peace plan which was based on a step-by-step resolution, strikingly similar to the Israeli-Palestinian Oslo peace accord which came out later. If the Indonesians had accepted it, war would have ended without further destruction and killings. Indonesia would still be here in an honorable way and East Timor would be enjoying a period of autonomy within Indonesia. A referendum would have been held at the end of twelve years from the day of signing. The problem is I was dealing with a dictatorship that does not understand that dialogue, concessions, and flexibility allow all sides to win. The military only understands the "we win" concept.

In spite of the relentless campaign of intimidation and bribery that went on for months, well over 90 percent of East Timor voted for independence. And according to internal UN sources an additional 6 percent of the votes were stolen through fraudulent ballot counting. Then came the violence. It was orchestrated. It was planned in minute detail over many months. Almost every town in East Timor was destroyed, almost every house. Not only of the rich, or the better off, but humble homes of the peasants, homes made of grass and thatch, all burned down. In one of the most unprecedented phenomena in modern history at least one-third of the population of the country was abducted at gunpoint and taken to another country via transport ship. My oldest sister (whom I had not seen in almost thirty years) was taken in a warship to Indonesia with her children. There are still over a hundred thousand of our citizens in West Timor camps. The repression was organized by an army with infrastructure, with money, with power. Two-thirds of the militias were from Indonesia (not East Timorese). This kind of violence was done by people alien to this society. Timorese who were part of the militias have surrendered saying they were given alcohol and totally possessed. There were hundreds of Indonesian police disguised as militia in the midst of shootings. But later they removed the disguises, and the army operated in uniform. My nieces who live on the south coast

> "It was the people who went to the phones, to the Internet, to the fax machines, sending a barrage of messages into Bill Clinton's office, to the U.S. State Department, to Tony Blair and Robin Cook in London, and to the French that made peace happen."

said there were never any militia there; instead it was the army burning things, because there were no journalists there—why bother hiding?

Meanwhile, during this bloodbath, I tell you, I was so sad, so alone. I had to handle hundreds of phone calls every day. I went to Washington and met with senators Patrick Leahy, and Tom Harkin, and people in the State Department like Thomas Pickering. I spoke at the National Press Club, and appeared on program after program for NBC, ABC, *Night Line*, and CNN—who were fantastic; I was on CNN constantly.

Hundreds of thousands of people made phone calls and sent Internet messages. And the tide began to change. At one point I thought if I didn't get the peacekeepers into East Timor, I would have failed. And I did not know what I would do with the rest of my life. I felt I betrayed the people, who trusted me, and because they trusted me, they took risks. I was constantly on the phone with people underground. Even in the worst times their phone was still working. I was on the phone to a Catholic priest, a great Jesuit priest. As the shooting was taking place he was under cover inside the house. I could hear on the phone cars driving by, killing, shooting. And he said, "I don't know if I will be alive a half hour from now." I tried to get the UN people to rescue him but even they did not feel safe. My own sister suddenly disappeared. But fortunately she and her family were next door to the UN and they managed just to jump the fence and enter the UN compound. I was in New Zealand attending the APEC summit when I heard President Clinton live from Washington say that Indonesia must invite the international community to intervene. And two days later the Indonesians did. Two days after that, I finally met President Clinton. Now meeting the most powerful man in the world was incredibly reassuring to all

Timorese, because once the president of the U.S. makes a decision, it's done. And Clinton was so personable, so charming, you feel totally at ease—and he asked pointed, informed questions. Much more intelligent than most journalists ask. That evening I phoned Xanana, the Resistance leader under house arrest in Jakarta, saying I had met with the president of the U.S. and was confident the peacekeeping forces would arrive soon—and so they did.

This turn of events was totally unprecedented for Indonesia. They were so used to crushing every opposition voice, peaceful demonstration, every dissident, to seeing their army as invincible—yet for the first time in history they were defeated. Scholars claimed they had never lost a battle though they failed to explain that the battles were against civilians. It showed the power of public opinion. Because it was the people who went to the phones, to the Internet, to the fax machines, sending a barrage of messages into Bill Clinton's office, to the U.S. State Department, to Tony Blair and Robin Cook in London, and to the French that made peace happen. In Australia tens of thousands were demonstrating. In Portugal over a million people demonstrated. And that made Clinton lead a charge to rescue the people of East Timor, and also showed that when the U.S. wants to use its power effectively for good, it can prevail. I am prepared to forgive the U.S. all sins of the past after this courageous leadership by Clinton.

Now you say this victory took courage, but I think more courage is required to be humble, to admit your mistakes, your sins, to be honest. More courage is required to forgive than is required to take up arms. Which means that I am not the most courageous person in the world. Because after all, courage is easier said than done.

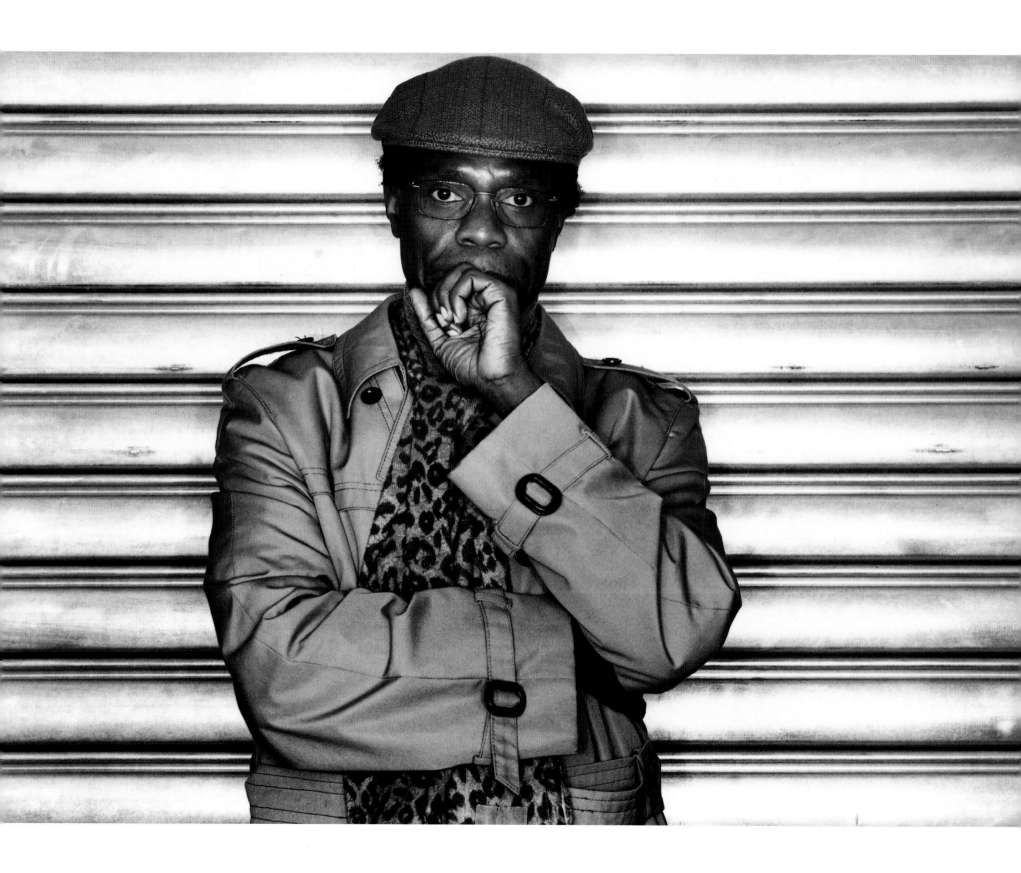

KOIGI WA WAMWERE

KENYA

POLITICAL RIGHTS

"I was put in the basement police cells and woke up in a sea
of water. I was naked and had been sitting in it all night. I stayed
in that water for about one month."

Koigi wa Wamwere is one of Kenya's best-known political prisoners. Author of several books, plays, and poetry, wa Wamwere was born to a poor family in a forest community, did well in school, and was awarded a scholarship to study at Cornell University, where he graduated in 1973. He returned to Kenya to work for democratic reforms, running for parliament in 1974, until his criticism of the Kenyan president and his government led to wa Wamwere's arrest in 1975. He was held with no charges, no judge, and no jury for three years. Released in December 1978, in 1979 he again ran for parliament and won. He served a poor rural district for the next three years. From August 1982 until December 1984, wa Wamwere was again held in prison without charges. In June 1986, he sought exile in Norway. On a visit to Uganda in 1990, Kenya's security forces crossed the international border, kidnapped wa Wamwere and detained him until 1993. Again he fled into exile. And again he returned to Kenya, where this time he was arrested on trumped-up charges that carried the death penalty. He was released on December 13, 1996, after domestic and international pressure on the government, to seek a treatment abroad for a heart condition. Wa Wamwere received a show trial and was sentenced in 1995 to four years in prison and six lashes with a cane. His lifetime of unrelenting activism for democracy and nonviolence has meant detention, torture, and imprisonment for much of his adult life. He has emerged from those experiences with a wisdom and a sense of peace almost beyond imagination.

Human rights work is actually a struggle to preserve life, one I have been involved in for a long time. Consciously, I got involved in the struggle for human rights as a struggle for democratic rights, since initially I saw human rights as the cornerstone of democratic freedoms.

As a student at Cornell University in 1971 I began asking why Kenya couldn't have those basic freedoms. I saw American life was a lot more open, that people could criticize their president and demonstrate openly. I encountered the writings and speeches of Martin Luther King, of Robert Kennedy and his brother John F. Kennedy, and those of Malcolm X. They inspired me to fight; they completely changed my life—completely. I had gone to Cornell to study hotel management, but I instead learned about the struggle for human rights. Once that dream was implanted in my mind, I could not do anything but pack my bags and return home to start what was going to turn out to be a long struggle.

When I returned to Nairobi in February 1973, Jomo Kenyatta was still president and calling for his ouster was tantamount to suicide. Nevertheless, I started saying openly that things in my country were not going the right way. It was a shock for people at home to hear me speaking critically and overtly about what was going on. I was lucky to have the support of my brother, and we very quickly put together a team of five young men who shared our dreams of respect for human rights, equality, and an end to corruption. We did not know how to go about the fight, where to start. And I decided that the most definite means of exposing the problems was through the press. So I became a freelance journalist. I had a feature article every week, and each time I published, the police would come and take me to the police station and have me interrogated. People thought that what I was doing was sheer madness. The police would take me to the station, interrogate me, charge me, and then I would be taken to court. Then most of these cases would get thrown out. They would

ask me to go home. I wonder what gave me the strength to go on; I guess the dream that I dreamt was so strong that it gave me a lot of energy to continue.

One article I wrote that attracted a lot of attention dealt with working conditions for forest workers. I was born and raised in a forest area, and my father and mother were forest workers, so I knew what I was talking about. It compared the treatment of forest workers in Kenya with similar workers in Tanzania. When the British were the colonial power here, all the workers between Kenya and Tanzania were treated more or less the same because the administration was identical. But after independence the Tanzanians were suddenly able to move forward whereas Kenyans remained just where they were. Besides writing, I went out and photographed the housing. The exposure of these working conditions made the government so angry. One well-known official in the government, Secretary Shamala, said I should pack and move to Tanzania. (Years later, however, he defended me in my treason case.)

In another attention-getting piece, I wrote about tribalism as a part of the ideology of exploitation. Again, it made people very angry. It seemed wrong the way the government was discriminating against certain tribes while allowing others to feel the government belongs to them exclusively, but that point of view meant I was called a traitor. I then wrote about corruption in government-controlled companies, a major issue. What was happening was that peo-

ple would collect money from peasants promising that they would buy land for them, and, in one typical instance, bought a big farm, only to afterwards throw the people out and keep the farm to themselves. And so I wrote about it.

Sometimes, I was risking my life to write about these things, but I wasn't thinking of it as a risk. After a while, though, things got worse. I had to go into exile at one point, because the threats were serious. And even while I was in exile (in Norway at this point) they sent people to try and assassinate me.

The first time they sent two people, an Italian and the son of a Malian diplomat in Nairobi. They were searched in Sweden after the train crossed the border and the Italian's gun was discovered so he was detained. The second hit man managed to make it to the Oslo train station. He had been given a Kenyan-Somali contact, but all Somalis looked the same to him, so the first Somali he saw he called over and said, "Here are the goods." The Somali thought the package was a kind of leaf that we chew to stay awake. But when he opened it, he saw it was a G-3 rifle with four hundred rounds of ammunition. He got the shock of his life. So he called the police. Then that man got arrested and finally confessed that he had been sent to come and kill me.

A little later they asked someone to hijack a plane I was taking from London to Tanzania. The man demanded to know, "What is my protection? What happens

> "Life is a permanent struggle between good and evil. In this struggle there isn't room for neutrality. I couldn't possibly see myself crossing the floor to the other side. I could never be at peace with myself. I would rather die."

after the hijacking?" And they really couldn't guarantee him anything. Strange, because when he first told me this story, I dismissed him. But then I realized he was telling the truth and I got the Norwegian police involved. We bugged my living room, then I invited him home to talk about it and be photographed by TV people. I said, "I think you are lying about all these stories," and he said, "How can I prove I am not?" I told him, "Let's go to the police and report this." He said, "Let's go to the commissioner of police." He told the commissioner, "Look, if you don't believe me I'll call the State House in Kenya." So he called and the operator knew him and put him right through. There was no way that kind of internal State House telephone transfer would have been made if they didn't know him very well. It became a big diplomatic incident.

Another time they sent somebody who pretended to be a bishop. He said he was the former chairman of the National Christian Council in exile and dressed exactly the part. He really fooled me. At home we did not eat without saying prayers. He would say prayers, which made me very embarrassed when I found out he was a fake. At one point I asked him to speak to the BBC about relations in Kenya and after the interview was broadcast the BBC called me. They said, "This isn't Bishop X; the real bishop is complaining!" He ended up confessing, saying he had been sent by the State House and giving us numbers of his contacts there. These were direct numbers to the president. It turned out he had been promised three million shillings if he could assassinate or kidnap me.

Another time, when I went to Uganda to visit, I tried to contact people at home. During the day I came out of the hotel in a town which straddles the Uganda and the Kenya side of the border, and I didn't know that security people go back and forth. That time I was in the company of somebody who actually, I think, sold me out.

I remember the day I was captured. It was July 1990. I noticed some people at the table, especially one woman who definitely looked Kenyan, looking at me. (Eastern Ugandans and the Eastern Kenyans have a complexion that is slightly different; Ugandans are darker.) Anyway, not a local person. I asked the innkeeper if Kenyans came there and I was told they did, so I decided to go back into the room. Later that night about five people, all masked, captured me. I never knew who they were. They kidnapped me from Uganda and brought me to Kenya. They first put me in prison, then went around to arrest my friends. My brothers were arrested and we all were charged with treason. One thing I didn't understand was why they didn't kill me. I was put in the basement police cells and woke up in a sea of water. I was naked and had been sitting in it all night. I stayed in that water for about one month. About a foot of water goes into the basement cell. They could freeze that water, make it so cold that you froze and shivered uncontrollably, and then make it so hot you felt like suffocating. The changes in temperature gave me a lot of pain. Of course they didn't give me

food. I was only given something to drink when I was under interrogation. I spent a month alone in isolation. I was interrogated during the day. They threatened to throw me off the roof. It was very scary.

I was brought before this panel at one point and one of the men stood up and said, "Now you know we have you in our hands," and I just said, "Yes." He said, "Do you accept that we are stronger than you?" I said, "Yes, but only to the extent that you have the police, the army, and all this. But my ideas are stronger than yours. What I am fighting for is greater than what you are trying to protect, so I don't accept you as my master." He said, "Look, I'll give you a deal. I am stretching out my hand to you; if you shake my hand you can go home. If you can't beat them, join them. That is what we are offering you. Shake my hand and you can go home with all your friends that are here." He put his hand forward and I said, "No." He said, "In that case you have to die." So I was blindfolded and handcuffed and returned to the cell. He said, "In a few days you will be taken to court and charged with treason."

Why didn't I shake his hand? Because of my conviction that if I tried to make peace with these people it would be like making peace with the devil. Life is a permanent struggle between good and evil. In this struggle there isn't room for neutrality. I couldn't possibly see myself crossing the floor to the other side. I could never be at peace with myself. I would rather die.

My mother went around the country trying to find a lawyer to defend me and only Shamala would do it. It was very, very brave of him to agree; and eventually we were released.

In 1975, they rounded us up and detained us without trial. I stayed in prison until December 1978. Then I came out and ran for parliament from a constituency that needed someone to speak for the poor. President Moi then invited me for breakfast. Initially, he spoke well of me and, because he sounded like a person who wanted to make a break with Kenya's past, I thought highly of him. I didn't know it wasn't going to last until we went to a rally somewhere and on the way back I remember very clearly people lining the road shouting, "Joshua! Joshua! Joshua!" Two days later, the president invited Jane, my wife, and me, for breakfast. He started telling me that he didn't want me talking on behalf of the dispossessed and I should stop asking for better land distribution and for repeal of detention. He said, "Let sleeping dogs lie or you will be the one to lie." I told him I understood the threat. He said to take his advice or I wouldn't get far.

Then I asked him if he remembered the meeting when people called him "Joshua." He pretended not to know what that meant. I told him that in Jomo Kenyatta, Kenyans had their Moses, who led them out of Egypt, but instead of taking them to the Promised Land, left them in the desert, when he died. I said, "Now Kenyans look upon you as their Joshua that will take them to the Promised Land. But you cannot take them to the land of milk and honey unless

"He said, 'Do you accept that we are stronger than you?' I said, "Only to the extent that you have the police, the army. But my ideas are stronger than yours. What I am fighting for is greater than what you are trying to protect....He said, 'In that case you have to die.'"

you give them freedom, unless you give them better wages, unless you give them land." I told him it was necessary to end the corruption. I told him he had led people to believe he would be a Joshua and so he should not let them down.

And again I was in prison, from 1982 until December 1984. I left the country in 1986 and went to Norway until 1990, only to be arrested again in Uganda and in prison until February 1993. I returned to Norway and then went to Kenya that September and was immediately rearrested. This was the time of ethnic clashes, and we had started the National Democratic and Human Rights Organization (NDEHURIO) to fight for human rights, investigate human rights violations, and expose the role of the government in perpetrating ethnic clashes.

At this point, things became tougher. I was having breakfast with my friend and lawyer Gibson Kamau Kuria at his home in Nairobi when we heard on the news that there had been a raid on a police station in a town a few hours away. Gibson said, "If you were in the Rift Valley, you could have been very easily accused of being connected with that raid." One of my friends said they could still do it. Gibson was very angry, since he believed that this was going beyond what they were capable of. But that Friday they did exactly what was predicted: they arrested me for the robbery on the police station, a complete frame-up.

When the police gave evidence against me in the witness box, they would give embarrassed smiles and look down. Some even admitted that their fabrication of the crime was shoddy and ridiculous. A lady in the Danish Embassy wanted to testify that we were together that night, at Gibson's house, but was instructed not to by the Danish Foreign Ministry. There was lots and lots of pressure from the international community, from the Robert F. Kennedy Center for Human Rights to Amnesty International.

But at this point, I had been in prison for two and a half years for treason, detained with charges, but without trial. They had me on death row and it was pretty clear that they were going to find us guilty. This was a classic mistrial. We could not give evidence in court. We could not cross-examine. Our lawyers were not allowed to give summing up arguments. This magistrate was behaving like somebody gone mad—although I sympathized with him because he exhibited a lot of sadness, as though he was being forced to do something he did not want to do. His children, his wife, and even his brother came to see me in the cells. It was a strange thing. Finally this magistrate decided to hand down the death sentence. But just then dictator Moi grew cold feet. You see, I have always felt that there was always some coordination between Moi and military dictator Abacha of Nigeria in their determination to hold onto power and their joint defiance of world opinion against them. But Abacha was always the leader and when world pressure against him in the wake of his execution of the prominent Nigerian writer Ken Sera Wiwa led to sanctions and suspension of Nigeria from the Commonwealth, Moi, the weaker of the two, no longer had the guts to proceed with our executions. And so we got a jail sentence instead of a death sentence. So in a way, like Christ, the condemnation and death of many in Nigeria led to our own redemption.

BISHOP WISSA

———

RELIGIOUS FREEDOM

"Protecting my people is part of my job. This is what
I am supposed to do. If you were at your house and someone
was beating up your child, wouldn't you stop him?"

*The Coptic (Egyptian Christian) Church traces its roots to Saint Mark, who is believed
to have established it in Alexandria in A.D. 64. Since that time, Copts have been at best
grudgingly tolerated, but often persecuted outright in Egypt. Today, there are nearly
ten million Copts living in Egyptian territory who face frequent harassment at the
hands of state and local authorities. Bishop Wissa's story is a visceral example of con-
tinuous oppression. On August 15, 1998, thirty-five miles north of Luxor, five Muslims
from the village of el-Kosheh allegedly murdered two Christians from their communi-
ty. The police investigating the case went on a rampage, and in the next two months
arrested and imprisoned twelve hundred Christians. More than half of the children,
women, and men arrested reported being tortured, many by beatings, whippings, and
electric shock to ears and genitals. Bishop Wissa witnessed the events in el-Kosheh, his
diocese, and personally interviewed over eight hundred victims. He reported the abus-
es to Egyptian authorities, human rights organizations, and the international commu-
nity. On May 9, 1999, the interior minister dropped the investigation and authorities
then arrested Wissa and charged him with defamation and other criminal offenses.
Bishop Wissa's trial is not yet over, and his courage in speaking out against discrimi-
nation and injustice deserves universal support.*

It was last summer, on August 15, 1998, that two people, both Copts, were killed
and the police started investigating. They started with detentions. Fifty, sixty people
a day, also Copts, were rounded up and held for weeks. Then they tortured people
with all forms of violence. They coerced people to testify falsely. I heard the screams
of people who were being tortured, so I went to meet the prosecutor of the state

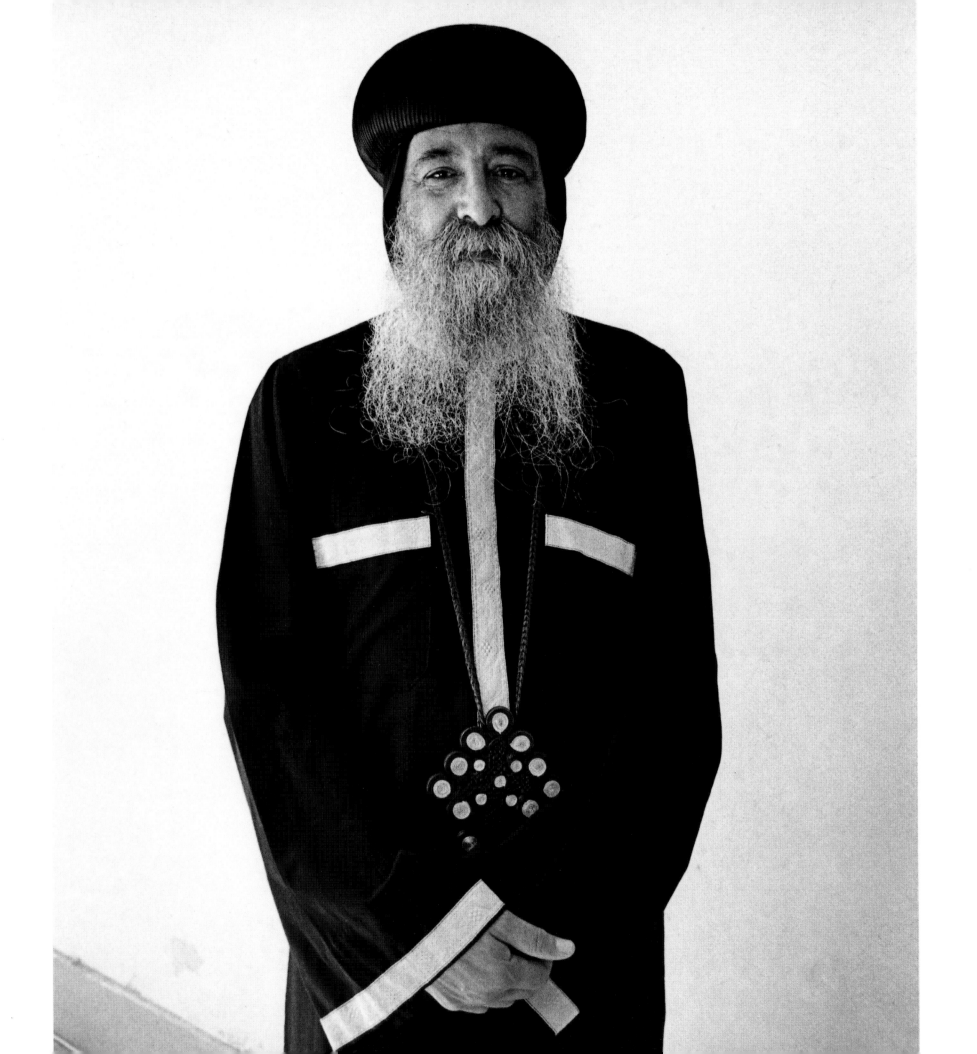

security board. I sat with him for an hour explaining all the circumstances in this village. I asked him to conduct legal investigations and to cease detaining and torturing people. But after I left nothing changed.

A week later, the police director in charge of the area arrived. I sent a bishop and two priests to meet him. They had a two-hour meeting; the first hour was very harsh. The police director told them that this area had not seen anything yet. He then realized that the priests and bishop were just as tough on their stand. He became nicer to them and he told them that a man called Michael was the murderer, that he was responsible, and said, "If I were you, I would advise him to go and turn himself in and confess." The police said that the two men who had been killed attacked Michael's daughter, sexually raped her, and she became pregnant. And so the police started torturing all of Michael's family, even his wife, and his youngest child. They took the boy to the desert and left the ten-year-old child there. A few weeks later the girl who had been allegedly raped by these two men came to my office. We had her medically examined and she was a virgin. So we proved that her father was not the killer.

The police then started looking for another killer. But the mass torture continued. They tortured by electricity; by applying electronic shock to sensitive areas, private parts of the body. They hung people upside down from their feet, tied them up as if they were crucified, stomped on them, hit them with sticks or whips. They would take their clothes off and throw cold water on their bodies, even on women. The torture sessions were very bad. I sent many memorandums to human rights groups even though I couldn't explain the depth of the ugliness of the torture. On September 17, the assistant to the minister of interior visited that area called el-Kosheh. He met with all the people who were tortured, taking each case individually. One man walked in. He didn't say anything. He just took off his clothes and showed traces of torture: whips and sticks, bruises. Then the two children, a small boy with his sister, came and described their situation. The sister, one year older than the boy, said that she was electrocuted on her chest and they both started crying.

The assistant to the minister of interior said: "All right, I know the situation now and I will tell the minister." So after that he went to the police and he released Michael Boktor and his two sons. They had spent one month and two days in prison. But to our surprise, they instead charged the cousin of one of the men who was killed. On September 18, fifteen people from the village of el-Kosheh (in the city of Sohâg five hundred miles south of Cairo) who were tortured went to the criminal prosecutor and showed him all their

> **"In spite of this overwhelming amount of evidence against the police, nobody would prosecute the government."**

scars and said they wanted to press charges against the four policemen responsible. The general prosecutor of Sohâg decided to transfer them to the medical examiner and pathologist. Then the medical examiner referred two people who were in critical condition to a bigger place. But nothing happened—in spite of this overwhelming amount of evidence against the police, nobody would prosecute the government. There were many people who wanted to file complaints against the police but they backed off when they realized that no action was taken. This was an incident that stirred up a huge reaction in Egypt and among international human rights groups.

We had a lot of discussions with His Holiness Pope Shenouda III of Alexandria and met with the minister's advisers and the president's advisers. But again, no action was taken to right the wrongs. On October 10, I, along with two other priests, was called by the criminal prosecutor for questioning. I was questioned on allegations that I coerced witnesses to change their testimonies, that I was hiding the evidence of crimes, that I was destroying the national unity of the country, and that when I preach, I preach against the government. The same five accusations were also levied against the two priests. And though the farmers reopened their case with the new attorney general, Maher Abdul-Wahed, again the inquiry was halted, with the prosecutor claiming the victims' scars were old

and no evidence linked the police to torture. Last week they finally closed the investigation of the four policemen who were accused of torturing the twelve hundred people. Not only were the police acquitted, they were each awarded one thousand Egyptian pounds for their trouble! They were not held accountable for anything. I am sorry to say that, but this is what happened.

But why should I be scared? They can't torture me because I am a religious man. My only crime is to have met all these high-ranking officials and sent memorandums to the president. I also appealed to Hafez Al Sayed Seada of the Egyptian Organization for Human Rights. And Hafez sent people from his organization to the village and they looked at the situation. They wrote a twenty-six-page report which was translated into English and sent everywhere in the world. That is all I did. Why should I be scared?

I have to defend my parishioners until the day I die. These are my children. Don't they call me father? If you went to the Coptic churches, you would see that they are filled with people. Protecting my people is part of my job. This is what I am supposed to do. If you were at your house and someone was beating up your child, wouldn't you stop them? Now if I see my children being tortured and screaming for help and I am quiet about it, I wouldn't be a good person.

KEK GALABRU

POLITICAL PARTICIPATION AND CHILDREN'S RIGHTS

"The authorities push the family to take poison,
so they die, the mother, the father, so many children, at the same time."

Born on October 4, 1942, Kek Galabru received her medical degree in France in 1968. She practiced medicine and conducted research in Phnom Penh from 1968 to 1971, and continued her work in Canada, Brazil, and Angola. In 1987–1988 Galabru played a key role in opening negotiations between Hun Sen, president of the Cambodian Council of Ministers, and Prince Sihanouk of the opposition. That led to peace accords ending the civil war in 1991, elections held under the auspices of the United Nations. Galabru founded the Cambodian League for the Promotion and Defense of Human Rights (LICADHO) during the United Nations transition period. LICADHO promotes human rights, with a special emphasis on women's and children's rights, monitors violations, and disseminates educational information about rights. During the 1993 elections, LICADHO's 159 staff members taught voting procedures to sixteen thousand people, trained 775 election observers, and produced and distributed one million voting leaflets. Since then, LICADHO continues to monitor abuses, provide medical care, legal aid, and advocacy to victims, as well as offering direct assistance to victims of human rights violations.

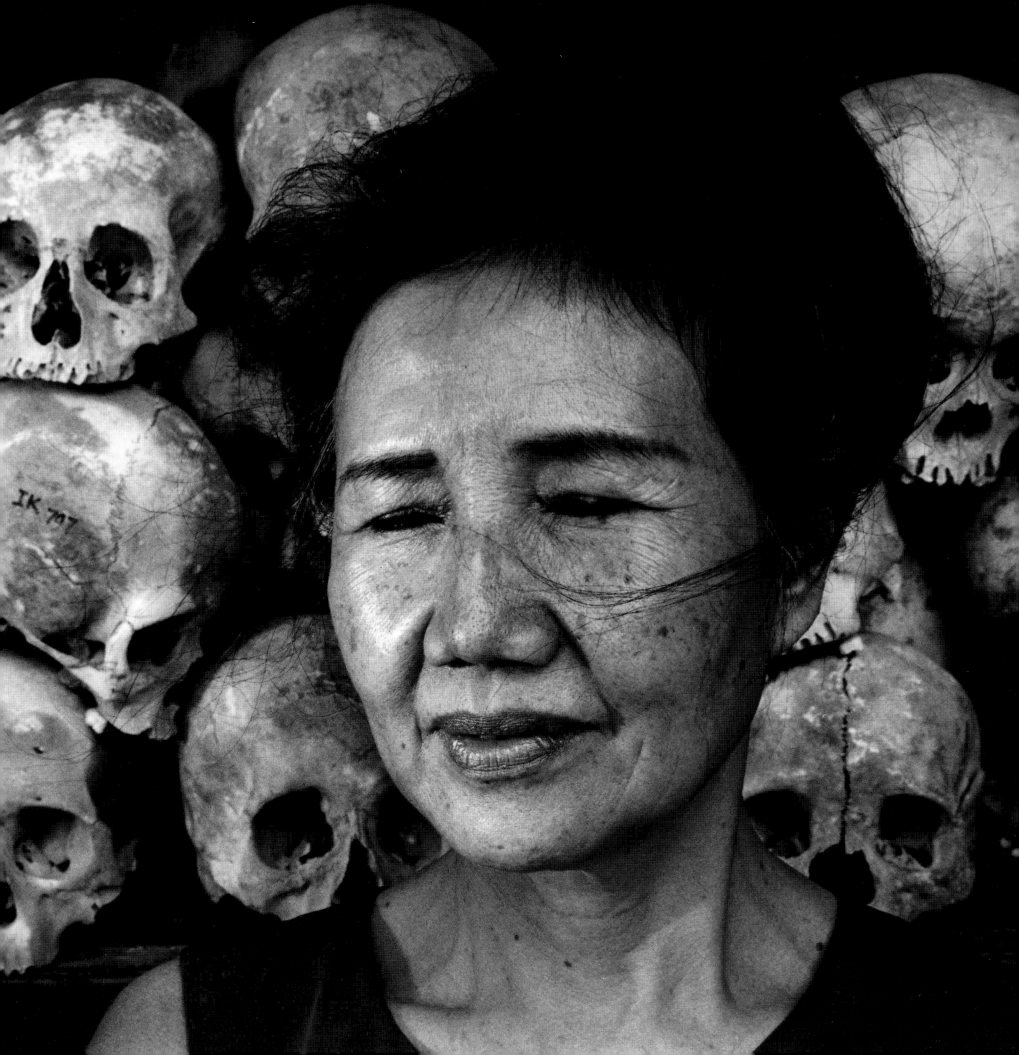

When the United Nations took over Cambodia with twenty thousand officers, we decided to start LICADHO (Cambodian League for the Promotion and Defense of Human Rights). We didn't have any money, so we opened a small office at my parents' home. Word spread quickly about this new organization, and within five or six months we had 180,000 supporters, all volunteers.

We wanted the UN to spearhead the elections and monitor the process, because that was the only way that this work could be protected. When the Royalist Party emerged in Cambodia to campaign for the 1993 election, the CPP (Cambodian People's Party and the ruling party) began to shoot the Royalist opposition in front of us. We were witnesses, and so was the UN. But the UN could do nothing because according to its mandate, they could only respond if they were attacked. For me it was unbelievable that I was going to be the watchdog of such a regime. But the purpose of LICADHO was to create an environment in which these practices would never occur again. What we saw the regime in Cambodia do was almost the same thing as the Khmer Rouge. Along with the UN, this time we documented the killings. In less than one year, hundreds of people were wounded and scores had died. Even though the ruling party could kill people, they could not stop the UN and the peace accord, and they had to permit the UN to go everywhere.

The UN set up a good network. They organized fifty thousand Cambodian volunteers for voter education. We published almost five hundred thousand booklets of the Universal Declaration of Human Rights to distribute to people, and a million one-page leaflets showing that you could vote by secret ballot. This was important because the CPP explained to people that they had a satellite that could see in the booths and tell whom you were voting for; and that if you didn't vote for them they would know. The CPP also brought people in front of Buddha and forced them to swear for whom they were going to vote, and as the CPP members were holding guns, people were afraid to vote against them. Then the CPP

told them that if they don't respect their oath, Buddha would punish them with death. But we told them that Buddha is good and respects justice, that he would punish the ones violating human rights, and protect the victims. We said that when they went into the booths they would be alone to vote for whomever they liked, but we warned them not to talk afterwards. Despite the intimidation of the CPP, more than 90 percent of the people showed up to vote. And they voted for the Royalist Party, and when it won, they talked. The CPP told them to be careful, to not trust so much in the UN. They said the UN is like a boat: the boat leaves, but they are the port and they will stay here, permanently.

Now we have peace at last, but we have had a civil war since 1970 and, as a result, we have a lot of children in the street, living in bad conditions. Sometimes they are orphans, with no parents at all; sometimes they have only one parent, usually their mother. Their fathers were killed. Or their parents are too poor so the children have to try and live on their own: paint a can to sell so they can get twenty-five cents per day; sleep in the street. They are prey to foreigners who come to Cambodia for sexual tourism, pigs. Asian men in the region prefer young girls; European pedophiles prefer boys. We have many brothels and at night you will pass those brothels and find young children—eleven or twelve years old. We talked to one, only thirteen. She was already in the brothel for two years. Asian men believe that after a certain age, say fifty, if they have sexual relations with a virgin girl they become younger. By having sex with a virgin they take all the energy, all the good things from the virgin, to themselves. Now, since we have the problem of AIDS, they especially want a real virgin, because they don't wear condoms. So they send an intermediary to the village to find a very poor family and buy girls for sex. The intermediary pays the family saying, "Your daughter can work in a restaurant or clean the house of my friend: here, I know that you are very poor, here is a hundred dollars." For them a hundred dollars is a lot of money. They don't even have ten dollars at home. Then the intermediary sells the

girl to a client for between five hundred and seven hundred dollars. The man stays with the girl for one or two weeks—it's up to him, but not more than one month, because by then he's used up all the good things from the girl. After, she is sold to a brothel for two hundred dollars. Her life will be a nightmare.

One girl whose mother sold her to a brothel doesn't hate her mother. She said, "This is my karma," meaning that in her previous life she did something very bad and has to pay for the error. The girl explained, "I have to be kind with my mother because my mother is still the person who gave life to me." That girl still sends money to her mother. Government statistics say that there are twenty thousand child prostitutes in Cambodia. But we think you can multiply that number by three or four, maybe five. There are a lot but we cannot go everywhere. As it is illegal, people hide. Still, everybody knows. This is very sad and hard for us.

Child workers are another big problem. The government closes its eyes to the situation and is angry because we denounce child labor. They say, "Do you prefer children dying?" We reply, "It's good if they work, as long as it's not dangerous work." Children should go to school, but the schools are not free because of the low salary of the teachers, who get less than twenty dollars a month. You need at least two hundred dollars to live a normal life in Cambodia. And if you are sick, you borrow the money from somebody and you pay 20 percent interest per month, so people sell all their land, their house, and they become homeless. Or else the family prefers the children die. When a situation develops like this, the authorities push the family to take poison: and so the whole family dies: the mother, the father, many children at the same time. They prefer dying like that to dying from starvation. It's too hard, you know, when children are crying out, "I'm hungry, I'm hungry." We have very high infant mortality. The highest in the world, I think. A hundred and eighty children out of a thousand die before reaching five years. In your country or in Europe, maybe less than one child dies out of a thousand.

Many times with our work, we were so depressed. Sometimes we felt like asking somebody to take care of LICADHO so we could run away because it's too much for us. It could be easy for us to take our suitcases, pack, and then take an airplane and not look back. But then we said, "Impossible, they trust us." They come and work and don't take money, although they have nothing. When we need them to monitor elections, they are here. And what we do is important—during the coup and after the coup, how many people did we save? When a victim comes to see us, they say, "I know that I would have died if you were not here." That gives us more energy. If we only saved one person—it's a victory.

There are around six to nine hundred people tortured by the police in custody every year to whom we give medical assistance. Every month we help one hundred thousand to two hundred thousand people. Without us they would die. In prison, they don't have food. Just one bowl of rice and no protein, ever. Sometimes they don't even have drinking water. People ask why we help criminals in prison. But not everybody in prison is a criminal. And even if they are criminals, they at least have the right to food and medical care. One woman owed fifty dollars, so she got two years in jail. And when she got out, she still could not pay, so she went back for four years. Four years for fifty dollars. We paid for her and she got out.

It's hard sometimes. But as I told my staff, now I have energy to work with you, but please learn how to do the job, as LICADHO is yours and not mine at all. Because one day, I will need some rest. I am fifty-six years old already; some day I will have to take care of my grandchildren. They have to continue the work alone. They have a lot of courage—and for me courage means that despite the intimidation of the ruling party, you do something good for the people, for the grassroots, for your country.

ANONYMOUS

SUDAN

———

HUMAN RIGHTS

"We are helping the people. The problem is that the government doesn't want this type of help. It is certainly to the government's benefit that people don't know much about laws because then people will not demand any rights. This is one reason why it would be difficult for me to reveal my name."

Freedom House, an organization based in Washington, D.C., describes the dire state of repression in Sudan, so perilous for human rights that it is the only place in the world where we were asked not to reveal the identity of the defender: "The Sudanese government and its agents are bombing, burning, and raiding southern villages, enslaving thousands of women and children, kidnapping and forcibly converting Christian boys, sending them to the front as cannon fodder, annihilating entire villages or relocating them into concentration camps called "peace villages," and preventing food from reaching starving villages. Individual Christians, including clergy, continue to be imprisoned, flogged, tortured, assassinated, and even crucified for their faith. Sudan gained independence from Britain in 1956. Thirty years later, Islamic extremists based in Khartoum seized control of the democratically elected government, launching a holy war against their own Christian citizens in the south. This war has led to the deaths of 1.5 million people and the displacement of 5 million more. Another 2.6 million people are at imminent risk of starvation, due to the regime's scorched-earth campaign and refusal to allow access to international relief agencies. The reign of terror reaches far beyond the Christian community, to every person, animist and Muslim alike, who is suspected of failing to adhere to the government's arbitrary code of conduct. Against all odds, and under threat of certain brutal torture and death, this human rights defender we call Anonymous spreads the word of liberty, offering Sudanese compatriots a path to a better future.

I became involved in human rights because of the political situation in Sudan, when I lost my job in 1989 along with ten thousand others. The government wanted to ensure that those not affiliated with the official agenda were marginalized. I felt that we who were lucky and who had an education needed to help those with the greatest need, people who lost their basic rights and who were arrested on a nearly daily basis. We were able to extend our activities in refugee areas and around some parts of the country.

We began by raising public awareness of the negative effects of the government policy of organized mass marriages. These marriages were one of the crucial points in the political agenda. The idea was to encourage marriage to promote an image of "a good Muslim" and to discourage promiscuity and sexual dissidence. The government organizes festivals and calls people to register their names. They gather over five hundred couples at a time by bribing them with fifteen thousand Sudanese pounds and sometimes a piece of land. Given the poor state of the economy, people are encouraged to get involved in these marriages, accepting the idea that their daughter will marry a person who has married three or four times in the past, as long as it relieves them of the responsibility of having the daughter.

So these young girls marry, become pregnant, and then after collecting the money and the land, their husbands run away. In the end the women are left alone with a child to raise. They go to the *Sharia* courts in the hope of gaining maintenance fees from their husbands, but this rarely works.

Instead, as Sudan PANA (the Pan African News Agency) reported on February 1, 2000, courts in Sudan have divorced some twenty-five thousand husbands in absentia in the past three years. In such cases, the law gives the defendant a month's notice to appear before the court after a divorce advertisement is published in a newspaper. If the ultimatum expires and the husband does not comply, the court will automatically divorce the wife "in his absence."

We monitor human rights violations like these, we discuss existing laws with women's groups to raise awareness, and we network among different groups to

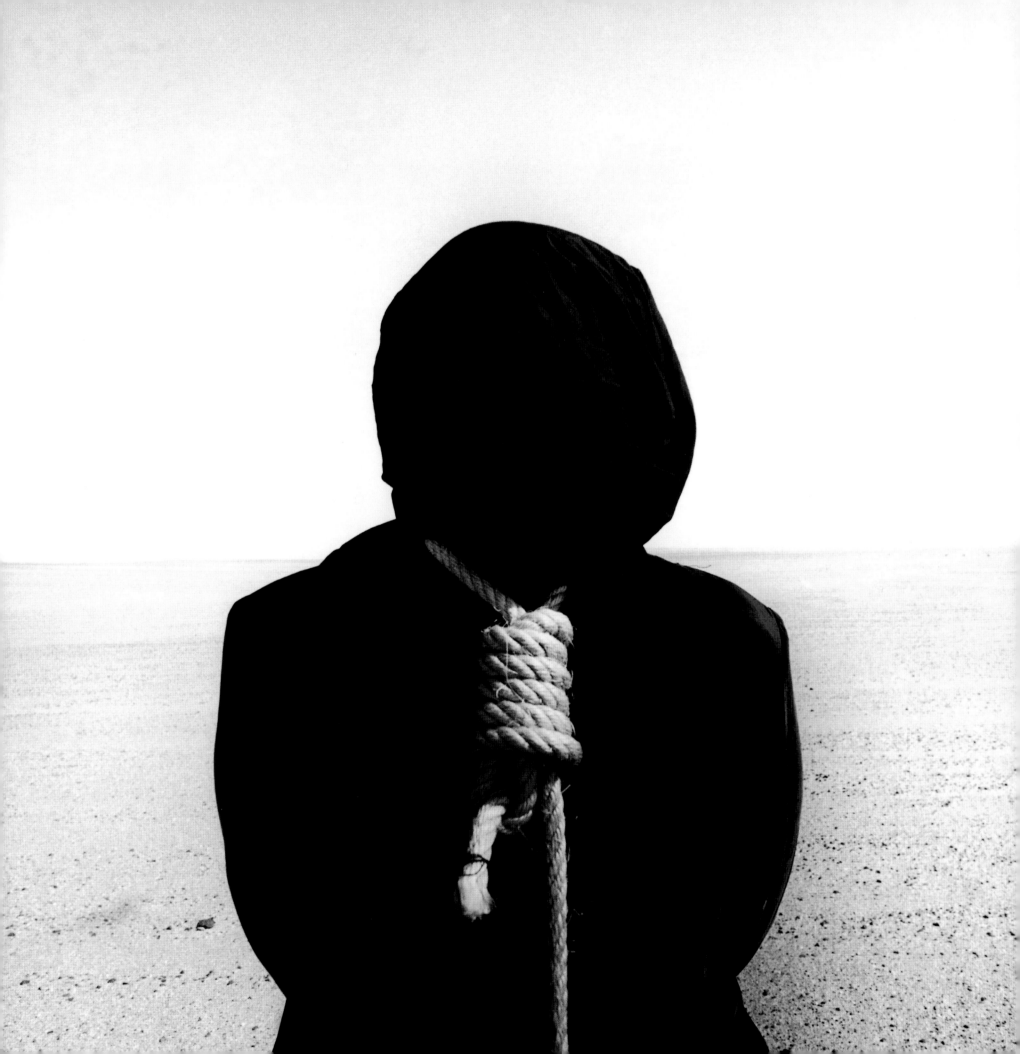

mobilize against these laws. Furthermore, we train young people to provide legal aid for the increasing number of displaced communities.

The vast majority of families in squatter communities are headed by women. The husbands are usually soldiers or unemployed men, so the women are forced to work. The easiest way to get money is to go in the streets and become a street vendor—selling tea or brewing the local alcohol, which is a traditional women's practice in the south and west. The women are, however, not aware that they are working illegally. They are subsequently arrested by the popular police force who search their houses, confiscate their belongings, and destroy their dwellings. Worse, the women can be lashed and fined £150,000 or more. One of our tasks has been to find some income-generating activities for these women. We go to courts on the behalf of the women arrested. And through networking developed with different organizations we started collecting money to pay the fines, a sum that was constantly increasing as these fines were revenue sources for the government.

We are helping the people, especially women, to become aware of their rights as human beings and as Sudanese, no matter what their ethnic group or religion is. The problem is that the government doesn't want this type of help. It is certainly to the government's benefit that people don't know much about the laws because then people will not demand any rights. This is one reason why it would be difficult for me to reveal my name. Those whom the government suspects of working on human rights are arrested, often tortured in ghost houses (which are unknown detention centers) or, if one is lucky, put in prison for an undetermined period of time. Just recently we had a journalist arrested who was kept in jail for a short while, comparatively—only two months. But he was tortured with both knees broken and his feet burned. They didn't want to release him because they were afraid that his family would object, so they kept him until his feet healed, just a week ago. There are so many incidents of the sort, as well as disappearances. People frequently disappear or are arrested, and the security people come the next day and say they died of "natural" causes. A well-known physician, the late Dr. Ali Fadl, arrested early on, in 1992, was tortured and developed a brain abscess, dying soon after. The death certificate indicated that he had cerebral malaria. His father was not allowed to take the body or even to see it, and the burial was done by security forces. This is only one of many cases.

As a consequence of the war, all young people in our country, after taking university entrance exams, are drafted and sent to *jihad*. They are given less than a month training—not nearly enough—handed weapons, and sent to the front. A group of forcibly conscripted boys escaped from a camp north of Khartoum last year. When the guards found out, they started shooting at them. The boys ran to the river but some did not know how to swim. More than fifteen were shot dead. This incident became public knowledge when the bodies floated along the Nile. Until that time the government denied it, claiming that the kids had attempted to escape, that they had gotten on a boat which had sunk, and that they had drowned as a consequence. But that was not true. They actually shot these poor boys while they were trying to swim or hide in the river.

The best way to stop these abuses is for people to be aware of their rights, especially deprived and displaced women. Over the past few years about seventeen NGOs working in women's rights have been formed. Women are forming cooperatives, developing income-generating projects, and the good thing is that these women are coming together independently of their ethnicity, religion, and race. This activity is even having an effect among Sudanese women outside the country. What is going on today seems to transcend political affiliation, and while it is slow, it is very encouraging.

Women have a particularly difficult situation in Sudan. First of all, the government issued a series of laws that restricted fundamental women's rights. Any woman who is traveling must submit her visa application to the Women's Committee at the Ministry of Interior. This committee makes sure that the woman in question has a male guardian to accompany her and that she has the consent of her husband. Second, a strict dress code dictates that every woman must cover her head and her hair completely, and wear a long dress covering her ankles. Employed women cannot hope to attain senior posts. There is a very well-known incident in the police department where two of the women reached the level of commander and were subsequently asked to resign. The government also changed family law to encourage polygamy and to give men more freedom, including making it easier for them to obtain a divorce. According to Islam, women are supposed to have access to divorce just as easily as men do. In practice, it is

extremely difficult for a woman to ask for divorce while a man can proceed with no explanations whatsoever.

Under the new family law, a man can declare *nashis* (violation of marital duties) when a woman does not obey. The husband is then allowed to place his unruly wife in an obedience home. He can refuse to divorce claiming that she, for example, goes out without his permission. This is considered sufficient justification. The government has also imposed a series of new inheritance laws that are also discriminatory to women. These new moral codes have terrible implications for society. Even if you, a woman, are just walking with a man, you have to prove that this man is your brother, or your husband, or your uncle.

Everywhere, if a woman is walking in the street without a veil, she can be arrested and lashed by the popular defense police. The same rules apply even if the women are pregnant, which is why there are so many stories of women aborting while being lashed. On buses, women have to sit in the two rows at the back. So it's been really difficult for women.

My father was a doctor. He worked in different parts of Sudan. He loved his patients. In one of the regions where he worked he was called *abu fanous,* "the man with the lantern," because he would do his rounds examining his patients in their homes, in their huts. My mother worked with different groups; Girl Guides, first aid, charity as well as church groups. Our home was always a busy home. We always had somebody who was sick coming for treatment, or giving birth in our house. My parents taught us how to love our people, however simple, however poor. We felt very much attached to them and my parents loved our family. My grandfather was a farmer and we still feel very attached to our extended family. I think my love of family made me love Sudan and regard all the Sudanese as my own family. I feel very much tied to my country. And I always had the feeling that I have to do something for my people, the same way my parents did and the way my father did for his patients. This atmosphere contributed to my taking on the work that I do today.

All over the country, the level of poverty is astonishing, especially among the displaced. Young people are willing to leave the country at any cost, so there is also a terrible brain drain happening. In some of the faculties, 70 percent of the students are girls because the boys avoid university since they are forced to go to *jihad* beforehand. Even now, there aren't any young men around, only girls, and many girls marry old men and foreigners, partly because most of the young men are away and partly because girls want to leave the country at any cost, even if it means marrying a foreigner of whom they know very little.

People are keeping quiet because they are forced to. One man who works in a bank told me that every employee in his office has two others watching him, not necessarily government agents but paid informers. Everyone is aware that the government takes advantage of the overwhelming poverty and pays people to spy on others. Youngsters are encouraged to spy on their own families and are kept on the payroll of one of the security forces. The international community could help this situation by exposing these human rights violations. What is happening could be reported through the independents such as CNN and BBC. It is not food aid for famine that is important, but media, newspapers, television coverage. That would make a difference. That would put pressure on the government, which is the cause of this deteriorating situation in human rights.

Because of this war we lost one and a half million lives and we are expecting more conflict. The south is a tragedy, but equally all the west, the north, everywhere. The country is really collapsing; the health system, education, everything. Yet at the end of the day, it is not the government who decides—it's the people. Since 1993, I have noted a new mood in the civil society. All Sudanese, and especially women, are becoming more aware of the importance of forming alliances, of trying to improve their lives, and trying to change what is going on in society. These special groups can do a lot for change. Ultimately, I don't think that the government will greatly alter in the coming five to ten years. But through this network that we are developing, and through the confidence and the hope of all human rights activists, change will come. I don't think I will witness this, but if you start moving things, there will be an effect.

Courage means a lot of things to me: it means commitment, it means hope. It means thinking first of others. It means a strong belief in human rights, a strong belief in the power of the people, and it means turning our backs on the power of the rulers. Courage will bring change to us in Sudan.

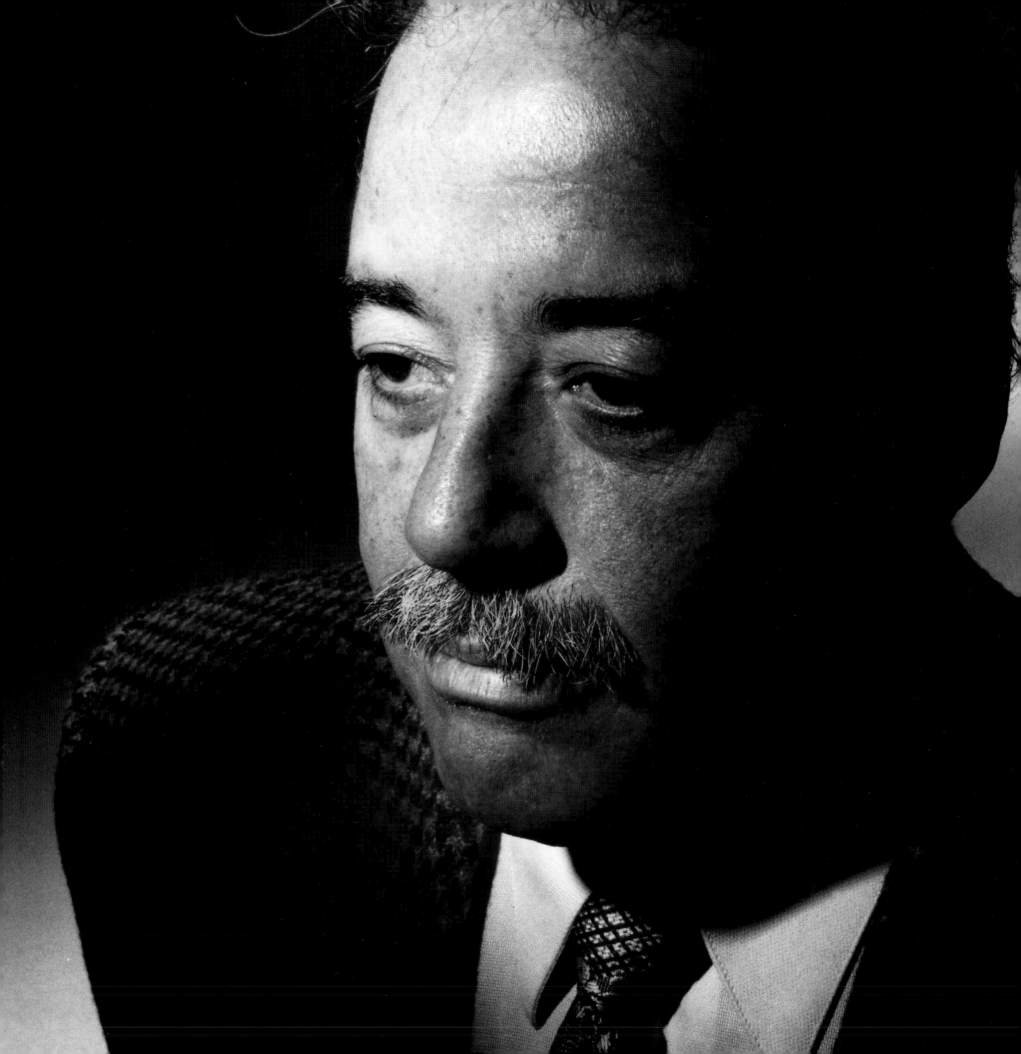

FRANCISCO SOBERÓN

———

HUMAN RIGHTS

"The civilian population were caught between the government countersubversive operations and the armed guerrillas. They had to live their life trying to survive in those two opposing pressures."

Dawn arrived in Peru in January 1980 and with it, a sight the world has never imagined. All over the country, dead dogs hung from lampposts announcing the first actions of Sendero Luminoso—the Shining Path, a Marxist guerrilla organization whose war against Peru's landed power oligarchy swept the country into a state of emergency from which it only now has begun to emerge. In those early days, Francisco Soberón, a young lawyer with a background in education and agricultural cooperatives, began to investigate alleged human rights violations. Taking up the cause of Peru's fragmented population caught between state security forces and the two terrorist groups, Sendero and the Tupac Amaru Revolutionary Party (MRTA), Soberón estabished Asociacion Pro Derechos Humanos (APRODEH) in 1985. The purpose of APRODEH is to combat the continued, egregious human rights abuses, including routine beatings, torture, "disappearances," and arbitrary detentions prevalent in a state where 16 percent of the country continues under complete military control to this day and all constitutional provisions are suspended. APRODEH has come to play an increasingly central role investigating and documenting human rights violations, and is known as one of the foremost human rights oganizations in Latin America. Soberón has had numerous roles, reporting to the international community, attempting to use the beleaguered judicial system, and educating the poor about their rights. In 1985, Soberón organized human rights groups from across the country into an effective coalition. He has served with numerous human rights organizations, including the United Nations, the International Federation of Human Rights (as vice president for South America), and the Coalition for an International Crime Court (as a member of the steering committee). In the violent, vicious military and political battle that has divided his country, Soberón has been viewed with suspicion and fear by both sides. Throughout the last arduous twenty years, Soberón has never failed to report abuse, even though doing so has endangered his life. Soberón could easily have sought a safer haven in his extensive travel on human rights missions throughout the world. However, he always returns to his homeland, determined to forge a new Peru, one based on human rights and democracy.

FRANCISCO SOBERÓN

In Peru, in the early eighties, guerrilla insurgency groups like the Shining Path and MRTA started committing acts of political violence in the highlands. Initially, no one paid much attention because everyone thought it was local activity, easily defeated. But the number of incidents started to grow. After two years, the government militarized those areas, declaring emergency zones, and that's when human rights violations emerged as a pattern. At the time, I was working with organizations of peasants in rural areas. Friends of mine at the Commission on Human Rights of the Chamber of Deputies in Peru asked me to help monitor the situation. So I started researching reports from the militarized areas.

There were no nongovernmental human rights organizations in those days, except for the Catholic Church, so we started APRODEH in 1982. At the beginning there were four or five of us. We organized a legal assistance unit, a communication unit, and a documentation center. As the violence spread, our work expanded. Within the first two months, we received the first report of the enforced disappearance of seventy people in Ayacucho; within the first two years, there were nearly two thousand enforced disappearances. In 1983, there was a case of journalists ambushed and killed walking through the highlands while investigating reports of abuse. The navy controlled the area, and though there was never a conclusion to the case, the extrajudicial executions appeared to be linked to the military. We started to make reports to Amnesty International, Human Rights Watch, the International Federation of Human Rights (FIDH), and other international institutions. We didn't know we could make reports to the UN or the Inter-American Commission on Human Rights; that came later.

In the next few years, the political violence spread all over the country, the demand for monitoring the situation was enormous. As other human rights organizations were formed, we tried to join forces with them and, in 1985, established what is now the National Coordination Network of Human Rights (Coordinadora Nacional de Derechos Humanos or CNDDHH) as a network of trained human rights defenders across the country, now made up of nearly seventy organizations. With the CNDDHH we produce an annual report on the state of human rights in Peru which is distributed domestically and internationally and we do lobbying in intergovernmental bodies.

But those first efforts were very difficult because we were in a cross fire of violence. The Shining Path and MRTA were the two armed groups operating, with daily violations of humanitarian laws. And the countersubversive operations of the armed forces were responsible for human rights violations regularly, permanently: disappearances, serial executions, torture, arbitrary detentions. So we went into the emergency zones very carefully. For example, one of our colleagues from a highland department, Angel Escobar Jurado, disappeared. He talked with me by phone in the morning, telling me that he was coming to Lima, bringing information about new cases of enforced disappearances. And at 7:00 that evening, when he was leaving his office, he was detained by men believed to be army personnel. He was never seen again. This case, like thousands of others, has not been solved yet.

The human rights defenders and the civilian population were caught between the government countersubversive operations and the armed guerrillas. They had to live their life trying to survive in those two opposing pressures. That is why so many innocent people were disappeared, killed, or accused of being linked to subversive groups. Their crime was to live in an area where the armed groups operated, where they had a presence. Sometimes they were pressured to give food to them, and though it was compulsory assistance, the armed forces then considered them collaborators. During all this violence, nearly six hundred thousand people

"The executive branch of the government intervened with the judiciary and the prosecutor's office, so it was impossible to hold the military and death squads related to the military responsible, despite the mounting evidence of egregious human rights violations committed."

were displaced from the highlands to small cities in the Andes or big cities on the coast—one of the social consequence manifestations of political violence.

By the early nineties, with armed groups still present, we human rights activists started to become more visible and also more vulnerable. They were hard years and personal security was needed to protect ourselves. An activist lawyer received an enveloped bomb, was severely injured in Lima, and had to leave the country. Several of our colleagues were killed, threatened, and several were exiled. During this period we had three elected governments—and this is important, because everyone thought that in Latin America, a gross pattern of human rights violations only occurred during military regimes. But Peru has never been under a military regime during the political violence of these last decades. Nevertheless, in these seventeen years of political violence we had five thousand persons disappear, and thirty thousand people killed.

It is true that a significant percent of these crimes were perpetrated by the Shining Path. But now, after the defeat of the subversive groups, the current regime is trying to present an official history that lays all the responsibility at the feet of the subversive groups, while trying to cover up all the responsibilities of the military and the death squads related to the military forces. And that is not true.

In 1995, the present regime introduced an amnesty law to "pardon"—or rather annul—all responsibilities of the armed forces from 1980 on. Fifteen years of abuses and crimes with no possibility of investigation, punishment, or justice.

Now all of these disappeared persons were peasants, Andean people, whose main language is Quechua, not Spanish. Considered second-class citizens, there was not much attention paid to what happened to them. Not until the Shining

Path started actions in Lima did the public opinion of the urban zones realize what was really happening. In 1992, eight students and one professor disappeared from La Cantuta University in Lima, and a year later their bodies were found. Later, it was revealed that a death squad within the intelligence service of the armed forces was responsible. This was the one and only case with military personnel responsibility that was brought to justice. The perpetrators were charged, but one year later, they were given amnesty by the regime.

So in the aftermath of those years of repression, there is a lot to be done to achieve truth, justice, and reparation: all related concepts, dependent on one another. There cannot be reconciliation in Peru if we do not achieve all three for victims of political violence, and the national system of justice appears incapable to respond to these needs.

So we have turned, instead, to the Inter-American Commission. Under President Fujimori, the executive branch of the government intervened with the judiciary and the prosecutor's office, so it was impossible to hold the military and death squads related to the military responsible for human rights violations. Despite the mounting evidence of egregious human rights violations committed by this regime, it was extremely difficult to get the United Nations to respond, because the government was freely elected. The international community is tremendously resistant to intervene in a so-called democratic state. But democracy can mean many things, can't it? And here, in Peru, the true concept of democracy has not yet taken root.

The present challenge for human rights organizations is to develop an integrated conception of human rights, defending and promoting not only the civil and political rights, but also the economic, social, and cultural rights.

MARIAN WRIGHT EDELMAN

UNITED STATES

CHILDREN AND POVERTY

"Here we have poverty killing children, more slowly,
but just as surely as guns, in a nation that has been blessed with
a nine-trillion-dollar economy."

Marian Wright Edelman, founder and president of the Children's Defense Fund (CDF), the foremost children's advocacy organization in the United States, is one of the great inspirational leaders of our time. Edelman grew up in a closely knit, deeply religious family, in a small, racially segregated southern town. After graduating from Spelman College, where she joined civil rights protests, she went on to Yale Law School, and became the first black woman ever admitted to the Mississippi bar. She directed the NAACP Legal Defense and Education office in Jackson, Mississippi, where she and coworkers were regularly harassed, intimidated, and threatened for their civil rights work. In 1968, Edelman was a major force behind the Poor People's March, the last great campaign of Martin Luther King, Jr., when tens of thousands of Americans descended on Washington, D.C., demanding respect for their rights. Soon after, Edelman founded CDF, whose mission, "to leave no child behind, and to ensure every child a healthy start, a head start, a fair start, a safe start, and a moral start in life," reflects her tough-minded idealism. Under Edelman's direction, CDF provides an effective voice for poor and minority children and those with disabilities. CDF researches and disseminates information on legislation affecting the lives of children, and provides support and technical assistance to a network of state and local child advocates. A best-selling author many times over, a mother, wife, lawyer, lecturer, and a political strategist on behalf of the poor, Edelman's capacity to transform rage into courage and action has made her a central figure in the quest for justice for the dispossessed in America over the last four decades. Hers is ultimately a wake-up call, imploring us to find our soul and save our nation.

It must be hard to be a poor child in America, hard, when so many have so much, to have little and to know it. When I was growing up in the South, without television, we didn't have the sense that one had to have all these things that our consumer and excessively materialistic society tells us we need. People didn't see poverty as something that set them apart. To be poor today, to be unable to get the basic necessities of life, and then to have the judgment about who you are as a person be based on material wealth, is much more difficult. Most of our measures of success have become external.

It is absolutely obscene that we are the sole remaining superpower, number one in military expenditures, military exports, military budget, first in health technology, first in billionaires and millionaires, yet we let our children be the poorest group of Americans. We have this booming economy and budget surplus, but there are 13.5 million poor children. All the industrialized countries protect their children against preventable diseases and sickness better than we do. Over 11 million children in this country are uninsured. It's shameful that we alone among wealthy, industrialized nations don't see that our children get a healthy start. We have much higher rates of infant mortality and low-birth-weight babies than our industrialized counterparts. We lag in preparing our children in science, math, and reading compared to many of our competitor industrialized countries that they are going to be up against in the new global village. And we lag the world most shamefully in protecting our children against violence. American children fifteen and under are twelve times more likely to die from gun violence than children in twenty-five other industrialized countries combined.

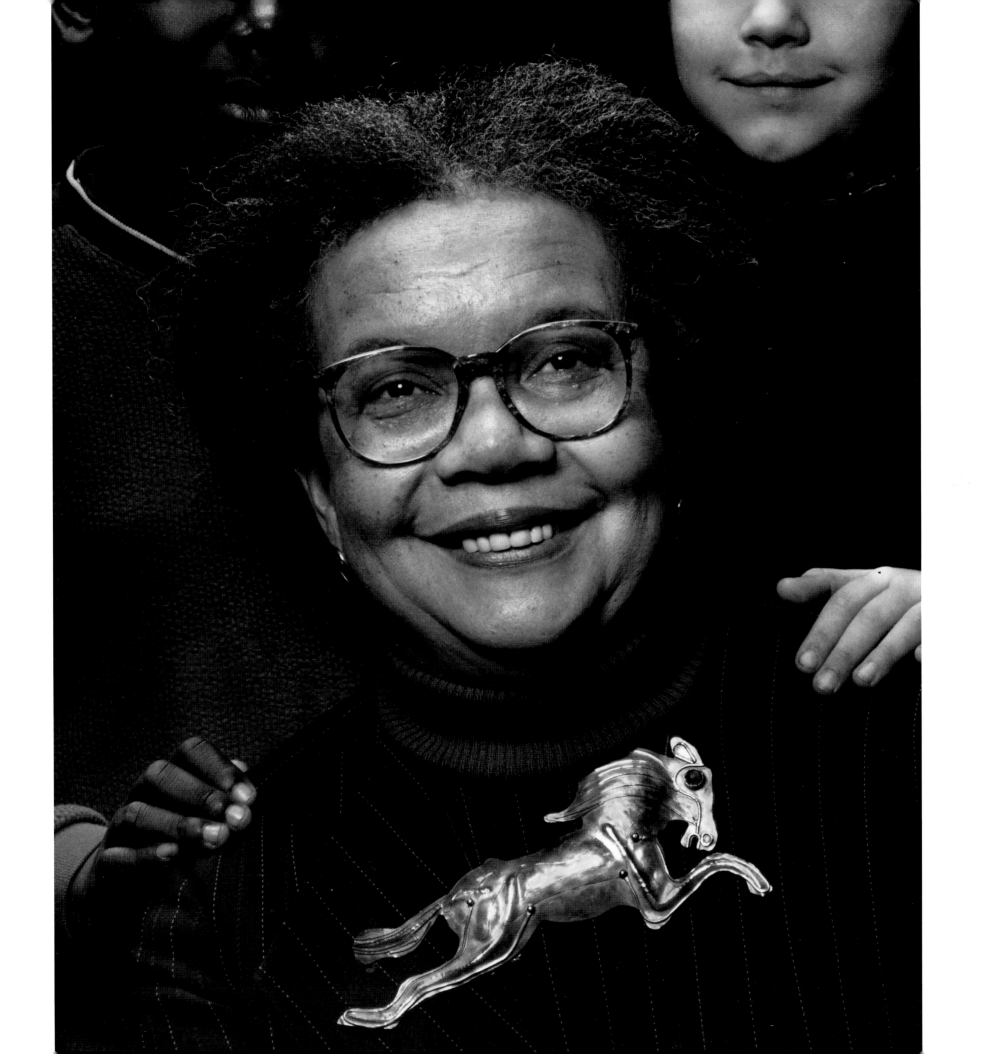

MARIAN WRIGHT EDELMAN

The fact that we spend more of our resources on military expenditures is not disconnected from the obsession we have with, and the glorification of, violence in our culture. On the cusp of a new era, we have some very fundamental decisions to make about who we are. We calculated how many Americans have killed themselves or other people in our own nation between 1968 and 1997. The total is 1.4 million. That is more than all the American battle casualties in all the wars in which we participated in this century. Between 1979 and 1997, nearly 80,000 children were killed by guns, far more than we lost in battle casualties in Vietnam. If you look at the over 200 million guns in circulation and how easily accessible they are to children and criminals, it's amazing to me that Littleton, Colorados don't happen more often. My recollection of that figure is that about 920,000 people have been killed by guns. And if you look at the 400,000 plus gun suicides done in this period, 92 percent of those were white, and of the homicides, about half were black and half were white. But this slaughter, the presence of guns, and the worship and tolerance of violence as power is something we are going to have to confront.

Here we are on the cusp of a new millennium. God has blessed us with more riches than we know what to do with, yet we let millions of our children go hungry, without shelter, and without other basic necessities of life. Here we are blessed with the best health technology, yet we have places where children's immunization rates fall behind those of some developing nations, and eleven million children are without health coverage. The Children's Defense Fund mounted a campaign in New York City where the preschool immunization rate has risen from 52 percent to 80 percent. We are trying to get it to 90. As a nation, we've got the means to prevent child gun deaths and to end child poverty and preventable diseases, but we haven't got the will. Here we have poverty killing children, more slowly, but just as surely as guns, in a nation that has been blessed with a nine-trillion-dollar economy. So I hope that we will find a way to redefine what we view as progress. There is much to do. We addict our children to consumption and tell them you have to have the latest material things in order to be viewed as somebody, yet we don't provide the education and training for them to get the jobs to get those things legally. We've also told rich kids that they need all those things, and they're finding that their appetites aren't really satisfied. So we have a spiritual poverty problem that is going to have to be confronted in a culture that treats children as consumers rather than as developing human beings in need of protection. That is probably the central issue we have to work on.

We lose a classroom full of children every two days. A quiet Littleton almost every day, in which nearly twelve children are killed by gunfire. But you know, it's dispersed and many of them aren't white so nobody pays attention. The attention to Littleton reminds one of the project in 1964 when middle-class white youths came to Mississippi to help black adults register to vote. The nation was shocked when two white youths were killed along with one black youth and they were exposed to the dangers which blacks faced. It was a wake-up call. A bunch of white youths were shot at school in a suburb in

"We lose a classroom full of children every two days. A quiet Littleton almost every day, in which nearly twelve children are killed by gunfire. But you know, it's dispersed and many of them aren't white so nobody pays attention."

Colorado, where most of the violence does not occur. Most of the violence occurs at home, and in the streets, and is perpetrated by people who know each other. To be talking about the President's proposal for a $1.5 trillion increase in this post—Cold War era to protect children against outside enemies, when they are being killed like fleas here at home, while they struggle to read and get ready for school, is obscene. Nothing short of a powerful movement is going to work and help change these wrongheaded priorities.

Well, the military has been very smart. They spread their bases and weapons production in every state, like the B-2 bomber, where they put a piece of construction in almost every congressional district. And so it's all about political fat and jobs in the local district and they're having a very hard time closing the bases. Everybody has their own favorite weapon systems. And so it is extremely difficult to change fundamental priorities. We certainly know how to give good prenatal care, and immunize children, and prevent child neglect, and provide them with health insurance. But we will succeed in protecting children only if there is a strong counterforce.

Race plays a big role in lots of complicated ways. It has been the tradition for powerful southerners to use race as a way of dividing the poor white and black citizens. Even though there are more poor white children and families who are struggling, more poor whites who are hungry, and more poor whites without health insurance, in their own minds, they have had poverty defined as something that is about "those other people"—black people and brown people. Many powerful, wealthy interests, whether they are big farmers or political operators, sought to maintain

control and power by keeping folks divided, and making poor whites feel that somehow they were much better because of that white skin. And so there was always an economic underpinning to racism that in many ways continues, and that is very sad. The issues of children, race, and poverty are intertwined.

One of the messages that we have to set forth is that most poor people today are working. Seventy percent of poor children live in a working family that is struggling to make ends meet. So if we really don't believe in welfare, why don't we make sure there is health care and child care and transportation available for working families. And we'll see what kind of debate we have, particularly in this era of budget surplus, about why many states are not really rushing to prepare people for work. That's going to be a real challenge. But the racial issue, and the fact that most poor people are white and work, is a hard one in the media and every place else. We have made a conscious effort over the last twenty-five years to try to redefine the face of the poor and hurting child. Black and brown children have a disproportionate chance of being poor and being at risk of all the worst things. Still, in numbers, there are more poor whites. We constantly try to say that the majority of children who are affected are white, and we always try to get white welfare recipients to testify so that the congresspeople realize this can happen to somebody they identify with. But there is such a long history of stereotyping that is constantly reinforced by the media, it is very difficult not to have people constantly put a black face on poverty. Being black, being black male and black female, makes it much harder to beat the odds. Ninety percent of our poor, brown, black, disabled, and

immigrant children are in public schools and so many people really don't think they can learn. They think it's pouring good money into bad vessels. And there are few school systems in America where all children are expected to learn and are supported in learning. As a result, the children who need the most get the least. They get the poorest schools, the poorest teachers, the poorest labs, the poorest books, and that's racism. And racism imprisons them in neighborhoods that have been red-lined. You see the same thing in the misapplication of the criminal justice system. And so if you go from a black and poor child's life in the beginning, they begin with two strikes against them. Although we have made great progress, it is still harder to be both poor and black. And if you look at life expectancy, or poverty, or violence, blacks are disproportionately victimized. We once did a sheet showing if you are a black male in America, you are far more likely to be killed than people in many other countries. We couldn't get it all on one page. We just folded it out to compare it with violence and death rates in other countries. So race is still a real problem. Black parents who have had black sons understand that their skin is the magnet for racial profiling, police assaults, and for just walking down the street. We know we have not solved the problem of race in America.

I was blessed to have been challenged to do something that's worth living and dying for, and to have a life that's never lacked purpose. And I have been blessed with extraordinary role models throughout, starting with my parents. There is a lot of discussion about mentoring. I had the great women of Mississippi as my mentors. I was a lawyer by the time I went back to Mississippi. One case I worked on involved an immensely courageous black woman, Mrs. Mae Bertha Carter, the first school desegregation plaintiff in Sunflower County. She wanted her eight younger children not to have to go into the cotton fields like her older kids. She described what it felt like the first day the white school bus came and she saw those kids go off to the formerly white school and how every afternoon she'd wait and count them all as they came in. She said they would share the horrors that would go on during the day, and she would just pray all the time. They got evicted, they got shot at, they had no credit. And we finally used her case to throw out freedom of choice in Mississippi. When I hear educational choice today, I remember so-called freedom of choice in earlier days. I have such a strong commitment to a strong public school education for every child. I never feel I am half as good as those incredible, ordinary people who, day in and day out, withstood beatings, assaults, and torments without bitterness and with a transcendent faith. I don't think I got a child out of jail who hadn't been beaten or worse. Extraordinary daily courage by extraordinary people who had grit made me feel I had a pretty easy life.

The first time I walked into a federal court in Mississippi, there were all these white male lawyers sitting around a table, and not a single one would speak or shake hands. I knew who I was and I had a job to do, but there were times when I was absolutely terrified. I happened to have been in Mississippi the first day that police dogs were brought out against civil rights demonstrators. I was trying

> "I am also clear that if we do not save our children, we are not going to be able to save ourselves. I cannot believe that God gave us all of these riches, and we would fail to take care of the most vulnerable among us."

hard not to get arrested because I knew my ability to get into the Mississippi bar was at stake. I watched in terror and awe as Bob Moses and Jim Forman and others including old people were attacked and scattered by these dogs. But Bob didn't move. To watch their courage on a daily basis just gives you enough to talk about to yourself and to think, "What are you complaining about?"

I am also clear that if we do not save our children, we are not going to be able to save ourselves. I cannot believe that God gave us all of these riches, and we would fail to take care of the most vulnerable among us. Taylor Branch said that never before in history have school children been the decisive factor in the transformation of a nation. We often forget that it was children who had to go through the mobs and weather the violence in Birmingham and Selma; children who were herded into the cattle cars and jails in Jackson. Their parents were terrified, but their children were the frontline soldiers. Look at the sacrifices of those four girls blown asunder in Birmingham. I was blessed by the opportunity that Dr. King and the Movement provided to feel empowered as a young person, and by how absolutely ready and prepared we were to die and to do whatever was necessary.

Commitment is both a gift of God and the luck of circumstance. I grew up in a family that really did believe in the graciousness of God. Mrs. Mae Bertha Carter said it very eloquently when she said, "God has a good purpose for all of us. And so God builds in those strengths to do what you have to do." And I think she was echoing Kierkegaard who said that everybody needs to open up the envelope of their soul and get their orders from inside of you. And nobody ever said that it was going to be easy. But you have to try.

Courage is just hanging in there when you get scared to death. One of the things that I remember about Dr. King is how as a young person he could always look scared to death. Look at his face in many of his pictures, he is depressed. He often did not know what he was going to do next. I remember him saying how terrified he was of the police dogs in the back of the car when he was being taken out to rural Georgia after being arrested. And in my little college diary, the first time I met him, I must have written down half of the speech he gave, about how you don't have to see the whole stairway to take the first step. You can be scared but shouldn't let it paralyze you. And he used to say over and over again, "If you can't run, walk; if you can't walk, crawl, if you can't crawl, just keep moving." That reflects courage. There comes a point in life when you look around and decide that this is not what life's about. It is not what God meant for you. And you have to change things. And if that means dying, that's fine. But it is not living. Otis Moss used an analogy recently that the worst thing to happen to a bird is not to kill it, it's to clip its wings, to clip it's tongue. Many people were terrified in the civil rights days but terror is a part of living in an unjust system. I felt that when I went to Crossroads, the Cape Town camp out in South Africa. When I saw those young people, I saw myself thirty years earlier, and I knew they would just not stop. That's courage—acting despite it all.

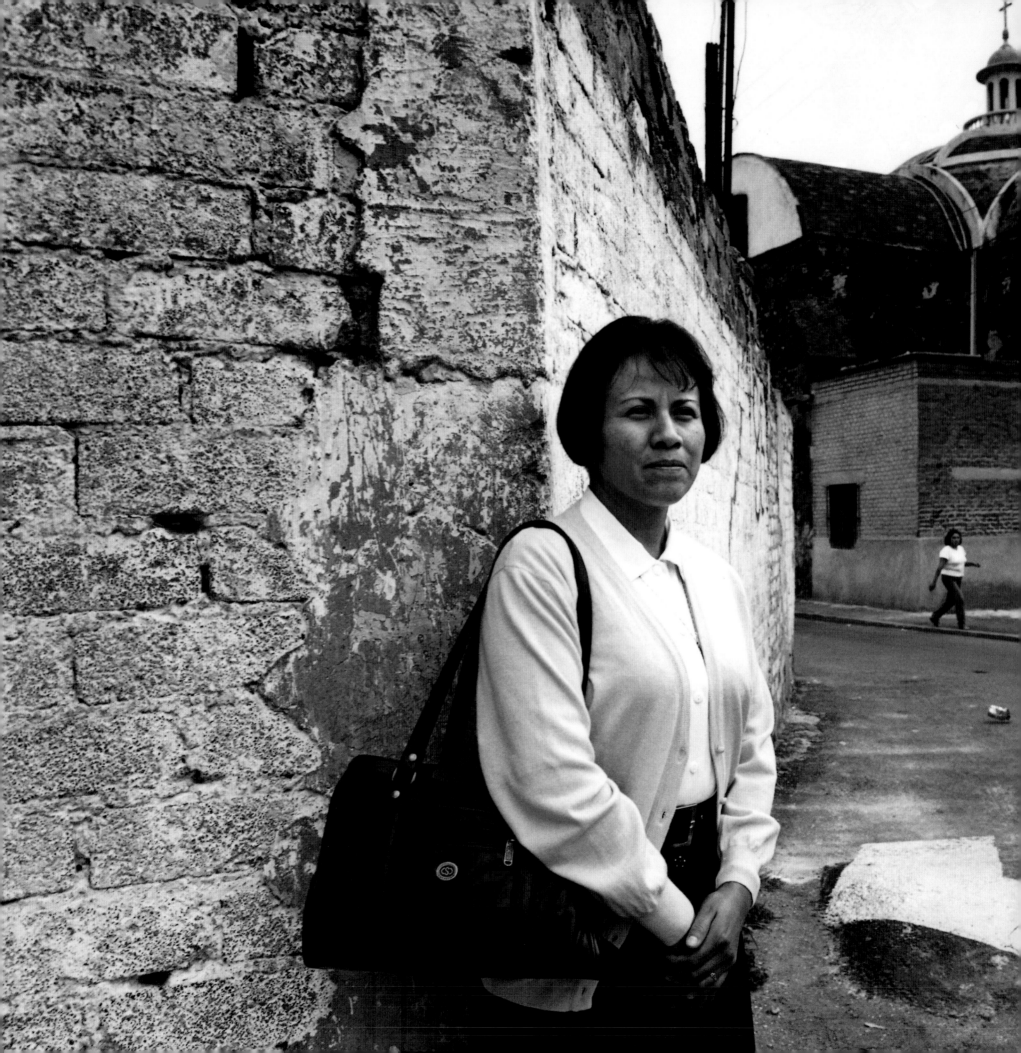

DIGNA OCHOA

MEXICO

HUMAN RIGHTS

"Anger is energy, it's a force. If an act of injustice doesn't provoke
anger in me, it could be seen as indifference, passivity.
It's injustice that motivates us to do something, to take risks, knowing
that if we don't, things will remain the same."

One of the foremost human rights attorneys in Mexico, Digna Ochoa was also a nun. As defense attorney at PRODH (Centro de Derechos Humanos Miguel Agustín Pro Juárez, known as Centro Pro, or "the Pro"), Ochoa took on some of Mexico's most politically charged cases, including the defense of alleged members of the Zapatista insurgency in Chiapas. She won acquittals in several highly publicized cases. In many cases, Ochoa's clients were subjected to torture and due process violations. Ochoa herself was repeatedly threatened with death, abducted, and subjected to extensive harassment. Just a few weeks after this interview, two men assaulted her in her own apartment. They blindfolded her, tied her up, interrogated her, threatened her, and pressured her to sign a statement. They cut her phone line, and opened a gas valve in a closed room. Miraculously, she survived. Her attackers left files stolen during an attack a few months earlier, while the next day PRODH staff found their offices had been ransacked. Nevertheless, Ochoa went right back to work at the Pro. In recent years human rights advocates, government investigators, and opposition leaders have been murdered in Mexico. The Inter-American Court of Human Rights required the Mexican government to take steps to assure the safety of PRODH staff in the wake of this pattern of persecution against the organization, but, on October 19, 2001, a group of armed men broke into Ochoa's office and brutally killed her. Her death has been condemned by human rights organizations internationally. To date, no one has been detained for her murder.

I am a nun, who started life as a lawyer. I sought a religious community with a social commitment, and the protection of human rights is one of the things that my particular community focuses on. They have permitted me to work with an organization that fights for human rights, called Centro Pro, supporting me economically, morally, and spiritually. This has been a process of building a life project, from a social commitment to a spiritual one with a mystical aspect.

My father was a union leader in Veracruz, Mexico. In the sugar factory where he worked, he was involved in the struggles for potable water, roads, and securing land certificates. I studied law because I was always hearing that my father and his friends needed more lawyers. And all the lawyers charged so much. My father was unjustly jailed for one year and fifteen days. He was then disappeared and tortured—the charges against him were fabricated. This led to my determination to do something for those suffering injustice, because I saw it in the flesh with my father.

When I first studied law, I intended to begin practicing in the attorney general's office, then become a judge, then a magistrate. I thought someone from those positions could help people. After I got my degree, I became a prosecutor. I remember a very clear issue of injustice. My boss, who was responsible for all of the prosecutions within the attorney general's office, wanted me to charge someone whom I knew to be innocent. There was no evidence, but my boss tried to make me prosecute him. I refused, and he prosecuted the case himself.

Up until that time, I was doing well. The job was considered a good one, because it was in a coffee-producing area and the people there had lots of money. But I real-

ized that I was doing the same thing that everyone did, serving a system that I myself criticized and against which I had wanted to fight. I decided to quit and with several other lawyers opened an office. I had no litigation experience whatsoever. But I was energized by leaving the attorney general's office and being on the other side, the side of the defense.

The first case I worked on was against judicial police officers who had been involved in the illegal detention and torture of several peasants. We wanted to feel like lawyers, so we threw ourselves into it. Our mistake was to take on the case without any institutional support. I had managed to obtain substantial evidence against the police, so they started to harass me incessantly, until I was detained. First, they sent telephone messages telling me to drop the case. Then by mail came threats that if I didn't drop it I would die, or members of my family would be killed. I kept working and we even publicly reported what was happening. The intimidation made me so angry that I was motivated to work even harder. I was frightened, too, but felt I couldn't show it. I always had to appear—at least publicly—like I was sure of myself, fearless. If I showed fear they would know how to dominate me. It was a defense mechanism.

Then, I was disappeared and held incommunicado for eight days by the police. They wanted me to give them all the evidence against them. I had hidden the case file well, not in my office, not in my house, and not where the victims lived, because I was afraid that the police would steal it. Now, I felt in the flesh what my father had felt, what other people had suffered. The police told me that they were holding members of my family, and named them. The worst was when

they said they were holding my father. I knew what my father had suffered, and I didn't want him to relive that. The strongest torture is psychological. Though they also gave me electric shocks and put mineral water up my nose, nothing compared to the psychological torture.

There was a month of torture. I managed to escape from where they were holding me. I hid for a month after that, unable to communicate with my family. It was a month of anguish and torture, of not knowing what to do. I was afraid of everything.

I eventually got in touch with my family. Students at the university, with whom I had always gotten along very well, had mobilized on my behalf. After I "appeared" with the help of my family and human rights groups in Jalapa, Veracruz, I was supported by lawyers, most of whom were women. The fact that I was in Veracruz caused my family anguish. At first I wanted to stay, because I knew we could find the police who detained me. We filed a criminal complaint. We asked for the police registries. I could clearly identify some of the officers. But there was a lot of pressure about what I should do: continue or not with the case? My life was at risk, and so were the lives of members of my family. After a month of anguish, my family, principally my sisters, asked me to leave Jalapa for a while. For me, but also for my parents.

I came to Mexico City. The idea was to take a three-month human rights course for which I had received a scholarship. I met someone at the human rights course who worked at Centro Pro, one of the human rights groups involved on my behalf. One day he said, "Look, we're just setting up the center and we need a

lawyer. Work with us." I had never dreamed of living in Mexico City, and I didn't want to. But I accepted, because the conditions in Jalapa were such that I couldn't go back. Two really good women lawyers in Jalapa with a lot of organizational support took up the defense case I had been working on. This comforted me, because I knew the case would not be dropped—I had learned the importance of having organizational backup. So I started to work with Centro Pro in December 1988. Since I began working with the organization, I've handled a lot of cases of people like my father and people like me. That generates anger, and that anger becomes the strength to try to do something about the problem. At work, even though I give the appearance of seriousness and resolve, I'm trembling inside. Sometimes I want to cry, but I know that I can't, because that makes me vulnerable, disarms me.

At this time, because of what happened to me, I needed the help of a psychoanalyst, but I wasn't ready to accept it. The director of Centro Pro prepared me to accept that support. He was a Jesuit and psychologist. For six months, I didn't know he was a therapist. When I found out, I asked him why he hadn't told me. "You never asked," he said. We became very close. He was my friend, my confessor, my boss, and my psychologist, too, although I also had my psychoanalyst.

The idea of a confessor came slowly to me. In Jalapa, I had been supported by some priests. When I first "appeared," the first place I was taken was a church. I felt secure there, though as a kid, I had never had much to do with priests, besides attending church. To me they were people who accepted donations,

delivered sacraments, and were power brokers. It made an impression on me to see priests committed to social organizations, supporting people.

Since I've been at Centro Pro, we've gone through some tough times, like the two years of threats we received beginning in 1995. Once again it was me who was being threatened. My first reaction was to feel cold shivers. I went to the kitchen with a faxed copy of the threat and said to one of the sisters in the congregation, "Luz, we've received a threat, and they're directed at me, too." And Luz responded, "Digna, this is not a death threat. This is a threat of resurrection." That gave me great sustenance. Later that day another of my lawyer colleagues, Pilar, called me to ask what security measures I was taking. She was—rightfully—worried. I told her what Luz had said and Pilar responded, "Digna, the difference is that you're a religious person." And I realized that being a person of faith and having a community, that having a base in faith, is a source of support that others don't have.

Now, some people said to me that my reaction was courageous. But I've always felt anger at the suffering of others. For me, anger is energy, it's a force. You channel energy positively or negatively. Being sensitive to situations of injustice and the necessity of confronting difficult situations like those we see every day, we have to get angry to provoke energy and react. If an act of injustice doesn't provoke anger in me, it could be seen as indifference, passivity. It's injustice that motivates us to do something, to take risks, knowing that if we don't, things will remain the same. Anger has made us confront police and soldiers. Something that I discovered is that the police and soldiers are used to their superiors shouting at them, and they're used to being mistreated. So when they run into a woman, otherwise insignificant to them, who demands things of them and shouts at them in an authoritarian way, they are paralyzed. And we get results. I consider myself an aggressive person, and it has been dif-

ficult for me to manage that within the context of my religious education. But it does disarm authorities. I normally dress this way, in a way that my friends call monklike. That's fine. It keeps people off guard. I give a certain mild image, but then I can, more efficiently, demand things, shout.

For example, one time there was a guy who had been disappeared for twenty days. We knew he was in the military hospital, and we filed habeas corpus petitions on his behalf. But the authorities simply denied having him in custody. One night we were informed that he was being held at a particular state hospital. We went the next day. They denied us access. I spent the whole morning studying the comings and goings at the hospital to see how I could get in. During a change in shifts, I slipped by the guards. When I got to the room where this person was, the nurse at the door told me I could not go in. "We are not even allowed in," she said. I told her that I would take care of myself; all I asked of her was that she take note of what I was going to do and that if they did something to me, she should call a certain number. I gave her my card. I took a deep breath, opened the door violently and yelled at the federal judicial police officers inside. I told them they had to leave, immediately, because I was the person's lawyer and needed to speak with him. They didn't know how to react, so they left. I had two minutes, but it was enough to explain who I was, that I had been in touch with his wife, and to get him to sign a paper proving he was in the hospital. He signed. By then the police came back, with the fierceness that usually characterizes their behavior. Their first reaction was to try to grab me. They didn't expect me to assume an attack position—the only karate position I know, from movies, I suppose. Of course, I don't *really* know karate, but they definitely thought I was going to attack. Trembling inside, I said sternly that if they laid a hand on me they'd see what would happen. And they drew back, saying, "You're threatening us." And I replied, "Take it any way you want."

"If we don't forgive and get over the desire for revenge, we become one of them. You can't forget torture, but you have to learn to assimilate it. To assimilate it you need to find forgiveness. It's a long-term, difficult, and very necessary undertaking."

After some discussion, I left, surrounded by fifteen police officers. Meanwhile I had managed to record some interesting conversations. They referred to "the guy who was incommunicado," a term that was very important. I took the tape out and hid the cassette where I could. The police called for hospital security to come, using the argument that it wasn't permitted to have tape recorders inside the hospital. I handed over the recorder. Then they let me go. I was afraid that they would kidnap me outside the hospital. I was alone. I took several taxis, getting out, changing, taking another, because I didn't know if they were following me. When I arrived at Centro Pro, I could finally breathe. I could share all of my fear. If the police knew that I was terrified when they were surrounding me, they would have been able to do anything to me.

Sometimes, without planning and without being conscious of it, there is a kind of group therapy among the colleagues at Centro Pro. We show what we really feel, our fear. We cry. There's a group of us who have suffered physically. On the other hand, my religious community has helped me manage my fear. At times of great danger, group prayer and study of the Bible and religious texts helps me. Praying is very important. Faith in God. That has been a great source of strength. And I'm not alone anymore. As a Christian, as a religious person, I call myself a follower of Christ who died on the cross for denouncing the injustices of his time. And if He had to suffer what he suffered, what then can we expect?

For years after my father was tortured, I wanted revenge. Then, when I was the torture victim, the truth is that the last thing I wanted was revenge, because I feared that it would be an unending revenge. I saw it as a chain. Three years after coming to Mexico City I remember that a person came to tell me that they had found two of the judicial police officers who tortured me.

The person asked if I wanted him to get them and give them their due. At first, I did have a moment when I thought yes. But I thought about it and realized that I would simply be doing what they did. I would have no right to speak about them as I am talking about them now. I would have been one of them.

I rarely share my own experience of torture. But I remember talking to a torture victim who was very, very angry, for whom the desire for revenge was becoming destructive. I shared my own experience, and that made an impression on him. But if we don't forgive and get over the desire for revenge, we become one of them. You can't forget torture, but you have to learn to assimilate it. To assimilate it you need to find forgiveness. It's a long-term, difficult, and very necessary undertaking.

If you don't step up to those challenges, what are you doing? What meaning does your life have? It is survival. When I began to work, when I took that case in which they made me leave Jalapa, I was committed to doing something against injustice. But there was something else that motivated me, and I have to recognize it, even though it causes me shame. What motivated me as well as the commitment was the desire to win prestige as a lawyer. Thanks to the very difficult situation that I lived through, I realized what was wrong. What a shame that I had to go through that in order to discover my real commitment, the meaning of my life, the reason I'm here. In this sense, I've found something positive in what was a very painful experience. If I hadn't suffered, I wouldn't have been able to discover injustice in such depth. Maybe I wouldn't be working in Centro Pro. Maybe I wouldn't have entered the congregation. Maybe I wouldn't have learned that the world is a lot bigger than the very small world that I had constructed. Thanks to a very difficult, painful experience for me and my family and my friends, my horizons were broadened. Sometimes I say to myself, "What a way for God to make you see things." But sometimes without that we aren't capable of seeing.

GUILLAUME NGEFA ATONDOKO

DEMOCRATIC REPUBLIC OF THE CONGO

POLITICAL RIGHTS

"We knew exactly how many people were killed. And we passed on the information. Then the government began to take notice."

Researching, recording, and exposing grave human rights abuses committed by Zaire's notorious dictator, Mobutu Sese Seko, Guillaume Ngefa risked his life on a daily basis. As founder and president of his country's premier human rights organization, L'Association Africaine de Défense des Droits de l'Homme (African Association for the Defense of Human Rights, or ASADHO), Ngefa monitored the bloody seizure of power by President Laurent Kabila in 1996–97 during which, Ngefa estimates, "200,000 refugees in Zaire, mostly ethnic Hutus, and thousands of Zairians were killed as a result of the deliberate strategy of extermination of a portion of the Rwandan population." Ngefa based his report on field research, along with a synthesis of reports by a number of human rights and humanitarian organizations. Persecuted first by Mobutu and then by Kabila, Ngefa and ASADHO gained a reputation for even-handed and well-documented reports of abuses, regardless of the ethnic affiliation of perpetrators or victims. As such, ASADHO is a pillar of moral and ethical support for Congolese working to reduce interregional and interethnic tensions. As a result of his unflinching honesty, Ngefa is now living in exile in Geneva, Switzerland, where he continues to work for human rights and for the dignity of his countrymen.

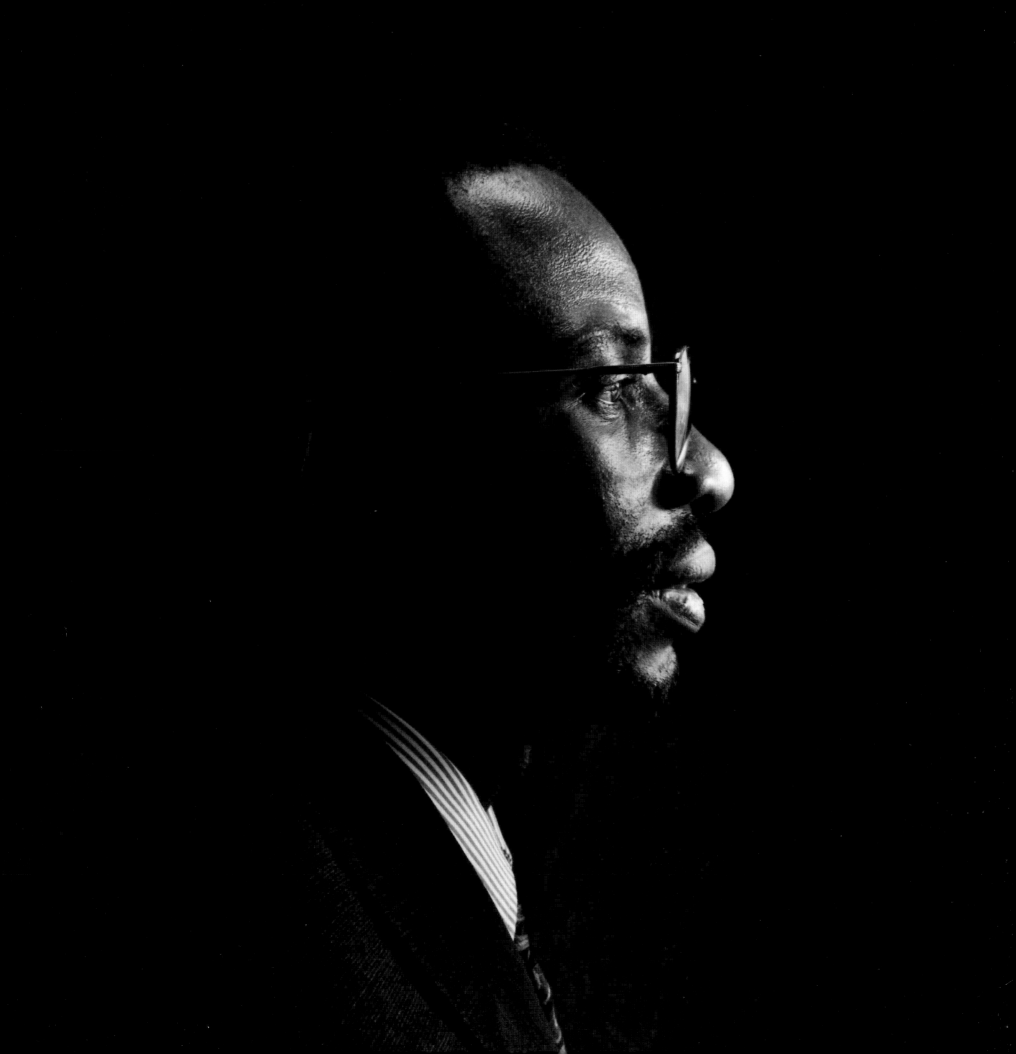

Human rights are rooted in my life. I'm told that as a child I reached out to others. I befriended pygmies, even though, in my community, they were considered to be animals. I cut bread with them, I brought them to our home, I gave them my clothes. It was a shock to the society around me but I saw the pygmies as my friends, just like anyone else.

While I was training as a Jesuit, one of my professors spoke about human rights. Later, I decided to leave the order and went to the University of Kinshasa. I was horrified by the ethnic hatred among students and the police informers planted in the university, so I became part of a network collecting information about the repression of the regime. I began to send this information to embassies in Kinshasa, listing who had been killed within one or another university. In 1986, I founded an organization called Club des Africanistes, a group where students interested in African matters could discuss their ideas. We organized a big meeting in Kinshasa, where students from all universities and institutions could discuss the issue of *francophonie* (French as a common language). Trying to organize this kind of meeting under one ruling party was dangerous, and I was soon charged with receiving money from foreign governments to destroy the regime. The dean warned me that if I continued with the "subversive activities" I would be expelled from the university.

When I returned to school, I created an organization to fight against ethnic divisiveness among students. When our numbers swelled to include over six hun-

dred members, we decided to run for student elections against the ruling party. We refused to endorse Mobutu and his old political cronies. The academic authorities accused us of being backed by foreign countries. Though we lost the student election, our message was heard within our university, and we were respected. Then the president of the university called us to say that our movement was becoming very political and would be banned. He threatened me with expulsion for the second time. I had one year left until graduation and so I tried to negotiate. We said, "We will not accept this ban. We will continue our movement because we think that our movement is not against the regime but is against some of these ideas which will affect the university in a very dangerous way." He accepted our compromise.

I graduated just when the general discontent with Mobutu began to open the political system. The time was right to start a human rights organization and participate in public affairs. First I recruited activists from our two university organizations. Our founders were old friends. We knew each other and trusted one another. We called ourselves ASADHO, and set out to investigate and document human rights abuses, to play a key role in society, to maintain independence from all political parties, and to hold onto our principles. The organization was national, drawing together people from different regions. We began working with lawyers, journalists, and physicians. Each group tried to strengthen or promote human rights by using their par-

> "The cops came, pointed their guns in my direction, and forced me into a car. They brought me to the Camp Tshatshi [home of presidential elite troops] and began punching people in my presence. One guy said, 'After him, it will be you.'"

ticular expertise. For example, our physicians gave us information about human rights violations suffered by victims of AIDS. Some people who had served as human guinea pigs had been injected with the AIDS virus, without their knowledge, in the name of "scientific research." We relayed that information to the outside world, to human rights groups and to the press. We published reports at the same time. We knew exactly how many people were killed. And we passed on the information.

Then the government began to take notice. I was arrested and beaten up many times in 1993 and 1995 and have had problems with hearing in the left ear ever since. Nobody would rent me an apartment because they were afraid that the security forces would destroy their house. Once when I was walking on the street the cops came, pointed their guns in my direction, and forced me into a car. They brought me to the Camp Tshatshi [home of presidential elite troops] and began punching people in my presence. One guy said, "After him, it will be you." I got nervous. I said, "Look, the American authorities know that I am here." After they beat me, they let me go.

In August 1995 I had dinner with the Swiss ambassador, the chargé d'affaires of Belgium, and some of my colleagues. That same day, I had published a report denouncing the elite troops' killing of thirteen members of the PALU (Parti Lumumbiste Unifié) party. As I was driving home after dinner, I was stopped by soldiers shouting, "Get out! Get out! Get out! Get out!" One put a gun to my head. They told me they would kill me. People recognized me and tried to help. The soldiers shot into the air and people fled, but the soldiers were afraid, too, and said, "Get into your car and go." As I was driving away, I thought they would shoot me in the back. When I got home my wife was waiting for me. I told her the story. "It was you?" she asked. She had heard the shooting. I realized that it was time to leave the country.

After obtaining a master's degree abroad, I returned from exile, continued my work, and told Mobutu that I wanted to change things. However, in 1997, during the rebellion led by Kabila against Mobutu, ASADHO disclosed a report denouncing the slaughter and extermination of Hutu refugees by Rwandese troops at the command of Kabila. In this context, I was threatened not only by Mobutu's troops, but also by Kabila's, who claimed that I was opposing the war of liberation, and promised to "tear me to pieces" if they found me. This is what made me decide to leave my homeland for good.

I didn't get a chance to become a priest, but with human rights I found a new vocation. It's the same: trying to create a voice for the voiceless. I'm against injustice; I will never stop. Courage is conviction, courage is your commitment to something. You just have to believe in what you are doing, that's all.

WEI JINGSHENG

———

POLITICAL PARTICIPATION AND IMPRISONMENT

*"If you do not fight tyranny, the tyrants will never let
you have an ordinary life. You must either surrender to them,
or dedicate your life to something greater."*

Wei Jingsheng came to symbolize the struggle for human rights and democracy in China, when, after the Cultural Revolution, he was among the first to demand a freer society. In spite of the threat of imprisonment, Wei spoke openly with the Western press, publishing articles demanding reform and comparing the policies of all-powerful Premier Deng with the disastrous Five-Year Plans of Chairman Mao. For his candor he was sentenced to fifteen years in the infamous Chinese laogai (prison labor camps), mostly in solitary confinement where he suffered serious abuse. Though Wei's health deteriorated, his determination grew ever stronger. On September 14, 1993, days before the International Olympic Committee's vote on whether China could host the games, Wei was released. Authorities hoped he had learned his lesson, but instead Wei contacted reformers who had been virtually silent since Tiananmen and was pivotal in reviving the democracy movement in China. After his meeting in 1994 with U.S. Assistant Secretary of State for Human Rights John Shattuck, the Chinese government lashed out, once again detaining Wei and holding him incommunicado for more than a year. The regime then subjected their most visible prisoner to a show trial and sentenced him to a second fourteen years in the laogai. In 1997 intense international pressure caused Wei to be sent into exile instead. Now based at New York's Columbia University, he travels the world, speaking out forcefully against China's continuing abuses of the human rights of its own people.

Living in jail and living in exile are both difficult. But from outside I can be much more help to the democracy movement than when I was shut in.

In exile, my health is cared for; I eat much better. But there are certain things that are much better in prison. For one thing, in prison, few people could disturb my peace of mind. I didn't have to listen to as much nonsense inside the prison as out here. In prison one's enemies are clear, and you try to make friends with your enemy, and soon one can win faithful friends from among one's captors. Outside, in exile, the conditions are exactly the opposite. There are many claiming and clamoring to be friends, but who are actually enemies, who will do things to harm you, and to harm the movement. This can get very complicated.

Some of the nonsense comes from people who, although they have been persecuted by the Communist system for years and years, remain Communism's greatest defenders. I find that embarrassing and very sad. A second kind of nonsense comes from Western politicians, politicians who live in free democracies. They understand the importance of freedom themselves, they enjoy that freedom, and yet they persist in defending Communist tyranny.

The second time I was in jail, before I was officially given a fourteen-year sentence, some of my jailers said, "What's the point of you fighting like this? Your so-called friends in the United States are very good friends with our leader. They are in a pact together. You are wasting your time." At the time I refused to believe them. But, now that I am outside, I am forced to believe because I have seen it with my own eyes.

I take strength from ordinary people, in both China and America. Every person wants his or her dignity respected, regardless of where they come from. This provides a continuous source of strength for my work. Democracies respect their citizens more than tyrannies. If you do not fight tyranny, the tyrants will never let you have an ordinary life. You must either surrender to them, or you dedicate your life to something greater. I try to reach people in the democracies, asking them to call upon their governments to see the Chinese Communist government as it really is. I haven't been successful yet, but at least this work has begun.

It is impossible to balance personal life and commitment to your country when you face such a massive oppressor. Your responsibility has to be with those who suffer. If you do not resist, the oppressors will never permit you to exist. So there is no way to achieve a balance—you simply have to give your life to the larger responsibility.

It is normal to protect oneself first. It is understandable. According to my younger brother and sister, I am an abnormal man. Before you embark on such a path you have to make a decision, you have to make a choice. My father was a leading general, so with my background I could easily enjoy the same privileges as other princelings currently enjoying the life of the rich in China. But I made the choice.

The time was December 1978. To make a decision like this, there is never one reason, there are always several. I was traveling in the countryside and saw the peasants and their living conditions so horrible that if you had any sense of humanity left, you had to feel compassion, sympathy for them. I began traveling when I was sixteen, and from that point on was always on the road. I sought out any opportunity where I could improve other people's living conditions. In December 1978, Deng Xiaoping gave a famous speech that seemed to crush the beginnings of democracy. The people who were active in democracy were so intimidated by his message and the aftermath of that speech that they began to back off. And at that time, I made the decision to stand up to Deng Xiaoping.

Nineteen ninety-seven was another moment when I had to make a choice. I was still in jail and until then had refused to leave jail before finishing my sentence. Deng Xiaoping had given me the choice: if I admitted I was wrong I could have left at any time. I always refused to do so. In 1997 I learned that the overseas democracy movement was so badly battered that there was very little of it left. I felt that if I did not leave jail to organize the overseas democracy movement, there might not be an overseas democracy movement at all. Since I have been in the West, just a year and a half, I think there have been two small improvements. First, the United States led all the other countries in a resolution condemning China at the United Nations. Secondly, the UN seems to be more unified against cooperating with China.

> "Chinese people have always coped with tyranny through humor. They used humor to articulate the absurdity of their experiences. To me, I feel humor is my nature, and my best defense."

When I was imprisoned, I felt a sense of solidarity with the suffering of imprisoned peasants whom I had met on my travels. I kept in mind that what I was doing was right, that it would help relieve those who suffered. I believed I would succeed. Those thoughts gave me hope.

In 1997, they beat me, put me in isolation, and took away all reading material. Under such conditions, a mind has no reference point; you become utterly confused. Many of those I knew in prison lost their minds. That was our captors' goal. Reading material is important, regardless of its content. It becomes a focal point and an effort; a way to give your mind direction. With no point of focus, you lose your mind. This is a very serious form of torture.

People from Beijing have a great sense of humor. Chinese people have always coped with tyranny through humor. They used humor to articulate the absurdity of their experiences. To me, I feel humor is my nature, and my best defense. There is another source of strength, the ability to protect your own dignity. That is very important, and the most difficult. You have to believe that what you are doing is right. If you believe in what you are doing, then all the suffering becomes secondary.

If you cannot prepare yourself for death, then you should not decide to defy the regime, and once you are prepared to die, you don't really look at your efforts in terms of success or failure. You look at it as a choice of doing the right thing. In my family, you take responsibility for what you do. That influenced me. Once you make the decision, you know there is a price.

Luckily, I come from a family of very stubborn people, so facing danger and facing repression is normal to me. At a crucial moment, some people think of their own survival, and they give up their dignity, their purpose, their ideals.

These people seem very weak. But when you think of doing it not only for yourself but for the dignity of others, then you know what you are doing is right. At that point, courage becomes richer. For a month I was sentenced to death and I had great fear. Then I thought to myself, "I will die anyway. Why die as a laughing stock to my enemies?" So I controlled my fear in that moment of crisis, and that moment passed. I held onto my dignity. Some courage is both physical and mental. Some people are simply born with it. Some people when facing danger start shaking, uncontrollably.

One should not look down at people like that because there's a bodily reaction and some people are just born with physical courage. Ever since I was very young, I had no physical fear—very little physical fear. The two most consistent comments from my grade school report cards were that I was stubborn, and that I had no fear. Of course, Chinese teachers don't like these two traits in their students.

Nobody is always right. So when you look at anything you always have to maintain a fair mind. When you yourself are wrong, you have to admit to it. Then reconciliation is easier. You have to be honest. I have locked horns with Chinese Communist leaders but none of them has ever questioned what I say. They hate me. They fear me. But they don't question what I say. Even the policemen in my prison regarded me in this way. Some even asked me for advice because they knew that I would tell them the truth. If you do that consistently, you can go anywhere. It reconciles people. You must demonstrate your trustworthiness. Through all these decades of fighting Communist leaders, there is not a single one who has ever accused me of lying. If you have finally achieved the reputation of fair-mindedness, even your enemy can come to trust you. This allows you to have a balanced life.

HELEN PREJEAN

UNITED STATES

THE DEATH PENALTY

"Patrick was dead, but I didn't have a choice. That day, my mission was born. It was just something I had to do because I knew I was a primary witness and I would take people there through my stories. So for fifteen years I have been working to stop the death penalty."

Louisiana, 1977. Brothers Patrick and Eddie Sonnier admitted mugging David LeBlanc, age seventeen, and Loretta Bourque, eighteen, one autumn night, but each blamed the other for murdering them and raping Bourque. Eddie was sentenced to life, Patrick to death by electrocution. In the summer of 1982, Sister Helen Prejean had moved into St. Thomas Housing Project, one of New Orleans's most violent neighborhoods, when a friend asked her to be a pen pal to Pat Sonnier. Viewing the proposal as an extension of her ministry to the poor, Prejean agreed, and opened her eyes to the underworld of life on death row. She accompanied Sonnier through the next two years, until the day the state shaved his head for the electrodes, strapped him into the chair, and executed him. Thus began for Prejean a lifetime commitment to the abolition of the death penalty. She recorded her experiences in her deeply moving best-selling book, Dead Man Walking. *Made into an acclaimed motion picture (for which Susan Sarandon won an Oscar in 1995 for her portrayal of Sister Helen), the book and movie's publicity propelled Prejean's worldwide campaign against capital punishment. The United States is the only western country that administers the death penalty: nearly four hundred people currently await executions there. Meanwhile, recognizing the needs also of the families of victims of violent crimes, Prejean also created SURVIVE, an advocacy group with which she continues to work closely.*

The death penalty legalizes the torture and killing of our own citizens and imitates their violence in order to deter or punish. I came to this realization only after my first witnessing of a state execution. When I came out of that execution chamber with Patrick, I was clear, clear inside. You are either paralyzed by something like that or you are galvanized. And I call being galvanized the resurrection principle of life—overcoming death, and resisting evil. You know how Gandhi said you have to expose evil and you have to actively resist? That day, my mission was born. Patrick was dead but I didn't have a choice. It was just something I had to do because I knew I was a primary witness and I would take people there through my stories. So for fifteen years I have been working to stop the death penalty.

But I see in my audience a distancing from the death penalty: "This is off my radar screen, these are just a few criminals." You have to bring people over to the victims. You've got to deal with outrage. When people meet a criminal through a story and then meet the victims and see what really helps victims to heal and what doesn't help victims to heal, at the end of it many people are crying. Even though they know the person has done a terrible crime, the experience of the dignity of a human being is there, also. That's why it was so hard to kill Karla Faye Tucker, because so many people met her on *Larry King Live*. You could see this was a loving woman. Yet the only thing we knew to do was freeze-frame her in the worst act of her life, judge her by that act—and kill her.

The death penalty is not a peripheral issue about what to do about a few criminals who have done terrible crimes. It epitomizes the three deepest wounds in our society that we need to attend to and heal. The first wound is racism, because the criminal justice system is permeated with racism—starting with who is a victim, and who cares. When white people are killed that is always considered the greatest crime in this country. So 85 percent of the people chosen for death are there because they killed white people. A recent study in Pennsylvania shows that racism also shows up in the disproportionate punishment given people of color who do the same crimes that white people do.

The second wound is the assault on the poor. It is not an accident that the thirty-six hundred people selected for death in this country are all poor. They don't have the resources to get a Johnny Cochran defense team. It is not an equal playing field when they go into court. Supposedly, in our adversarial system, you have the prosecution and you have the defense. The jury is going to listen to arguments from both sides and make a decision. But all the resources are on the prosecution side and when the defense comes in, they can rarely prevail. We consider it poor people's individual deficiency that accounts for their poverty. In Europe they have much more of a social sense. If crime begins to proliferate they ask, "What are we doing wrong as a society?" They look at the fabric. They look at the soil. In America we think, "That apple is bad, get another barrel, burn the bad apples."

The third wound is our penchant to try to solve social problems through violence. We have been doing this for a long time. Our country was built on violence: violence against slaves, violence against Native Americans, and the kind of violence born by not allowing everyone to have a voice—such as women who, for a long time, could not vote.

That is why I don't consider execution a peripheral issue; I consider it central to the social fabric of our country, and an act of profound despair. We don't know what else to do, so we imitate criminals' worst possible behavior. We kill people who kill other people because we say, "You don't deserve to live a life. You aren't human the way the rest of us are, so you are disposable." It's a very dangerous, pernicious attitude. It leads to the death of our citizens in other ways, too. You see, the death penalty is very explicit. We take people who are alive through a process of torture and then kill them.

This begins on a personal level with all of us; we need to be involved in trying to change what we know is wrong. Consciousness is the first step, and the way that happened to me was to get to know people. In our society people wear four sets of gloves. We don't touch each other. We avoid certain neighborhoods. We never go to prisons. Death row is far away from us. We never see criminals—they are distant from us. So it is easy to do anything to them. Look how quickly that affects how we think and act. Right now a key way for politicians to get points is to outdo each other in mandating harsh punishments for criminals.

The U.S. Supreme Court has upheld that it is not against the dignity of a human person to execute them. Amnesty International defines torture as an extreme mental or physical assault on someone rendered defenseless. Then take a scenario where we hear of a crime that someone took their victim and kept them locked in a house and told them, "We are gonna execute you, we are gonna shoot you in the head Tuesday night at 9:00," and then when it comes to 7:00 they bring the victim out and say, "Not tonight, another night." And they bring the person back and they wait again, they take the person out and put the gun to him and say, "Not tonight." And then add to this that their family is watching while this happens. This is the practice of torture—this is the death penalty. Some people have been brought to the death chamber just an hour from death and received a stay of execution—knowing it might happen again.

One of the things I have found that drives the death penalty is people's concern for safety: "If we don't execute them, they are going to get out in a few years and they are going to kill again." It is important for them to know that most states have long-term sentences, either life without parole or mandatory long-term sentences for people who have been convicted of felony murder or first-degree murder. We can be safe without imitating violence.

Similarly, the death penalty does not make a criminal remorseful. Remorse has to do with a personal transformation, empathy, and compassion, and the ability to experience the victim's pain and say, "I am sorry." Some of the people who have committed terrible crimes are limited in their capacity to empathize with other human beings, because in their whole life they had never received that kind of love. And death coming at them does not increase that capacity to feel for others. In fact it can have the opposite effect, because their life is threatened. Self-preservation kicks in. They wrap around themselves tighter and have less capacity to love or to feel for others.

You know the root of *forgive*? It means "give before," fore-give. Which means that you are perpetually in a stance of love—that the evil and hatred are not going to overcome you. Some people have a lot of trouble with that: the connotation of forgive and forget, and, closely connected to it, healing and closure.

With the victims' families in Oklahoma City I will always remember one man who stood up in the midst of the sharing and he said, "Let's not use that word *closure* anymore." He said, "By God's grace we can get back on the current of life, I can learn to cope. But there is not a day in life that I will not think of my daughter. And closure sounds like we have closed that chapter, almost like it is a compartmentalization." I have known victims' families who would rather use the word *reconciliation*: "I can reconcile myself into a love stance. But forgiveness sounds like it is okay. And I can never say that."

How did Hemingway put it? "Courage is grace under pressure." Courage for me is very close to integrity. It means doing what you need to. Acting. Getting out there to change things. I don't call it courage when I accompany someone to execution. That is an act of love. Though they may be courageous in the way they go to their death, holding on to their dignity when they die. But for me, courage comes more in tackling the American system and believing and hoping in people so that we continue to change things. Courage is that steadfastness to continue—even if it means that you are going to be threatened. Like when we did our first walks in Louisiana we would get these threatening calls, "You bleeding-heart liberal, you murder-loving people," or "I'm gonna give a donation to the group in the form of quarters that are going to be melted down into bullets." And cars stopped, and people gave you the finger, and they yelled at you. Because violence really does trigger violence. The whole thing of execution is, "Get him, get him."

My dream is that human rights is what's going to bring us into the new millennium, that the more and more we grow into the sense of our community, our respect for each other, the dignity of people, that we can learn much better how to build a society. It comes back to me, the goodness, and that goodness inspires, energizes. You know how when Jesus was executed he said, "Father forgive them, they know not what they are doing?" I really think that that lack of consciousness and awareness is what makes us so insensitive to each other, and so we do these things to each other. If we bring people to consciousness and their own best hearts, they will respond. And so that is what we have to do.

KAILASH SATYARTHI

INDIA

—————

CHILD LABOR

"Small children of six, seven years and older are forced to work fourteen hours a day, without breaks or a day of rest. If they cry for their parents, they are beaten severely, sometimes hanged upside down from the trees and even branded or burned with cigarettes."

Kailash Satyarthi is India's lodestar for the abolition of child labor. Over the last decade he has emancipated over 40,000 people, including 28,000 children from bonded labor, a form of slavery where a desperate family typically borrows needed funds from a lender (sums as little as $35) and is forced to hand over a child as surety until the funds can be repaid. But often the money can never be repaid—and the child is sold and resold to different masters. Bonded laborers work in the diamond, stonecutting, manufacturing, and other industries. They are especially prevalent in the carpet export business, where they hand-knot rugs for the U.S. and other markets. Satyarthi rescues children and women from enslavement in the overcrowded, filthy, and isolated factories where conditions are deplorable, with inhuman hours, unsafe workplaces, rampant torture, and sexual assault. Satyarthi is now out on bail on false charges brought against him by a disgruntled carpet export company executive after Satyarthi appeared on an exposé aired on European television. The constant death threats are taken seriously—two of Satyarthi's colleagues have been murdered. Satyarthi heads the South Asian Coalition on Child Servitude, which he cofounded in 1989. Under his leadership, SACCS carries out public awareness campaigns, advocacy, legal actions, and direct intervention to emancipate children and women from bonded and child labor. SACCS rallies national and international institutions and nongovernmental organizations to bring pressure on governments, manufacturers, and importers to stop exploiting illegal labor. Satyarthi organized and led two great marches across India to raise awareness about child labor, and, in 1998, organized over ten thousand NGOs around the world to participate in the Global March Against Child Labor. Still there is much to do. There are 6 to 10 million children in bonded labor in India alone. There are 250 million children forced into child labor across the world, including 246,000 children working at agricultural labor and in sweatshops in the United States. Satyarthi's job has just begun.

Bonded labor is a form of modern-day slavery, where ordinary people lose the most basic freedom of movement, the freedom of choice. They are forced to work long hours with little rest. Over five million children are born into such slavery. Their parents or grandparents may have borrowed a petty sum from a local landlord and consequently generations and generations have to work for the same master. They are prisoners—forbidden to leave. Another five million children are sent to work when their parents receive a token advance and this small amount is used to justify unending years of hardship.

The conditions of bonded labor are completely inhuman. Small children of six, seven years and older are forced to work fourteen hours a day, without breaks or a day of rest. If they cry for their parents, they are beaten severely, sometimes hanged upside down from the trees and even branded or burned with cigarettes. They are often kept half-fed because the employers feel that if they are fed properly, then they will be sleepy and slow in their work. In many cases they are not even permitted to talk to each other or laugh out loud because it makes the work less efficient. It is real medieval slavery.

We believe that no other forms of human rights violation can be worse than this. This is the most shameful defeat of Indian law, our country's constitution and the United Nations Charter. Our most effective armor in this situation is to educate the masses and to create concern and awareness against this social evil. In addition, we attempt to identify areas where child slavery is common. We conduct secret raids to free these children and return them to their families. Follow-up on their education and rehabilitation is an equally vital step in the whole process. We lobby different sectors of society, parliamentarians, religious groups, trade unions, and others, who we believe could influence the situation. We have about a hundred full-time and part-time associates in our group. But we have also formed a network of over 470 nongovernmental organizations in India and other South Asian countries.

For us, working with enslaved children has never been an easy task. It very often involves quite traumatic situations. These children have been in bondage ever since the time they can remember. Liberty for them is an unfamiliar word. They don't know what it is like to be "free." For us, the foremost challenge is to return to them their lost childhood. It is not as simple as it might sound—we really have to work hard at it. For instance, one of the children we've freed was a fourteen-year-old boy, Nageshwar, who was found branded with red-hot iron rods. Coincidentally, at that time, an official from the RFK Center for Human Rights was in India and she came across the boy in New Delhi. The trauma Nageshwar went through had made him lose his speech. He was even unable to explain his condition. It was only later through other children that we came to know about what had happened to him. We really have to work hard to reach such children.

As you may be well aware, marches and walks have been an integral part of our Indian tradition. Mahatma Gandhi marched several times to educate the people (and also to learn something himself!). Keeping in view their strong impact, especially when it comes to mass mobilization, marches have always occupied a prominent place in our overall strategy to combat child slavery. Marching doesn't

mean that we are trying to impose anything. Our demonstrations have about 200 to 250 marchers, half of whom are children—children who have been freed from bondage and slavery. They act as living examples of the dire need to educate people about both the negative impact of the bonded labor system and the positive impact of their newly gained freedom. The other marchers are representatives from human rights organizations, trade unions, and social organizations who join in solidarity. We go to different villages every day, and conduct public meetings, street theater, cultural activities, and press conferences to put across our message to the people.

Two years ago we welcomed the prime minister's promise to act against child labor, if not against bonded labor. We were hoping for some positive results, some impetus to reforms. But even after all this time, no action has taken place. It is very unfortunate. The pronouncement initially created some fear in the minds of employers, but now it is going to prove counterproductive to reform. People by now realized it was nothing more than a political gimmick and that there was no real will behind it. The employees are a varied lot. When a child is bonded to a street restaurant, the employer is usually an ordinary person of some remote village or town. But when children are employed in carpet weaving, or the glass industry or the brassware industry, the employers are "big" people. They generate a lot of foreign exchange through exports and are always considered favorably by the government.

Despite this, I am not in favor of a total boycott or blanket ban on the export of Indian carpets. Instead I have suggested that consumers buy only those carpets that are guaranteed made without child labor. Consumer education is a must to generate demand for such carpets. We believe that if more and more consumers pressed this issue, more and more employers would be compelled to free child workers and replace them with adults. It is unfortunate that in the last few years in India, Pakistan, and Nepal, the numbers of children in servitude have gone up,

"These children have been in bondage ever since the time they can remember. Liberty for them is an unfamiliar word. They don't know what it is like to be 'free.' For us, the foremost challenge is to return to them their lost childhood."

paralleling the growth in exports. For instance, today in India we have about 300,000 children in the carpet industry alone with the export market of over U.S. $600 million a year. Ten or fifteen years ago, the number of children was somewhere between 75,000 to 100,000 and at that time the exports were not for more than U.S. $100 million. The direct relation between these two is clearly evident. This fact compelled us to launch a consumer campaign abroad. Health and environment have been the prime concerns among the consumers in the West—in Germany, in the U.S. But the issue of children was never linked with this consumer consciousness. People thought of environment and animal rights, but they never thought about children. But in the last couple years, I am proud that the child labor issue has gained momentum and has become one of the big campaigns in the world. What began with awareness and publicity has now expanded to issues of compliance.

We have recommended the establishment of an independent and professional, internationally credible body to inspect, monitor, and finally certify carpets and other products have been made without child labor. We formed the Rugmark Foundation as an independent body with nongovernmental organizations like UNICEF. They appoint field inspectors, and give all carpets a quote number that gives the details of the production history of the carpet. The labels are woven in the backside of the carpet, and nobody can remove or replace them. This is a significant step in ending this exploitation.

But even this task of educating Western consumers is not so easy. It does involve its share of risks. For example, a German TV film company, after initial research, exposed the employment of children in the carpet export industry. The story was of an importer in Germany, IKEA, who had announced that they would deal only with child-labor-free goods. So reporters started investigating. They came to my office and ashram and interviewed me. Their interview was of a very general nature but when the film was shown later it mentioned Sheena Export in detail, which resulted in the cancellation of a big

order from IKEA. Sheena Export, one of the biggest players in the field, became notorious, which affected their exports to other countries, including the United States, which was worth U.S. $200 million a year. The company is politically very powerful (one of the brothers is the transport minister in the state of Haryana) and so they decided to fight back.

I know that the entire carpet industry, or the majority of it, opposes me. They believe I am their enemy; they just want to eliminate me. They wanted to take me to Haryana, the state known for the worst human rights violations, fake encounters, illegal custody, and killings of people in jail and in police stations. I was arrested on June 1. They wanted to arrest me legally, but they never informed the Delhi police, which is required under Indian law. Because the police came from another state and had no jurisdiction, they couldn't legally arrest me in my home in Delhi. But they tried. I was able to make phone calls and consult a few people on this, and finally I told them that they could not arrest me. The Haryana police did not pay any attention and threatened to break in. They took out their pistols. As you can imagine, their presence had created terror in the whole neighborhood. I was finally arrested and later released on bail. It was not the first time, though it was the first that such a big plot was cooked up against me. At times in the past I have faced such threats. Two of my colleagues have also been killed.

I think of it all as a test. This is a moral examination that one has to pass. If you decide to stand up against such social evils, you have to be fully prepared—not just physically or mentally, but also spiritually. One has to pull oneself together for the supreme sacrifice—and people have done so in the past. Robert F. Kennedy did, Mahatma Gandhi, Indira Gandhi, John Kennedy—the list can go on endlessly. Resistance—it is there always, we only have to prepare ourselves for it. We will have to face it, sooner or later. It is the history of humanity, after all.

PATRIA JIMÉNEZ

MEXICO

GAY, LESBIAN, AND TRANSGENDER RIGHTS

"We have to force the government to provide equal treatment, to stop discrimination, to respect the right to health care and a job for gays. In order to exercise these rights you have to demand them."

Mexico's first openly homosexual member of Congress, Patria Jiménez Flores was elected in 1998 at the age of forty-one. The ninth of ten children in a conservative Catholic family, Jiménez overcame her own family's prejudices to confront the bigotry of society at large. She works on issues of homophobic violence, violations of basic rights, sexual and sexuality education, cultural activism, and awareness of AIDS and other sexually transmitted diseases. In addition she is a leader on domestic violence initiatives and a supporter of peace negotiations with the Zapatista rebels in Chiapas. As a member of the national legislature, Jiménez works on behalf of sexual minorities, and for the dispossessed and voiceless throughout Mexico. Between 1991 and 1993, some twenty-five gay men were assassinated in Mexico, mostly among the Chiapas transvestite community. Jiménez has been a relentless advocate for justice, pressuring police to reopen the investigations. On the day of this interview, Jiménez was on the phone to Chiapas, hearing from local human rights organizers that authorities had used violence again that morning, and her presence would help prevent confrontation. Could she possibly come in time for the demonstration? Despite the caseload of legislation confronting her, Patria Jiménez was on the next flight.

PATRIA JIMÉNEZ

Twenty-five transvestites were executed, one by one, in the state of Chiapas. The murders were carried out with high-powered weapons, those reserved for the exclusive use of the armed forces and the judicial police. There was a private party at which someone allegedly made a video, so what the governor allegedly did was to kill all the people who may have had something to do with that. And while violent discrimination is more pronounced in municipalities with a right-wing party in power, other states within Mexico have had their share of human rights violations against gay, lesbian, or transgendered people.

In Mexico City, with the election of the new government (the Party of the Democratic Revolution), we saw a change to greater visibility and freedom of expression. Proposals we made to improve the human rights situation of sexually diverse people included the creation of the first community center for them. We could have done it alone, but it was important to have government support. This is an ongoing struggle.

I have been a lesbian activist for twenty years. I think that not feeling guilty about it, not having to request permission simply to live without hiding, is liberating. I don't know if it's a consciousness that you learn. I certainly was strengthened by feminist discourse, by finding groups of women who reflected on everything—sexual roles, the division of labor, violence. What I learned is that you can't discriminate on the basis of a human condition. You can't ask a Chinese person to have round eyes, or someone to change their skin color, or a homosexual to be heterosexual. But in my culture this truth is not universally acknowledged.

It starts, of course, in the home, this phenomenon of family violence against children who are gay. It begins with silence, with marginalization within the family environment, with punishment. By brothers, fathers, uncles. In a minor, small way, I felt this while growing up, too. Family conversation was always negative when it came to the issue of homosexuals. And, of course, that's what makes someone repress the idea that he or she is a homosexual.

Let me tell you one story. At one point, one of my brothers was threatened by my relationship with one of his girlfriends. She had written me a letter, and he opened it before I did—because he was jealous, I suppose. Of course, I wasn't involved with his friend in any way. I was only sixteen at the time, and he was maybe nineteen. At that point I still didn't have any idea that I was a lesbian. And this letter didn't really say anything special, but after reading it my brother spoke to me in really offensive terms. "You fucking lesbian," he said. I responded, "But why 'fucking'? And I don't understand—what's wrong with being a lesbian? Why is it an offense?" I didn't like his attitude. Furthermore, I knew it showed a lack of respect to read my letter. It was my first experience of rebellion, of responding to the prejudices of the larger society we live in, of personal anger.

You see, I was never in the closet. I left home so they wouldn't try to take me to a psychologist or psychiatrist. But when I did finally leave home I was out in the streets—literally—marching and proclaiming who I was. The first demonstration I went to I unfurled a poster at the Iranian Embassy, because they were killing women who took off their veils. It was a big sign saying: "Mexican Lesbians Against

> "My fear disappears when I begin to speak in these situations, without raising my voice…. I'm afraid inside, but calm outside. It's only when I get home that I react. The morning after, I wake up and say, 'What did I do?'"

the Assassination of Iranian Women." People looked at it, and came back to look again. We always took the opportunity to forthrightly declare that we were lesbians protesting this or that. Because I believe it is very important to get involved within social movements as lesbians, homosexuals, and bisexuals, and to work within them, like the indigenous movement in Mexico, for example. That gave us presence, and made us, and them, realize that one is not alone.

In my life I have heard a lot of stories from women. Stories that explain what it means to live a gay, lesbian, bisexual, or transgendered life, with all its disadvantages, in such a heterosexist society. I began late in the 1970s to consider ways to solve problems or, at least, to diminish the levels of anxiety with which gay people lived.

By the time I actually had lesbian relationships, I was already very independent. I left home because I knew I would not be able to change my entire family, and it was always a given that they were going to try to change me. I tried to write them a letter saying I thought I had already learned everything that I could from my family, and everything I had left to learn was beyond the boundaries of our closed world. That was a crisis for them. My sisters told my mother I had a sexual deviation problem. But by the time they actually reacted, I was already gone. Later, I rebuilt my relationship with my mother. She imagined that my world was full of problems, that I would never have a home. But I showed her that I had a house and a job, and that I had continued studying. And when we finally sat down face to face to talk, she said to me that the only thing she wanted to know is whether I

was happy. Then she said, "But why can't you be like your sisters?" And I responded, "Would you really want their lives for me?"

Still, my whole life I always felt my mother's support, her love. Parents always know if their children are gay. With me, my mother never spoke about gay issues, but she'd buy me a pair of pants, or a particular shirt, as though she knew. And she seemed to understand that what I was doing was right for me.

With being lesbian comes the pressure of tremendous responsibility. There's always a pressure to show that we're better. I don't know if it's positive or negative, but we strive to be the best we can at work. It's part of our seeking acceptance and I like to think that through this effort we can support and help other lesbians. Part of my effort is to show that I'm qualified. Though I don't actively feel discrimination, because I think I've done my job well, I recognize that discrimination is impregnated in daily life. It can be felt in the way people look at you.

Here's one example. In Orizábal, in the state of Veracruz, the mayor decided to detain all transsexuals who are prostitutes. So what did they do? They picked up the prostitutes, and all the gays and lesbians, too. How did they pick them up? By their appearance alone. The prostitutes were liable to be picked up for actions, administrative violations: for selling their bodies, for lascivious conduct. But lots of young gay people were brought to jail solely because of their appearance. Similarly, if young people were caught carrying condoms, they were accused of prostitution.

There is discrimination. In Mexico City and the other big cities, gay people gain strength from being part of a group. But elsewhere in Mexico, people are alone and isolated. When someone in this situation gets our telephone number, they call us; and today, we get hundreds of calls. The movement has done a lot, providing services, creating groups, supporting sexual diversity.

But there is much more to accomplish. What I would like to do through radio and television programs is to get families to know that they should not discriminate against their children. We're pushing for a climate in which young gay men and lesbians can have positive relations with their families and friends.

But there is an outside world, too, to contend with. It's still a reality that someone gay could lose their job if it becomes known. A professional, a cardiologist, even someone of real eminence can be fingered as a homosexual by anyone on the street. The professional then might lose his or her job. Still. Today. That's why we need legislation. This is a process that has been evolving, the understanding that it is important for gay people to know that they have rights. For twenty years that's been our work—to explain that we are citizens, that we pay taxes. And now that sexually diverse communities understand that they have the same rights as everyone else, our work is to get them to exercise their rights. We're just at the point where gay people know that we have power. We surprised ourselves when we proposed to march to the center of Mexico City during the annual demonstration. People showed up by the thousands and said, "Yes, we are citizens." It was an important step in the process we are living now. We can't reach all gay people in Mexico, but our organization is becoming more

accessible all the time. But we have to force the government—it doesn't matter if it is the National Action Party, the Institutional Revolutionary Party, or the Party of the Democratic Revolution—to provide equal treatment, to stop discrimination, to respect the right to health care and a job for gays. In order to exercise these rights you have to demand them.

But things are slowly changing—and for the better. We've reached agreements related to young people unable to finish their studies because of their sexual orientation, as in the case of transgendered people, who often feel that their only option is prostitution. We're discussing this with authorities on the district level, so that when transgendered people arrive, dressed however, they are not discriminated against. They should be treated as citizens with access to this type of privileges, scholarships, and services that the government gives to other people, so they can have a trade. And we've had a positive response. We've also asked on a district level for the establishment of places to sell condoms in public, to help limit the spread of HIV, along with a person who can dispense information, but at this time even basic salaries are not sufficient to purchase condoms.

We succeeded in establishing the office of the Social Ombudsman, who receives complaints from citizens, gives support, investigates complaints, and punishes wrongdoers. They are going to open a window for people to lodge complaints, related to sexual diversity—whether you were fired or kicked out of your school or your apartment, or suffered some physical attack. They'll work on your case and give you advice—without discrimination. These are the things we have seen on the positive side of the balance.

"You can't ask a Chinese person to have round eyes, or someone to change their skin color, or a homosexual to be heterosexual. But in my culture this truth is not universally acknowledged."

There have been some interesting developments in working with the men and women members of the Chamber of Deputies. We eliminated the terms "homosexualism" and "homosexual practices" from the legal vocabulary (considered under the criminal code to be aggravating factors in the crime of corrupting minors). Representatives from all political parties accepted this change as natural and normal at the negotiating table. They said it was fine, a good proposal, and moved it forward to the Senate. In Mexico City, it will also be approved. So progress has been made.

The right-wing National Action Party and the Church have led powerful attacks against gays and lesbians. We requested a meeting with Church leaders to ask them to stop discriminating against sexually diverse people. There was no response, so I made a proposal to groups of religious people (who happen to be gay) to make a pilgrimage to the Virgin of Guadalupe. It was a great initiative, because we will reclaim the right to be spiritual, to profess a religion, without having to worry about the religious hierarchy. When I look back on this, I will know I did the best that I possibly could. For my private life, I steal time. I don't really have time, just little pieces, days, sometimes hours. My work schedule includes lesbian groups, the lesbian-gay movement, my work in Congress, the legislative initiatives on which I work, marches, meetings, protests, publishing a magazine, writing. Plus the congressional commissions on which I sit—which are important for me: equality and gender, human rights, and population and development. But I just don't have time for everything.

And I will look back and realize the true meanings of many things, like courage. Courage is when, in Chiapas, you ask a general to remove his troops from a com-

munity because they are entering houses at night, frightening people. You have to talk to that general, to confront someone with weapons and power, to overcome your timidity and fear. Today they tell me I'm going to Chiapas, to lead the people on a march into the community of La Realidad. When we get to the roadblock, there will be armed paramilitaries. These are the most risky situations: entering communities in which my truck is surrounded by paramilitaries threatening to burn it, saying that they will kill us. It used to make me afraid, but it doesn't any more. Because I am never alone. Even when people ask me to go in front, to confront the troops or the paramilitaries, they come with me, so we're a group.

My fear disappears when I begin to speak in these situations, without raising my voice. I just try to explain to people what's going on. I'm afraid inside, but calm outside. It's only when I get home that I react. The morning after, I wake up and say, "What did I do?" That could be brave. I don't know. I'm not someone who takes risks. Others have been beaten up, but this has not happened to me. If that happens to me some day, it will be part of the work. I just hope they don't hurt me too badly.

But I take courage by realizing that here is an opening, and we have been able to move forward on difficult cases. I've gotten a reputation of being a good advocate. But it works because there is openness on the part of the other side. They are small cases, but they are very important, because they have to do with people's lives—someone in jail, rape victims, a pregnant woman, a person kicked out of work after twenty-five years. Very small cases, but it's their lives. And it's so worth fighting for.

GABOR GOMBOS

HUNGARY

MENTAL DISABILITIES RIGHTS

"There was a relatively young man with severe mental retardation in the cage. We asked the staff how much time he spent in the cage. The answer was all day, except for half an hour when a staffer works with him. And I asked them, why do you keep this person in the cage?"

Throughout the world, people with mental retardation, elders with dementia, and people of all ages who suffer from psychological illnesses, from depression to schizophrenia, are regularly abandoned to a life of discrimination. They are often locked away in insane asylums where degrading conditions include pervasive inactivity, filthy spaces, and the use of physical restraints, including confinement to cages. Denied adequate privacy, medical and dental care, food, water, clothing, blankets, and heat; rehabilitation and reintegration into society are rarely the goals of their treatment, medications are chronically overused and misused, and there is almost a complete failure to provide informed consent for treatment and experimentation. The chronic shortage of resources includes a serious lack of trained staff, and few avenues of complaint for violations against this most vulnerable and marginalized segment of society. Gabor Gombos knows these conditions all too well. Between 1977 and 1990 he was confined four times to psychiatric wards in Hungarian hospitals. He emerged determined to overhaul psychiatric care, first in his country and then across Europe. To this end, Gombos cofounded the first NGO active in Hungarian mental health issues (EGISZ, the National Family Association of the Mentally Ill) in 1993, and the following year, cofounded Voice of Soul, Hungary's first NGO for ex-users and survivors of mental health facilities, where he still serves as chair of the board. Gombos is also a member of the board of directors of the Users, Ex-users, and Survivors of the Psychiatry Movement in Europe, and the European Network on Constraint and Collaboration in Psychiatry, and is on the editorial board of Out Loud. *He is cofounder of the Hungarian Mental Health Interest Forum. Gabor Gombos's tireless work on behalf of people with mental illness has helped end the previous damaging and derogatory practices of that time and brought the human potential of those with mental disabilities into the light at last.*

In Hungary, there are fifty-three social care homes for the mentally ill, similar to the old American state mental hospitals (as opposed to psychiatric hospitals and psychiatric wards, basically for acute patients, where patients spend at most two or three months). Most of these fifty-three institutions were started in 1953 by the Communist Party, which maintained that mental illness was a characteristic feature of capitalism, and would disappear under Communism. And after a few years they discovered there were still mentally disabled people in society. How to solve the problem? They set up these institutions very far from bigger cities and towns, to make mentally disabled people invisible for the majority of society. If you don't see them, they don't exist.

Depression is a nationwide problem as with everywhere in the civilized world. The Hungarian suicide rate is one of the highest suicide rates in the world.

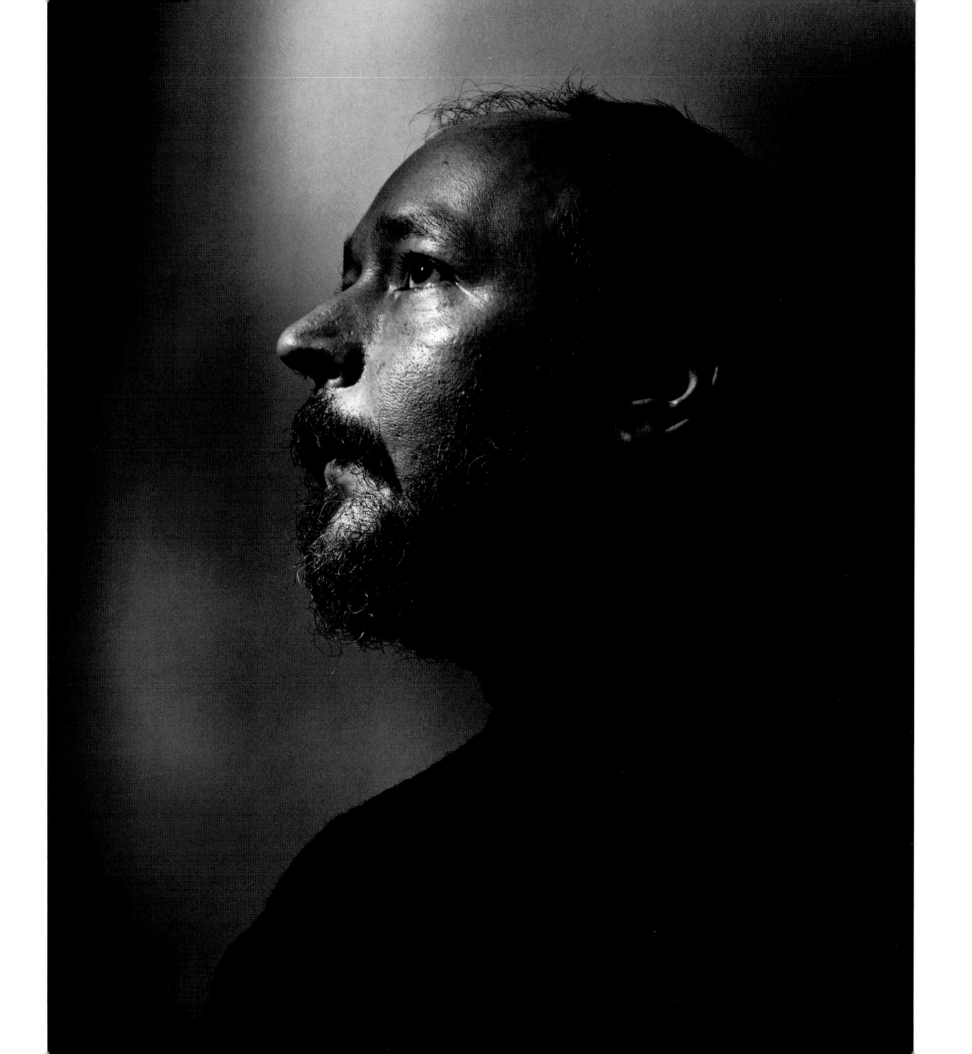

Classic psychiatric disorders (severe depression, manic depression, schizophrenia) are as prevalent everywhere. So we have 100,000 people with schizophrenia, another 100,000 people with severe depression or manic depression. There are a few thousand beds in psychiatric hospitals and wards, and a few thousand more in the homes for the mentally ill. Even the newest post-1994 facilities reflect the attitude of the society, the discrimination, the prejudice, the stigma against people with mental disabilities. The buildings are modern, but the attitudes are old, designed without rooms for occupational therapy, without a common eating facility, and with cages for acute cases.

What is missing is a flexible and reachable network of various social services for people with mental disabilities: a sheltered place to live, support in feeding, shopping, and other needs. But there are no outpatient services like that. With as little as half an hour a day, these people could be not only equal members of society but able to earn their own living. But because these services are completely missing, the only choice for the family or for the local authorities is to condemn people to social care homes for the mentally ill. This is really tragic. The lack of resources is not the main reason for the government's failure to do anything (a much-heard complaint) because an unreasonable amount is spent for services that are ineffective and (by the way) violate basic human rights. On a fact-finding trip to an institution, for example, we noticed a relatively young man with severe mental retardation in the cage. We asked the staff how much time he spent in the cage. The answer was all day, except for half an hour when a staffer works with him. And I asked them, why do you keep this person in the cage? And the answer was for his own protection.

The average waiting list for admittance to a group home is about three years, and if you consider that the conditions are abhorrent, that they are not rehabilitation institutions but are custodial institutions, it seems surprising that there are people waiting. It doesn't mean that these people want to be there; it means there is no other choice, or that their guardians are forcing them to be there. The Hungarian guardianship system itself is a severe violation of basic human rights. If someone has a psychiatric diagnosis or one of mental retardation and if someone therefore believes that person is incompetent, then they can initiate guardianship procedures, and some local official makes a decision about a temporary guardianship, lasting sometimes for two or three years. It means all your civil rights are controlled by your guardian, including your property, house, and money. Abuse is common.

Medically you can be forcibly treated or hospitalized against your will, only if you have been admitted voluntarily. The guardians circumvent this by proclaiming the patient incompetent and then condemn them for life to "voluntary" care. In the new social care homes for the mentally ill, more than 90 percent of the residents are under guardianship, and this is shameful.

One of the issues we address is occupational therapy. There is very little, and what exists is not very therapeutic. On the other hand, patients do real work for the institution cleaning bathrooms and washing floors—for free. They should be paid the minimum wage for this real custodial work they perform instead of being exploited by the institution. The fact that they perform these services indicates that they can survive perfectly well in society with minimal support.

"Even the newest post-1994 facilities
reflect the attitude of the society,
the discrimination, the prejudice, the stigma
against people with mental disabilities."

We walked through one facility for three hours with the psychiatrist, the director, the chief nurse, and others, and not one patient seemed to recognize or initiate conversation with any of the staff, as though they had no relationship. Yet this home is very proud that it has a psychiatrist at all since most of these institutions do not have one. The psychiatrist said he only needs to see patients with acute symptoms and only 5 percent are acute so he's there only three afternoons a week. My question was, why should the other patients live in social institutions designed for the mentally disabled? Why not in ordinary social care homes for the elderly, for instance? Or shelters for the homeless? I know the answer: because there are no alternative shelters. But how amazing that the chief psychiatrist said they don't need to see a psychiatrist. It's an insane asylum, after all…

A few words about institutions for mentally ill and mentally retarded people. I told you that most of the social care homes for the mentally ill are mixed institutions. And you can find people with mental retardation in every one of these places. I must tell you that, on average, the human rights violations in the institutions for the mentally retarded are much more severe. It's not a question of money and a shortage in financing. It's a question of attitudes. it's the exception when the staff beats a mentally ill person. But it's very often an everyday practice in many of these institutions for the mentally retarded that the staff beats some of the patients.

The last time I was in a mental hospital was in 1991. At that time I was very, very depressed, and I was a voluntary patient. But when I wanted to leave I was not allowed. Since we had no real legislation about this, the doctor simply changed my status in the medical documents to involuntary, because he decided I'd become agitated or confused—I don't know. The courts had nothing to do with this. The court made several visits to the wards. They interviewed some selected patients, most of whom were overdrugged and some of them had just been electroshocked. After the electroshock, your memory is not really clear. So they said, "Yes, yes, it's okay."

The main indication for electroshock is severe depression. Twenty years ago, the major indication was schizophrenia. Now they say that it's contraindicated in schizophrenia. My wife was electroshocked twenty-six times for schizophrenia, only to be told that it was a severe mistake. She is suffering long-term side effects from those electroshocks. I was lucky, because my mother protested against my treatment so I have never been shocked, just treated with drugs.

My contact with psychiatry began when I was three years old. My uncle committed suicide. A few months later, my mother became very depressed and delusional. She was hospitalized many times when I was a child, and when not in the hospital she worked outside the home to care for me and my grandmother. So I was raised mainly by my grandmother, who was also mentally ill. She died when I was ten. Being afraid that I'd be put in an orphanage, my mother married. But my stepfather drank a lot, which did not help my mother's emotional stability. Her hospitalizations increased and she tried to commit suicide several times. My mother lost her autonomy, her

social contacts, her social roles over time and applied for a disability pension. She lost her job, which was devastating for her. So her life was narrowing and narrowing and narrowing. And the only goal which remained for her was for me to grow me up successfully. As soon as I became more or less independent, my mother died. Her death was mysterious because she was an outpatient at the mental health hospital where she was an involuntary subject in a double-blind drug experiment.

When I discovered the true cause of her death, I went really crazy, completely psychotic, with threatening hallucinations. So psychotic that I didn't go to the psychiatrists. I didn't eat. I didn't leave my home. I couldn't. The reason that I am here is that one of my friends unexpectedly visited me, and discovered that I was visibly psychotic. But he was an old friend and didn't think that the answer to my state was hospitalization. He could understand my situation. I had lost my mother. He knew something about her very doubtful autopsy. So he moved into my apartment for weeks, spent all his time with me, forced me to eat something.

For weeks, I couldn't understand what he told me. He recognized this and didn't try to speak to me; he was just together with me. And that was what I really needed. After three weeks, I recognized that I had passed my deepest crisis. Without any help from the psychiatric establishment, with only the very human help from my friend, I had survived this very critical period.

That was the beginning of a new life. I began to question many things that I had believed in before. That resulted in another crisis. But now I had the self-confidence that, with the proper support from people who are close to me, I could survive. Before that, starting at age seventeen, when I felt ill, I had gone to the psychiatric institution more or less voluntarily and there I was treated as an object. I received some injections, some pills, was told to try to relax, that it had nothing to do with my disorder; that "we are trying to help you"; that "you cannot help yourself at all because it's the biochemistry of your brain." And I believed it. But when I emerged out of my second psychotic experience with my friend's help, I felt that I did have some control over my illness.

I had always tried in the past to find someone to make my decisions for me. I couldn't imagine that I would be the one to control my own life. It is not easy if you start when you are over twenty-five, but not impossible. Then I was lucky. I got a grant from the French Ministry of Culture for studies in metaphysics. So I did some research in France, four months in a completely strange environment, a very good opportunity to start a long, long dialogue with myself, to make certain things clear.

And then I understood that physics was not my real profession. It was a kind of medication in my childhood to have a goal, which was not easy at the time in Hungary, one that belonged to the elite professionals in the Communist countries. But when I came back from France, some people contacted me and asked me to help them organize a nongovernmental organization for the families of people

> "I remind myself that many of the mistakes in mental health care come from a helping attitude. But they want to help you without asking you, without understanding you, without involving you, 'in your best interest.'"

with mental disabilities. I joined because of my mother. And after a time, became more and more involved. I met my wife through these activities, and we decided to get married. And this was the moment when I realized that I would be seriously committed to helping people who share my terrible experience of so-called psychosis, and changing the way society reacts to it, and so changing the world.

The transition to teaching was hard. I have never suffered from a learning disability, but I suffered from very similar emotional deprivation, a violation of my emotional privacy. Now I am very involved in this movement, called Users, Ex-users and Survivors of the Psychiatry Movement in Europe. We say we are lucky to have survived a very antihuman mechanism which doesn't kill the patients biologically, but the end result is very often a socially dead person living in a social care home for the mentally ill. I had a very simple choice: Did I want to take up this role and have a chance to find myself? Or not take up this mission and lose that chance?

For years I believed that it was my mission to do research in physics. There were extremely heavy competitors there, but not supporters. In my private life, my mother was the only person who was a supporter. My real father never supported me; my grandmother maybe wanted to, but what she actually did was something completely different. In the world of human rights advocacy for people with mental disabilities I discovered people who shared my experience, who gave me all their support, all their expertise, all their knowledge. And I tried to return that in kind. Solidarity, you know? This was the first time in my life when I experienced solidarity.

I remember that Edmund Hillary wrote in one of his books that when he was an adolescent he dreamed that as an adult he would be a very courageous person who would climb high mountains and discover undiscovered lands. And when he looked back at his life, he wrote that he never felt he succeeded, because every time he climbed onto a mountain, he was very much afraid. But what he learned is that even if you are afraid, even if you are not courageous, you can do things if they are important for you. In spite of the fear, you feel the presence of a peaceful entity. Even when I experience strong panic—which happens quite often—I do have some kind of spiritual peace. So, emotionally, I can be very threatened, very frightened, and even my soul can be confused, but still I feel that peace. It's not an abstract entity. But if I do not feel it, then it is a sign that I might do the wrong things. I remind myself that many of the mistakes in mental health care come from a helping attitude. But they want to help you without asking you, without understanding you, without involving you, "in your best interest."

I can understand those who are on the other side of this mental health care. I don't suppose that they are less valuable human beings. And by understanding, we can influence each other, at least on a personal level. And I really believe that change, social change, can happen only if it happens in various levels. If decision makers, as human beings, embrace human relationships with people with mental disabilities, and with other disabilities, this will advance change and understanding like nothing else.

MARINA PISKLAKOVA

RUSSIA

DOMESTIC VIOLENCE

"A woman called the hot line and said her husband planned to kill her.
I called the police but the officer immediately called the husband, saying,
'Look, if you do it, do it quietly.' And I realized there was no hope."

*Marina Pisklakova is Russia's leading women's rights activist. She studied aeronauti-
cal engineering in Moscow, and while conducting research at the Russian Academy of
Sciences, was startled to discover family violence had reached epidemic proportions.
Because of her efforts, Russian officials started tracking domestic abuse and estimate
that, in a single year, close to fifteen thousand women were killed and fifty thousand
were hospitalized, while only one-third to one-fifth of all battered women received
medical assistance. With no legislation outlawing the abuse, there were no enforce-
ment mechanisms, support groups, or protective agencies for victims. In July 1993,
Pisklakova founded a hot line for women in distress, later expanding her work to
establish the first women's crisis center in the country. She lobbied for legislation ban-
ning abuse, and worked with an openly hostile law enforcement establishment to bring
aid to victims and prosecution to criminals. She began a media campaign to expose
the violence against women and to educate women about their rights, and regularly
appears on radio and television promoting respect for women's rights. Pisklakova's
efforts have saved countless lives, at great risk to her own.*

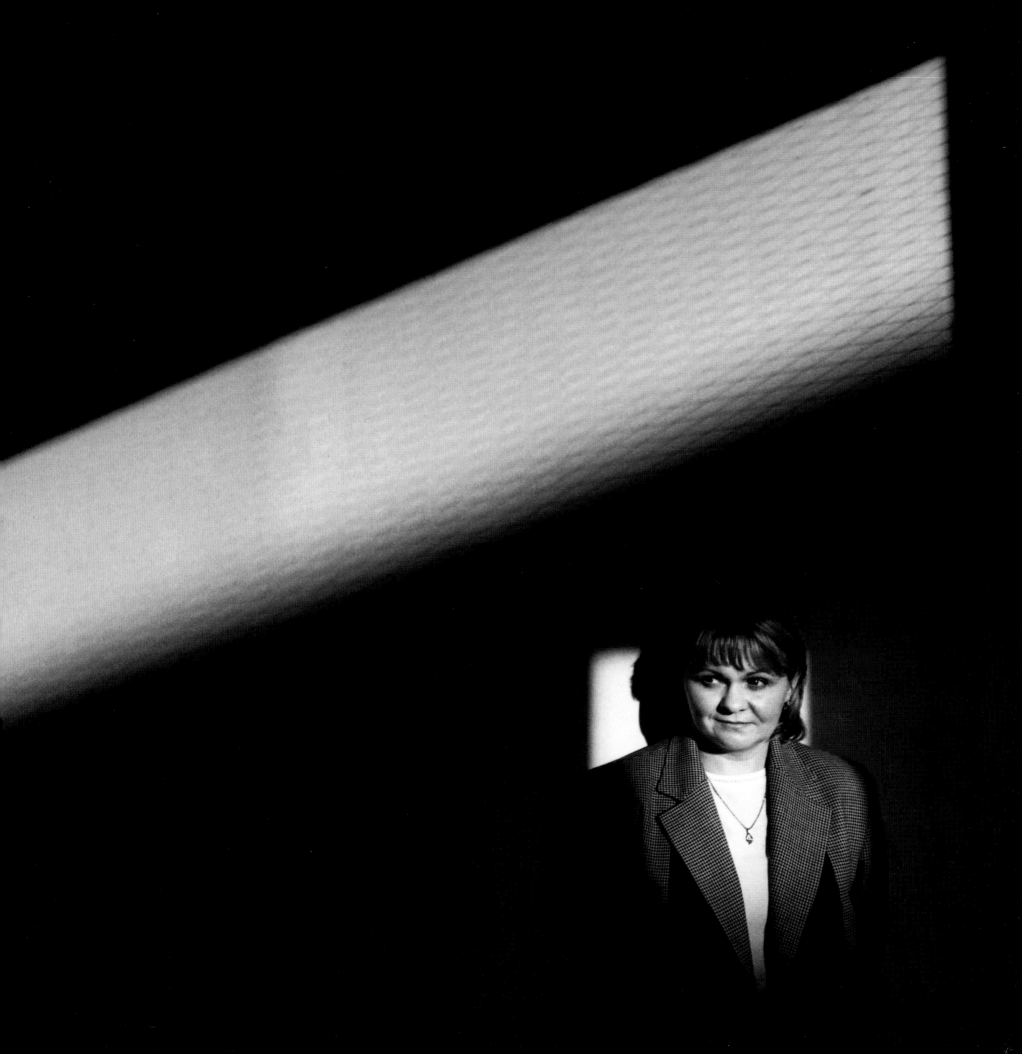

When I started the first domestic violence hot line in Russia in 1993 (we named it Anna, Association No to Violence), I was alone, answering calls four hours a day, every day, for six months. I was counseling people in person the other four hours. I couldn't say no; there were so many women. I had no training, no distance, no boundaries. But at the same time, I don't know how I could have done anything differently.

Without realizing what I was embarking upon, I began this work while a researcher at the Institute for Socio-Economic Studies of the Population within the Russian Academy of Sciences. While coordinating a national survey on women's issues, one day I received a survey response I did not know how to classify. It described a woman's pain and suffering at the hands of her husband. I showed it to some colleagues and one of them told me, "You have just read a case of domestic violence." I had never heard this term before. It was not something even recognized in our post-Soviet society, much less discussed. I decided I needed to learn more about this mysterious phenomenon.

Shortly thereafter, I encountered the mother of one of my son's classmates in front of the school. Half of her face was severely bruised. She wouldn't tell me what had happened. One evening a few days later, she called me. Her story shocked me. When her husband was wearing a suit and the button fell off, and it was not fixed quickly, he took a shoe and slapped his wife in the face. For two weeks she couldn't go out. She was really distressed, and hurt—physically and emotionally hurt—because half her face was black and blue. I asked her, "Why don't you just leave him?" A very typical question. And she said, "Where would I go?" I said, "Divorce him. Get another apartment." She said, "I depend on him completely." And in this exchange, I saw everything: the way the abuser was consolidating control, decreasing self-confidence, and diminishing self-esteem. I also heard her story of how he would come home and go to the kitchen, touch the floor with his finger, and, if there was the slightest dirt, ask sneeringly, "What did you do all day?" The floors in Russian kitchens always have some dirt, especially if you have kids at home who are running around—the kitchen is often the center of family life in our small apartments. For outsiders, scenes such as I have just described might seem ridiculous, but I was to soon discover that they were commonplace. For this woman, our conversation was an opportunity to communicate with someone who didn't judge her, who didn't say, "What did you do wrong?" I didn't realize that I had actually started counseling her. But I did realize from her story that from psychological violence comes physical violence.

So I started thinking that I should help her; I should refer her to somebody. And then I realized that there was nowhere to go. I cannot tell you my feelings. I really felt hopeless and helpless. In Russia there is a saying, "He beats you, that means he loves you." I now knew the meaning of that saying. I asked myself,

> "That's when the husband told her, 'I will kill you and nobody will know. And I will just say to everybody that you ran off with another man and left your baby.' I started calling her every morning just to make sure that she was alive."

"What can you do about a cultural attitude?" But I knew what I had to do. I started the hot line. One cold January day, a woman called in and I started talking with her. After a few minutes, she stopped, saying, "I am not going to talk to you on the phone. I need to see you." So I said, "Okay," and when she came in, her first tearful words were, "I'm afraid my husband is going to kill me and nobody will know." She told me her story. Her husband was very nice until she told him she was pregnant. At that point, everything turned upside down. He became very controlling. She was vulnerable and dependent: "I was terrified; his face was not happy. It was like he'd won. As though he was thinking, 'It's my turn. Now I can do whatever I want to you.'" The danger was real.

My first reaction was, "Oh, my God, what am I going to do now?" I knew the police would do nothing. But I called the police in her district anyway. The officer seemed nice, but then he immediately called the husband and said to him, "What is your wife doing? And why is she going around talking about family matters? Look, if you do it, do it quietly." I realized how hopeless the problem really was for her. Her problem became mine. I could not walk away. I called a woman I knew who was a retired lawyer and said, "I don't have any money and this woman doesn't have any money. But she needs help. She needs a divorce and a place to live." In Moscow, housing is a big problem. When this woman married her husband, she traded her apartment to his family and now his brother lived there. So she had nowhere to go. She was

trapped. Her story got worse. When their first baby was nine months old, her husband tried to kill her. "I don't know how I survived," she told me. The lawyer and I helped her file for divorce. That's when the husband told her, "I will kill you and nobody will know. And I will just say to everybody that you ran off with another man and left your baby." I started calling her every morning just to make sure that she was alive. For three months, the lawyer counseled us at each stage and helped us develop a plan.

In the midst of all of this, the situation took a scary turn. The woman called and said: "They know everything we are talking about!" Her mother-in-law worked at the phone company and we quickly figured out that she was listening to her calls. I said, "You know, maybe it's better. Let them hear about all the support that you have outside." So we started pretending we had done more than we actually had. On the next phone call, I started saying, "Okay, so this police officer is not helpful, but there are lots of other police I am going to talk to about it and your lawyer will, too. So don't worry." The next time she came to see me, and she said, "They became much more careful after we started talking that way." Eventually her husband left their apartment, partly because the lawyer told us how to get him out, and partly because he and his family realized that she was educated about her rights now. Ultimately, they got a divorce. Her father-in-law came to see her and said, "You have won, take the divorce, and take back the apartment; you will never see my son again."

Soon after this success, a friend of hers in a similar situation started legal proceedings against her own ex-husband and also got her apartment back. I was elated, and for the first time, encouraged! Even in Russian society, where there were few legal precedents, a woman who is willing to do so can stand up for her rights and win. But these stories are just a small fraction of the thousands we continue to hear day after day. Unfortunately, most of the women who call us do not know their rights, nor do they know that they do not have to accept the unacceptable.

There have been some bad moments along the way. One time I picked up the phone and a male voice started saying, "What is this number?" I was cautious since it was not common for a man to call our hot line like that. I responded with "Well, what number did you dial?" And he said, "I found this phone number in the notes of my wife and I am just checking—what is it?" I told him, "Why don't you ask your wife? Why are you calling?" And at first he tried to be calm and polite, saying, "Look, I'd just like you to tell me what it is." And I said, "If you don't trust your wife, it's your problem. I am not going to tell you what it is and I am not asking your name. If you introduce yourself maybe we can talk." And then he started being really aggressive and verbally abusive and he said, "I know who you are. I know your name. I know where you are located. I know where you live. And I am going to come there with some guys and kill you." My husband was there with me at the time and saw I was really scared, though

I said to the man on the phone, "I am not afraid of you," and just hung up. I still don't know whose husband it was. He never came. Another time, my phone at home rang late at night and a man said, "If you don't stop, you'd better watch out for your son." This really scared me. I moved my son to my parents' home for a few months. That was tough for a mother to do.

There are different estimations of domestic violence in Russia. Some say now that 30 to 40 percent of families have experienced it. In 1995, in the aftermath of the Beijing Women's Conference, the first reliable statistics were published in Russia indicating that 14,500 women a year had been killed by their husbands. But even today, the police do not keep such statistics, yet their official estimates are that perhaps 12,000 women per year are killed in Russia from domestic violence. Some recognition of the dimensions of this problem is finally surfacing.

Under Russian law, however, only domestic violence that results either in injuries causing the person to be out of work for at least two years, or in murder, can be considered a crime. There are no other laws addressing domestic violence in spite of years of effort to have such laws enacted by the Duma. But, in my work and in our fledgling women's movement, we have on our own expanded the functional definition of domestic violence to include marital rape, sexual violence in the marriage or partnership, psychological violence, isola-

> "The attitude during Soviet times was that if you are a battered wife, then you had failed as a woman and as a wife. It was the woman's responsibility in our society to create a family atmosphere. Women came to me who had been brutalized for twenty-six years."

tion, and economic control. This latter area has become perhaps one of the most insidious and hidden forms of domestic violence because women comprise 60 percent of the unemployed population—and the salary of a woman is about 60 percent of a man's for the same work.

A friend started working with me in January 1994, and by that summer we had trained our first group of women who began to work with us as telephone counselors. In 1995, I started going to other cities in Russia putting on training sessions for other women's groups that were starting to emerge and who wanted to start hot lines or crisis centers. Next, we started developing programs to provide psychological and legal counseling for the victims of domestic violence.

By 1997, we had also started a new program to train lawyers in how to handle domestic abuse cases. Under present Russian law, the provocation of violence is a defense which can be argued in court to decrease punishment. This is perhaps the most cruel form of psychological abuse, because it all happens in the courtroom right in front of the victim. She is made to look responsible. The victim is blamed openly by the perpetrator. Regrettably, there are still many judges who will readily accept the notion that she was in some way responsible, and let the perpetrator avoid being held accountable for his actions. The final trauma has been inflicted.

At the start of the new millennium, we have over forty women's crisis centers operating throughout Russia and have recently formed the Russian Association of Women's Crisis Centers, which is officially registered with and recognized by the Russian government. I am honored to have been elected as its first president.

My parents have been incredibly supportive of my work. My father, a retired military officer, once said to me, "In Soviet times you would have been a dissident, right?" And my reply to him was, "Probably, because the Soviets maintained the myth of the ideal—where domestic violence couldn't exist, officially." The attitude during Soviet times was that if you are a battered wife, then you had failed as a woman and as a wife. It was the woman's responsibility in our society to create a family atmosphere. It was up to her to maintain the ideal. That's why women came to me who had been brutalized for twenty-six years. I was the first person they could turn to openly, and confide something they had to hide within themselves throughout their life. This is still true to a great extent today.

I am not an extraordinary person. Any woman in my position would do the same. I feel, however, that I am really lucky because I was at the beginning of something new, a great development in Russia, a new attitude. Now, everybody is talking about domestic violence. And many are doing something about it.

ASMA JAHANGIR
AND HINA JILANI

PAKISTAN

HUMAN RIGHTS STRATEGIES

"You are fighting with your pen, you are fighting with the instruments of law, against a power with a gun, a power that does not recognize the law."

For the past two decades Asma and her sister Hina have been at the forefront of both Pakistan's women's and human rights movements. Both have been subjected to twenty-four-hour-a-day surveillance by the state since 1996. In 1980 they helped found the Women's Action Forum to help women obtain divorces from abusive husbands. In 1981 they founded the first all-women's law firm in Pakistan, and in 1986 they founded the Pakistan Human Rights Commission, where Jilani serves as chair. Threatened with death from the very halls of parliament when she called for the abolition of repressive shari'a laws contravening constitutional protection of women, Jahangir also put her life on the line in 1993 when she represented an illiterate fourteen-year-old sentenced to death for blasphemous graffiti on the side of a mosque. Muslim extremists stormed the court-house, smashing Jahangir's car and attacking her driver. A gang of armed thugs subsequently raided Jahangir's brother's home, holding her family hostage. In 1998 the United Nations Commission on Human Rights appointed Jahangir special rapporteur on extra-judicial, arbitrary, and summary executions. Hina Jilani runs the largest free legal aid center in Pakistan and is known for her defense of women's and children's rights, and for her efforts to promote religious tolerance. On April 6, 1999, Samia Imran, one of Jilani's clients, who sought divorce after a four-year separation from her husband, was in the offices of the law firm for a meeting with her mother and uncle. They arrived accompanied by a former chauffeur who drew a gun, shot and killed Imran, and almost killed Jilani. Imran's family considered the divorce a shame on their family that justified this "honor killing." Imran's father, the chair of the Peshawar Chamber of Commerce, awaited news

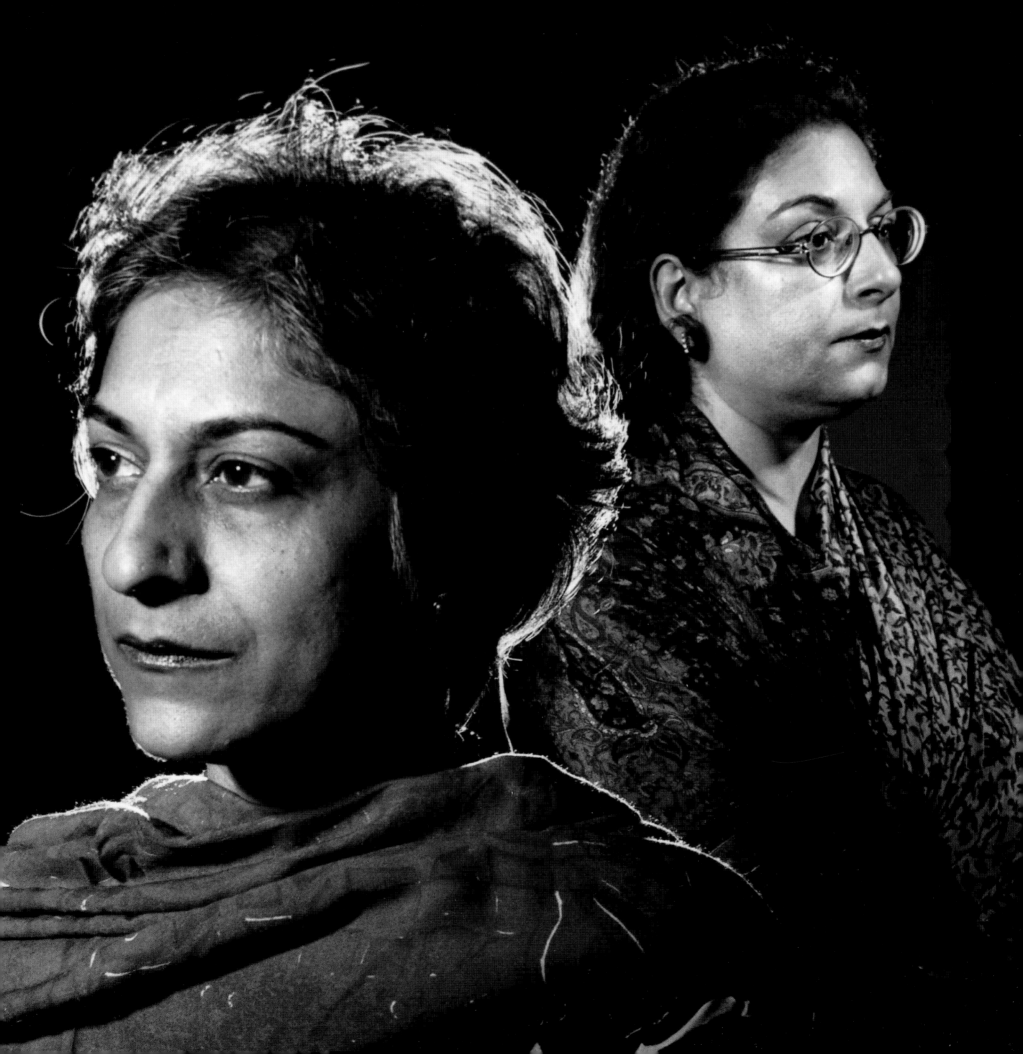

of his daughter's death at a nearby hotel. The father subsequently filed kidnapping charges against Jilani and Jahangir. Five hundred women were murdered in honor killings in Pakistan in 1998 and Jilani is known throughout the world for her outspoken criticism of the practice. Sisters in blood and in spirit, they are an inspiration to all.

JILANI Activism is vital for those who wish to fight for human rights. A human rights defender at the desk is only a reporter. A human rights defender in the field is a foot soldier. We are the ones who will make a difference. Exposing realities is not easy. If people get the message that only extraordinary people do this work, then the movement becomes static and discourages others from joining. That's why I am always keen to stress we are just ordinary people who have made up our minds that we have a cause we are fighting for.

My sister Asma and I grew up in an environment in which human rights were always talked about. My father was a politician who stood for basic freedoms. He took chances with his political career rather than compromise on fundamental rights. He was also one of the very few people who consistently spoke out for religious tolerance and urged expression of dissenting views.

Asma and I began working as lawyers in Pakistan in the 1980s, fighting martial law. We were dealing with victims of the regime all the time. That experience drew us into the human rights movement. We were able to give impetus to the movement through our work. The law became a tool in our hands that we used in court—though you must understand that there is a limit to what you can do with law in a country like Pakistan, where the rule of law doesn't enjoy respect. Law has become an instrument of repression, rather than an instrument for change. So human rights involves work both at the legal and at the social level. In fact, you can't work on human rights in an isolated way—you have to respond and react to the environment in which you live. Under the early days of military rule the strategy was to go out into the streets and make ourselves visible, because the courts were terrible at that time. And though many people were afraid to come out into the streets, those who did joined our movement.

JAHANGIR The priorities have always been that human rights and political development are connected—you can't say you want human rights only for a specific issue. Rights for children, rights for bonded labor, rights for women, they are all part of our struggle. They are all compromised by the system we are fighting, a system that doesn't recognize rights. In 1968, the first time I actually organized a demonstration of women, I had just finished school—I was sixteen. Martial law was accepted all over, and people actually associated martial law with economic development and stability. But even as a young girl, I was conscious of the fact that you cannot expect democratic economic development if it does not allow the participation of all people.

> "A human rights defender at the desk is only a reporter. A human rights defender in the field is a foot soldier. We are the ones who will make a difference."

Using the court system was nothing new to us. Our father was placed in preventive detention many times for his opinions and he defended himself each time. Once he challenged the law that stopped courts from reviewing preventive detention cases. He argued there had to be an objective reason, not an arbitrary one, for the detention. He put the responsibility squarely on the judicial system, saying, "Who will see the objectivity if the courts are not there to look at it?" And he won, and that tool of government repression fell from their hands.

During the war between East and West Pakistan, he was very vocal about the rights of East Pakistanis. As a result, we went through a very difficult year. I was called a traitor's daughter many times. I went out one day with some older women who had asked me to come because they had these little pamphlets to distribute that spoke of the rights of East Pakistanis. About seven of us were standing on the roadside and because I was the youngest, they said, "Why don't you just give the brochure to people as they stop in their cars?" And this one man, while I handed it to him through the window, he rolled down his window and spat on my face. So one has seen that kind of intolerance.

When our father was in jail, I was a student and I just turned eighteen. I organized a petition for him that actually challenged military governance. It was the only case in Pakistan that said that a military government is an illegal government. It was amazing that we could do it. Actually, when you are doing something like that you are not only getting to know what your principal stands are going to be in life, but you also get to know your society, and how it works, and with that knowledge you determine your strategies.

We've been fighting honor killings for many, many years. It doesn't automatically become an international issue—you have to really keep the flag raised, to work the media as well as the courts. It's very important for a human rights activist to be media-friendly. They want news. And so whatever you do, there has to be news in it; even though you are giving them new statistics, are you giving them a new face? Are you giving them a new story? A new story makes new news. It was through the media that honor killings became a front-burner, international issue.

When I became (United Nations) special rapporteur on extrajudicial killings, it was the first issue that I put into my mandate. And now the special rapporteur on independence of the judiciary has also taken it up. Here is an example. One day a client of ours seeking divorce was shot, murdered, at our office by a gunman hired by her father (who felt his daughter's divorce would bring shame upon their family). Public opinion was already leaning toward us. People had seen films about the issue and were aware of it and the press was aware. And the fact that the government resisted condemning this murder—because the bias of the government was so clear—and worse, that the parliament then resisted it, actually made news for us.

But it got worse. The chamber of commerce put forth a resolution implicating us in the murder! This was reported in the newspapers and there was a demonstration organized against us and open threats. The government stood by as a silent spectator. In fact they helped the murderers, who were never, ever touched. First, the government filed an information report to the police against Hina and me in another city saying that we had murdered that girl. Second, they told the entire administration not to arrest the murderers. Arrest warrants were not even issued until after they managed to get bail, many days after the murder had taken place. We are still in court about it. And now the real murderers have been declared innocent by the police.

So you see that, in this kind of work, you're fighting in a complex situation. You are fighting with your pen, you are fighting with the instruments of law, against a power with a gun, a power that does not recognize the law and has an insidious influence with the government. So the most important thing is, it cannot be an individual fight. The formation of the Pakistan Human Rights Commission in 1986 helped focus our work, gave it structure. Today I can stand up in Pakistan and say, "This is wrong." I can do it because I know that colleagues are there who think like me and we will all work together. It is important that we give each other strength. We draw on each other's strong points. Let me give you an example. We are lawyers, so if there is a case anywhere they will send it to us. But our Human Rights Commission annual report is written by two other colleagues (and I don't think anyone can write better than they) who are using their expertise in this way. A third colleague is very good at media, communications, at getting the word out. So you get to the front line not because you are actually the person doing the important work, but because you have distributed the work and somehow you evolve as a person who has been chosen for the front line by the whole movement. That's how I feel about myself. Teamwork is absolutely crucial and essential. And recognition has to be given to all the people out there who made this movement—together.

JAHANGIR As a sister, I work with Hina in the office. But on many of my other issues we really don't work together. I do my own thing.

JILANI Sibling rivalry is always there. But the point is, though we may be sisters, that is just incidental. We are both independent. Neither of us is inspired by the other alone; instead we are inspired by our surroundings. I am a very laid-back person, but one thing I can't tolerate is injustice. That makes that adrenaline run, which makes me get up and take action.

JAHANGIR Leadership involves the ability to conceptualize goals, share responsibilities, and set things in motion. Yet the only way that we survive is to have people who are working together and draw strength, draw confidence from each other. None of us is fool enough not to realize what the risks are; nevertheless, we try to mitigate them whenever we can. We are ordinary enough to feel fear at times. We are ordinary enough to feel the pressure. But we just go on.

JILANI I deal with fear by looking around me and saying we'll survive and we'll do this again. It's like one more bridge. I look around and see that others have overcome that fear. It's not that I am not frightened. I am. Not just for myself,

> "None of us is fool enough not to realize what the risks are; nevertheless, we try to mitigate them whenever we can. We are ordinary enough to feel fear at times. But we just go on."

but for Asma at times, at a very personal level. I don't have children, but Asma has. And I have brothers and sisters and a mother. And they have been attacked. It's difficult to say how we deal with it. The guilt is there. It happens. And the concern is there—even greater than guilt.

JAHANGIR I honestly tell you, I have been able to overcome fear. It was not easy. But every time I felt frightened I would go to the home of the Human Rights Commission's director. I would invite all our friends there and we would have a good laugh. A sense of humor and the warmth of the people around has made me survive. If I were sitting by myself, isolated, I would have gone crazy. But the minute I see a half-dozen of my colleagues, well, it's a jolly day—I don't feel scared at all. Of course, our families have to pay the price for our commitment, I feel no guilt about it at all. I have thought about it very carefully. I think that if I die tomorrow my children will be well looked after. They have a very good father. They have three grandparents who are still alive. They have an aunt who is not married. They are nearly grown, my children: 23, 21, and 17. So in terms of building their values (which is what I was most interested in as their mother), they've got that. They have to learn to live in a society that is very brutal and very violent. There is no guarantee for anything, and I think my children understand that now, appreciate it. They are very worried for me. I have had to sit them down, and explain to them, and even sometimes joke with them and say, "Okay, now what I am going to do is get myself insurance, so when I die you will be rich kids." They have gone through psychological trauma but they have dealt with it. It has made them stronger people.

Once seven armed people came into my mother's house (where Hina lives), looking to kill me and my children. And they took my brother, my sister-in-law, my sister, and their kids as hostages. Hina had fortunately just left the house in the morning with my mother. We always joke with her that it was one hour to mincemeat. But it was really very scary. That was one time that I was really upset about my family, extremely upset.

And I appreciate very much that my brother and sister, especially, because they are not human rights activists, have never said, "Give up." Never, ever have they said that this danger they experienced was because of me. That has been such a source of strength for me. They make me feel so proud. How can they be so decent about it? How can they be so understanding? It makes me more brave that there are people like them in this world.

The danger is real. Sometimes I have to tell my colleagues in the Human Rights Commission, "Take a back seat." We have a very good understanding on this, because I am already in danger, whether we stop or don't. So why put another person in danger?

JILANI I never feel a sense of futility—ever—because I think what we do is worth doing. In the years that we have been working, the small successes count for a lot. They may be few and far between but the point is they are significant. We feel that something is there, a light at the end of the tunnel. And we have seen that light many times.

HARRY WU

THE *LAOGAI*

"It is not enough to free one dissident when the stakes are so high. In the greater balance, we are all equal, and each victim of the *laogai* deserves the same rights."

Brought up as one of eight children of a Shanghai banker, Harry Wu attended a Jesuit school before enrolling in Beijing College of Geology in the late 1950s. In the throes of a Communist purge, his university was given a quota of counterrevolutionary elements, and relegated Wu to nineteen years in the Chinese gulag, known as the laogai. *There, he survived physical and psychological torture, living for a time on only ground-up corn husks. In his autobiography* Bitter Winds, *he describes chasing rats through the fields in order to "steal" the grains in their nests, or eating snakes. After his release, Wu accepted a position as an unpaid visiting scholar at the University of California, Berkeley, arriving in the United States in 1985 with forty dollars. After ten days of pursuing research by day and sleeping on a park bench by night, he landed a job on the graveyard shift at a doughnut shop where he ate three meals a day and had a place to stay at night. (To date, he cannot touch a doughnut.) Wu returned, or tried to return, to China a total of five times. While there, twice in 1991 and once in 1994, Wu documented conditions in prisons and labor camps for* Sixty Minutes, *and other news programs, and was placed on China's most wanted list for his exposés. In 1995, on his fifth trip, he was caught. While Wu spent sixty-six days in detention, awaiting news of his fate, a worldwide campaign for his release was launched, including demands that Hillary Clinton boycott the Beijing women's summit. China released him, and his return to U.S. soil was celebrated across the country. Today, Wu frequently testifies on Capitol Hill about the latest abuses he has uncovered—the for-profit selling of executed prisoners' organs by Chinese officials, the illegal export of prison labor products (such as diesel engines and Chicago Bulls apparel), the frequency of public executions, the unfair restrictions on reproductive rights and their appalling enforcement procedures. The Laogai Research Foundation, which Wu founded and directs, estimates there have been fifty million people incarcerated in the laogai since 1950, and that there are eight million people in forced labor today. Harry Wu's self-proclaimed goal is to put the word laogai in every dictionary in the world, and to that end, works eighteen-hour days crisscrossing the country and the globe speaking with student groups and heads of state to make this present-day horror become a past memory.*

Human beings want to live as human beings, not as beasts of burden, not as tools for another's use. People must respect each other enough to live with one another but retain the right to free choice: to choose their religion, their culture. Under totalitarian regimes, people are never treated as human beings. There is no free choice. If you talk about individual rights, you are automatically opposing the government.

Many American politicians and American scholars echo the Chinese lie that a different concept of human rights applies in China. The Chinese leadership argues that the most important category of human rights is economic rights. Jiang Zemin, president of China, said, "My first responsibility to human rights is feeding the people." In response, I would say that I can feed myself if I am

free—I don't need you to do that. Unfortunately, some Westerners say, "The Chinese never talk about individual values, they talk about collective rights, so don't impose Western human rights standards on the Chinese. Democracy is a Western idea." This is pure hypocrisy, because there is only one version of the Universal Declaration of Human Rights, of which China is a signatory. We don't have a Chinese version and an American version. It's universal.

The West mostly focuses on freedom of speech and freedom of religion, while trying to release religious dissidents, political dissidents, and student dissidents. So most of the West's focus is on the individual, this Catholic father, that Tibetan monk. On the one hand, it is very important to call for their freedom because life belongs to a person only once, never twice. We must save them. But we Chinese say "Never focus on only one individual tree; focus on a forest."

Let me tell you a story of the three W's: Wu, Wei, Wang Dan. I am the first "W." In 1957, while attending university in Beijing, I spoke out against the Soviet Union's invasion of Hungary. For this I was labeled a "counterrevolutionary" and sentenced to life in the *laogai*, the Chinese term for gulag. Ultimately, I gave nineteen years of my life to that system. In 1979, the year I was released, the West was applauding China for opening up. Mao was dead, the Cultural Revolution was over, and it seemed that Deng Xiaoping would herald a new era for China. But that same year, the second "W," Wei Jingsheng, was imprisoned for expressing himself, for calling for the fifth modernization of democracy for China. In 1989, when I was in the United States and Wei was

serving the tenth year of his sentence, another young man, Wang Dan, was imprisoned for his role in the student democracy movement. The Chinese government imprisoned each of us in three different decades for peacefully expressing our opinions; we all received second sentences in the 1990s. With respect to individual rights, not much has changed since 1957.

The first year of my first time in prison, I cried almost every day. I missed my family, especially my mother, who had committed suicide because I was arrested. I thought of my girlfriend. I was Catholic, so I prayed. But after two years, there were no more tears. I never cried, because I had become a beast. Not because I was a hero, not because I had an iron will, but because I had to submit. I don't think anyone under those circumstances could resist. From the first night in the camps, we were forced to confess. The confession destroys your dignity. If you don't come up with a confession, you are subjected to physical torture. And you have to keep your confession straight, all the time, from the beginning to the end. You never can claim you are innocent. You can only cry out, over and over, "I am wrong. I am stupid. I am crazy. I am shit. I am a criminal. I am nothing." At the same time, there is forced labor. Labor is one of the ways to help you become a new socialist. Labor is an opportunity offered by the party for your reform. The final goal is for you to turn into a new citizen in the Communist system.

They said my crime was light, not serious, light. But my political attitude was the problem. "I did nothing wrong," I said. "You trapped me. I am not going to admit to any crime." I wouldn't confess. They separated me from all the

people in my life, my classmates, my friends, my teachers, my parents. I was totally isolated. I thought, "I am a mistake. They don't like me. I am something wrong. Let me think about it, okay." And then, "Yeah, I am wrong." Step by step, I lost my dignity, lost my confidence, lost my rank. I started to believe I was a criminal. It was as if we Chinese were living in a box all our lives where we never saw the sky. If you never escape from the box, you come to believe that it is the truth. That is reprogramming, which in the end reduces you to a robot. One drop of water can reflect the whole world, but many, many drops become a river, an ocean.

Nineteen years. How many days, how many nights? I punched someone in the nose and stole from people. I never cried. I stopped thinking about my mother, my girlfriend, my future. Some people died. So what? They broke my back. I had human blood on my lips. I had forgotten so much.

In 1986, I first came to the United States as a visiting scholar. I remember the day in October of that year when I gave a talk on the *laogai*. I told myself, "You are not Harry Wu. You are a storyteller." Suddenly I could not stop. For twenty minutes, the students were very quiet. I finished my talk and I realized I had come back as a human being. The end of that talk was the first time I said, "I am so lucky I survived."

When I first came to America, nobody knew me. Just like in the camps, I was anonymous. The Chinese government put me on the wanted list because I touched the heart of the issue. If you want to talk about dissidents, the Chinese

are willing to speak with you, but not if you talk about the *laogai*. Can you talk to Hitler about concentration camps? Can you talk to Stalin about the gulags?

I don't know why I survived. You think of yourself as a human being, fighting for your dignity, fighting for your future, fighting for your life, fighting for your dream. Life will only belong to you once. Sooner or later you and I are going to go to the grave. Some people take thirty years, eighty years. Once I was in exile, why shouldn't I have enjoyed the rest of my life? Why did I need to go back to China? I tried to enjoy it. I felt guilty. Especially when people were calling Harry Wu a hero. The West is pushing me because it is always in search of a hero. But a real hero would be dead, dead. If I were a real hero like those people I met in the camps, I would have committed suicide. I am finished—there is no Harry Wu. That is why I ultimately decided to go back to China.

In 1991, I visited the *laogai* camp where Wei Jingsheng was held in China. He was in the Gobi Desert and I wanted to get some video footage to show people the situation. In the past, I posed as a prisoner, a tourist, or a family member. This time I posed as a policeman. They didn't recognize me. In a guesthouse, many policemen waved to me, and I waved back to them. But when I tried again to collect evidence in 1995, they caught me trying to enter China from the Russian border. They arrested me and showed me these pictures I had taken. This time, I was sentenced to fifteen years.

Now I am working on birth control issues, because this is another systemic human rights problem in China. Without government permission, you can't

have a child in China. I have a copy of the "birth-allowed" permit and the "birth-not-allowed" permit from the Fujian province. After one baby, you are supposed to be sterilized. If you are found to be pregnant a second time, the government forces you to abort. You cannot have a second child, unless you live in the countryside. In this case, you can wait four years and then have a second baby. Then, after that baby's delivery, you are forcibly sterilized.

An American sinologist told me the population growth in China is terrible, causing problems not only for the Chinese, but the whole world. And I said, "Do you agree to forced abortion in the United States?" He replied no. "But why are you applying that standard to the Chinese?" I responded. "It's a murder policy. It's a policy against every individual woman, against every individual." Government statistics tell us that in one area of China alone, 75 percent of the women between the ages of sixteen and forty-nine have been sterilized—1.2 million people. Every month there are about one hundred abortions.

Today, the Chinese people do have the right to choose different brands of shampoo but they still cannot say what they really want to say. Will the right to choose one's shampoo lead to the right to choose one's religion, as some would argue? It's quite a leap.

My choice was simple—imprisonment or exile. But what people don't understand is that exile itself is torture. Exile, too, is a violation of human rights. We never applauded the Soviets when they exiled dissidents. Yet, when the Chinese

exiled Wang Dan, the State Department and the White House claimed it as a victory for United States engagement policy.

Of course, I do think it's worthwhile to try to free someone from the machine, but I would rather see the machine destroyed. I come from the *laogai*. Wei Jingsheng came from the *laogai*. Now Wang Xiaopo is in the *laogai*. Catholic priests are in the *laogai*. Labor activists are in the *laogai*. Most of the people in the *laogai* don't have a name, they don't have a face. It is not enough to free one dissident when the stakes are so high. In the greater balance, we are all equal, and each one of the victims of the *laogai* deserves the same rights, not only the political dissidents, but even the criminal prisoners. This is not to say that we should excuse the crime, but each prisoner must be offered the same protection. You tend to forget that when you only talk about famous prisoners of conscience. It's hard to say what percentage of prisoners are political compared to those that are criminal. You can present the question to Chinese authorities and they answer that in China there are no political prisoners. They will say, for instance, that it is legal to practice your own religion, but if you practice Catholicism they arrest you and charge you with disturbing society and participating in an illegal gathering instead.

Every totalitarian regime needs a suppression system. The funny thing is that nobody talks about that system in Communist China. They say that it doesn't exist, or that they only use it in the case of particular individuals. I've given talks about the *laogai* at all the top universities in the United States. When I was at

> "I want people to be aware of
> how many are in prison.
> Aware of the products made in China
> by prison labor: the toys, the footballs,
> the surgical gloves. Aware of what
> life is like under forced labor.
> This is a human rights issue, not one
> of imports and exports."

Yale, I spoke to Jonathan Spence, who wrote the most widely used college text on China. I said to him, "Jonathan, you speak Chinese very well, you have a Chinese wife, you include so many Chinese terms in your work. But what about *laogai*? The victims of the *laogai* number more than those of the Soviet gulag plus the concentration camps. Of course, you've heard of it, but it never appears in your reports, your articles, your books. You don't want to talk about it—why?" Why doesn't Steven Spielberg film the *laogai* the way he did the concentration camps?

I want to see *laogai* become a word in every dictionary, in every language. *Lao* means "labor," *gai* means "reform." They reform you. Hitler, from the beginning, had an evil idea: destroy the Jews, destroy the people. The Communists in the beginning had a wonderful idea to create a paradise, a heaven, to relieve poverty and misery. In the beginning they were like angels, but at the end they were like devils. The Chinese perpetrate a lot of physical torture, but also spiritual torture and mental torture. They say, "Let us help you to become a new socialist person. We won't kill you, because of our humanity. You were going wrong. Confess. Accept Communism and you will, through reform, reestablish the community spiritually, mentally, totally."

Before 1974, *gulag* was not a word. Today it is. So now we have to expose the word *laogai*: how many victims are there, what are the conditions the prisoners endure, what is the motivation for such systematized degradation? I want people to be aware. Aware of how many men and women are in prison. Aware of the

products made in China by prison labor: the toys, the footballs, the surgical gloves. Aware of what life is like under forced labor. Aware of the so-called crimes that send people there. This is a human rights issue, not one of imports and exports.

I totally understand this is difficult talking about *laogai* today. I said to President Clinton, "I wish you would be the first world leader to condemn Chinese *laogai*. I beg you. Just one sentence. It won't cost you anything." And I criticize U.S. policy as a typical appeasement policy. U.S. leaders ask me, "Are you suggesting isolation or containment?" That kind of polarization is too cheap. I never suggest isolation and I never suggest sanctions. But you should not tell me a one-sided story. When you try to tell me that trade is improving the lives of the Chinese common people, this is only one side of the story. I don't argue that economic levels are improving, that a middle class will appear, property rights will come to the fore, and that the society will reorganize. But you have to tell me the other side of the story. The profits from the industry will only benefit the Communist regime. You don't talk about it. The Chinese Communist regime is stable. Why? Because you support it financially.

China will become more important in the near future. When we witness a Communist hegemony in the East, then we will debate why. Why did we ignore the growing strength of this authoritarian regime? Let me quote another Chinese idiom: "If you want to stop the boiled water, you only need to stir it. The better way is to withdraw the fire from the bottom." The West needs a long-term China policy, one that supports all of the desires for freedom and democracy in China.

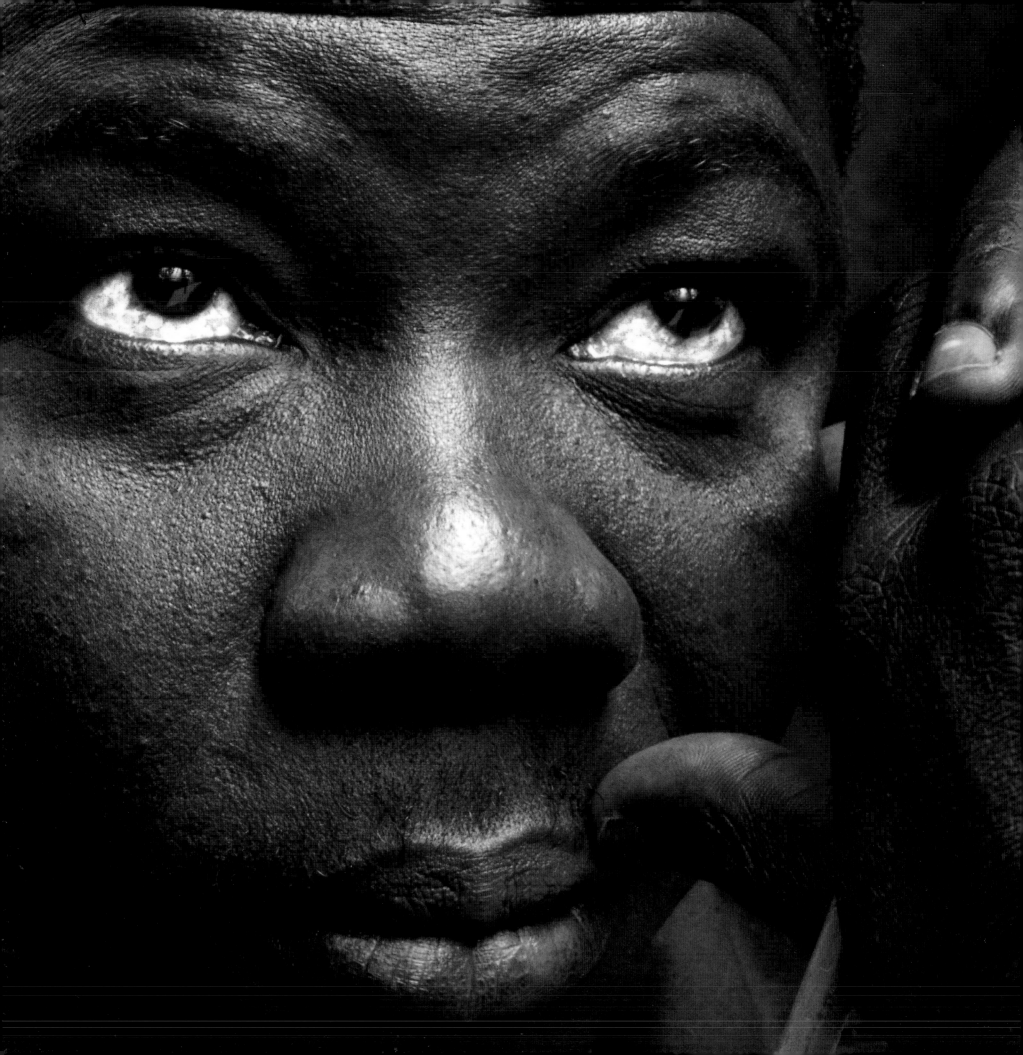

FREEDOM NERUDA

FREE EXPRESSION

"After soldiers beat and killed university students, fifty thousand people demonstrated to demand an investigation. Human rights leaders were arrested and thrown in jail for months. I couldn't stand the official lies. I decided to expose the courtroom drama."

Journalism has become one of the world's most dangerous professions, with dozens of deaths and hundreds imprisoned because of their exercise of free speech. Freedom Neruda exemplifies the extraordinary courage of these engaged journalists who report the news despite severe restrictions by the state. Born Teiti Roch D'Assomption in the Ivory Coast in 1956, he chose the name Freedom Neruda to symbolize his ideals. Neruda graduated from the University of Abidjan and taught until 1988, when he began working as a copy editor at Ivoir Soir. Within two years Neruda had become an investigative reporter, working for Ivoir Soir, La Chronique du Soir, and La Voie. As the current chief editor of La Voie, Neruda has consistently covered the repressive government first of President Henri Konan Bédié and, after his overthrow, on December 24, 1999, that of General Robert Guei—despite the government's relentless attacks on Neruda and his staff, subjecting them to arbitrary fines, charges of "insulting the dignity of the head of state," assaults, arrests, threats, and harassment. In 1995, Neruda's office was firebombed. In December 1995, after Neruda published a satirical article blaming the national soccer team's loss to South Africa on "bad luck" occasioned by President Bédié's presence at the game (a reference to Bédié's electoral posters claimed he'd bring "Good Luck" to the country), Neruda's colleagues at Ivoir Soir were arrested, and he went underground. In 1996, Neruda was apprehended and sentenced to two years in prison for "offenses against the head of the state." All three journalists refused to accept a "pardon" (tantamount to admitting guilt) from Bédié; instead they took advantage of their experience to conduct an investigation, while behind bars, on prison conditions. Neruda was released from prison in 1997 and continues to speak out, speak up, and speak "truth to power."

When political pressures relaxed in the Ivory Coast, people had the right to create their own parties. Workers were allowed to organize trade unions. And there was the opportunity of creating several newspapers. Along with two friends, I created my own: *La Chronique du Soir*. It was difficult because we had little funding and, as ours was the first independent paper, the government didn't condone our existence. We had problems; distribution was one of them. My paper would arrive at the distributor's office at nine, but it would never appear on the market before three.

After soldiers killed students and beat others at the public university, fifty thousand people demonstrated to demand an investigation. That was February 12, 1992. Human rights leaders were arrested and thrown in jail for months. The press accounts of the trials were one-sided. I was at the demonstrations and saw what happened with my own eyes. So when I watched TV later, I couldn't stand the official lies. I decided to expose the courtroom drama. Thanks to our efforts, several months later the demonstrators were freed. That is why I decided to work in our country for democracy, freedom of press, freedom of expression, and freedom of speech.

These events marked a turning point for our country. In 1960 the Ivory Coast gained independence from France, and for the next thirty years we were ruled by a single party. In 1991 the government passed a censorship law where almost everything was forbidden. Under this law journalists in the Ivory Coast have many duties and obligations—and almost no rights. And if you read these laws and you want to become a journalist you really should go grind peanuts because it is better for you.

Bédié became president in December 1993, and by February 1994 we started writing that he was implicated in a corruption scandal involving the sugar industry. A few months later, we were sentenced to one year on criminal libel charges. They said that any corruption issues were from the past, and as Bédié had ascended to the presidency, it was inappropriate for us to publish the story. Since Bédié became the head of the state, fourteen journalists have been arrested. But we were able to publish, although they threatened that at any moment they could throw us in jail. In French there is a sentence that says that when you are in prison there is a spear suspended above and at any moment it can fall on your head.

By this time we were writing that the president was corrupt and our stories were picked up by the U.S. press. But the government newspaper, the TV, and the radio started saying that Bédié is a blessing for our country, that he will bring good luck, and that he has been working well for us. This propaganda was too much. At that time our national soccer team played the South Africa team and the score was tied, 2-2. Everybody in the Ivory Coast was sure that this popular team, which had such great soccer players, would win the Africa Cup. The next game was on Saturday, December 16, 1995, and Bédié was at the stadium. When our team was beaten, 1-0, we joked, "He has brought bad luck to the Ivorian team." We were sentenced to two years for criminal libel.

We spent a year in prison. Thanks to several organizations all over the world, the Committee to Protect Journalists, Human Rights Watch, Amnesty International, and Reporters sans Frontiers, we were released after twelve months.

Naca Prison is a very hard one. It is the biggest prison in the Ivory Coast. There were six thousand inmates when we arrived and over one hundred died in detention during the first four months of 1996. We were so poor that we could never get enough to eat and constant vomiting reduced people to skeletons. You find it at Naca Prison even right now. In our case, the prisoners knew that we did not steal or kill so they had great respect for us. We were able to hold onto life in this prison because our newspaper sent us food every day. But many people were starving. They would give a small cup of rice at 8 A.M. and then nothing until the next morning, or two potatoes in the morning and then nothing until the next morning.

It's funny that the Ivorian human rights league was continuously denied access to the prison until the 1992 demonstrations, when one of its members, a law professor, was imprisoned for seven months. He said, "You see—I've always been telling you I would like to see the prison and now I finally got access."

In the prison there are different categories. We were in a building for government officials and Europeans. Our publisher and two other journalists and I shared a four-person cell. The prisoners respected us and the guards tried to be helpful.

After eight months the president said he would pardon us, but we refused. We said, "No, we are fighting for justice." Release would be good but not if you can't look in your neighbor's eyes. So we stayed for four more months.

I have three children—two daughters and a son who is two and a half. When Atika was eight months old, his mother took him to Cameroon. But she sent him home and he arrived the very day I was arrested. My daughters were in the house with my brothers when I was arrested. The oldest is fifteen and the second is eight. I had to find somebody who could take care of the baby. It took four or five days. I didn't want people to think I was running away from my trial because it would have been a big shame. The judge said he was going send me to Naca Prison but he would give me one week to get everything in order.

Several countries in Africa are like the Ivory Coast. You have two opportunities: fight for human rights and prepare a good future for your kids, or choose to bend and do what the party decides. So you take care of your family, you go on working doing what you have to do. But when they arrest you, you can die. So you better fight so your children will have a good future.

I tell my children that at any moment I can die. It is better to know. And I tell them, too, that at any moment I can be arrested. I wish my work didn't have a negative impact on my children. But I know that if I want a good future for them we must struggle, each of us, in our own way.

Resource Guide

ANONYMOUS
c/o Robert F. Kennedy Memorial Center for Human Rights.
Contact: Todd Howland
1367 Connecticut Ave. NW Suite 200
Washington, DC 20036 USA
Tel: +1-202-463-7575 / Fax: +1-202-463-6606
www.rfkmemorial.org

AL SAYED SEADA, HAFEZ
The Egyptian Organization for Human Rights
8/10 Mathaf El Manial St. 10th Floor
Manial El Roda. Cairo, Egypt
Tel: +20-2-363-6811 / Fax: +20-2-362-1613
E-mail: eohr@idsc.gov.eg
www.eohr.org.eg

ARIAS SÁNCHEZ, OSCAR
Progresso Humano
Apt 8-6410
1000 San José, Costa Rica
Tel: +506-255-2955 / Fax: +506-255-2244
E-mail: info@arias.or.cr
www.arias.or.cr

BUJAK, ZBIGNIEW
05-822 Milanowek St.
Wysoka 1, Poland
Tel: +48-22-758-3217
E-mail: Zbigniew.Bujak@agora.pl

HIS HOLINESS THE DALAI LAMA
c/o The Office of Tibet, New York
Tashi Wangdi, Representative
241 East 32nd St.
New York, NY 10016 USA
Tel: +1-212-213-5010 / Fax: +1-212-779-9245
E-mail: otny@peacenet.org

International Campaign for Tibet
Contact: Johhn Akerly
1825 Jefferson Place NW
Washington, DC 20036 USA
Tel: +1-202-785-1515 / Fax: +1-202-785-4343
E-mail: info@savetibet.org
www.savetibet.org

DOGBADZI, JULIANA
c/o Forefront Leaders
333 7th Ave, 13 Floor
New York, NY 10001 USA
Tel: +1-212-845-5200 / Fax: +1-212-253-4244
www.forefrontleaders.org

GALABRU, KEK
LICADHO
P.O. Box 499
Phnom Penh, Cambodia
Fax: +855-23-336-09-65
E-mail: president@licadho.org

GARZÓN REAL, BALTASAR
Fundación de Artistas e Intelectuales
por los Pueblos Indigenas de Iberoamerica
Contact: Adriana Arce
C/ Escorial, #16-2B
28004 Madrid, Spain
Tel: +3491-523-0951 / Fax: +3491-523-2943
www.funindio.org

GOMBOS, GABOR
31 Klauzal Street
H-1072 Budapest, Hungary
Tel/Fax: +361-268-9917
E-mail: gombosg@axelero.hu

Mental Health Interest Forum
Szigony Street 13A
H-1803 Budapest, Hungary

HARRIS, BRUCE
12648 Burning Tree Lane
Coral Springs, FL 33071 USA
E-mail: correobruceh@hotmail.com

HAVEL, VACLAV
Prague Castle
Kralovska Zahrada 50
119 08 Prague 1 - Hrad, Czech Republic
Tel: +420-224 373 727 / Fax: +420-224 373 726
www.hrad.cz

HUSSEINI, RANA
P.O. Box 830199
Amman, 11183 Jordan
Tel: +962-79-545-776 / Fax: +962-65-931-117
E-mail: ranahuss@nets.com.jo

HSAW WA, KA
Earthrights International
1612 K Street NW. Suite 401
Washington, DC 20006 USA
Tel: +1-202-466-5188 / Fax: +1-202-466-5189
E-mail: infousa@earthrights.org
www.earthrights.org

JAHANGIR, ASMA AND HINA JILANI
Human Rights Commission of Pakistan
Secretariat/Punjab Center
Aiwan-I-Jamjoor, 107-Tipu Block
54600 New Garden Town, Lahore, Pakistan
Tel: +42-583-8341 / Fax: +42-588-3582
E-mail: hrcp@hrcp-web.org
www.hrcp-web.org

JINGSHENG, WEI
The Wei Jingsheng Foundation
415 East Capitol St. SE, Suite 2
Washington, DC 20003 USA
Tel: +1-202-543-1538 / Fax: +1-202-543-1539
www.weijingsheng.org

JIMÉNEZ FLORES, PATRIA
Closet de Sor Juana
Nevado 112 Departamento 8
Mexico DF 03300 Mexico
Tel: +5255-5672-7623 / Fax: +5255-5420-1762
E-mail: Patriaj@hotmail.com

JONES, VAN
Bay Area Police Watch
A Project of the Ella Baker Center for Human Rights
344 40th St.
Oakland, CA 94609 USA
Tel: +1-510-428-3939 / Fax: +1-510-428-3940
E-mail: van.jones@ellabakercenter.org
www.ellabakercenter.org

KANDIC, NATASA
Humanitarian Law Center
Makenzijeva 67
11110 Belgrade, Serbia and Montenegro
Tel: +381-11-444-5741 / Fax: +381-11-444-3944

KASSINDJA, FAUZIYA
c/o Equality Now
P.O. Box 20646. Columbus Circle Station
New York, NY 10023 USA
Tel: +1-212-586-0906 / Fax: +1-212-586-1611
E-mail: Info@equalitynow.org
www.equalitynow.org

MAATHAI, WANGARI
Greenbelt Movement
P.O. Box 67545,
Nairobi, Kenya
Tel: +1-254-20-571-523
E-mail: gbm@wanachi.com
www.greenbeltmovement.org

MENCHÚ TUM, RIGOBERTA
Fundación Rigoberta Menchú Tum
Contact: Eduardo de Leon, Executive Director
Ave. Simeon Canas 4-04, zona 2
Ciudad de Guatemala 01001 Guatemala
Tel: +502-2232-0793
E-mail: rmt@terra.com.gt
www.frmt.org

MÉNDEZ, JUAN
International Center for Transitional Justice
20 Exchange Place, 33rd Floor
New York, NY 10005 USA
Tel: +1-917-438-9300
E-mail: info@ictj.org

MULLER, BOBBY
Alliance for Security, Vietnam Veterans of America
1725 I Street NW, 4th Floor
Washington, DC 20006 USA
Tel: +1-202-483-9222 / Fax: +1-202-483-9312
E-mail: afs@vi.org
www.vvaf.org

NERUDA, FREEDOM
Embassy of the Ivory Coast in Iran - Tehran
Tel: +98-21-242-8794 / Fax: +98-21-240-0938
E-mail: freedomtr@hotmail.com

NGEFA ATONDOKO ATOI, GUILLAUME
12 rue Dizerens, Apt. 22
1205 Geneva, Switzerland

ASADHO
12 Avenue de la Paix Apt.1
Kinshasa 1, Republique Democratique du Congo
E-mail: asadho@hotmail.com

O'BRIEN, MARTIN
Atlantic Philanthropies
4/10 Donegall Sq East
Belfast, BT1 5HD, Northern Ireland
Tel: +44-28-9023-2500 / Fax: +44-28-9023-2225

Committee on the Administration of Justice
45/47 Donegall Street, Belfast
Northern Ireland, BT1 2BR
Tel: +44 28 9096-1122 / Fax: +44-28 9024-6706
www.caj.org.uk

OCHOA, DIGNA
Center PRODH
Serapio Rendon 57-B
Colonia San Rafael
Mexico DF 06470, Mexico
Tel: +52-55-5546-8217
E-mail: prodh@sjsocial.com
www.sjsocial.org/PRODH/

ORTIZ, SISTER DIANNA
Torture Abolition and Survivors Support Coalition International
4121 Harewood Rd. NE, Suite B
Washington, DC 20012-1597 USA
Tel: +1-202-529-2991
E-mail: info@tassc.org

PISKLAKOVA, MARINA
ANNA Ul. Dmitriya Ulyanova
Dom 3, library 95, Moscow, Russia
Tel: +7-095-135-1163 / Fax: +7-095-335-96-48
E-mail: marina@emeraldgp.com

Emerald Institute for International Assistance
699 Hampshire Road, suite 204
Westlake Village, CA 91361 USA
Tel: +1-805-374-1272 / Fax: +1-805-374-1274

PREJEAN, SISTER HELEN
3009 Grand Rte., St. John #5
New Orleans, LA 70119 USA
Tel: +1-504-948-6557 / Fax: +1-504-948-6558
E-mail: hprejean@aol.com

PRIETO MENDEZ, JAIME
Comité Ad Hoc de Protección a Defensores de
Derechos Humanos
Carrera 5 No. 33A-08, Bogotá, Colombia
Tel: +57-1-288-8050 / Fax: +57-1-287-9089
E-mail: jprieto@cinep.org.co
Contact: Adriana Salazar

RAMOS-HORTA, JOSÉ
Ministry of Foreign Affairs and Cooperation
Palacio do Governo
Dili, Timor-Leste
E-mail: gabinetemnec@yahoo.com

SARIHAN, SENAL
Association of Women of the Republic
Mesrutiyet Caddesi 20-3
06650 Kizilay Ankara, Turkey

SATYARTHI, KAILASH
The Global March Against Child Labour
E-868. Chittaranjan Park
110019 New Delhi, India
Tel/Fax: +91-11-2627-8358
www.globalmarch.org

SOBERÓN, FRANCISCO GARRIDO
Asociación Pro Derechos Humanos
JR. Pachacutec 980 – Jesus Maria
Lima, Peru
Tel: +51-1-4247057 / Fax: +51-1-4310477
E-mail: fsoberon@aprodeh.org.pe
www.aprodeh.org.pe

SOURANI, RAJI
Palestinian Center for Human Rights
29 Omar El Mukhatar St.—Qadada Building
P.O. Box 1328
Gaza City, Gaza Strip, Via Israel
Tel/Fax: +972-8-282-4776
E-mail: pchr@pchrgaza.org
www.pchrgaza.org

STREMKOVSKAYA, VERA
6 Kedyshko Str, Apt. 47
220012 Minsk, Belarus
Tel: +35717-266-2570

SULTAN, ABUBACAR M.
Rua Major Kakangulo
197, UN Building
Luana, Angola
Tel: +244-2-3323-48 / Fax: +244-2-3370-37

*Wona Sanana Project—Fundacao para o
Desenvolvimento da Comunidade
Av. Eduardo Mondlane, 1270 1 andar,
PO Box 2935 Maputo, Mozambique
E-mail: childdb@teledata.mz*

TANRIKULU, SEZGIN
Turkiye Insan Haklari Vakfi
Lise Caddesi Eyyup Eser Apt KaTel: 1 No: 2 Yenisehir
Diyarbakir, Turkey
Tel: +90-412-228-2661 / Fax: +90-412-228-2476
E-mail: tihvdbakir@ttnet.net.tr
www.tihv.org.tr

TULA, MARIA TERESA
282 Baker Street East
St. Paul, MN 55107 USA

*Companion Community Development Alternatives
609 East 29th Street
Indianapolis, IN 46205-4199 USA
Tel: +1-317-920-8643 / Fax: +1-317-920-8649
E-mail: cocodaindy@igc.org*

TUTU, ARCHBISHOP DESMOND
Contact: Mrs Lavinia Browne
PO Box 3162
Capetown, South Africa 8000
Tel: +27-21-424-5161 / Fax: +27-21-424-5227

VIET HOAT, DOAN
International Institute for Vietnam
4908 Ravensworth Rd.
Annandale, VA 22003 USA
Tel: +1-703-256-0277 / Fax: +1-703-256-0918
E-mail: thuctran@aol.com
www.vietforum.org

WA WAMWERE, KOIGI
National Assembly, Parliament Buildings
P.O.Box 41842
Nairobi, Kenya
Tel: +254-221-291 ext. 2588
E-mail: kwamwere@hotmail.com

WIESEL, ELIE
Boston University
745 Commonwealth Avenue
Boston, MA 02215 USA

WISSA, HIS GRACE BISHOP
Center for Religious Freedom
A Division of Freedom House
1319 18th Street, NW
Washington, DC 20036 USA
Tel: +1-202-296-5101 / Fax: +1-202-296-5078
E-mail: religion@freedomhouse.org

WOODS, SAMUEL KOFI
Foundation for International Dignity (FIND)
18 Dundas Street
Freetown, Sierra Leone
Tel: +232-22-226267

WRIGHT EDELMAN, MARIAN
Children's Defense Fund
25 E Street NW
Washington, DC 20001 USA
Tel: +1-202-628-8787 / Fax: +1-202-662-3510
E-mail: cdfinfo@childrensdefense.org
www.childrensdefense.org

WU, HARRY
Laogai Research Foundation
1925 K Street, NW Suite 400
Washington, DC 20006 USA
Tel: +1-202-833-8770 / Fax: +1-202-833-6187
E-mail: laogai@laogai.org
www.laogai.org

YUNUS, MUHAMMAD
Grameen Bank
Mirpur, Dhaka 1216 Bangladesh
Tel: +880-2-801-1138 / Fax: +880-2-801-3559
E-mail: Yunus@grameen.net
www.grameen-info.org

*Grameen Foundation USA
Contact: Alex Counts (President)
1029 Vermont Ave NW, Suite 400
Washington, DC 20005-3517 USA
Tel: +1-202-628-3560 / Fax: +1-202-628-3880
E-mail: info@gfusa.org
www.grameenfoundation.org
www.gfusa.org*

ZALAQUETT, JOSÉ
Providencia 545, dep. 65
Santiago, CP 6640307, Chile
Tel: +562-204-4540 / Fax: +562-209-7639
E-mail: jzalaque@terra.cl

Additional Resources

**ROBERT F. KENNEDY MEMORIAL CENTER
FOR HUMAN RIGHTS**
1367 Connecticut Avenue NW
Washington, DC 20036 USA
Tel: +1-202-463-7575/ F: +1-202-463-6606
E-mail: info@rfkmemorial.org
www.rfkmemorial.org

AMNESTY INTERNATIONAL
5 Penn Plaza, 14th Floor
New York, NY 10001
Tel: +1-212-807-8400 / Fax: +1-212-627-1451
www.amnestyusa.org

HUMAN RIGHTS WATCH
350 Fifth Avenue 34th Floor
New York, NY 10118-3299 USA
Tel: +1-212-290-4700 / Fax: +1-212-736-1300
E-mail: hrwnyc@hrw.org
www.hrw.org

HUMAN RIGHTS FIRST
333 Seventh Avenue 13th Floor
New York, NY 10001 USA
Tel: +1-212-845-5200 / Fax: +1-212-845-5299
E-mail: info_NYC@humanrightsfirst.org
www.humanrightsfirst.org

WITNESS
80 Hanson Place, 5th Floor
Brooklyn, NY 11217 USA
Tel: +1-718-783-2000 / Fax: +1-718-783-1593
E-mail: witness@witness.org
www.witness.org

FOREFRONT
333 7th Ave, 13th Floor
New York, NY, 10001-5004 USA
Tel: +1-212-845-5274 / Fax: +1-212-253-4244
E-mail: forefront@forefrontleaders.org
www.forefrontleaders.org

COMMITTEE TO PROTECT JOURNALISTS
330 Seventh Avenue, 11th Floor
New York, NY 10001 USA
Tel: +1-212-465-1004 / Fax: +1-212-465-9568
E-mail: info@cpj.org
www.cpj.org

U.S. DEPARTMENT OF STATE
Bureau of Democracy, Human Rights and Labor
2100 C Street NW
Washington, DC 20520 USA
Tel: +1-202-647-1716
www.state.gov

ACKNOWLEDGMENTS

Speak Truth to Power was created with the help of many. I am most grateful to all the defenders who took the time to participate in this project, for sharing their lives, their time, their innermost thoughts. What started out as a survey became, ultimately, a spiritual journey about the power of one.

This book was a collaborative effort. I want to thank Eddie Adams for all the time, effort and energy he devoted to this project, and for going forward when the going got rough. Alyssa Adams played an invaluable role in keeping us on track. Melissa LeBoeuf spent countless hours setting up photo shoots with people who were difficult to reach in far-off lands at all hours of day and night in a multitude of languages, remaining cheerful and efficient throughout, even when the rest of us were not. Carrie Trybulec spent over a year sending letters and proposals, setting up interviews, making phone calls, speaking with airlines and travel agents, and performing all sorts of other painstaking work, then watched my children so I could write. Carrie, this book is in great part a result of your efforts and sacrifice, and you have my eternal gratitude.

Ever since 1981 when Amnesty International granted me a summer internship, I have been blessed by the opportunity to meet and work with the foremost human rights defenders of our time, many of whom are included in this book. Other old friends and leaders in the field might not be found among these pages, but their vision and influence are well represented here, as I relied on their invaluable advise for countries, issues, and champions to include in the work. I am especially grateful to Michael Posner who was always there for me, day and night, and who put the entire staff of the Lawyers' Committee for Human Rights at my disposal. Many thanks to Lili Brown, Camille Massey, Mary Morris, and all your colleagues. Bill Schulz of Amnesty International USA was of invaluable help, as were Maina Kiai in London and Steve Rickard, Carlos Salinas, and Adotei Akwei in Washington. Ken Roth and the staff of Human Rights Watch gave valuable assistance, as did Anne Cooper and the staff of The Committee to Protect Journalists, and Lodi Gyari, John Ackerly, Tenzin Thakla, Lesley Friedell, and the staff of the International Campaign for Tibet. I am grateful to all those who helped with research and who facilitated meetings, including John Allen, Mike Amitay, Joseph Assad, Vincent Azumah, Holly Bartling, Layli Miller Bashir, Stefan Beltran, Michelle Bohana, Lesley Carson, Lili Cole, Wilson DaSilva, Pat Davis, Robert Drinan, Peter Edelman, Joe Eldridge, Frank Ferrari, Lynn Frederickson, Yael Fuchs, Ellen Hume, Suzie Jakes, Michael Kennedy, Kasia Kietlinska, Diamond Liu, Marysia Ostafin, Katie Redford, Eric Rosenthal, John Shattuck, Brenda Shelton, Gare Smith, Jean Kennedy Smith, Jane Spencer, Valerie Thomas, and Alice Zachman. To transcribe the interviews, I called upon friends and friends of friends, and in a volunteer network that made this book possible on a shoestring budget. Thanks to Kelly Fagen Altmire, Eleana Ditanna, Itzel Fairley, David Gross, Suzy Wills Kelly, Alicia Kochar, Michele Nelson, Denise Oliviera, Virginia Stevens, Heather Troup, Brian Turetsky, and Annelle Urriola. My dear friend Lynne O'Brien took up the arduous task of identifying and organizing the transcribers for the last five months of the project, transcribing many herself, and her enthusiasm and efficiency were vitally important throughout; thank you, Lynne.

Transcriptions finished on each interview, I then sent them on to Nan Richardson. Our friendship spans a quarter century, and it is difficult to describe how central Nan was to the production of this project. When I conceived the idea, Nan was the first person I turned to, and her enthusiasm inspired me to write a proposal. Her remarks on that proposal readied it for presentation to Random House. Nan suggested I use her agent, Sarah Chalfont, at the Andrew Wiley agency to negotiate the deal, which Sarah did with tremendous positive energy, standing by the project at every turn in the road. Nan was there also, with me every step of the way, editing my edits of the interviews, waiting patiently for my re-edits, and then editing again, and returning them to me. Each transcription went through a minimum of eight edits, sometimes more. Original versions of several interviews were over thirty pages long; narrowing them down to a core four or five pages while retaining the most compelling material required imagination and sensitivity. I relied on Nan's judgment throughout. Having never written a book before, I was blissfully unaware of the complexities of the publishing industry and the requirements for actual production of a photography book. Nan took responsibility for layout, design, and production, and without her insider's knowledge, dogged determination, and supreme organizational skills, this book would never have been produced with such care and timeliness, and for that I thank her. When we ran into difficulty, Nan was always reliable and fair. Nan, for all your help and support throughout, thank you.

Sincere thanks to the rest of Nan's staff at Umbrage who packaged this book in its original hardcover edition and published its subsequent editions, especially the amazing Isadora Zubillaga for her tremendous work on the Spanish edition

and the international outreach, to assistant editor Camille Robcis, who worked on the book night and day, tracking people to the ends of the earth and keeping a thousand details in order, when chaos seemed to reign, and to Lesley Martin, Sophie Fenwick, and Elaine Luthy. Thanks to Yolanda Cuomo and Kristi Norgaard for strong and inspired design, and endless enthusiasm. I am grateful at Crown to Philip Turner, who believed in this book through thick and thin; to Doug Pepper and Steve Ross, who stood up and said yes when no would have been so much easier; to Teresa Nicholas, director of production; and Rachel Pace and Tina Constable. Thanks also to Peter Bernstein whose vision allowed the project to go forward.

In the theater presentation thanks first to Ariel Dorfman for his superlative efforts in making a true drama out of these interviews, and his energetic work over the last two years in supporting the play in a dozen countries his agent Peter Hagen for his support. Larry Wilker and Elizabeth Thomas at the Kennedy Center for taking on the premiere; director Greg Mosher for his vision for the production, one of his frequent human rights contributions, and actors John Malkovitch, Kevin Kline, Sigourney Weaver, Afre Woodward Rita Moreno, Hector Elizondo, Alec Baldwin, Giancarlo Esposito, and Julia Louis Dreyfuss, who were so generous in their time and support.

The cost of making this book and the related materials far exceeded the actual funds available for completion, and many participated in making its existence possible. I am most grateful to Agnes Varis of Agvar and the Generic Pharmaceutical Association and to Paul and Phyllis Fireman at the Paul and Phyllis Fireman Fund for their major support, to Daniel and Ewa Abraham, Elliot Broidy and Matt Gohd, David and Storrie Hayden for their personal generosity, Eunice Kennedy Shriver at the Joseph P. Kennedy, Jr. Foundation, along with Doug Cahn, Sharon Cohen, and Paula van Gelder at the Reebok Foundation, Debbie Dingell at the General Motors Foundation, and Sidney Kimmel. In addition, we relied heavily on in-kind donations from a number of generous supporters. At the Robert F. Kennedy Memorial, Dean Smith first saw the value of sponsoring the project while Lynn Delaney allowed me to call upon the staff of the R. F. K. Center for Human Rights whenever I needed their help; Fran Warring created meticulous records out of thousands of scraps of paper from countries and currencies too numerable to mention. Thanks to R. F. K. staff members Abigail Abrash, Josefina Harvin, Carrie Heitmeyer, Margaret Huang, David Kim, Anjali Kochar, Alex Mundt, Margaret Popkin, Stephen Rickard, Kimberly Stanton,

and James Silk. At Coudert Brothers, the kindness, generosity, and wise counsel of Anthony Williams kept this project out of trouble and on track; my sincere gratitude to him and to his indefatigable assistant, Lee Stiles. At United Airlines, Joe Laughlin came through with wings to remote places, sometimes at the eleventh hour, like the prince he is. Also thanks to Anne Costello, Anne Wexler, and Bernie Willett at American Airlines, to Fred Malek at Marriot, to Bob Burkett at Northwest, to Christopher Hunsberger at the Four Seasons in Washington D.C., and for facilitating the Starwood Westin Palace, Madrid, Christopher Evans and David Stein.

I would also like to thank Marcel Saba of the Saba Agency for offering help when we really needed it; Joel Solomon for organizing the Mexico trip as well as transcribing and translating for Digna Ochoa and Patria Jiménez; Charlie Roberts for translating for Jaime Prieto and Maria Teresa Tula, and the ARTI transcribers for their excellent work. A special thanks to those whom we hoped to include in the book until oceans and time proved obstacles we could not overcome for this edition, namely Olissa Agbakoba of Nigeria, Willy Mutunga of Kenya, Jacqui Katona and Yvonne Margarulas of Australia, Zazi Sadou of Algeria, and Bambang Widjojanto of Indonesia. A very special thanks to Moulud Said who worked so hard to facilitate access to his people, the Sahrawi of Western Sahara. To the women in Algeria, I deeply regret that your government yanked our visas hours before arrival and we therefore missed hearing your stories; similar regrets are extended to those in Kosovo, Rwanda, and Chechnya, who we hoped to include here—someday we will work together. Writing this incomplete list makes me realize how blessed I am to be involved in human rights, in work so compelling that it naturally creates an expansive support network. We are not alone. Thanks to you all. I am blessed by extraordinary friends and family whose love and support sustain me, and who put their many resources at my disposal, especially Susan Blumenthal, Chris Downey, Beth Dozoretz, Rhoda Glickman, Ethel Kennedy, Rory Kennedy, Andy Karsch, and Mary Richardson Kennedy.

Albert Camus said, "In the depth of winter, I finally learned that within me, there lay an invincible summer." My love to three little girls who never fail to show me all the joys of summer: Cara, Mariah, and my smallest companion, Michaela, who sat on my knees or hid beneath my desk as I typed.

—KERRY KENNEDY

ACKNOWLEDGMENTS

I would like to acknowledge Melissa LeBoeuf for producing this project over the past three years, for her hundreds of phone calls, late hours, finesse in logistics, her refusal to accept the word no for an answer, for scheduling fifty photoshoots worldwide, and for her unwavering and untiring dedication—I thank you. I would like to thank my wife, Alyssa Adams, for her photo editing skills and for her help in pushing this project during its final stages.

I would like to take this opportunity to thank the people who have opened doors for me during my career, giving me the breadth of experience as a photographer and a person, laying the foundation to make this project attainable to me as a photographer: Walter Anderson of *Parade* Publications; Hal Buell, Keith Fuller, Lou Boccardi, and Wes Gallagher, all of the Associated Press; and John Durniak and Arnold Drapkin of *Time* magazine. I also want to thank The Eddie Adams Photojournalism Workshop board of directors for their continued support over the past thirteen years and their shared belief that one photographer can make a difference: Vince Alabiso, Larry Armstrong, Adrienne Aurichio, Hal Buell, Barbara Baker Burrows, James Colton, Dave Einsel, Steve Fine, John Filo, Maura Foley, Mayanne Golon, Tom Kennedy, Kent J. Kobersteen, Eliane Laffont, Nancy Lee, Richard LoPinto, M.C. Marden, Carl Mydans, Gordon Parks, Joe Rosenthal, Kathy Ryan, Patrick T. Siewert, and Michele Stephenson.

My sincere acknowledgments to Kodak Professional Division for their Tri-X Pan film used in making these images and to the following manufacturers for the cameras used in creating these portraits: Nikon (for the F5), Mamiya (for the RZ67), and Contax (for the Contax 645). A special thank you to Richard LoPinto, Bill Pekala and Sam Garcia of Nikon, and Henry Froelich and Jan Lederman of Mamiya for their continued technical support and friendship. A much-appreciated thank you to both George Smol and Charles Griffin who printed the pictures for book and exhibition, respectively, under a tight deadline.

To my first family, thank you to my children, Amy, Susan, and Edward and their mother, Ann. To my youngest, everyday, at least once, I'll embrace my ten-year-old son, August. I'll look into his sparkling blue eyes and say, "I love you!" Thank you, my son, for your inspiration and confidence.

And a very special "thank you" to the unknown soldiers without guns—I salute you.

—EDDIE ADAMS

Speak Truth to Power, the multimedia exhibition of photographs,
opened at The Corcoran Gallery, Washington, D.C.,
and is traveling internationally to selected venues including:

Columbia University, New York, New York

The National Civil Rights Museum, Memphis, Tennessee

Museum of Modern Art, Jacksonville, Florida

The Winter Olympics/ Sundance Festival, Salt Lake City, Utah

Cultural Center of the Municipality of Athens, Park of Freedom, Athens, Greece

Museo de Arte de Puerto Rico, San Juan, Puerto Rico

Sala Alcala 31, Madrid, Spain

Museum of Photographic Arts, San Diego, California

Forum of Cultures 2004, Barcelona, Spain

Festa dell'Unita, Genoa, Italy

Rothko Chapel/The Station, Houston, Texas

Martin Luther King Historical Site Museum, Atlanta, Georgia

Albert Schweitzer Institute, Quinnipiac University, Hamden, Connecticut

University of North Carolina, Chapel Hill, North Carolina

Korea Democracy Foundation, Seoul, Korea

Tulane University, New Orleans, Louisiana

Centro Cultural Recoleta, Buenos Aires, Argentina

For more information about the exhibition and education materials
contact: amy@umbragebooks.com

Published by Umbrage Editions, New York
www.umbragebooks.com

Printed in Spain

ISBN 1-884167-33-0

9 8 7 6 5 4 3 2 1

Library of Congress Cataloging-in-Publication Data
is available upon request.

Umbrage Editions, Inc.
515 Canal Street, New York, New York 10013
www.umbragebooks.com

Publisher and Editor: Nan Richardson
Marketing Director: Amy Deneson
Exhibitions Director: Launa Beuhler
Production Director: Andrea Dunlap
Associate Designers: Kristi Norgaard, Emily Baker, Tanja Geis, Anna Knoell
Editorial Assistant: Whitney Braunstein

Book Design: Yolanda Cuomo Design, NYC

Map: Jeffrey L. Ward Graphic Design

Please visit our website at: **www.SpeakTruthtoPower.org**